D0852150

APR 3 0 1999

The
POWER
of
GLAMOUR

The Women Who Defined the Magic of Stardom

Crown Publishers, Inc.
New York

The
POWER
of
GLAMOUR

SAN DIEGO PUBLIC LIBRARY
LA JOLLA BRANCH

ANNETTE TAPERT

PHOTOGRAPH EDITOR: ELLEN HORAN

3 1336 04760 3882

Copyright © 1998 by Annette Tapert
Title page illustrations by Shawn Banner.
Photograph credits appear on page 250.

All rights reserved. No part of this book may be reproduced or transmitted in any form or by
any means, electronic or mechanical, including photocopying, recording, or by any
information storage and retrieval system, without permission in writing from the publisher.

Published by Crown Publishers, Inc., 201 East 50th Street, New York, New York 10022.
Member of the Crown Publishing Group.

Random House, Inc. New York, Toronto, London, Sydney, Auckland
www.randomhouse.com

CROWN and colophon are trademarks of Crown Publishers, Inc.

Printed in China

Design by Lauren Dong

Library of Congress Cataloging-in-Publication Data
Tapert, Annette.
The power of glamour / by Annette Tapert. — 1st ed.
Contents: Gloria Swanson, Joan Crawford, Norma Shearer, Carole Lombard,
Kay Francis, Dolores Del Rio, Constance Bennett, Claudette Colbert,
Katharine Hepburn, Greta Garbo, Marlene Dietrich.
1. Motion picture actors and actresses—United States—Biography. I. Title.
PN1998.2.T29 1998
791.43'028'092273—dc21
[B] 97-46790

ISBN 0-517-70376-9

10 9 8 7 6 5 4 3 2 1

First Edition

for Georgia and Nicholas —
the stars of my life

And for Jesse —
with infinite gratitude

Contents

Acknowledgments

This book would not have been possible without the assistance of those who knew these legendary women, friends who graciously opened their address books, and those who supported me in various shapes and forms:

Adolfo, Cleveland Amory, Steven Aronson, Joan Axelrod, Bryan Bantry, Betty Barker, Jeanine Basinger, A. Scott Berg, Bill Blass, Betsy Bloomingdale, Lillian Burns, Michael Butler, John Cantrell, Cynthia Cathcart, David Columbia, Tommy Corcoran, Arlene Dahl, Gloria Daly, Ray Daum, Milly de Cabrol, Frances Dee, Linda Donahue, Douglas Fairbanks Jr., Pamela Fiori, James Galanos, Leonard Gershe, Jerry Goldsmith, Ellen Graham, Nina Griscom, Sydney Guilaroff, Richard Gully, Bill Hamilton, Curtis Harrington, Kitty Carlisle Hart, Peter Hathaway, John Heilpern, Reinaldo Herrera and Carolina Herrera, Nancy Holmes, Leonora Hornblow, Jean Howard, Betsy Kaiser, Wayne Lawson, Sara Lewis, Dorothy Manners, Jacques Mapes, Jack Martin, Richard Mauro, Peter McCrea, Roddy McDowall, Nolan Miller, Lee Minelli, Laura Montalban, Marlene Noble, Helen O'Hagan, Tarquin Olivier, Wayne Parks, Peter Plant, Peter Rogers, Richard Roth, Yvette Mimieux Ruby, Sharon Sondes, Leonard Stanley, Wendy Stark, Marti Stevens, Noel Taylor, Sara Vass, Peter Viertel, Connie Wald, Shelly Wanger, J. Watson Webb, Mignon Winans, and Michael Wollaeger.

A special thank you:

To my ever-patient, understanding editor and friend, Betty A. Prashker.

To my photo editor, Ellen Horan, for her remarkable eye and flawless attention to detail.

To Douglas Whitney for making his voluminous photographic archive available to me. You were this project's white knight. Your thoughtfulness, generosity, and enthusiasm touched me deeply.

To Ellen Hollander, a guiding light.

Introduction

Until this century, glamour was associated with the occult. The word denoted an attractiveness that was exciting, romantic, fascinating—an attractiveness too powerful to be real. Such personal power had, therefore, to be allied with sorcery.

At the end of this century, glamour has become something of an exact science. Plastic surgeons can sculpt perfect faces and bodies. Fashion designers can swathe women in clothes calculated to be flattering. And press agents can create an image that is suited to the needs of the times. Although it may be sorcery, it's hardly magical—this attractiveness has all the charm of computer programming.

But for a decade and a half, there was true glamour in America. It came from Hollywood, starting in the silent era and lasting until the start of World War II. At its most vivid—in the thirties, a decade that is sometimes regarded as the golden age of cinema—it took the drabness of the Depression and simply overwhelmed it, casting a magical spell over the American public. With lavish sets and dazzling costumes and, most of all, actresses who were beautifully coiffed and expertly made-up, the studios created a romanticized vision of America that gave its beaten citizens dreams, courage, and hope.

This was, of course, a contrived, quasi-scientific effort. Behind the scenes, studio publicists had the task of inflating the stars into larger-than-life figures. At the same time, they protected the stars from negative publicity, hushing up any scandals. Stars were coddled, groomed into sophisticates, and then displayed like valuable, exotic show animals.

The fan magazines were complicitous in these propaganda campaigns. Their entire mission was to profile the stars in ways that reinforced studio-created images. They photographed their mansions and had the stars pose in beautiful clothes. When they interviewed the stars, they concentrated on rags-to-riches stories, beauty tips, and highly edited accounts of romances.

The unsurprising result was that the public came to believe that a star's life was the same off-screen as it was in the movies. In this way, screen idols became American royalty. And then, as American movies made their way around the world, these actors and actresses became the planet's first international celebrities.

Then, as now, the star-making machinery was about self-invention and reinvention. Would-be actresses escaped from generally drab backgrounds and arrived in Hollywood eager to become their fantasy selves. The studios did the rest. Teeth were straightened, jaws realigned. Doctors recommended by the studios prescribed strict diets. Studio-approved beauticians reshaped eyebrows. Makeup experts

changed the size of a mouth; costume designers created individual styles that enhanced a physical asset or hid a figure flaw.

But the concept of glamour is not, in the end, reducible to fashion and cosmetics—it's about the woman herself. And in the 1930s, in particular, personality was the key ingredient in a star's glamour. Photographer George Hurrell, the grand seigneur of Hollywood portraiture during this period, once said that the glamour of the stars of the 1930s was not an illusion. "You could feel an atmosphere to it," he observed. "You felt inspired when someone like Dietrich or Crawford walked into the room. The real stars were conscious of glamour. That's part of what it meant to be professional."

Before I fully understood what Hurrell meant, my intention was to profile a series of screen actresses who had influenced fashion and beauty, starting from the silent-screen era and ending with some contemporary star. My lists of possible profiles were long and fascinating; they were also unbalanced. Because when you look at the sweep of glamour in Hollywood, you see that the majority of actresses who made an impact came from one period— the so-called glamour era.

The more I researched the 1930s, the more intrigued I became with several actresses whose names no longer resonate but who epitomized fashion, beauty, and personality during the thirties. And the more I looked at photographs of them taken both on and off the screen, the more I concluded that their style still resonated. Kay Francis, Constance Bennett, Dolores Del Rio—these actresses have been given only brief acknowledgment in film books. They deserved, I thought, a bigger place in film history.

The female stars of the 1930s—from the nearly forgotten Kay Francis to the unforget- table Garbo—strike me not just as style and glamour icons but as pioneers. In varying degrees they set the patterns for stardom that actresses for the next six decades have emulated. More importantly, they represented the nation's first group of prominent career women. Their on-screen personae embodied the fantasies of modern women and fueled dreams for millions. They became what we now call—in a phrase that conveys the remarkable impact of Hollywood—role models.

All of these eleven women were put under contract by their studios to be developed into glamour queens. But each woman refutes the myth that the 1930s star was solely a creation of those studios. Joan Crawford, for example, embraced the star system and is generally cited as its quintessential product; in fact, she was the ultimate architect of her persona. While the MGM chiefs surely provided her with the blueprint, it was her limitless ambition and desire to be adored that led her to devote all her energies to living as if her entire life were conducted with cameras turning on a vast movie set.

Katharine Hepburn—who fought the attempts of RKO executives to mold her and who seems to be Crawford's opposite—succeeded because, like Crawford, she understood that she was the ultimate guardian of her image.

Carole Lombard realized early on that if she was going to make it in Hollywood she had to project the same screwball persona offscreen that she played on film, so she worked closely with Paramount to coordinate her publicity.

Claudette Colbert, Paramount's other queen of screwball comedies, did the opposite. She protected the woman she knew herself to be: a sophisticated East Coast stage actress who was

first and foremost a lady. She also brought her well-bred fashion look with her from New York City and refused to let the studio makeup artists and hairstylists work on her.

Greta Garbo fashioned her own myth by refusing to do anything that didn't please her. Although Garbo paradoxically achieved Hollywood immortality for her inability to handle stardom, the Kay Francis story is actually far more dramatic—and tragic. Now almost forgotten, Francis was the cinema's most celebrated clotheshorse during the 1930s. Her entire career was based on fashion and glamour, and American women followed her lead; as a style influence, her only competitor was Joan Crawford. But unlike Crawford, she so hated the business of being a star that she was punished—indeed, ruined—by the studios.

Norma Shearer's success is usually attributed to the fact that she was the wife of Irving Thalberg, MGM's head of production. But long before she married, Shearer had learned how to pose to hide her short, chubby legs. She figured out how to look into the camera to disguise the fact that she was somewhat cross-eyed. Shearer's popularity had begun several years before she became Mrs. Irving Thalberg—and at that time she actually earned more than her future husband.

Constance Bennett, one of the enfants terribles of Hollywood, was, at one point, the industry's highest-paid actress. As a product of European finishing schools, she needed no one to groom her. She was also independently wealthy as a result of her marriage to (and divorce from) an East Coast blue blood. Bennett's film career was, for her, a lark. She always knew that real life held more fascination.

Dolores Del Rio was the first Mexican actress to succeed in Hollywood. Her exotic beauty and ability to wear clothes made her a hot property. But she also knew that "when they give you wonderful clothes, they give you bad parts." By 1940, she realized that her employers had no interest in nurturing her talent. And so she left for a more rewarding career and life in her native country.

Marlene Dietrich was and still is the icon of thirties cinema glamour. Hollywood afforded her the opportunity to construct her image out of her own excesses and intuitions. With the help of makeup, lighting, and costuming experts, she carved out a screen persona that matched the temptress she was in real life— smoldering, wise, and worldly. And unlike Garbo and Hepburn, she didn't hide behind her man-tailored clothing; she wore pants in a way that enhanced her image as a seductress.

Gloria Swanson's career had virtually ended by 1934, but when she rocketed to stardom in the early 1920s, it was Swanson who made "glamour" synonymous with Hollywood. She was the first "movie star" and the first to understand that audiences wanted these stars to be exceptional creatures both on and off the screen. Achieving megastardom before studios had sophisticated publicity departments, she crafted her own image.

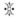

All these actresses lived the part in a way that suggested there was more than an anecdotal congruence between the fashion and glamour they displayed on the screen and the fashion and glamour of their private lives. Given that, I have chosen to illustrate this book primarily with off-screen photographs of these women. These photographs are less often seen than movie stills and, in their novelty, are more rewarding to look at. And they prove more

dramatically than any prose that, during the thirties, Hollywood's biggest stars really did live and dress on a scale more glamorous than we have seen at any time since.

Exceptions? Even those who don't know much about Hollywood will protest that Katharine Hepburn and Greta Garbo don't fit this description. Theirs was a casual, mannish, anti-glamour look. But that anti-glamour approach had such enormous power that it created a kind of reverse glamour.

Objections? Readers may wonder why I chose not to include Bette Davis, Myrna Loy, and Irene Dunne, to name only a few. Bette Davis and Myrna Loy were not notable on-screen clotheshorses. Nor were they known for their personal style. Irene Dunne, though a celluloid fashion plate, lived a very private life and was rarely seen in public.

In the end, though, objectivity and completeness are to no point when the subject is glamour. The topic is highly personal; its very subjectivity is what makes us respond so passionately to what is, after all, a fairly ephemeral notion. So the closest I could come to a coherent selection process was to choose women whose personal tastes and personal struggles struck me as still timely.

The evolution of these eleven actresses—how they used their often modest beauty to become fashion and style exemplars—is what appeals most to me. Here they were, fighting to succeed against great odds in a tough industry governed completely by men who had created a system that gave them almost dictatorial power. And in the process of being exploited, these women used classic feminine arts—style, wit, guile—to outsmart the system.

For those of us who are too young to remember these glory days, it is all but impossible to conceive of the magnitude of the stardom these women achieved. Our stars today are photographed pushing baby strollers, appearing in public with uncombed hair, arriving at airports wearing leggings and sneakers. As a general rule, they feel their stardom should hinge on talent rather than on who they are as people or on how they present themselves in their off hours.

The women I've profiled were almost exact opposites of today's stars. With the exception of Greta Garbo and Katharine Hepburn—though both knew the impact their dress-down togs had on the public—none of these women would ever have considered leaving the house without being perfectly turned out. For them, lunch at Romanoff's was like walking onto a movie set. They didn't do it just because the studios expected them to dress and act like stars at all times. It was part and parcel of who they were or who they had become.

Mae West once said, "A real star never stops." These women would not have applauded Sharon Stone's decision to wear a $22 Gap turtleneck to the Academy Awards presentation in 1996. They would not have understood Demi Moore's decision to appear on the cover of *Vanity Fair* showing her naked pregnant body.

To these eleven women, glamour meant intrigue, mystery, knowing how much to reveal and when to reveal it. They had the ability to change the temperature of a room when they entered it. What they practiced both in public and in private was akin to glamour's original meaning: witchcraft.

In the end, perhaps it's very simple. Beauty is not that rare. And many people have talent. But glamour—glamour *is* fame.

—*Annette Tapert*

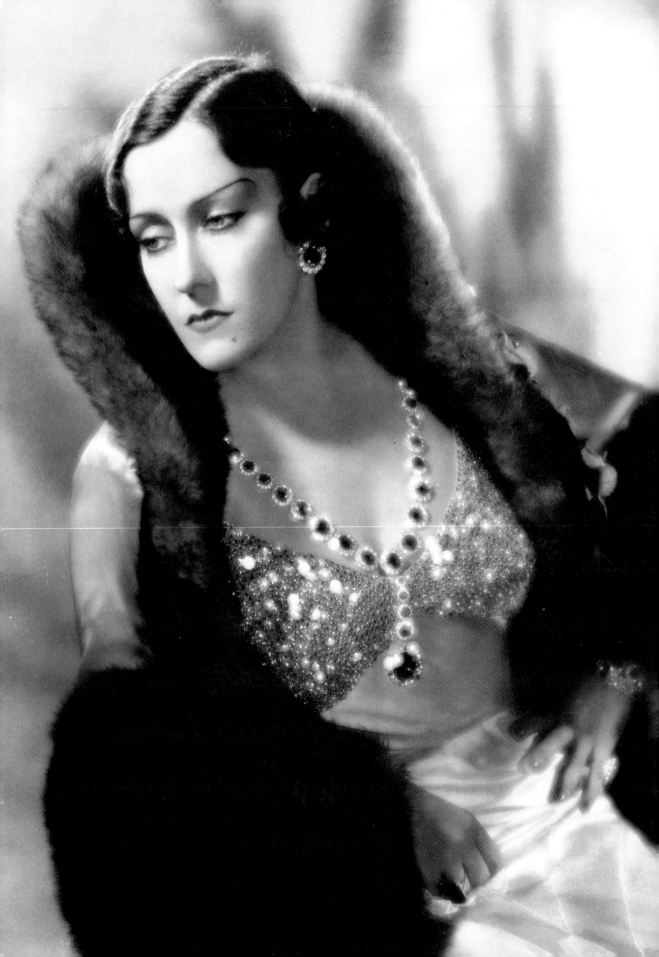

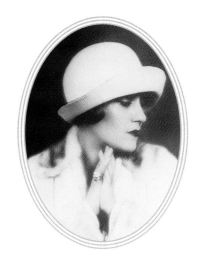

Gloria Swanson

When people meet me, they expect me to bite them, I guess because they expect me to be Norma Desmond," Gloria Swanson once said about her memorable role in Sunset Boulevard as a faded silent-screen actress. "A lot of people thought Norma Desmond was the story of my life. I'm not a recluse, nor am I out of the past. . . . It's amazing to find so many people who I thought really knew me could have thought Sunset was autobiographical. I've got nobody floating in my swimming pool."

She had a point. Norma Desmond had waited twenty years for a comeback. Gloria Swanson never waited for anything in her life. Instead, she seized her opportunities as they presented themselves and when they had played themselves out, she cut her losses and moved on, consistently reinventing herself as she went along.

"When you put them all together and add them up, Gloria Swanson comes out the movie star of all

movie stars," observed Cecil B. DeMille, decades after the actress's rise to stardom in the twenties. "She had something that none of the rest of them had."

What Gloria Swanson had was glamour, written in big capital letters in large sparkling lights. And it was Swanson's dazzling persona in the 1920s that put "glamour"—then a rarely used word—into common usage, making it synonymous with Hollywood.

It all started in 1919 when DeMille tapped Swanson to star in a series of lavish films that depicted upper-class folk embroiled in domestic entanglements. Swanson was magnificently gowned and dripping in real jewels. The characters she played were young women with exciting, high-voltage problems. They had to wrestle with sexuality and infidelity—either their own or their spouses'.

In these six films Swanson did such unconventional things as divorce her husband for a rake, then remarry the husband. Or she was a bland wife, rejected by her husband, who transformed herself into a beauty and won him back. In another film she played a woman who had two fiancés.

Although Swanson was only twenty when she started making the movies that established her as an icon of glamour, she was eager to

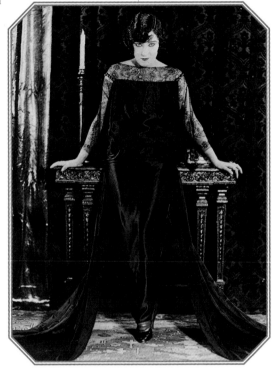

BY 1926, Swanson was the most imitated star in the world.

make the transition from reality to illusion. "I have decided that when I am a star, I will be every inch and every moment a star," she said. "Everyone from the studio gateman to the highest executive will know it."

Off-screen she also liked to be swathed in luxurious fabrics and significant jewels and wear them against a backdrop of splendor. In life as well as in films, she indulged in dramatic love affairs and serial marriages. She entertained on a scale that would have impressed Marie Antoinette.

For a movie-crazed public desperate to live vicariously through its movie stars, Swanson's filmic and off-screen lives seemed to merge. And Swanson fed the myth. "The public didn't want the truth," she commented years later.

But behind this saga of conspicuous consumption, there was another story being played out: the very public education of a practical, down-to-earth woman, who, at twenty-six, recognized that she was a prisoner of fame. She saw with unusual clarity that stardom was an impediment to a good marriage and a contented personal life. She understood that stars were victims. And yet she not only struggled to keep her values intact, she continually stood up to the industry titans who were out to exploit her.

Swanson's career is like a capsule history of

the movies. The tale of the pint-size pipsqueak who became a Napoleon in skirts is a miniature portrait of the progress of women in this century.

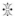

"I feel sure that unborn babies pick their parents. They may spend a whole lifetime trying to figure out the reasons for their choice, but nothing in any human story is accidental," Gloria Swanson wrote in her memoirs, *Swanson on Swanson*. But aside from the fact that she was a clotheshorse from a young age, very little in Swanson's childhood seems connected to her later life.

Gloria May Josephine Swanson was born in Chicago in 1899. Her father was a civilian attached to the U.S. Army Transport Service; her early life was spent moving from one army base to another. As an only child, she was doted on by her mother, who went to considerable lengths to outfit her in fancy clothes as a way to camouflage two worrisome flaws: unusually large ears and oversize teeth. In every other way she was a beautiful child with unique features. From her Italian ancestors, Gloria had inherited an olive complexion. From her Swedish and German forebears, she got almond-shaped blue eyes—so pale and clear that you felt as if you could see through them.

Even as a young child, Swanson spent considerable time with adults and was sophisticated beyond her years. "I dreamed steadily of being a grown-up," she said. By her early teens she was wearing soignée frocks that made her appear older. At fifteen she visited Essanay Studios in Chicago with a movie-mad aunt who was invited by the company's owner to have a peek at the new medium of moving pictures. Swanson's air of sophistication caught the

attention of the studio's casting director, who asked her to return in exactly the same outfit she was wearing that day: a black-and-white checked skirt with a slit up the front, a black cutaway jacket, and a green waistcoat that her mother had modeled after an outfit worn by the celebrated ballroom dancer Irene Castle, a leading fashion trendsetter.

In her first role Swanson rushed onto the set and handed a bouquet of flowers to a bride. Not much of a part, but she made enough of an impression to be offered a contract as a stock extra at $13.25 a week.

"In those days no one ever thought of becoming a motion picture actress. It was like saying 'I want to be a burlesque queen,'" Swanson observed in later years. Why did she take the contract? Money. She detested school. With a job, she could finally persuade her mother to let her quit and be what she always wanted to be: a grown-up.

By 1915, Swanson was working regularly, playing thirty-year-old women in comic two-reelers with Wallace Beery. Swanson was next teamed up with Charlie Chaplin, but his whimsical slapstick skits were lost on her. After he'd coached her for hours, she finally told the comedian that she failed to see the "humor in many of the things he was asking me to do." He responded by asking for a replacement. Swanson, Chaplin thought, "didn't have a strong enough comic sense to be in his picture."

It wasn't just Chaplin who perplexed her. The business itself held little allure for Swanson. She found motion pictures so "crude and silly" that she wouldn't watch her own movies from beginning to end even when she landed featured roles that had her playing mature socialites.

The novelty of moviemaking might have

ended in Chicago—and Swanson might even have pursued her larger ambition to be an opera singer—if it hadn't been for a sudden turn of events. Her father had been transferred to the Philippines, and she and her mother decided to take a vacation in California en route to Manila. Before they left, Essanay's casting director gave Swanson a letter of introduction to Mack Sennett, the comic genius.

The Essanay executive wasn't the only one who thought Swanson had something special. Wallace Beery had written to her from California suggesting she ought to try her luck out west. And as it happened, Beery was waiting at the train station to greet Swanson and her mother.

Once in Los Angeles, Mrs. Swanson announced that she was divorcing her husband and that the stay in California would be permanent. As for her daughter, she may have wanted to be an adult, but she was still an impressionable teen. When Beery informed Gloria that the studio where he worked was eight hours away and that he'd made the drive specifically on her behalf, a romance quickly followed. Several months later she celebrated her seventeenth birthday by marrying the twenty-nine-year-old actor.

It was only on her wedding night that Swanson discovered Beery was far from a cuddly protector. He was a brute who handled his underage virgin wife like a caveman. She endured her first grown-up mistake for two months. When she learned she was pregnant, Beery gave her medication that he said would ease her morning sickness; it turned out to be a drug that induced a miscarriage. With that, she ended the marriage.

Still, her marriage to Beery was a blessing. For it was he who encouraged her to use her let-

ter of introduction to Mack Sennett. After one film, Sennett hired her at his Keystone Studios for $100 a week. Once there, Swanson immersed herself in the development of her craft as a distraction from her personal nightmare. And she soon decided that if she was going to be in movies, "I was going to be good in movies. I was one of the first deadpan comedians. I was funny because I didn't try to be."

At Sennett, she quickly became a featured player in homespun romantic comedies and for the first time was required to play an ingenue. She now looked like a teenager, but already she possessed a sense of identity that enabled her to make astonishingly mature decisions. Sennett realized Swanson was star material, which for him meant moving her out of lighthearted material and into slapstick.

It only took one film, *The Pullman Bride*, in which she was forced to play a cutie scampering about in a ridiculous bathing suit and lace-up galoshes, to convince Swanson that slapstick was not for her. "It was somehow not respectable. I hated the vulgarity that was just under the surface of it every minute." When Sennett promised he'd make her another Mabel Normand, she fired back that she was never going to be "another anybody" and walked off the lot.

Swanson moved on to Triangle Films, where she starred in a succession of second-rate dramas. She was given full star treatment and free rein to choose her costumes. But for all that, Swanson still wasn't quite sure what she had to offer the film world. She was a runt—just a little over five feet in high heels—with larger-than-life features that still made her self-conscious. She covered her mouth when she smiled to hide her enormous square teeth, wore her hair in a style that covered her large

AN EARLY portrait of Swanson taken in a New York studio.

ears, and chose outfits that camouflaged a thick waist. She didn't realize that she had an innate seductiveness and style that permeated everything she did; the way she held a cigarette, the way she sat or crossed her legs, the wide open smile that oozed charisma, even her name, suggested that she was meant for bigger things.

"What I saw was authority, as well as beauty, in Gloria Swanson, when I first noticed her simply leaning against a door in a Mack Sennett comedy," Cecil B. DeMille wrote in his memoirs. "I saw the future she could have in pictures if her career was properly handled." When she signed with DeMille's unit at Paramount, he assigned her to his cycle of marital films. It only took the first one, *Don't Change Your Husband,* to make Swanson an overnight sensation.

"The public, not I, made Gloria Swanson a star," DeMille wrote. It was the dawning of the Jazz Age, and DeMille's studies of marriage and divorce offered America a series of tales that paralleled the new liberal moral standards. These films were a significant departure from the candy-coated Victorian romance yarns that had turned Mary Pickford into Hollywood's first movie star. And in the same way that Pickford's purity, innocence, and steadfastness had been an inspiration for women, Swanson was the lodestar of the twenties, setting the tone for a new kind of female—sensuous, provocative, worldly.

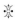

The clothes she wore on and off screen made Gloria Swanson Hollywood's first high-fashion influence—no one before her had worn in her private life the same kind of clothes she wore in the movies. Fans marveled that Swanson never wore the same dress twice.

Her gowns and hairstyles were copied by thousands of adoring women. Because of this large following, her fan mail during the twenties was never less than ten thousand letters a week. She soon became the first movie star required by her contract to appear in public fashionably dressed. And that she did. She was the first to wear bracelets on her upper arms, and she created a fad for jeweled sandals. By 1926 she was the official queen of the screen, the most imitated movie star in the world, and the most photographed woman of the decade.

Still, her fans weren't quite sure why they found this woman with the oversize head, prognathous jaw, and dished nose so compelling. Swanson didn't conform to the accepted notion of beauty. In the looks department, women in silent films were typecast as ingenue, vamp, or matron; she fit into none of these categories.

Elinor Glyn, the flamboyant English writer whose steamy novel, *Three Weeks,* caused such a sensation that she was brought to Hollywood in 1920 to write *The Great Moment* for Swanson, defined the actress's allure in historical terms. "Egyptian! Extraordinary, quite extraordinary. You're such a tiny, dainty little thing," she told Swanson. "But of course if your proportions are perfect, they can make you any size they want. Your proportions are Egyptian; anyone can see that when you turn your head. You have lived there in another time."

Glyn helped Swanson refine her appearance and manners and stressed that a great part of her uniqueness was in her face. Of course, as with all silent-screen performers, everything registered in Swanson's eyes. "She has perhaps the loveliest eyes I have ever seen," Glyn wrote in *Photoplay* magazine in 1921. "They are strange eyes, not altogether Occidental, which

gives them their charm—blue eyes, a little up at the corners and the lashes half an inch long."

For all of Swanson's awareness of her irregular looks, it never occurred to her to copy anyone else. She even refused DeMille's repeated pleas to have her nose reconstructed. By allowing her face to be what it was, she found ways to make it more dramatic. After a few films, she decided not to conceal her chin mole; it became a trademark and was copied the world over. In time, the Swanson look had a major impact on other actresses. Joan Crawford idolized her so much that she not only tried to emulate the look but also remade several of Swanson's films and patterned her screen career on Swanson's notion of continual reinvention.

When Swanson went to New York in 1923 to make a series of films, she replaced the fancy hairstyles she had worn in the DeMille films with a sleek bobbed cut

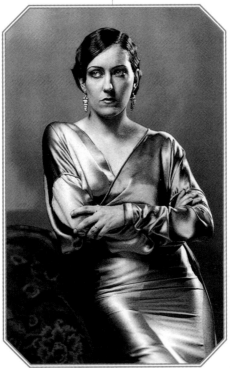

SWANSON WAS the most photographed woman of the twenties.

(the same style that Vidal Sassoon would popularize in the sixties). When the public got its first look at this hairstyle in *Manhandled* (1923), female fans quickly followed her lead. She also dispensed with the elaborate costumes she'd worn on and off the screen. When *The Humming Bird* (1924) was released, she displayed a tailored look that reflected her urbane New York life.

When she went to Paris in 1924 to make *Madame Sans-Gêne*—another first; no other Hollywood star had made a film abroad—she embraced the understated elegance of the French couture houses, most notably Jean Patou. And she brought René Hubert, the couturier who had designed the costumes, back to America. She launched his career here as a costume designer for her films, and he designed her off-screen clothes as well. "She once showed me clothes she had made in Paris during the twenties," recalls Noel Taylor, the costume designer who created her clothes for the Broadway play *Twentieth Century* in 1950. "They were built up inside because she was so small."

Swanson was never putty in the hands of fashion or costume designers. She worked closely with René Hubert, and when she made *Sunset Boulevard*, the costumes were a true collaborative effort with Edith Head. "I knew every centimeter of my body," she said. She had learned along the way that if she lengthened her skirts in the back and dropped the waistline in the back, she looked taller. She also knew that uneven lines gave her height, so she often wore one cuff of a jacket trimmed in fur. When she wore a long gown with only one sleeve, millions of women rushed to their closets with scissors. To minimize her broad shoulders she had things cut on the bias. Though she was diminutive, she favored oversize accessories. She wore turbans,

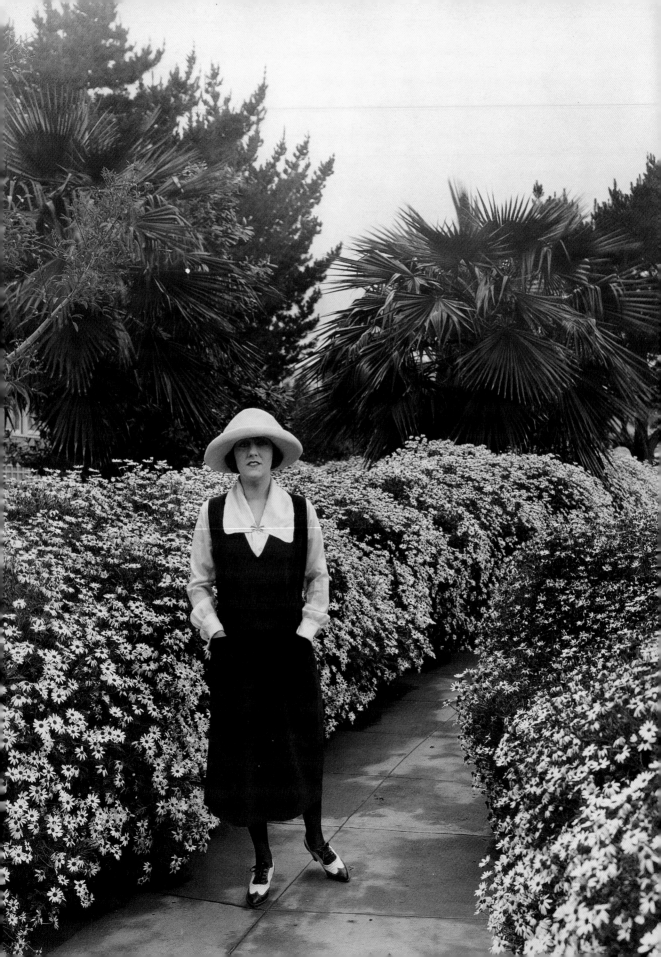

diminutive, she favored oversize accessories. She wore turbans, cloches, and peaked hats that would draw attention away from her large head. "She thought she had a short neck, so she often wore cowl necks to hide it, and she wore a lot of V-necks or off-the-shoulder styles," says her daughter, Gloria Daly.

"Working with Mr. DeMille was like playing house in the world's most expensive department store," Swanson observed. Pinkerton detectives arrived at the set with chests of jewels from which she chose whatever she wanted to wear in the film. Her dressing room was decorated like an elegant hotel suite. Each day violinists played as she was escorted to the set. And once when she was shaken after filming a scene with a lion, DeMille rewarded her by producing a box filled with trinkets and suggested she choose something to calm her nerves. "I picked out a gold mesh evening bag with an emerald clasp and immediately felt much better," she said.

DeMille's expensive taste quickly rubbed off on Swanson. And so, beyond her attraction as a clotheshorse supreme, the other ingredient of Swanson's fame was how much money she spent. Her yearly clothing bill for personal and professional purposes was supposedly the highest of any star, totaling in the region of $125,000 a year—she reportedly spent $10,000 on stockings alone.

It didn't matter if these figures were grossly exaggerated. What was important was that her fans believed what they read. "The public wanted us to live like kings and queens. So we did," she told a journalist in 1965. "And why not? We were in love with life. We were making

more money than we ever dreamed existed and there was no reason to believe that it would ever stop."

To prove it, Swanson bought a twenty-two-room mansion on Crescent Drive in Beverly Hills that had belonged to King Gillette, the razor blade magnate. The walls of the house were hung with tapestries or covered in peacock silk. She performed her daily toilette in a black marble bathroom with a golden tub. The house had a small movie theater, elevators, and a 1,000-square-foot terrace which overlooked a garden that *Photoplay* magazine described as "gorgeousness beyond other grounds." She was chauffeured about in a leopard-upholstered Lancia.

Swanson entertained lavishly. She thought nothing of hosting a soiree for three hundred and giving each guest a solid gold compact or cigarette case as a party favor. Another time, she had liveried footmen attend her guests at a dinner party. To her amusement she later found out they'd been hired from Central Casting. In New York she bought a $100,000 Manhattan penthouse—she made sure the elevator was perfumed—and a 25-acre estate on the Hudson River.

The studio described her in press releases as "the second to earn a million"—Pickford was the first—"and the first to spend it." As Swanson's salary rocketed, she lost all concept of finances and just forwarded her bills to the Paramount accountants who deducted them from her wages and deposited whatever was left, if any, in the bank. The spendthrift was always in debt, but even that realization didn't force her to put a cap on her spending. She once went to New York to borrow $25,000 and then blew it all on a private railway car back to California.

GLORIA SWANSON in the garden of her Beverly Hills estate.

Swanson became the representative of the opulent life enjoyed by the silent stars. For all her indulgences, however, she was not a frivolous person. Early on in the game, it became apparent to her that her scant education had left a gap. And so she set out to cultivate herself. Her extravagances were a part of that education. But she also read voraciously: one of her prized possessions would always be her collection of first editions. She honed her talent as a painter and sculptor. She went to make movies in New York in part because of what the city had to offer culturally. And her curiosity extended beyond the artistic. In 1926 she invented a wireless communication system for her house and patented the idea. After suffering severe stomach problems in 1927, she became a natural food devotee before anyone knew about brown rice and vitamins. Her interest in healthy living would, over time, become her greatest passion.

In Hollywood, Swanson was an anomaly. "I've been Hollywood's guinea pig for more years than I care to remember," she told Hedda Hopper in the 1940s. When she gave birth to Gloria Junior in 1920, while married to her second husband, Henry Somborn, she was the first female star to have a baby at the peak of her career. Despite the protests of Jesse Lasky, Paramount's cofounder, who believed motherhood would rob her of her glamour and wanted her to hide her pregnancy and the baby from the public, she announced the birth. In her case, motherhood added to her fame. After divorcing Somborn, she adopted a son, which made her the first actress to adopt and the first to do so as a single woman.

Swanson was also the first queenly star to engage in serial marriages. She had six in total. For the woman who battled industry heavy-weights, her personal story was a typical one of a woman looking for a father figure. And for a woman who by all accounts had sex pouring out of her, and who inspired love in every man who crossed her path, her choice of husbands was curious. With the exception of the last marriage, she chose only sponges or weaklings. "The mess I made of marriage was my fault," she said in 1965. "I can smell the character of a woman the instant she enters a room, but I have the world's worst judgment of men. Maybe the odds were against me. When I was young, no man my age made enough money to support me in the style expected of me. There's no sense kidding myself—I loved all the pomp and luxury of that style. When I die, my epitaph should read: 'She Paid the Bills.' That's the story of my private life."

After Somborn, she married the Marquis de la Falaise de la Coudraye, which made her the first film star to marry a title. From there she moved on to Michael Farmer, an international playboy with whom she had another daughter, Michelle. After a ten-year hiatus she had a two-month marriage to William Davey, supposedly a wealthy stockbroker but actually a marginally solvent man who turned out to be an alcoholic. In 1976 she married William Dufty who was seventeen years her junior.

But it was Swanson's third marriage in 1925 that completely fulfilled her fans' dream of glamour. Henri de la Falaise had been her interpreter while she was making *Madame Sans-Gêne* in Paris. It didn't matter that the marquis was an impoverished aristocrat. He represented culture and society. And he physically looked the part: tall, racehorse slender, supremely elegant.

Her fans weren't the only ones who

regarded this union as the pinnacle. Fifty years later when an interviewer assumed that *Sunset Boulevard* had been her greatest moment, she sharply corrected him: "Absolutely not. The great event for me was having been the first star to marry a nobleman."

When the newlyweds stepped off the boat in New York and began the cross-country trip on a private train to California, thousands of cheering fans lined the railroad tracks in every town. And the return of Madame la Marquise to Hollywood, after a two-year absence, was pure royal pageantry. In a town where the spectacular can be an everyday occurrence, the tribute that Hollywood paid Swanson was unparalleled.

Traffic was halted for miles as motorcycle escorts led Gloria's white Rolls-Royce limousine from the Los Angeles train station to the corner of Sunset and Vine, then the site of Paramount Studios. The street was roped off, and in the middle a raised platform had been erected. Overhead was a huge banner: "Welcome Home, Gloria!" A brass band played in the noonday sun. Schoolchildren were given the day off to greet Swanson and her consort, and thousands of them lined the street with their parents and flung roses at Swanson as her car drove by. Hedda Hopper proclaimed the event an "emotional orgy."

That night, during the premiere of *Madame Sans-Gêne* at Grauman's Chinese Theatre, mounted policemen held back the crowds that jammed the streets for ten blocks in every direction. Once Swanson and the marquis had inched their way into the theater, the audience of a thousand rose to their feet. Those in the balcony flung orchids and gardenias. And then to orchestral accompaniment, everyone from Cecil B. DeMille to Mary Pickford sang "Home Sweet Home." Minutes later she was instructed by the head usher to leave immediately. The police could no longer contain the crowd. And so Swanson, who was dressed in clinging silver lamé, and the marquis, who'd worn his ribbons and medals, sneaked out through the orchestra pit and out to the backstage alley to her waiting limousine.

For Swanson, this was unquestionably the crowning moment in her career: she had officially replaced Mary Pickford as the nation's most beloved actress. But behind the scenes, Swanson had suffered an intense personal drama. Just before her wedding in Paris she had discovered she was pregnant. She knew that if she delivered a child only seven months after her marriage, the public and the movie industry would deem her morally unsound, and the professional consequences would be disastrous.

The day after the nuptials, without even telling the marquis, she had an abortion. But the doctor bungled the job, and for weeks she lay in a Paris hospital fighting for her life. That Gloria Swanson was mortally ill from a "mysterious illness" only increased her fans' ardor. Newspapers published her temperature daily, while the public waited with bated breath for her recovery.

Swanson had sacrificed something she desperately wanted and had endangered her life to protect her career, but she also knew that marrying a blue blood and having a near-death experience had provided Paramount with millions of dollars in free publicity as a world headline for six weeks. "All that cheering tonight had nothing to do with my acting," she told her mother, after the premiere. "It was all publicity. I'm just twenty-six. Where do I go from here?"

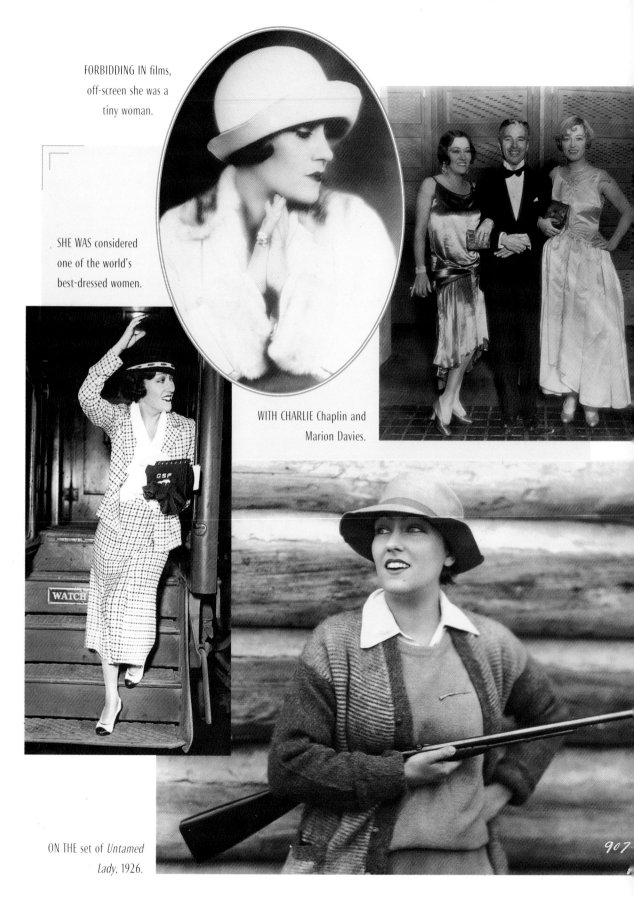

FORBIDDING IN films, off-screen she was a tiny woman.

SHE WAS considered one of the world's best-dressed women.

WITH CHARLIE Chaplin and Marion Davies.

ON THE set of *Untamed Lady*, 1926.

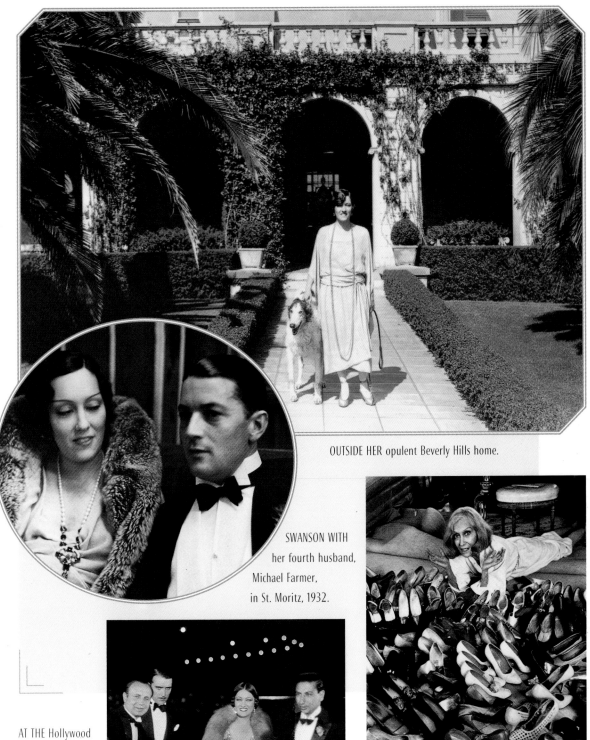

OUTSIDE HER opulent Beverly Hills home.

SWANSON WITH
her fourth husband,
Michael Farmer,
in St. Moritz, 1932.

AT THE Hollywood
premiere of
Madame Sans-Gêne
with her third hus-
band, the Marquis
de la Falaise, 1927.

GLORIA IN her New York City apartment, 1975.

27

*

By 1925 it seemed not to matter if Gloria Swanson's films were good or bad. "People went to all of them," she said. "They thought of me as part of their families. They liked to visit me regularly; see if I had changed since the last picture." Of the more than twenty pictures she had made since working with DeMille, only one, *Under the Lash,* had done poorly at the box office; in that movie she had played a farmer's wife in dull, high-buttoned housedresses.

How she handled her career in the face of intoxicating fame is proof that underneath those fancy headdresses was a gutsy woman. She was as much of an anomaly in her profession as she was in her personal life. No wonder DeMille called her "young fellow." She did not trade in the currency of coyness.

Instead, her steely side had surfaced early on. In 1920, just before the release of her first DeMille picture at Paramount, Jesse Lasky sensed he had a red-hot star on his hands. So he gave Swanson a contract before the film was out that paid her only $200 a week for two years and included an option for the studio to renew for two additional years with only a small salary increase. She innocently signed it.

After the megasuccess of *Don't Change Your Husband,* the studio sold her other DeMille pictures as Swanson films with her name heading the marquee. In short, studio and movie houses were cashing in on her to a degree that looked a lot like exploitation. She consulted an attorney, who told her the contract would never hold up in court, as it was completely one-sided, binding only Swanson. While Swanson was smartening up, she discovered she was pregnant with Gloria Junior, so she decided to use that as leverage; her leave of absence would end with the expiration of her contract.

For Gloria Swanson to be off the screen for a year would have been a considerable loss to Lasky. When he pointed out to her that the contract could be extended for the amount of time she was out of work, she dropped the bomb on him. Fearful of losing his hottest property after she'd given birth, he agreed to make her a star. That, of course, meant no more DeMille pictures. They would be Gloria Swanson films with no other name sharing the marquee.

Once she had that first concession, Swanson asked for the moon, and she got it. Her salary was now to be $2,500 a week and was to escalate over the next five years to $7,000 by 1925. And she didn't stop with money. She wanted her own custom-built star bungalow, musicians on the set, studio cars at her beck and call, and trips to Europe. Still, Lasky continued to try to outfox her at every turn, making the terms of her contract as vague as possible with regard to how many films she was required to make to merit that salary.

But the low point for Swanson was Lasky's strategy when Henry Somborn left her shortly after the birth of her daughter. Somborn was a partner in a film distribution company (he later owned the famous Brown Derby restaurant). By the time Swanson married him he had, unbeknownst to her, fallen on hard times; she was soon supporting a man who was nearly twenty years older than she was. This is rarely a recipe for happiness. The studio forbade Swanson to seek a divorce on grounds of desertion, fearing that a second divorce less than a year after she had given birth could make the public turn against her.

While she was in marital limbo, Swanson

began a romance with Marshall "Mickey" Neilan, a devilishly attractive director. Somborn used the affair to sue her for divorce on grounds of adultery. Not only did he list Neilan but he cited thirteen others as well. Included among them were DeMille and Lasky. Somborn was also asking for a $150,000 settlement on the grounds that he had been responsible for her lucrative contract.

Aside from Neilan, the whole accusation was ludicrous. Swanson was prepared to fight the suit, certain that she'd win. Lasky wanted her to pay Somborn off to keep the story out of the media. To further drive his point home, he produced a telegram from the Hays Office, the newly created censorship bureau that assured Americans there was a firm moral standard being upheld in Hollywood films. Will Hays, director, said a court fight would endanger Swanson's career and tarnish the motion picture industry.

After grudgingly paying Somborn off, she discovered that the telegram from Hays was a fake. Jesse Lasky had concocted it to prevent her from taking a course of action that he thought would ruin her career and which, by the way, would have made a sizable dent in his pocketbook. Instead of walking out on her contract or suing Lasky, she again used information as leverage.

It wasn't money she was after this time: it was the chance to make better pictures. After DeMille, she had made a series of run-of-the-mill films with director Sam Wood, whom she considered unimaginative. "The only things that changed were the number and length of the dresses I wore," she said. She wanted to work with Allan Dwan, one of the premier directors of the silent era. Like Swanson, he too had cleverly figured out how invaluable he

was to Famous Players–Lasky. He loathed Hollywood, and, fearing he would leave, Lasky and his partner, Adolph Zukor, let him work in New York to keep him happy. Swanson by now was also fed up with Hollywood. To work with Dwan was a way to escape "the den of thieves." With him she made some of her best films—*Zaza, Society for Scandal, Hummingbird,* and *Manhandled* among them.

In 1925, after her triumphant return from Paris, there was a larger issue. The studio was dangling a million dollars a year for four pictures in front of her. By now she loathed Jesse Lasky and all movie executives. To her, their "exploitation of stars' lives was ruthless and intolerable." And so, once again, she became a trendsetter by being the first star to turn down a seven-figure deal.

She chose instead to invest in the United Artists Corporation, the releasing and distribution company founded in 1920 by Mary Pickford, Douglas Fairbanks, Charlie Chaplin, and D. W. Griffith. By producing her own movies for release by United Artists, she would receive all the profits from her own productions, and as a UA partner she would get a share of the profits of the other films that the company distributed.

This new venture spelled artistic freedom and the opportunity to make fewer films a year —and, she thought, better films at that. Her first effort, *The Love of Sunya,* was a complicated script that called for Swanson to play five different parts. Now frightened by the financial responsibility of being her own entity, she chose to give her fans what she knew they loved: a romantic story with a handsome leading man and a spectacular wardrobe. This time, though, by playing multiple roles she could give them more of what they liked. Costumer

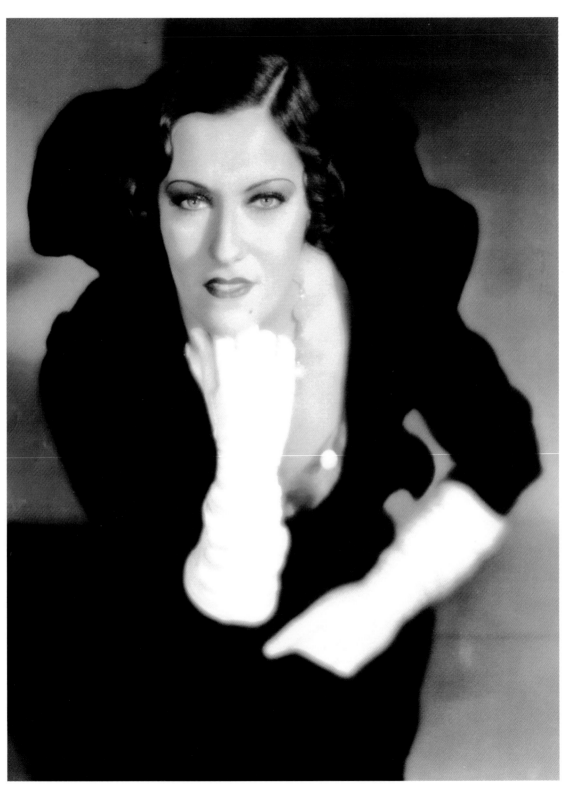

AT THE height of her career, her clothing bill was $125,000 a year—supposedly the highest of any star.

René Hubert pulled out all the stops. It was a grand luxe production in which Swanson out-Swansoned Swanson. Naturally the queen of extravagance overran the budget. The film was not the megahit that Swanson had hoped for, however, nor was it well received by critics.

As a producer, she realized that even with Gloria Swanson's screen magnetism, each film was a game of Russian roulette. And so Swanson the producer resolved to restore Swanson the actress to her former peak and to prove herself artistically. She decided to adapt the Broadway hit *Rain* for the screen. The play, based on a short story by Somerset Maugham, is the tale of a minister in the South Seas who attempts to reform a prostitute but falls prey to her body instead and then kills himself. Before Swanson embarked on the project, the Hays Office had forbidden producers to do a screen version of the play. But Swanson out-smarted Will Hays by buying Maugham's story, "Miss Thompson," instead of the play. She named her version *Sadie Thompson* and then denied it had any connection to *Rain.* The film was a triumph both financially and artistically, and she was nominated for best actress in the first Academy Awards presentation in 1928.

But there's nothing like a hit to make an artist lose her judgment. For Swanson, that lack of judgment led her to misread a man who had the funds to finance her. A man who exuded power and strength. A financial wizard who relieved her of the pressure of looking after her business affairs. The man was Joseph P. Kennedy, the Boston millionaire and father of the future president. Brash, charming, wildly ambitious, Kennedy was itching to be a successful movie producer.

On the surface, he was the ultimate daddy figure for Swanson. She had gone so far over

budget on *Sadie Thompson* that she was forced to sell her New York estate. And she was more than a million dollars in debt as a result of investing in United Artists, financing her film company, Gloria Swanson Productions, Inc., and maintaining her grand lifestyle. If she would allow Kennedy to reorganize her production company, he assured her, they would both make a fortune. That offer, combined with his irresistible boyish appearance and personality, led to the inevitable. Several months after meeting in 1927, they became lovers. For the next three years, Swanson and Kennedy lived dual lives with their respective spouses. In Beverly Hills the lovers maintained a separate residence together, though Gloria and Joe, with his wife, Rose, often formed a triangle and traveled together. Kennedy timed his visits to Los Angeles when Henri de la Falaise was in Paris working as the European representative for Pathe Films, which coincidentally was owned by Joe Kennedy, who had installed the marquis in the job.

Kennedy's ego was equal to, if not larger than, his intellect. As the producer for the queen of the screen he wanted to make a big splash with their first film project together. Swanson wanted to top the success of *Sadie Thompson.* Kennedy thought a brilliant follow-up would be *Queen Kelly,* an original script by the director Erich von Stroheim. Though Stroheim was an acknowledged creative genius in Hollywood, he also had a reputation for being a temperamental perfectionist, an incurable egotist, and a profligate spendthrift. He was renowned for shooting more footage than could possibly be used, and he made his films very long in order to dissect the psychology of his characters. He'd been hired and fired from several films. He also had a reputation for

hoodwinking producers by selling them a story they liked, but only after seeing the finished product would the producers discover it was something completely different from what they'd bought.

Kennedy thought putting these two flamboyant talents together would create something extraordinary. Against everyone's advice in Hollywood, Swanson, too, became convinced that she and Stroheim could create a masterpiece. In *Queen Kelly*, Swanson—who was now twenty-nine years old—plays an Irish convent girl kidnapped by a prince who has fallen in love with her. The prince is engaged to the mad queen of a mythical kingdom who discovers the romance and banishes the girl, who then goes to South Africa. Time passes and after a complicated series of events, Kelly finds herself the madam of a brothel. Years after her encounter with the prince, he finds her and they're happily reunited.

Volatility flashed on the set daily. Stroheim was shooting endless retakes and turning the film into a form of exotic erotica that Swanson thought was "rank, sordid and ugly." Half of the film was finished when she realized it would never pass the censors and she had lost all hope of exercising artistic control. She halted production on the set one day by saying "Excuse me, I've got to make a phone call," and never returned. She shelved the half-finished film at a loss of $800,000. (Years later, she edited the existing footage and released a version of the film in Europe and South America.)

Swanson, however, made a stellar recovery with *The Trespasser* (1929), her first talking picture. Her speaking voice was one of the best of the new medium, and she amazed everyone with her talent for singing. The film was a run-away hit, and she was again nominated for an Academy Award. Kennedy, who was still her partner, was delighted to turn a profit after the *Queen Kelly* debacle, but his ego couldn't accept the fact that his idea had failed and *The Trespasser*—Swanson's brainchild—had triumphed. By the time of her second talkie, *What a Widow*, in 1930, which was not a success and had been Kennedy's idea, Swanson "began to question his judgment." Three years after their first meeting, the romance and partnership abruptly ended when she questioned him about the company finances over dinner at their Beverly Hills love nest. Not used to being grilled, much less by a woman, he walked out of his living room when she fired questions at him and she never saw him again. Swanson had intuited correctly. As she delved deeper, she discovered Kennedy had nearly bankrupted her.

Once again Swanson had been deceived by someone she trusted. At the same time her partnership with Kennedy was dissolved so was her marriage to Henri de la Falaise, who complained: "I married a businesswoman."

"Although I could feel anguish and despair as well as the next woman," Swanson observed in her memoirs, "I couldn't succumb to them, or wouldn't. . . . I was a survivor. For me, endings would always be inseparable from beginnings of what followed, and so I got up like a spaniel coming out of a lake and shook off my tears."

With her financial affairs in a shambles she shut down her production company and negotiated a million-dollar four-picture deal with United Artists. But Swanson on celluloid was no longer creating a sensation, even with Coco Chanel designing her costumes for her second contracted film, *Tonight or Never* (1931). That her career had taken a downward turn had less

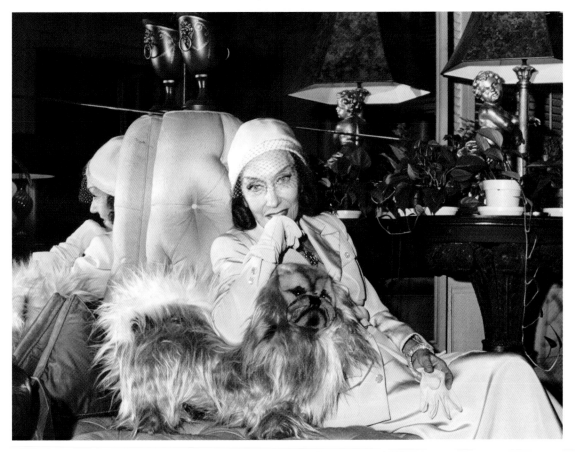

SWANSON POSING in her New York City apartment, 1975.

to do with badly constructed scripts and poor dialogue than with the fact that her downfall happened in tandem with the Depression. The opulent lifestyle she was so admired for in the twenties no longer inspired envy but rather resentment.

Her third effort under this contract, *Perfect Understanding*, was one of the great financial disasters of 1933. She never made the fourth film. Instead, she went to Fox to make *Music in the Air*, a film that required her to play a temperamental opera diva. Neither René Hubert's lavish costumes, Swanson's singing voice, nor Billy Wilder's snappy dialogue made an impact with the public. And so in 1935 Swanson found herself out of work for the first time in twenty years. MGM's Irving Thalberg signed her up, but when he died suddenly in 1936, the projects she was working on with him came to naught. Harry Cohn at Columbia put her on salary, but nothing gelled there. Swanson at thirty-six wasn't about to relegate herself to mother roles. The last straw was when she found a suitable script for herself and sent it to Cohn who told her the Los Angeles telephone book was more interesting. That picture turned out to be *Dark Victory*. A year later, when it became a huge success with Bette Davis, Swanson sent Cohn a copy of the L.A. phonebook along with a note that read: "Enjoy."

By 1938 she was playing the thankless role of the great star idling in Hollywood. "I had

stayed too long at the fair," she commented later. But Swanson was too proud to slip away unnoticed. Her exit was as grand as any Mr. DeMille could have created for her. In her sprawling mansion, which was already a monument to a bygone era in Hollywood, she threw a cocktail party and announced to her friends and colleagues that she was finished with Hollywood because Hollywood was finished with her. And with that she sold her house with most of its contents and moved to New York.

Her net worth was about $250,000—her asking price per film for a decade of her career. The days of throwing dinner parties for two hundred, hiring fleets of limousines, and taking over entire floors of hotels were over. "When I'm down on my luck," she said decades later, "when I hit bottom, I know there's nowhere to go but up. That roller coaster Hollywood taught me that."

GLORIA SWANSON relaxing in Nassau, 1940.

And so Swanson set out to reinvent her life.

As it happens, she was always more than just an actress. She was a Renaissance woman with a head full of ideas. In the ensuing years, she engaged in a variety of business enterprises. Her first was Multiprises, Inc., a company that developed and marketed the inventions of World War II refugee scientists from Germany and Austria, whose immigration she spon-sored. She also had a contract with a Seventh Avenue dress manufacturer designing budget-priced clothes for large women. For nearly two decades Swanson traveled to department stores promoting Forever Young, and the label saw sales of over $100 million. Her interest in health prompted her to create a line of natural beauty products called Essence of Nature Cosmetics. As usual she was way ahead of her time. In the mid-1940s she began lecturing to women's groups and civic organizations on nutrition, and she vigorously lobbied to get Congress to pass the Delaney Amendment, an act that, when passed in 1951, limited the spraying of crops with insecticides. In the 1950s she was involved in international pollution research. She actively pursued her talent as a sculptor. There was also a brief stint as a reporter with United Press International, during which she covered everything from bullfights in Spain to the Grace Kelly–Prince Rainier nuptials.

As for her acting career, Swanson returned to Hollywood in 1941 to star in *Father Takes a Wife*, but it was not the triumphant comeback she had hoped for and no other offers followed. So she tried her hand at the stage and starred in comedies on the strawhat circuit. In 1948 she ventured into the new medium of television, becoming the first actress to have her own talk

show. By then she had shelved any hope of a screen comeback. But in 1950 she was invited to Hollywood to star in Billy Wilder's haunting inside portrait of cinema land. That film was, of course, *Sunset Boulevard*. And Swanson, in the role of Norma Desmond, made a comeback unparalleled by any star who had returned to the screen after a long absence.

Though Swanson was not like Norma Desmond, she was in fact the only person who could have accurately portrayed the neurotic silent-movie queen who lives in an outmoded mansion endlessly planning a dramatic comeback. For it was Swanson who symbolized Hollywood's most opulent era. She brought to the part her experience and knowledge of that world. What she also displayed was her extraordinary talent as a performer—she was nominated a third time for a Best Actress Oscar. A gift that many critics were unaware that she had. That, of course, irked her more than the accusation that she was typecast. "I played everything and never the same thing twice," she commented. "I was a French actress in *Zaza*, a gum-chewing clerk in *Manhandled*. I wore boys' clothes in *The Humming Bird*. Every part, every role was different. I was a good actress before *Sunset Boulevard*. I've played character roles all through my movie career.... Give me a wig and a lamb bone and I'll play Henry the Eighth."

Sunset was Swanson's sixty-third movie, but many were seeing her for the first time. And she created as much of a sensation as she had in the twenties. She toured the country to publicize the movie, appearing on television and attending premiere parties, flashing the trademark strong, square smile and looking miraculously young in soft black dresses and shadowy hats. The public was mesmerized by this fifty-year-old woman whose skin was so youthfully luminous that she wore no foundation coverage or rouge. They wanted to know her beauty secrets, and health guru that she was, she proudly shared her organic food regimen. Swanson's singular style also aroused the fashion industry. Neiman-Marcus presented her with their Distinguished Service Award in the Field of Fashion to honor her for her role as the established clotheshorse of the movies. When owner Stanley Marcus discovered that she had designed the gorgeous hats and dresses that she wore to the three-day festivities he was so impressed that he included them in a fashion show with the creations of Balenciaga and Dior.

In 1951 she made *Three for Bedroom C*, a weak film in which she portrayed a movie star. Critics were, of course, hoping for another *Sunset Boulevard*. Typically she was barraged with screen offers to play awful imitations of Norma Desmond. And she astutely saw that if having a movie career meant resurrecting Norma Desmond over and over again, she would rather not have it. Still, the queen of comebacks was not averse to making the occasional foray back into the business. She took a stab in 1962, playing Agrippina in *Nero's Mistress*. She made a television movie, *Killer Bees* (1974), and her last screen appearance was in *Airport 1975*, portraying herself.

The fact that, after *Sunset Boulevard*, there were really no roles for her to play had more to do with Swanson than anything else. She had become over the years an epic character so big that any role she attempted was smaller in comparison.

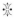

"I've never had to pay a five cent piece for publicity in my life and I never will," Swanson once

told Raymond Daum, a television producer with the United Nations whom she met in 1956 and who became her closest confidant. Even in later years she relied on the power of stardom to do what she wanted. If she was attending an important function or even going to see a movie, she would have someone call ahead. "Tell them I'm coming. What good is a name if you can't use it?" And of course there would be an official waiting at the curb to greet her when she alighted from her limousine. Behind that throwaway line there was a deeper message: it was the knowledge that she had earned every ounce of her fame and that she deserved the right to use her name as she pleased.

But in spite of that realistic attitude, she was at the bottom line a movie star. She took herself very seriously and didn't realize that there was a bit of Norma Desmond in her: egocentric, dramatic, temperamental, extravagant, impatient. "She lived for her fans and her public," observes Daum. "Even in her later years she would never admit openly how much she cared about her fans and the letters they sent. Up until her death, the fan mail continued to come in, diminished in numbers only slightly after sixty years and six generations of new fans." Swanson kept a Rolodex of their names and addresses from all over the world and a complete record of her correspondence. Often she called fans at random on the telephone, enjoying their surprised reaction when she would say, "Hello, this is Gloria Swanson."

As she grew older she became more aware of her rightful place in the history of the industry. That awareness bred a to-the-manner-born quality. "Swanson had a sharp, clearly enunciated, cultivated voice and prided herself on being a grand lady," observes Wayne Lawson,

who worked as freelance editor on her memoirs. "She was very careful how she presented herself, and was never off her guard." When she made *Killer Bees* in 1974, she requested that the cast and crew address her as Miss Swanson and that she would address them by their surname. "I once telephoned her while we were shooting," recalls Curtis Harrington, the film's director, "and I said, 'This is Curtis,' and she said 'Who?' But after the wrap-up, I called her and said 'This is Mr. Harrington, Miss Swanson' and she said, 'It's Gloria to you.'"

Like many stars, she thought of herself in the third person and saw everything through the eyes of a publicist. And because of that she was a master choreographer of every public moment. When she toured the country promoting her memoirs in 1980, her appearances at bookstores for autograph signings were orchestrated as if she were stepping onto a movie set. She requested that her table and chair be elevated so that when fans approached her they wouldn't have to look down and she wouldn't have to look up; she wanted to be at eye level with them. And of course the silver screen's first clotheshorse did not disappoint in the area of costuming. She would arrive all in black, wearing a veiled hat with a high feather in it. "Very much like what Norma Desmond wears to the studio in *Sunset Boulevard*," recalls Wayne Lawson. "Though she was eighty-one, she looked sixty, and her body was still in great shape." When television interviewers came to profile her, she needed a minimum of two hours to get ready. That preparation wasn't just for herself; she also wanted to set the stage in her Fifth Avenue maisonette. "We turned the

EVEN IN later years, Swanson still exuded sensuality.

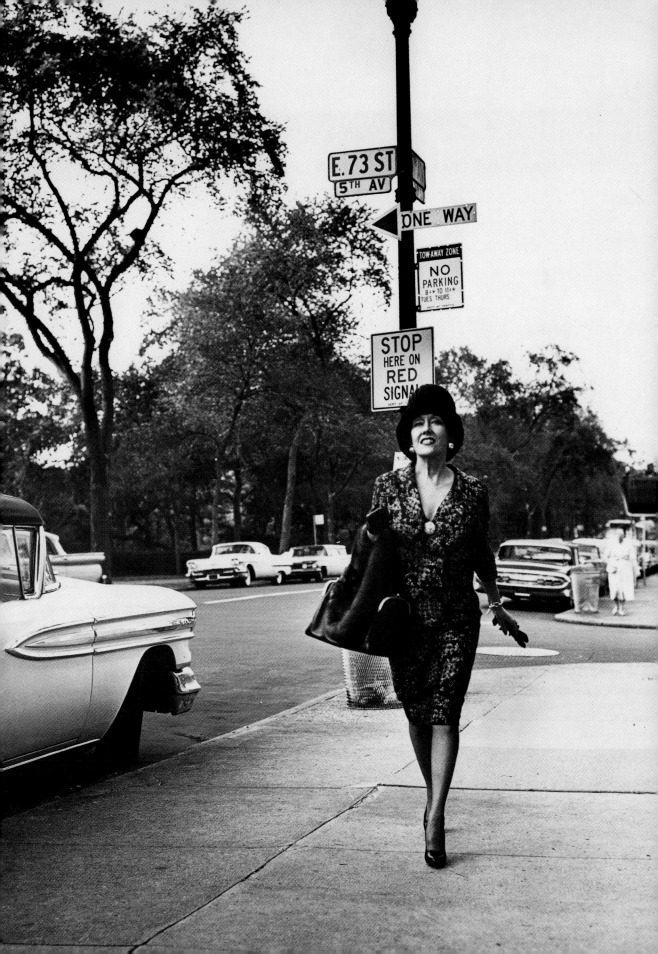

apartment into an Arabian Nights for these occasions," Raymond Daum remembers. "We arranged the flowers, sprayed perfume in all the rooms, and lit scented candles everywhere. She would wait for the reporter in one of her perfect little chairs, custom built for her tiny frame. When they arrived, she was Gloria Swanson."

Though her persona was always first and foremost, Swanson tempered her imperial demeanor with a warmth and an insatiable energy that was irresistible to all those who knew her. She was riddled with curiosity and described herself as a mental vampire. "She was head and shoulders intellectually on any subject— politics, business, science," says photographer Ellen Graham, who did numerous sittings with Swanson during the last decade of her life. "Even at age eighty, she still transmitted a combination of sex and intellect."

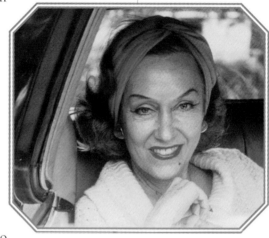

SWANSON ALWAYS retained her flawless skin and bone structure.

"She invented things like crazy," Raymond Daum recalls. "The last thing was a toilet that didn't take too much water." In 1971 she appeared in a limited run on Broadway in *Butterflies Are Free.* She shared her artistic talent with the public in 1978 when she had a one-woman show in London of her paintings and bronze sculptures. Two years later she was chosen to design a stamp commemorating the United Nations Decade for Women. It was completely apropos that one of this century's first liberated females would design a stamp

celebrating her sex. "When I hear women talking about feminism, I'm always amazed," says Gloria Daly. "My mother never thought about that sort of thing. She just did it. She was an example, despite the code of her day, of doing things her way."

And yet for all of Swanson's independence, the one thing that had eluded her was a man she could lean on and respect mentally. "I want a man who is mentally and physically stronger than I am," Swanson told Ellen Graham in 1974. "I would like someone to say 'Don't worry,' and take care of me just once. Someone with whom I can have mental intercourse on any subject. I've had everything in my life but that." That was before she married William Dufty, a writer who shared her interest in natural food and wrote *Sugar Blues,* the 1975 best-seller that provoked the macrobiotic nutrition revolution. After traveling the world together—she helped him publicize the paperback edition— he proposed by uttering the magic words, "I want to take care of you."

Swanson's wish became a reality when she was seventy-seven, but there was one more beat in her romantic life. She still thought of herself as a femme fatale, and her heart was still young and easily fooled. She fell prey to the charms of Brian Degas, a good-looking man forty years her junior. It was Degas's idea to stage her art show in London. When it was praised by critics, Swanson credited him with

giving her a new lease on life. His next coup was negotiating a $500,000 contract with Random House for her memoirs, which would be split among him, Swanson, and Dufty, who would act as the ghostwriter.

By the time the book was published in 1980, she was completely infatuated with Degas (she had by now, according to sources, ordered Dufty out of her life). "She fell for Degas hook, line and sinker," says Raymond Daum. "She was like a young girl. She would sit on his lap and cuddle and coo and say to me, 'Look at that boy, he could play a leading man.' The whole situation was like a parallel to Norma Desmond, except in this case Degas made the schemer Joe Gillis in *Sunset Boulevard* look like an angel."

Daum discovered that Degas was bilking Swanson out of almost all of the modest fortune she had left and had stolen valuable personal mementos and relevant documents relating to her career. But Swanson refused to believe Daum or her family when they came to New York to deal with the problem. "This man will give me a new beginning and a new career," she told Daum. By 1982, Daum remembers, she was so broke that all but one of several telephone lines had been taken out of her apartment because she couldn't pay the bills. A few months before she died of a stroke in April 1983, the bubble burst when two producers who'd been negotiating with Degas for Swanson to star in a Broadway show taped their conversations with him in which he spoke disparagingly of her. "When they played the tapes for Gloria, she finally realized she'd been betrayed, and it broke her heart," says Daum. "I'm convinced this fueled her death."

While this scenario was being played out, Swanson had appointed Daum to serve as her archivist. Once he'd organized her collection of over 500,000 pieces of memorabilia he then arranged for it to be sold to the University of Texas at Austin in 1982. "I'm giving you my plum," she told him. "My life is going out the door with these boxes. I want you to look after it." (Daum went to Texas with the archive and was the curator of the collection for nine years.) Swanson made Daum promise that the collection be presented in such a way as to give people "an impression of me, my life, and my career. Above all, let them remember me for being not only an actress but someone who had many interests and involvements. And don't let them think I was like Norma in *Sunset Boulevard.* Show them through my papers, pictures, correspondences what I thought was important."

If Gloria Swanson had written her obituary she would probably have wanted to be listed as an actress, producer, designer, inventor, painter, sculptor, and nutritionist. The last thing she would have wanted was to be labeled as the screen's first "glamour girl," which of course she was. "The one word my mother could not stand was 'glamour,'" says Gloria Daly. "She used to say, 'What does that mean?' And yet, if ever there was a glamorous person it was her."

Swanson didn't need the word to describe her aura; she wore glamour like a second skin. In the end, the magical spell she was able to cast over all those who came into her orbit, either in person or through celluloid, had less to do with beauty or fashion than it did with the sheer intensity of her personality, which she effortlessly transmitted in her every gesture.

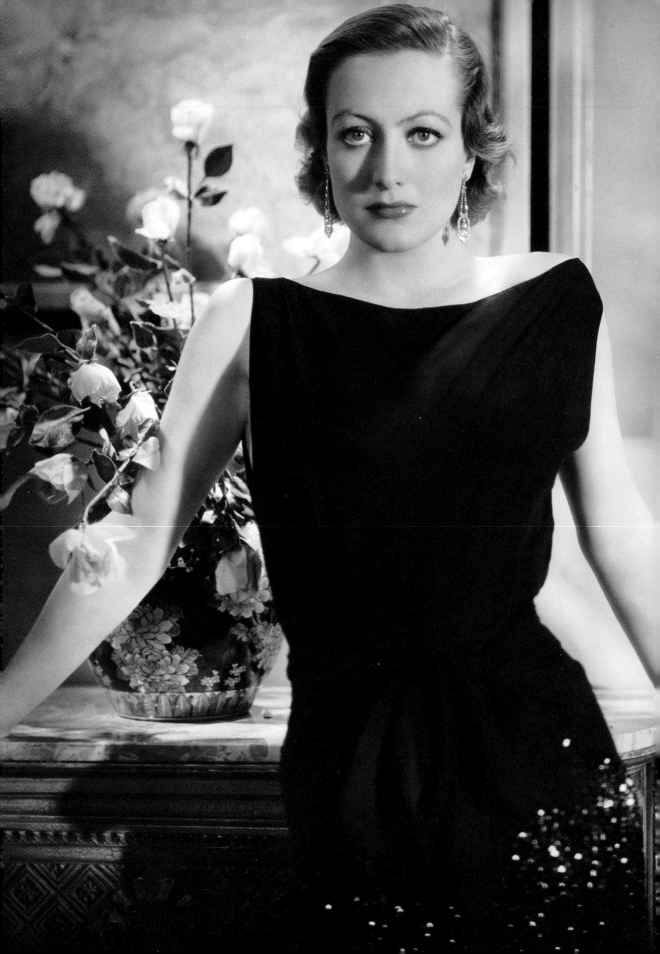

Joan Crawford

Long before it ended in 1977, Joan Crawford's life was a perfect scenario for a Joan Crawford movie. It had all the right elements: a wrong-side-of-the-tracks childhood, a lucky break, and a gallant struggle to succeed. And once at the top, she had another struggle to stay there. But all that effort paid off. She had massive, sustained success as she redefined and reinvented herself with every era so that her career spanned five decades.

And yet, aside from film buffs and her fans, Joan Crawford is mostly remembered for a moment from a 1981 film in which she didn't even appear. That film—Mommie Dearest, adapted from a book by her eldest daughter, Christina Crawford—starred Faye Dunaway as a forbidding, irrational shrew. In this camp classic of a film biography, Dunaway-Crawford punishes little Christina for the shockingly trivial offense of having wire hangers in her closet. "No wire hangers! No wire hangers!" Dunaway shouts

as she grabs the child by the hair with one hand and pounds her ears with the other.

Joan Crawford had been dead for four years when the film version of *Mommie Dearest* was released. She couldn't defend herself, and those who knew her could not be heard over Christina's excoriating postmortem.

But set aside, if you can, the image of that miserable, shoulder-padded harridan shrieking her way across the screen. Instead, look at the one fact about Joan Crawford that can be confirmed: more than any other actress, she mastered the art of the Hollywood glamour game. By dint of dogged hard work and determination, she turned herself into an actress, and though she was not a great one, she was an immensely watchable one. She was the only actress of her generation who, when her career seemed to be over, rose like a phoenix from the ashes, won an Oscar, and resurrected it. She still holds the record for the longest career of any actress. By those standards, she was the most successful American actress in the history of cinema.

"Not one good moment on the Good Ship Lollipop" is how Crawford described her childhood. "Boardinghouses, hash joints, and dime stores. But I'm not complaining, because if it hadn't been for that sort of beginning there would have been no Joan Crawford."

She was born Lucille LeSueur on March 23, 1906, in San Antonio, Texas. Her father was a day laborer who deserted the family when she was an infant. Her mother moved Lucille and her older brother to Lawton, Oklahoma, and married Henry Cassin, a small-time vaudeville theater owner. Her affection for her stepfather inspired her to change her name to

Billie Cassin; visits to his theater made her dream of becoming a dancer.

Henry Cassin was not without his flaws. After going on trial for embezzlement, he moved the family to Kansas City, then disappeared from their lives. Mrs. Cassin labored in a hand laundry and provided a home for her children in two dingy rooms behind the shop. Crawford remembered her as a remote, loveless figure who favored her mean-spirited, worthless brother.

By the time she was eight, Crawford was doing menial jobs in exchange for an education at a Catholic girls' school. The situation became Dickensian when she transferred to a fancy boarding school, where she was a maid, cook, and servant to thirty paying students—and received regular beatings with a broomstick if she failed in her chores.

Her teenage years perked up when the boys at school noticed her good looks and began to invite her to dances. "I thought I had a toothache. I put my hand to my face and realized that I was smiling, something I had not done for months," she recalled. "I knew a phase of my life was over." She renewed her passion for dancing and, though dressed in gaudy bargain-basement frocks, was the life of every party.

Her first beau encouraged her to tone down her brassy personality, refrain from dancing every dance, and indulge in a few intellectual pursuits. Crawford followed his advice. She enrolled at Stephens College, an all-girls school in Columbia, Missouri, where she waited on tables to pay the tuition.

She struggled academically and felt like a social misfit: "I tried hard to be one of them. I lowered my voice, stopped using makeup, gave my wardrobe a complete overhauling, ripping

off lace and bows." But during her first semester, a sorority wouldn't accept her because she was a working student. With that, she left college.

Back home in Kansas City, she took dance lessons, entered contests, and worked at a series of low-level jobs—telephone operator, gift-wrapping clerk, shop girl—until she auditioned for a traveling revue and was chosen for the chorus line. Imagining how her name would look in lights, Billie Cassin became Lucille LeSueur again. She was not, however, true chorus girl material. At five feet four inches, she was shorter than most, plumpish, and not an outstanding talent.

She overcompensated with a raw enthusiasm that translated into charm and with a fierce determination to improve herself. She learned to apply makeup in a way that enhanced her generous mouth, and she wore a girdle to slim her waist and hips. Her kicks got higher; in a matter of months she was promoted to a top position in the line.

AN EARLY portrait by Clarence Sinclair Bull before her metamorphosis.

In Detroit she caught the attention of J. J. Shubert when she knocked a glass off his table while dancing. He offered her a place in *Innocent Eyes*, his lavish production opening at the Winter Garden Theater. Twenty-four hours later she was in New York City. It was there that Harry Rapf, an MGM scout, spotted her

in the chorus line, gave her a screen test, and offered her a five-year contract at seventy-five dollars a week.

When Lucille LeSueur arrived at the MGM studios in January of 1925, she weighed 150 pounds. Her hair was dark and frizzy. She had freckles. Apart from her expressive blue eyes, her beauty was undistinguishable from that of the other young girls who had landed in Hollywood. But she had one characteristic many of them didn't: an almost maniacal determination to succeed. When she read in a movie magazine that screen stars arrived at the studio by 7:00 A.M. to get into makeup and costume, she followed suit—even though she had no roles to play. Instead, she spent her days doubling for established stars and posing for corny publicity stills.

She finally appealed to Harry Rapf, who pushed to get her a few bit parts. Her first two appearances in silents piqued the interest of the publicity department enough to engineer a contest in a fan magazine to give the up-and-coming actress a new name. When her third movie, *Old Clothes*, in which she costarred with Jackie Coogan, was released, Miss LeSueur was now Joan Crawford.

Off-screen she was linked to several hard-living young millionaires and was named as a corespondent in a couple of divorces. Her name and face began to appear in newspaper columns; she became known as the "Hey-hey, Charleston kid," a party girl who haunted nightclubs and entered dance contests. (In less than two years she won eighty-four trophies for the Charleston and the shimmy.) She dyed her hair flaming red; painted her lips a hard scarlet; wore short and spangly gowns, feathers, bows, and very high heels; and looked exactly like what she was—a hoofer.

Even with her new name, however, Crawford wasn't getting the results she wanted. Her roles were bland; she saw colleagues like Constance Bennett graduating to better parts. She realized that if she was going to make it as an actress she had to learn the craft. That meant devouring every piece of advice offered to her.

So when Edmund Goulding, who directed her in a costarring part in *Sally, Irene and Mary*, told her not to "exhaust the audience by overacting," she worked on her technique. When Paul Bern, the cultivated MGM producer, told her she had to improve herself, she hired tutors in English and history from the University of Southern California, refined her table manners, and wore the designer dresses Bern gave her. And when cameraman Johnny Arnold said her

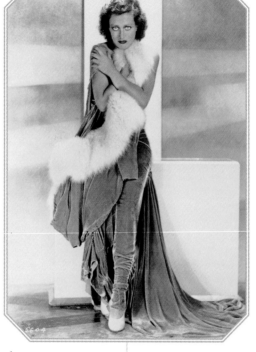

face and bones were "built for the camera" but she was overweight, she ate only steak and vegetables until she lost 20 pounds. The result was a perfectly molded pair of cheekbones and eyes that had grown bigger with the disappearance of extra flesh.

By the end of 1927 she had appeared in six films and played opposite most of the male stars at MGM: John Gilbert, Ramon Novarro, Lon Chaney. And a promising future at MGM was ensured when Louis B. Mayer offered to lend her the $18,000 she needed to buy a small house on Roxbury Drive in Beverly Hills.

Bona fide stardom came in 1928 when she played a dance-mad flapper whose passion for life in the fast lane mirrored her own off-screen persona. *Our Dancing Daughters* was to the twenties what *Saturday Night Fever* was to the seventies: it completely captured the feeling of the era. Crawford sported a windblown bob, wore costumes that showed off her great legs, and performed a highly evocative rendition of the Charleston on a table. At last, moviegoers saw her earthy, exuberant sex appeal. Overnight she became a symbol of the Jazz Age; the era's premier chronicler, F. Scott Fitzgerald, proclaimed her "the best example of the dramatic flapper."

JOAN CRAWFORD, at right, posing for George Hurrell.

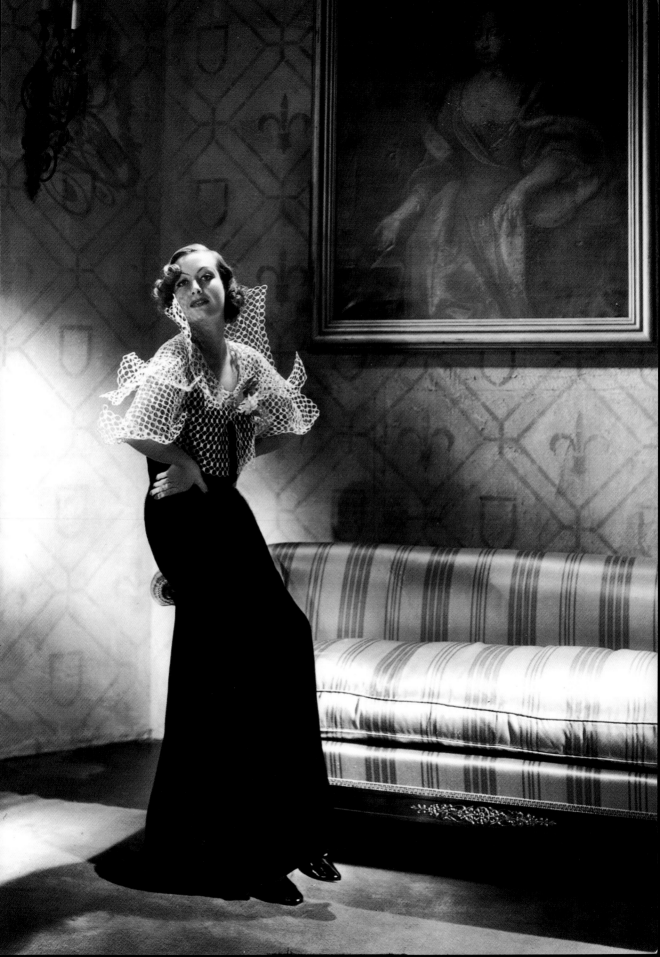

Mayer raised her salary to $500 a week. Fan mail poured in; she was the heartthrob of young men and the idol of millions of girls. In her next few films, MGM gave the public the Crawford image they wanted: a party girl. Off-screen, the star was entering the next stage of her metamorphosis.

By now Crawford was engaged to the actor Douglas Fairbanks Jr., whose father and step-mother, Mary Pickford, were the reigning king and queen of Hollywood. Junior was the town's great catch. Artistic, well-read, and beautifully mannered, he was her Prince Charming. As for Fairbanks, he loved Craw-ford for who she was: a chorus girl, "vital, energetic, very pretty and quite unlike anyone I had known before."

The press gobbled up the new romance between the humble girl from Kansas City and the scion of movie royalty. "She and I had come a good way toward creating our own images of each other," Fairbanks wrote in his memoirs, "some of it no doubt influenced by what the columnists and fan magazine hacks wrote about us." On June 3, 1929, days after they finished filming *Our Modern Maidens,* they were married.

"I was doing fine until I hit Pickfair. I was out to tear up the world—in the fastest, brashest, quickest way possible," Crawford observed years later. "Then I saw myself through the Pickfair eyes—and every last bit of my self-confidence dropped away from me. Shyness overwhelmed me, and I got a terrific inferiority complex. Immediately I set out to change myself in every way."

On-screen she made a successful transition to talkies. Off-screen, Crawford was deter-

mined to become a lady fit for a prince, a woman who could hold her own in the upper echelons of the Hollywood community. Because Doug spoke French, she took French lessons. She read anything that was labeled a classic. She learned to dress more sedately. She softened her hair color to a deep auburn.

Crawford's stage set for her new persona was a ten-room Georgian-style house in Brent-wood, which would double in size over time. She decorated it in what she called the "apoth-eosis of taste" with green and gold brocades, French reproduction furniture, a gilt grand piano presiding in the living room, and a prominent display of her collection of two thousand dolls. But her friend William Haines, the former actor turned interior decorator, soon persuaded her to throw it all out and allow him to create an all-white interior, then very much in fashion in Hollywood. Following the lead of her in-laws, Joan combined her name with Doug's and called the house El Jodo. She understood that being a woman of class meant learning to serve good food and knowing how to set a proper table for every occasion. El Jodo became the setting for ele-gant dinners, and fan magazines began to char-acterize her as a leading hostess.

Crawford's efforts to become a supreme hostess bordered on parody. Tarquin Olivier, the son of Jill Esmond and Laurence Olivier, remembers his mother describing the time she dined at El Jodo. "Although it was dinner for four, it was black tie and place cards," he recalls.

Another time she hosted a dinner for six in honor of Noël Coward at her grand dining table, which could have seated fourteen. The absurdity of the situation was not lost on Coward, who sent a note via the butler to

another guest, the fan magazine writer Dorothy Manners: "If you're ever up this way, drop in. Noël."

Along with her social elevation, Crawford wanted classier roles. And so began diction classes and sessions with vocal coaches to give her voice a patrician timbre. For the next decade her roles mirrored her own life as she alternately played high-life ladylike women and working-class girls who were lifted out of their social station because of sound values and good manners.

It was the latter, however, on which her stardom was built. By 1930, Crawford was the number one female actress at the box office; she would stay among the top ten for the next six years. On-screen and off, more than any other actress of her time, she embodied the American dream, and that endeared her to millions of working-class women who felt they had a brighter destiny than their circumstances suggested.

Fairbanks's career, however, wasn't producing the same results. In 1931 he was under contract at the First National studio and earning $72,000 a year. Crawford's annual income of $145,000 created a gap sizable enough to put a strain on the marriage. While she was devoting her entire life to her career, Fairbanks was realizing there was more to life than pictures. Outside of acting, his passions were painting and writing; his skill at both earned him assignments in *Vanity Fair* and *Cosmopolitan.* He also liked more sophisticated, worldly folk. He relished weekends at San Simeon with William Randolph Hearst's crowd and preferred Hollywood's colony of English actors.

For all of Joan's efforts to become Doug's equal, she didn't really enjoy herself. "I learned to smile less, not throw my head back when I

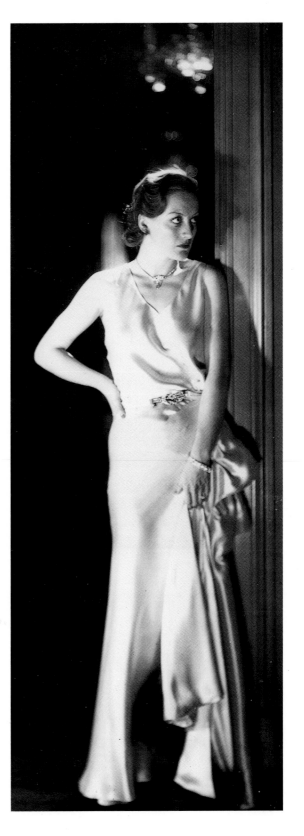

CRAWFORD ON the beach at Malibu with her first husband, Douglas Fairbanks Jr.

AN UNRETOUCHED photo. What Joan's fans did not know was that she had freckles.

CRAWFORD CELEBRATING her son Christopher's tenth birthday at Chasen's.

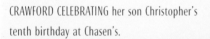

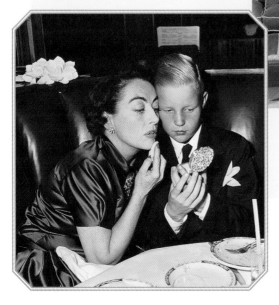

"GLAMOUR SHOULDN'T be superficial," she said. "It should be part of your lifestyle."

SHE FELT her devotion to her fans was paramount to her success.

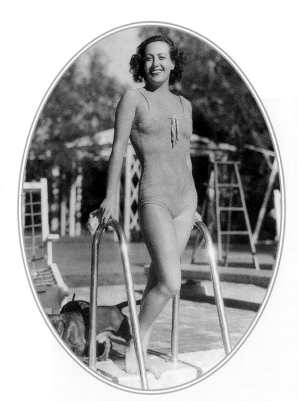

JOAN WAS obsessive about her body, as she
was about most other things.

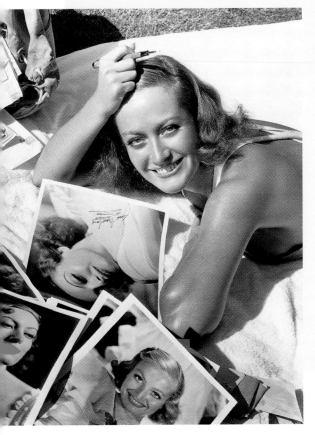

HER FACE and bones were built for the camera.

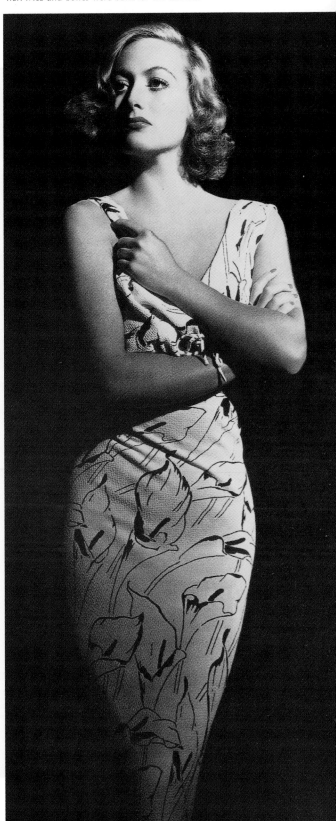

laughed. I became piss-elegant," Crawford remembered. "The climax came one morning at the studio when I fluffed a line and said, 'Oh, *feces*.' I think it was then that I realized I'd tried too damned hard to turn a pumpkin into a carriage."

She had also met Clark Gable on the set of *Possessed*. What ensued was an affair so torrid that Louis B. Mayer sent Joan and Doug to Europe for a second honeymoon to avoid a scandal. On their return, they separated and were divorced in 1933. As for Joan and Clark, they remained close friends until his death and had an on-again, off-again affair between their various marriages until his final one in 1955.

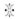

"I played the star Joan Crawford, not the woman Joan Crawford, to the hilt. Partly because of the image thing. Partly because I felt that I photographed better than I actually looked, so I tried desperately to make sure my makeup and wardrobe lived up to the image on the screen. And partly because after my marriage to Doug failed, I wanted to prove to everyone, especially myself, that I could be a lady in the classiest sense of the word, without Doug's elegant little world to play in."

The patriarchal Louis B. Mayer and the tight rein he kept on his stable of stars, molding and shaping them to merge with the public's fantasies about them, were tailor-made for Crawford's emotional needs. Like so many of the stars of that era, her background had left her without any blueprint for life; at bottom she was a lonely woman with an inferiority complex who yearned to belong. She had a fierce need to be loved and protected; to get what she needed, she was desperate to please. All this made her a blank canvas in the hands of the studio's publicity department.

"I realized early on that Mayer was right; I was obliged to be glamorous. Fortunately or unfortunately, I went a few steps beyond Mayer's expectations," Crawford observed years later. "If people wanted to see Joan Crawford the star they were going to see Joan Crawford the star. They paid their money and they were going to get their money's worth. In my day a star owed the public a continuation of the image that made her a star in the first place."

Ultimately, the credit for the creation of the character called Joan Crawford goes to the actress herself. "I don't think Mayer and Strickling [MGM's publicity chief] were as concerned about the Crawford image as she was," said James Merrick, an MGM publicist who worked on twelve Crawford films. Her focus on her image was simply a continuation of her initial hunger to succeed. Now that she was a star, she found that she loved the glamour, the money, and even the hard work. "Her horizons, her standards, her interests, and her enthusiasms were limited to her own professional world," recalls Douglas Fairbanks Jr. "She had few diversions away from her work—unless one counted her favorite tranquilizers: knitting and learning how more sophisticated folk decorated their houses and bodies. Never, before or since, have I known any other professional who expended more personal energy on self-improvement courses and on her relations with her fans and the press."

Her devotion to her fans proved to be profitable. When MGM learned in 1935 that she had received 900,000 fan letters, the studio signed her for five years at $1.5 million annually in return for five pictures each year. At the same time, her relationship with her admirers was more than a shrewd career move. Crawford

sincerely believed that it was her fans who had levitated her to stardom and it was her duty to show her gratitude. She made sure that photographs were personally autographed and that all letters were answered, even going so far as to recruit family, friends, and fans to her Brentwood house for one day of assembly-line work each weekend to cope with the deluge of mail. When she traveled, she routinely informed the press of her agenda and gave her fan clubs a timetable of her daily schedule. "These fans put me where I am," she told interviewers more than once. "If they want to know my where-

abouts at any given time, they damn well better be told. If it wasn't for them, I'd be back in Kansas City."

To maintain her movie-star glamour, Crawford did everything to extreme. When not working, her regime consisted of a daily swim, a one-mile jog each morning, and a dozen push-ups. To maintain tight skin and muscle tone, she took cold showers, rubbed her skin with ice cubes after exercising, and had regular massages.

This regimen burned away everything that was not Joan Crawford and helped to give her

JOAN AS a blonde for *This Modern Age,* 1931.

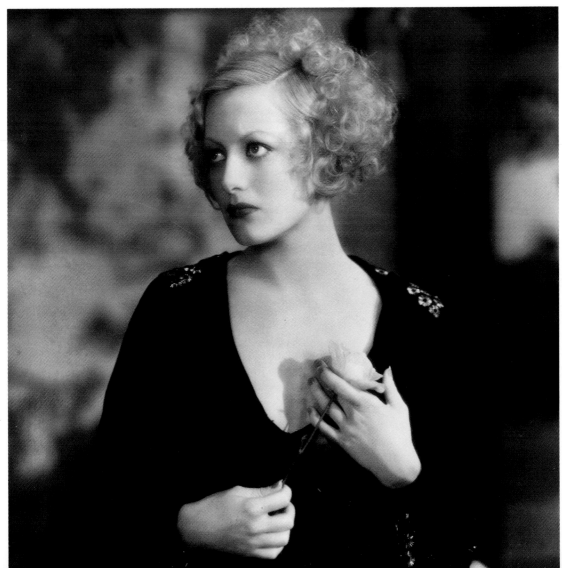

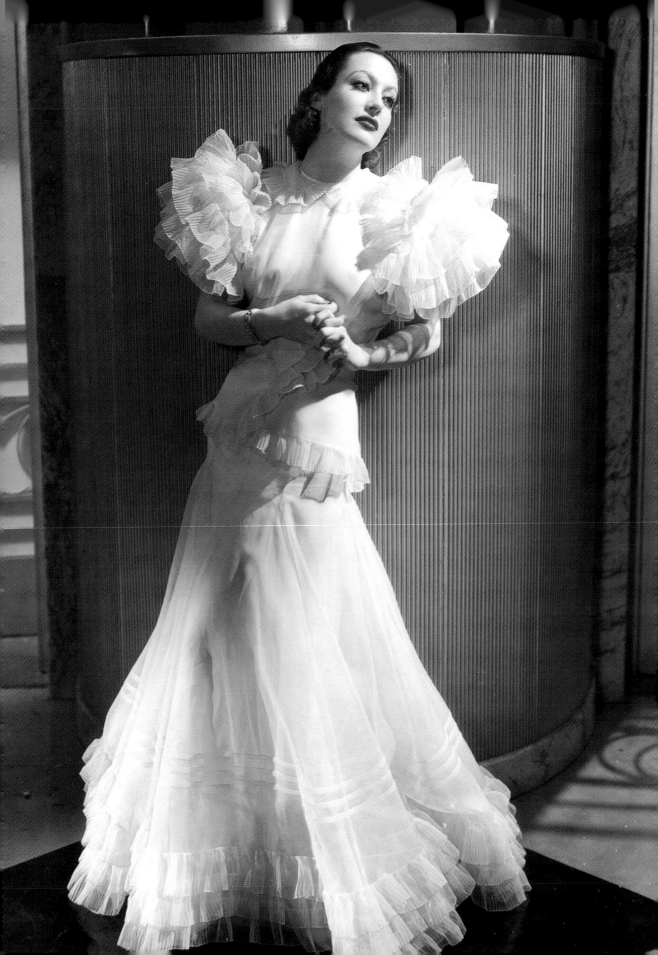

the look that cemented her fame. Except for a brief time during the silent-film days when she affected the looks of two of her idols, Pauline Frederick and Gloria Swanson, and a fleeting period during the early thirties when she tried to emulate Garbo, Joan Crawford was not an imitator. In playing up her larger-than-life features, she had, by 1933, perfected a look that was completely her own. Her eyes were heavily lined to accentuate their hugeness, a generous mouth was further enlarged to enhance its sensuality, and her severe, square jawline was accentuated so that it showed off her fabulous cheekbones.

Even more remarkable than her profile was her ability to continually reinvent herself. Today the most popular image of Crawford is the sculpted and forbidding glamour she fashioned for herself in *Mildred Pierce.* This was but one phase of four decades in which her hair, her eyes, her mouth, and her fashions continually metamorphosed. Unlike such contemporaries as Claudette Colbert and Norma Shearer, who had a signature look and didn't alter it, Crawford's trademark was change. Though she was a classic product of the star system, she was at the same time a true original, far ahead of her time. And this ability to change her appearance was a huge factor in the longevity of her career.

A key element in this effort was Adrian, MGM's costume designer extraordinaire, whose designs personified thirties glamour and who was responsible for creating a singular look for Greta Garbo, Jean Harlow, and

JOAN CRAWFORD in *Letty Lynton,* 1932, wearing the dress that became the first important influence on fashion in film history.

Norma Shearer. From 1929 to 1943, Adrian designed everything Crawford wore on the screen and most of what she wore in her personal life. He eased her away from overdone dresses with bows and frills, giving her a more tailored, sophisticated style. Instead of de-emphasizing her football-player shoulders, he exaggerated them with padding, which in turn showed off her small waist and made her slim hips look even slimmer—a silhouette that would dominate styles from the second half of the thirties through the forties. "Adrian had a profound effect both on my professional life and personal life," she said in later years. "He taught me so much about drama. He said nothing must detract. Everything must be simple, simple, simple. Just your face must emerge. He made me conscious of simplicity."

The seminal event in the Crawford-Adrian partnership occurred in 1932, when he designed the starched white chiffon dress with gigantic puffed and ruffled sleeves that she wore in *Letty Lynton,* still heralded by costume designers and fashion historians as the "single most important influence on fashion in cinema history." Macy's quickly sold 500,000 copies of this frock in its Cinema Shop. Crawford was named the Most Imitated Woman in the World and became the cinema's premier fashion trendsetter. The connection between her film and personal wardrobe was indelibly made when she took one of the *Letty Lynton* gowns with her to Europe and had Adrian make the same side-slanted hats that she wore on-screen.

The resounding success of *Letty Lynton* prompted MGM to put the publicity machine into high gear and publicize her as a glamorous star on a scale with Greta Garbo and Norma Shearer. (The studio, Crawford once said,

spent "more on my wardrobe, per movie, than on the script.") Crawford rose to the occasion. She posed, she preened, she was the first star to share her rough-and-tumble beginnings in the movie magazines, and she solidified her image through them. She revealed her packing solutions for a European trip to readers. She gave them beauty and fashion tips and told fans that with ingenuity they could be glamorous on a shoestring.

In the process, Crawford became an oracle for working-class girls, for she instilled in them the notion that a polished appearance was crucial to social advancement. So it didn't matter to them that her on-screen high-fashion clothes were completely incongruous with her "shopgirl" parts. When reviewers criticized her for this, she was reminded by Joe Mankiewicz, her producer and writer for nine years, that her female fans wanted to see her in a dreamy version of their own life: "She doesn't want to see you in a housedress with armpit stains. She wants you dressed by Adrian, as she would like to be."

But those sessions with Adrian never translated into a style that made her a lingering fashion influence. Over time her look became even more constricted until she looked completely like what she was: a movie star. Her high-heeled ankle-strap shoes, which she began wearing in the thirties, remained a constant. She continued to match her dress to her shoes and later extended this habit to her gloves, hat, and handbag. "The one deadly mistake is to select accessories that almost match," she advised. "Nothing kills an outfit quicker." In this area she left nothing to chance—shoes and handbags were always made of the actual fabric and then plastic-laminated.

During the fifties, she traded her shoulder pads for plain, simple designs that she accented with fantastic jewelry, furs, and flamboyant hats. After Adrian left MGM, Crawford's name was no longer linked with a designer. More often than not, she designed her clothes herself.

"She would look at magazines," recalls Betty Barker, her secretary for twenty-two years, "and would take a top from one photo and the skirt from another. She had a Japanese dressmaker in California who would execute the designs for her, and she had a form of Joan's body in her workroom."

Peter Rogers, Crawford's close friend in later years and who was responsible for the Blackglama mink "What becomes a legend most" campaign, remembers she had one signature style in every color: "It was a boat-neck dress, cut down in a V at the back, and it had belled dolman three-quarter sleeves."

Crawford was equally obsessed with the construction of her clothes. She had learned to sew as a young woman, and in the days when she couldn't afford to buy nice dresses she made them. So confident was she in her sense of how her clothes should fit that, even when she bought from Hattie Carnegie and Chanel in the thirties, she did the alterations herself.

Crawford was without a doubt addicted to clothes. She was known to change them as often as five times a day. At the height of her stardom, she owned more than a dozen fur coats in a variety of species: "I look at them and know I'm a star," she confessed. Her closets were a tour de force, with separate storage space for dresses (cataloged according to season, climate, and function), shoes, hats, and even handbags. She once bought a new dinner dress from Adrian and told him she was going

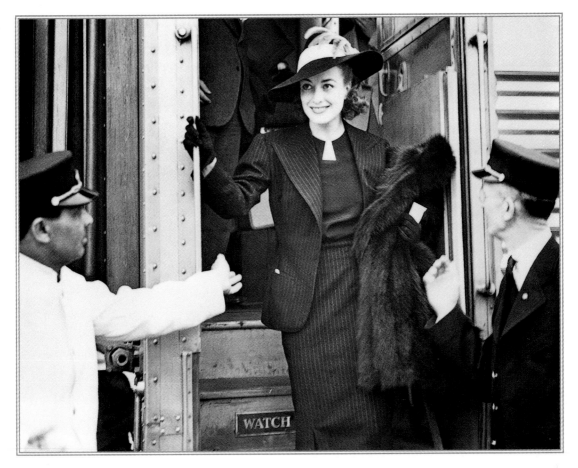

EVEN STEPPING off a train was orchestrated into a media event.

to wear it that night to the Biltmore Theater to see the Lunts perform.

"But, Joan, you've already seen the play," Adrian exclaimed.

"Well, not in this dress," Crawford shot back.

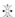

"As a human being, Miss Crawford is a very great actress," the director Nicholas Ray said after making *Johnny Guitar* (1954) with her. As Crawford worked tirelessly on her image and played out the role of movie star, she also worked to create a movielike life for her off-screen persona.

A classic way for someone as emotionally insecure as Crawford to assume a viable personal identity was through marriage. In her next three marriages she would play a variety of wife roles that ran the gamut from being an artistic-creative partner to going into retirement and playing housewife to a second-rate actor to becoming the exemplary corporate wife.

Her second marriage, to the actor Franchot Tone in 1935, was a major step in her self-improvement program. Tone was a well-educated, well-bred, wealthy easterner who had defied his patrician roots to become a founding member of the left-wing Group Theater.

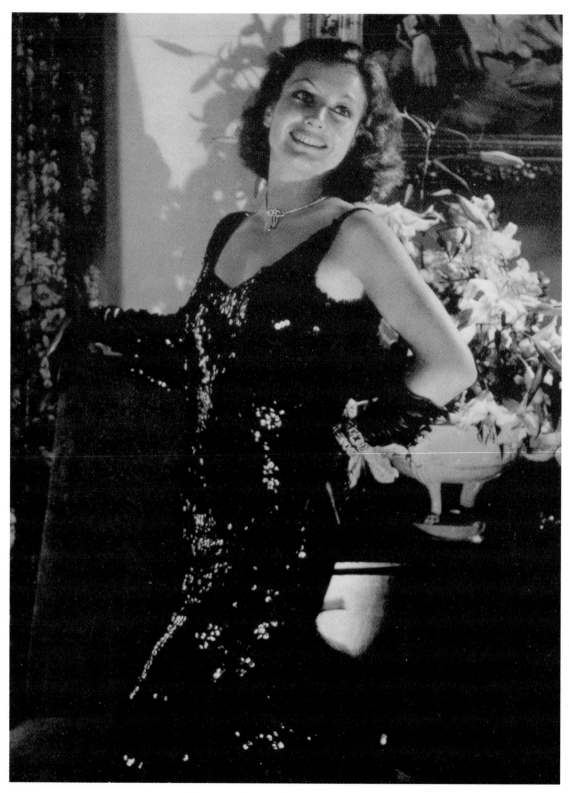

A 1932 sitting with Steichen for *Vanity Fair* magazine.

His decision to work in Hollywood had been a way for him to generate income for the financially troubled acting troupe. Crawford met him on the set of *Today We Live* in 1933. Tone, who was attracted to her intensity and vibrancy, fell instantly in love with the woman behind the glitz. To Joan, the actor was an irresistible blend of WASP polish and sensitive aesthete; she was charmed that Tone lived for his art and higher ideals.

Unlike Fairbanks, Tone didn't care about the Hollywood social whirl. He spent his evenings at plays and concerts—if, that is, he wasn't reading at home. He introduced Joan to theater and read to her from Shakespeare, Shaw, and Ibsen. He instructed her in the teachings of Stanislavsky, the Russian acting guru, and shared his love of opera with her as well.

What Crawford now envisioned for herself was a life that intertwined love and passion with a dedication to the pursuit of their artistic goals. She built a theater in back of her Brentwood house, where she and Tone staged one-act plays. She was so impressed by Tone's love of opera that she took voice lessons with a coach from the Metropolitan Opera. And dinner parties at her home were now musical evenings. "God, they were dull," recalls Dorothy Manners, who was Louella Parsons's assistant and later became her successor at the *Herald Tribune.* "Joan would read

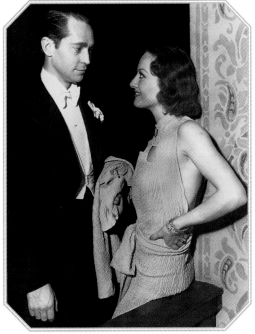

JOAN CRAWFORD with her second husband, the actor Franchot Tone.

the entire libretto of an opera while the score played on a record player in the background."

It was Joan's vision that she and Tone would become a celluloid version of the Lunts: artistic equals, costarring together. But this script was not to be. Tone's career as a top leading man never gelled, nor could he ever reconcile himself to giving up the theater. With those two dilemmas came the realization that for all of Joan's lofty notions of creative partnership, her appetite for movie stardom was larger. Their marriage became a cliché: Tone drank, became physically abusive, and then philandered. Joan divorced him. And, just as she had done with Fairbanks, she felt it was her obligation as a star to tell Louella Parsons first.

Crawford's next move in the personal fulfillment sweepstakes was to tackle motherhood. Shortly after divorcing Tone in 1939, she adopted Christina. But while she played mother, Crawford's career was going through changes.

Audiences and critics began to tire of her; in 1937 she was no longer on the list of top ten box office stars. A year later, along with Garbo, Dietrich, Hepburn, and many others, Crawford was declared "box office poison" by a chain of movie houses that placed a full-page ad in the *Hollywood Reporter* claiming they were tired of losing money on big-name stars who had lost their popularity.

While other stars made light of it, Crawford did not. Uttering her immortal line, "I will play Wallace Beery's grandmother if it is a good acting part," Crawford plunged ahead and in rapid succession made four of her best films: *The Women, Strange Cargo, Susan and God,* and *A Woman's Face.* When *A Woman's Face* was released in 1941, she had been at MGM for sixteen years. Except for Garbo and Shearer, Crawford was the only MGM star to have made the transition from silent star to sound star. She had, over time, become a credible actress. And at thirty-five she was more beautiful than ever.

For all that, Louis B. Mayer wanted to replace his stable with new faces. His method of eliminating the older actresses was to give them bad films; they, in order to preserve their dignity, would exit gracefully. The plan worked. After Crawford had a series of flops and Mayer awarded plum parts to newcomer Greer Garson, Crawford got the point and demanded a release from her contract. In 1943 she cleaned out her dressing room and left the only real home she had ever known. Whatever bitterness or hurt she felt, she never revealed. To the very end of her life she remained loyal to Mayer and the system he imposed, even at a time when it was popular for aging stars to attack it.

When she left MGM, Crawford had a third

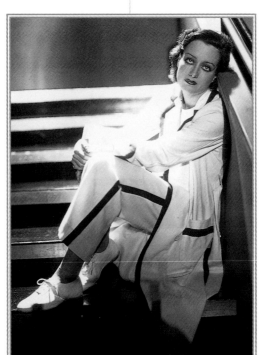

"THE CAMERA saw, I suspect," said director George Cukor, "a side of her that no flesh-and-blood lover ever saw."

husband to lean on. In 1942 she had married Philip Terry, a contract player she'd met on the set of *Mannequin.* Attractive, outgoing, but not larger than life like his predecessors, Terry was sympathetic to her career problems and satisfied her instincts that this time she needed not an exciting man but a solid one who could be a father to her daughter and expand the family by adopting a son, Christopher.

Though she signed a contract with Warner Brothers within days after leaving MGM, Crawford rejected the scripts submitted to her as not good enough for a star of her caliber. Instead, she played housewife, sending Terry off to RKO Studios every morning with a packed lunch she had made herself. She contributed to the war effort by joining several volunteer organizations. What this temporary hiatus really did was give full vent to her mania for cleanliness, tidiness, organization, and, according to Christina Crawford, discipline. As the war created a servant shortage, Joan ran the house herself and indulged her legendary passion for cleaning. Her friend William Haines arrived for dinner one evening to find her on her hands and knees scrubbing the kitchen floor, wearing an Adrian dress and jewels. Another friend witnessed her scrubbing the underside of the dining room table. "Someone might

drop a napkin and look up at the bottom side," she explained. "I'd be embarrassed if it were dirty." Considering it unhealthy to sit in bathwater, she replaced bathtubs with shower stalls. And of course there was her legendary fondness for plastic slipcovers on the upholstered furniture to guard against dust, dirt, and germs.

"There were spells between cooking, cleaning, washing, and sewing when I never gave movies a thought," she told Hedda Hopper. She may have pushed filmmaking out of her mind, but she didn't forget she was a star, nor did she want the public to forget it. And so she continued to court the press. When journalists arrived at the house, they were escorted to the garden where they found her playing with little Christina, who was dressed identically to her mother in a gingham dress handmade by Crawford.

In 1945, Crawford didn't have to work at keeping her image alive. The release of *Mildred Pierce* and the Oscar for Best Actress signaled a renaissance in her career. The story, adapted from the James M. Cain novel, was a classic Crawford formula: a woman of humble origins is deserted by her husband, supports her two daughters by working as a waitress, and then rises to become a restaurant tycoon. The only difference is that the warm, spirited shopgirl was replaced with a mature woman hardened by responsibility and unlucky in love.

Mildred Pierce launched a new persona for Crawford that would carry her through most of the seventeen pictures she made from the mid-forties to the end of the fifties: a lonely, brittle, successful middle-aged woman in search of love. And these roles, in turn, paralleled some of Crawford's real-life drama.

She divorced Philip Terry in 1946, realizing

that they had absolutely nothing to say to one another. "I married because I was unutterably lonely," she later admitted. "Don't *ever* marry because of loneliness. I've owed him an apology from the first." Now following what seemed to be a pattern, her response to the divorce was to adopt. This time it was two girls she claimed were twins, but who were in fact born a month apart.

Crawford thrived in her second film career. Her fans were more loyal than ever and still hung on to every piece of beauty and fashion trivia she imparted, which was a lot because Crawford's love of publicity was, if possible, greater than ever. She lavished attention on the movie-magazine photographers, making sure they got in to the private parties she attended for a half hour of photo ops. She was also eager to pose for all layouts that showcased her as the picture of motherhood and domesticity. The photographers showed their gratitude by respecting her wish for only full-face shots.

Unfortunately middle age brought on insecurities. She felt threatened by the younger actresses who appeared in her films. During these years her drinking escalated and her ritual of evening cocktails was changed to begin earlier in the day. On the set she drank 100-proof vodka from a flask encased in one of the many covers she had designed to match her outfits.

The other problem was the films themselves. Even in a bad movie, Crawford was good, and she gave some fine performances during these years, but the pictures were, for the most part, corny, overblown tales of vengeance and domination. As her roles grew more formidable, the scripts grew weaker. So did her leading men. She was no longer starring opposite Clark Gable and Spencer Tracy.

Instead, her costars were second-rate actors who could never hold their own against her.

In real life she finally met a man as strong and willful as she was—Alfred Steele, the president of Pepsi-Cola. Her decision to marry him in 1955 was the same as her reason for the Terry union: "I was unutterably lonely. I was unfulfilled. Stories that I've always had scores of men waiting around to date me simply weren't true. I can't tell you how many nights after I put the children to bed I've stayed up alone. I am a woman with a woman's need, a husband." (Crawford was no wallflower. During her single period she had her full share of romantic interludes, which for the most part seemed to be based on a very basic need for sex.)

The difference between this marriage and the previous ones was that Steele was a confident man with a clear sense of his own identity. It never once entered his mind that he would become Mr. Joan Crawford. Instead, she became Mrs. Alfred Steele in every sense of the word.

Initially, they were far from compatible. Although Crawford admired Steele's strength, she had grown accustomed to having her husbands do her bidding. Steele admired her for her professional achievements, but he also expected her to be his corporate consort.

The marriage coincided with a decline in

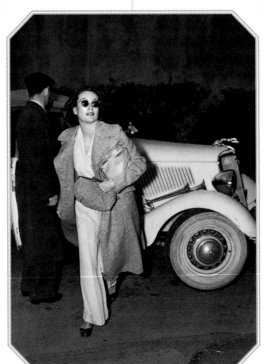

RARELY SEEN in pants, Joan arrives at the studio for a morning call.

Crawford's career. By 1956 she was fifty and film offers were sparse. After *The Story of Esther Costello* (1957), she had a hiatus of almost three years. Her antidote was to channel her energy into helping Steele make Pepsi-Cola the soft drink of choice. Together they traveled the globe promoting the Pepsi gospel.

For Crawford, every public appearance was like walking onto a movie set. Her makeup and her hair were always camera-perfect. Her speeches were written for her, interview questions were submitted beforehand, and she handled it all with her cool professionalism. During one nine-city tour she did 175 print interviews, 41 television shows, and 65 radio programs. Decked out in flamboyant hats, swathed in fur, and wearing her diamonds, she played Joan Crawford to the hilt at bottling plant openings and banquets for high-ranking officials of foreign countries.

Crawford was so committed to the marriage that she sold her Brentwood house and moved to New York City, where she and Steele bought an eight-room duplex on Fifth Avenue. The modernist firm of Skidmore, Owings and Merrill served as architects. True to Hollywood history, she had Billy Haines give the apartment an updated version of the sterile all-white look—low tables and scaled-down sofas and chairs in tones of green and

POSING AT her home in Brentwood.

WITH ACTOR John Emery.

yellow, accented with Crawford's preference for white carpeting. As always, great thought went into Crawford's wardrobe needs and her preference for closets arranged by color; her dressing area in this apartment had a massive closet for a shoe collection that now totaled 304 pairs.

Happiness was short-lived, however. Steele died of a heart attack in 1959 at age fifty-eight. Like the previous marriages, this had been a four-year run. Grief and mourning, however, were cut short by the realization that she was broke. Steele had been a brilliant salesman—taking Pepsi-Cola sales from 87 million bottles in 1955 to roughly 300 million at the time of his death—but he hadn't handled his own finances well. During their marriage, he had borrowed close to half a million dollars from Joan for the buying and renovation of the Fifth Avenue apartment, thinking that Pepsi would foot the bill, which it did not. Two weeks before his death she loaned him $100,000, of which she had no record. The kitty was more than just empty; he had left her with his debts.

Crawford went back to Hollywood to appear in *The Best of Everything*. She had only four scenes in the film, but contractually she positioned herself to make it seem as if she was still the biggest star in Hollywood. She demanded that her name on the credits be separate from the rest of the cast, and her dressing room trailer stood apart from the others. But Hollywood had changed in her absence, and

she couldn't control the attitudes of those around her. Jean Negulesco, who had directed her in *Humoresque* (1946), didn't give her courtesy star treatment this time, and the younger costars didn't bend to kiss her ring.

After *The Best of Everything* Crawford was away from the screen for three years. She returned with the macabre camp classic *What Ever Happened to Baby Jane* (1962), starring opposite Bette Davis. The movie was a box office hit and reinforced the careers of both actresses, and though Davis received far more attention for her flamboyant role, Crawford's more understated performance was touted as one of her best. But it also catapulted her into a House of Horrors cycle. She made five more films, each time playing a more grotesque character. Her swan song was *Trog* (1970). As one critic noted, "A real waste of time closes Crawford's career."

Joan supplemented her income between films by writing two books. One was her autobiography, *Portrait of Joan,* which she later admitted was a saccharine portrait: "I've been protected by studio PR men most of my life, so I don't do a good job on my own. I really don't know who to be. I'm a goddam image, not a person, and the poor girl who worked on it had to write about the image. I think she'd have been better off with Lassie."

Crawford's other tome, *My Way of Life,* was a kind of high-level "Hints from Heloise." She offered advice on fashion, decorating, and entertaining with tips like "Don't forget to light the candles before you serve the meat loaf."

Her important work during these years was as a working member of the Pepsi-Cola board of directors. She put in eighteen-hour days traveling around the world, opening and tour-

ing bottling plants, and making personal appearances in cities where sometimes as many as sixty thousand people showed up to get her autograph. In the role of goodwill ambassador she could once again act out the part of Joan Crawford, the star. She traveled with as many as thirty-five pieces of luggage and was accompanied by her personal maid. Crawford's requirements for the Pepsi promotional junkets were the same as for her movie tours. Among the list of items that were to be in her three-bedroom hotel suite prior to arrival were a steam iron and board, a professional-size hair dryer, red and yellow roses, one bowl of peppermint Life Savers, one carton of Alpine cigarettes, cracked ice in buckets, two bottles of Dom Pérignon, and two fifths of 100-proof Smirnoff vodka. She also demanded that a maid be waiting for her in the suite. The maid was to stay there until Crawford dismissed her.

Crawford's many demands were a drop in the bucket compared to the publicity she generated. In 1972, Pepsi-Cola estimated that the company had received 350 million print and broadcast exposures based on Joan Crawford's books, films, press conferences, and personal appearances. The Crawford name was now as synonymous with Pepsi as it was with padded shoulders and plastic slipcovers. But starlike ways and a dominant personality hadn't endeared her to Pepsi's president, the equally indomitable Don Kendall. Throughout 1972 she realized that her promotional tours had dwindled. In 1973 she learned by reading it in the *New York Times* that the company was putting her out to pasture.

For the first time since 1929, Joan Crawford was without a platform. She could have filled her insatiable need for stardom by granting the dozens of requests for interviews she

still received, but she discovered that journalism had changed along with everything else. The new breed of reporters who came to visit her wanted to unmask the myth. And so she began refusing interviews. No longer able to afford her Fifth Avenue duplex, she moved to smaller quarters in a high-rise apartment on East Sixty-ninth Street.

For the next five years Crawford lived quietly. She spent her days watching favorite television shows and answering her still mountainous fan mail. Every month five to ten thousand letters written or typed on pale blue stationery with the heading "Joan Crawford" were sent out.

Her social life was spent with a small circle of friends who, for the most part, were recent acquaintances. A typical evening was an early dinner at "21," her favorite restaurant. The place held special meaning for her. As a young chorus girl in New York she'd washed her underwear in the basement

ON THE MGM lot with Fred Astaire during the filming of *Dancing Lady*.

when it was a speakeasy; as a star she'd been a regular for forty years. At "21" she was still guaranteed a proper movie-star entrance, with the owners and waiters standing at attention to greet her.

"I went there at least once a week with her," recalls Peter Rogers. "One time she got out of the limo and then threw her mink coat off, letting it drag slightly on the floor, and said to

me, 'Let's show them how a real legend makes an entrance.'"

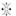

So what was the legend really like? According to Christina Crawford in her book, *Mommie Dearest,* she was a manipulative, neurotic, possessed woman who abused her and her brother. Christopher Crawford claimed at the time of publication that the book was a mild account of what happened. But Cindy and Cathy, the two younger children, said it was an assortment of malicious lies, and many of Joan Crawford's friends regard the book as an envious daughter's revenge.

"I knew many of the stories that Christina told in that book firsthand," says the costume designer Nolan Miller, who became a friend of Crawford's in the early 1950s. "Christina had her own ax to grind. She did get punished a lot. She was a very strong-willed child. I used to see Joan tell her to do something and she would flatly refuse. As a result they locked horns early. All that frustration came out in the book. At the end of Joan's life, she and Christina weren't speaking. And when Joan didn't include her in her will, Christina wrote the book as a retaliation."

That Crawford was a devout perfectionist there is no dispute, nor have her friends ever

denied she was a disciplinarian. It was Crawford's belief that discipline was what had made her a success; without it you were lost in life, unable to cope with problems.

"She was obsessed with manners and learning," says Marti Stevens, the singer and actress. "So there was a passion that often took a negative form." Those who knew Joan Crawford attest that she should never have been a mother. "She was not a maternal person. It was not her instinct," says Dorothy Manners, who had known Crawford since her Coconut Grove days. "Adopting those children was the thing to do. Joan was a kind person, but her blind spot was her children."

In later years Crawford gained perspective. She told her friend Jeanine Basinger, the film historian, who knew Crawford during the last two decades of her life, that motherhood hadn't been her best role. While many believe that there is a general truth to *Mommie Dearest,* I could not find anyone who believed the infamous wire coat hanger incident.

What the memoir failed to do was illustrate the ordeal of Crawford's career and the effect it had on her life. If the bizarre episodes described in *Mommie Dearest* did occur, would they have happened if Crawford had not become that abnormal, exotic creature—a movie star? It is only from the vantage point of

DURING THE thirties she created a fad for white pique.

stardom that explanations for her behavior can be offered.

One of the occupational hazards of being a star is the erosion of the original personality. Once the image or persona takes over, life becomes a conflict between fantasy and reality. Crawford's life was an amplified version of this conflict. She had invented herself to such a degree that her inner reality—or what she had ever possessed of an inner reality—had been wiped out. She was totally about her image.

As a result, there must have been a surreal quality to her life during those epic Hollywood years. The overwhelming unreality of her life formed a combustion in her psyche which more often than not was exacerbated by alcohol. When the volcano erupted, at least two of her children were the victims.

"Joan tried to be all things to all people," observed Helen Hayes, who was a Crawford friend for nearly fifty years. "I just wish she hadn't tried to be a mother." To her friends she was sentimental and kindhearted, and she helped people in the movie industry, rooting for the underdog at every turn.

"*Mommie Dearest* was not an accurate portrait of who Joan Crawford was as a person," says Jeanine Basinger, who taught a course on her at Wesleyan University. "How many people do

you know about whom you can say, 'This is a person I can count on one hundred percent'? If she was your friend she was there." Crawford, she insists, understood fully the difference between herself and her image. "She knew that Joan Crawford was a business and it was up to her to keep up the business. She probably had too big a grip on reality. Her life had been so hard."

During the forties the "electrified bull-dozer," as she was then called, told an inter-

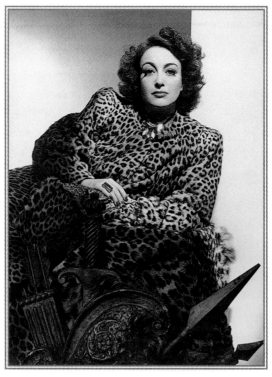

PUBLICITY WAS a part of Crawford's need for success.

viewer she was working on developing a sense of humor. In later years she had a sense of humor that went unacknowledged by inter-viewers and biographers. "If you knew her well enough, you knew she was playing a game, which was playing Joan Crawford the movie star," observes Peter Rogers. Like the time Rogers asked if she'd enjoyed a Neil Simon play: "I loved it, darling. I got three standing ovations." Or when the Players Club honored her. She camped up the awards luncheon by sweeping across the dining room carrying trays of food à la Mildred Pierce.

In later years she rarely talked about herself or her illustrious career; her apartment was devoid of early glamour shots. And if you were a close pal, she was comfortable letting you see the legend unmasked. "She would greet me at the door of her apartment in her muumuu,

rubber thongs, her hair pulled back in a pony-tail, and no makeup," says Rogers. "She'd make a huge vodka for each of us, and then I was invited into her dressing room to talk to her while she put on the Joan Crawford face."

By 1974 she began turning inward. She re-embraced the Christ-ian Science faith, which she had discov-ered in the 1930s. She gave up her longtime smoking habit and miraculously stopped drinking. Crawford's cold-turkey approach to her vodka addiction amazed her friends and family. Neither time nor age had withered her extraordinary discipline.

She became more and more of a recluse. "The most difficult thing for a star to face is that it's over," observes Nolan Miller, who vis-ited her at the end of her life. "Crawford was a star of such magnitude and she loved being one so much. She was sort of a Norma Desmond character; she never really got over it." But she told Peter Rogers that she enjoyed her solitude: "I've spent my whole life being told what to do. Now I have time to learn who I am."

Crawford's death was, in fact, her last star turn and proof of her indomitable will. In 1976 she began deteriorating. Her weight dropped to 85 pounds. Excruciating back pain forced her to spend most of her time in bed.

Most likely she had cancer. She refused all medical treatment and the only painkiller she took was aspirin. Instead, she relied on a Christian Scientist practitioner to help her die.

"I believe she knew she was dying and planned her death," says Rogers. "She and her secretary shredded all her papers." Two days before she died, she gave away Princess, her beloved Shih Tzu. Her only companions at the end were her housekeeper and a loyal fan from Brooklyn who ran errands for her. On May 10, 1977, she woke up, and though barely able to move from her bed, she insisted on making breakfast for the two women. Afterward she returned to her bedroom and called out to ask if they were enjoying the breakfast. Shortly after that she died of a heart attack.

The day after Crawford's death, Jack Valenti, head of the Motion Picture Associa-tion, requested a minute of silence on all the Hollywood lots. Two months after her death, at the headquarters of the Academy of Motion Picture Arts and Sciences, a memorial film about Crawford—film clips and reminiscences by industry stalwarts—played to a packed house.

To date, Joan Crawford is the only star for whom all the guilds banded together to give an industry-wide tribute. And it makes sense. Crawford was the ultimate symbol of Hollywood. She had followed all the rules of the golden era. She lived the way a star was supposed to live. She behaved the way a star was supposed to behave. She did more than live up to the image, she surpassed it. And even to the still-living legends in 1977, she was the ultimate. In the creation of Joan Crawford, Hollywood stardom had reached its zenith.

"TO THIS day I go out there looking like a star and I'm damned uncomfortable when I don't," she once said.

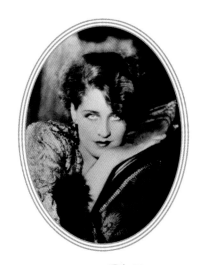

Norma Shearer

Norma Shearer was the glittering third link in the MGM triumvirate that also included Joan Crawford and Greta Garbo. Though her screen persona has not remained as indelible as theirs, she brought as much radiance, beauty, and individuality to the screen as her two colleagues.

Over the years film historians have belittled her talent and dismissed her success because she was the wife of Irving Thalberg, MGM's head of production. True, she would not have played all the epic roles he handpicked for her if she hadn't been his wife, but you have only to see her films to know that she was well cast in those parts and that she deserved whatever opportunities came her way. She was a hardworking, fiercely determined woman whose talent would have propelled her to a distinguished film career without the guiding hand of Thalberg.

Thalberg did not create something out of nothing. What he saw was a naturally gifted, strong, emotional actress who, with strong scripts, the best costumes, good lighting, and the right camera angles, could be turned into a star.

Norma Shearer's initial grooming began in Montreal in a year that has never been determined. Filmographies list her birth date as anywhere between 1899 and 1904. "You pick a number and I'll be it," she once told Arlene Dahl. The year 1902 appears to be the one that most writers favor.

She grew up in comfortable middle-class circumstances. Her father, Andrew Shearer, owned a successful lumber business, but he was a passive figure in stark contrast to her flamboyant mother. Edith Shearer had tired of her husband early on and was notoriously unfaithful to him. Her dramatic clothes and unusually white skin fueled the ludicrous rumor that she was a heroin addict. "I get whatever placidity I have from my father. But my mother taught me how to take it on the chin," Norma once said.

Norma always described her childhood as a "pleasant dream." She was the youngest of three children—her brother, Douglas, became a pioneering sound engineer in Hollywood, and Athole, her sister, was married to Howard Hawks, the film director. Shearer's dream, however, was marred by mental illness. Athole suffered a mental breakdown while still a teenager, and it would be the first of many until she was eventually institutionalized in the 1940s. Both parents experienced emotional problems and were treated in and out of hospitals. During her career, Norma went to great lengths to keep their hospitalizations out of the press. The family secret, as well as her own fear of "going Athole's way," would always be her cross to bear.

Sensing that Norma was artistically inclined, Edith saw in her younger daughter all her own unrealized dreams. By the time she was seven, Norma was studying with Montreal's top teacher and being groomed to be a concert pianist. Norma intensely disliked school; Edith educated her at home until she entered high school in 1912. At that point, the dream of a piano career was replaced by Norma's desire to be an actress.

The starstruck Norma lacked a few key attributes, however. She was a diminutive five feet two, but with broad shoulders, thick arms, peasantlike hands, and chubby legs. And she had a cast to her left eye; though she was not literally cross-eyed, the eye was oddly askew in her glance. On the plus side, Norma had innate charm and a vitality that made her shimmer—qualities that would make her screen presence so magical.

"She made herself beautiful," her high school friend, Margery Cohen, told biographer Gavin Lambert. To keep her weight down and to tone her figure, she took up athletics. She also spent long hours in front of a mirror experimenting with beauty products.

The "pleasant dream" changed when her father's business began to fail in 1920. The family was forced to move from a comfortable home to shabby rented accommodations in an inferior neighborhood. Not one to wait for the tide to turn in an already barren marriage, Edith seized the moment. In a "Let's put on a show" spirit, she packed up Norma and Athole and headed for New York City so that her daughters could break into show business.

The Shearers set up digs in a downtrodden boardinghouse that had no heat. Edith worked as a salesclerk. Norma and Athole were hired as extras in a series of films at five dollars a

day. Athole soon got discouraged, but Norma continued, more enraptured than ever by the process of moviemaking. While appearing in D. W. Griffth's *Way Down East*, Norma witnessed the perfectionism of Lillian Gish, whose exhaustive attention to detail and endless requests for retakes she would later emulate.

Her ambitions were temporarily squelched when Griffth told her that blue eyes looked blank on the screen. Florenz Ziegfeld, the theatrical impresario, was more direct: with her legs, her figure, and her eye problem, he said, Norma didn't stand a chance in any performing arts medium.

Norma spent long hours, day after day, in the waiting rooms of casting agents and booking agents, only to be told she was "not the type." She eventually found a believer in Edward Small, the first agent to handle film talent, who got her a featured role in *The Stealers*. She looked frumpy and matronly as the daughter of a minister, but something in her appearance sparked the attention of the general manager of Universal Studios in Hollywood, who offered her a one-year contract. This time she was thwarted by her biggest fan: Edith Shearer insisted upon a first-class train ticket for Norma as well as for herself. The studio was not about to give star treatment to an unknown, much less a ticket for her mother. More out of pride than concern, Edith persuaded Norma to turn down the offer.

With no money and no other prospects, Norma took up modeling, posing for the two top illustrators of the day—Charles Dana Gibson and James Montgomery Flagg. Her likeness began appearing on magazine covers, and she soon found herself on billboards around the country as the Springfield Tire girl.

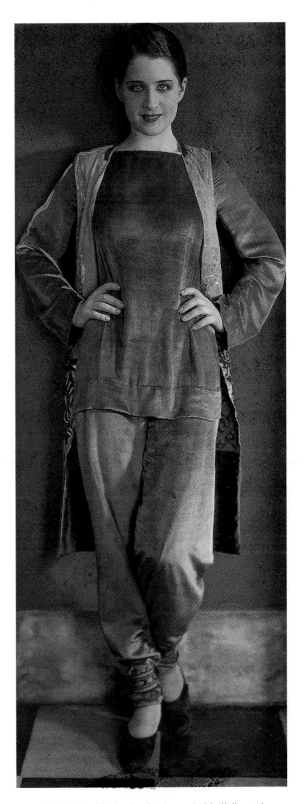

NORMA IN 1925, shortly after her arrival in Hollywood.

Modeling offered Norma the opportunity to analyze her looks and to figure out how to emphasize her good features and play down the bad ones. To make herself appear taller she walked with her head held high and assumed a ballerina posture. She realized that posing at a three-quarter angle would make her legs appear thinner and show off her handsome profile. By observing her close-ups in *The Stealers*, she saw that she would have to move in specific ways and use certain gestures in order to cover up her eye problem. She invested what little money she had in a visit to a renowned eye doctor, who gave her strengthening exercises and taught her a technique to help her keep the eye in focus. At night she went to the theater and studied the technique of stars like Ina Claire, Lynn Fontanne, and Katharine Cornell. She paid equally close attention to their offstage life—what they wore, how they lived, and what they said to the press.

After nearly a year of waiting for more screen work, she was cast in six films back-to-back. "A paralytic camera and flat lighting register a rather bland face rather pretty but somehow unformed," observes Gavin Lambert of these early films in his biography *Norma Shearer*. "Her figure is still plump, the cast in her eye disconcerts briefly in a few close shots, but more important than the way Norma looks is the impression she creates—an actress whose power has been switched on. You want to see it happen again."

Someone felt exactly that way. In March 1923, just after the release of her last film, she received an offer from Hal Roach, who wanted her for one of his serial comedies. Two days later the Mayer Company (a year later it would merge to become MGM) weighed in with a better offer for a six-month contract in Holly-wood with option renewals at $250 a week and the promise of an immediate screen test for a leading role—and as a bonus the studio would pay for Edith's transportation.

Norma took this offer in stride. In her mind she was already a star. Just before the train pulled into the Los Angeles station, she changed into a fashionable suit and hat, ready to extend her hand to studio heads who, she assumed, would be waiting to greet her. To her surprise no one was there. But the moment never registered as a disappointment. Instead, she entered the grand office of the Mayer Company the next morning with the same amount of confidence.

"A slim young man ushered me into a sumptuous office," Shearer recalled. "He was very gracious and polite, and I thought he was the office boy. I was somewhat dismayed when he followed me into the office and closed the door behind him. He sat down at the massive desk, eyed me impersonally, and announced that his name was Irving Thalberg and that he was the general manager."

It's never been recorded whether or not Norma had ever heard of the twenty-three-year-old "boy genius," Hollywood's most innovative and creative executive. He was small and frail as a result of a heart ailment that had plagued him since childhood. At the same time Thalberg had an aura of strength and confidence that overwhelmed all those who came in contact with him. Still, Norma hadn't forgotten her lack of star treatment the previous day, and to regain her ground she told him his offer was but one of three she'd received from Hollywood and that the one she'd turned down

SHEARER IN 1925, outside her modest bungalow in Hollywood. She was, even then, one of MGM's most popular stars.

from Universal in 1921 because of "prior commitments" had been for more money than what Thalberg had negotiated.

Thalberg politely reminded her that the Universal contract was for less. He knew that, he said, because he had made the Universal offer as well as the one from Hal Roach. After leaving Universal, Thalberg was set to work with the comedy producer and had asked him to look Norma up in New York. When his deal with Roach fell through, he went to work for Louis B. Mayer and renewed the offer to sign her up.

"I knew I was licked then," Norma remembered. "This man had a way of putting one down in a courteous but definite way that made you almost like it." As promised, she got her screen test for a lead, but it was such a disaster that Louis B. Mayer declared Thalberg's latest find a has-been before she'd begun. It was just what Griffith and Ziegfeld had predicted: "Strong lights placed on each side of my face made my blue eyes look almost white and, by nearly eliminating my nose, at times made me seem cross-eyed," Norma remembered.

The day after the test, a cameraman encountered Norma leaving Mayer's office in tears. As a favor he looked at the test, decided she'd been badly handled, and got permission to reshoot her. He rehearsed Norma with the camera. When he mentioned that her left eye seemed to spin out of focus, she acted surprised. It didn't happen again. Both Thalberg and Mayer were pleased with the new test, but was she demoted to a minor role in her first Hollywood film, *The Wanters.*

Still green behind the ears, she was cast in small, safe parts and loaned out to other studios to gain experience on someone else's ticket. She made six quickies in eight months.

It was on one of these loans that she fell madly in love with Victor Fleming, the dashing director, whose prowess with women was legendary. Though he dumped her as quickly as he'd bedded her, the heated affair exacted from her a performance, in *Empty Hands,* strong enough to convince Thalberg to cast Norma opposite America's heartthrob, John Gilbert.

He Who Gets Slapped could easily have ended her career, for her role as a bareback rider required her to wear a tutu that revealed her thick limbs, and the cast in her eye was still a problem. Thalberg, however, liked the chemistry between Gilbert and Shearer and cast her with him again in *The Snob* (1924). The director, Monta Bell, saw the excitement she could elicit on the screen. Off-screen he was smitten. Bell directed her in five more films, and under his tutelage—though she never gave him the credit—she developed her acting skills through his instructing her in camera technique, encouraging her to tap into her imagination and emotions, and allowing her to play a variety of types.

In later years, Norma liked to mythologize her romance with Thalberg, claiming it was love at first sight on both sides. Thalberg, however, showed no interest. As befitted his professional stature, he squired the superstars of the silent era, most often the fast-living, gorgeous Constance Talmadge, who repeatedly refused his offers of marriage.

Norma's relationship with Thalberg at this point was strictly a professional one. It centered on her frequent complaints that the studio was casting her in too many unimportant melodramas. Why, if her films made money, the reviews were good, and she had a following, were better roles going to lesser actresses—namely, Marion Davies, whom

Norma outranked in popularity polls in 1925.

In Thalberg's view, he was the best judge of what roles an actor should play. Besides, if her films were doing well, what was the problem? Again, she felt licked, but not enough to stop her campaign. It was this relentlessness that eventually attracted Thalberg's attention. "Something was understood between us, an indefinite feeling that neither could analyze—whether he was merely regarding me with a grave eye or I was weeping in his office or storming on the set," she said years later.

Things got more personal in July 1925, when Thalberg invited her to be his date at the premiere of *The Gold Rush.* The limousine, the flashbulbs popping as she stood by his side wearing a gown borrowed from the wardrobe department, entering the Coconut Grove on Thalberg's arm after the movie—the feeling of power had an intoxicating effect. Norma resolved that very night she would marry Irving Thalberg.

During the next year her dates with Thalberg were so sporadic that she jokingly referred to herself as "Irving's spare tire." But when Monta Bell proposed to her in the autumn of 1926, Norma more than declined: "I'm going to marry Irving Thalberg," she announced. This would have been news to everyone, including Thalberg. He was still actively pursuing the hard-to-get Talmadge.

The spare tire had learned how to swallow her pride and become an expert at the waiting game. She accepted all his invitations while artfully making sure she didn't appear too eager. She made no demands on him. She deferred to his archetypal hovering Jewish mother, who felt that no woman was good enough for her son, except maybe herself. When in Thalberg's company, Norma

matched his graceful reserve while exhibiting both compassion and sensibility.

At twenty-eight, Thalberg faced a tenuous future. He had suffered a heart attack in 1925, and he knew his life would be cut short by his heart problem. He wanted marriage and a dynasty. While he struggled to free himself of Constance Talmadge's emotional hold on him, Norma Shearer was showing him that she was built for more than just stardom. She was up to the demanding role of playing consort to Hollywood's crown prince.

All this time, Shearer was working tirelessly on her acting technique. She improved her figure under the guidance of Madame Sylvia, the masseuse and fitness expert to the stars, who claimed to break up fatty tissues by squeezing the flesh hard and then letting it slip through her fingers like mashed potatoes. The fiasco of the first screen test still haunted Norma, and she hounded the cameramen for tips to glamorize herself—one of which was to use vivid green eye shadow, which she thought enhanced her eyes.

Talent for Thalberg was the only true aphrodisiac, and that, in the end, was what sealed the relationship. After seeing a rough cut of *The Student Prince* (1927), he called Shearer into his office. The meeting looked like business as usual. He was sitting behind his desk, and he greeted her with his normal graceful reserve. The only discernible difference was the tray of diamond rings set before him. He merely looked up, smiled languidly, and said, "Pick one."

Finally she had the part for which she had auditioned so long. Still, she was careful not to overplay the scene, and she matched his timing by simply returning the smile and choosing her ring.

The wedding took place on September 29, 1927. It was a Jewish ceremony—Norma had converted—and a corporate event. Louis B. Mayer was the best man. Cedric Gibbons, the MGM art director, designed the flower arbor. And a handful of MGM executives and several contract directors were present. Louella Parsons, the only reporter invited, wrote that the bride "gave her most realistic performance" to date.

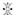

Mrs. Irving Thalberg was now officially "queen of the lot." The title brought envy from colleagues like Joan Crawford and Marion Davies. In Crawford's case it was the fear that the best parts would be given to the woman "who was sleeping with the boss." For Davies, who was the mistress of William Randolph Hearst, it was the realization that Norma had a more secure role. As a star who was invented solely by Hearst's money, Davies intuited that her career would be short-lived.

Initially, Norma's career was not elevated by the marriage. The first few movies she made after becoming Mrs. Thalberg were routine films not unlike the others. What Norma realized and what others didn't was that she had to justify the career opportunities that came her way as a result of being the boss's wife. And so she continued to perfect herself. She swam and

THIS PHOTO by George Hurrell convinced Thalberg that Shearer could play a siren in *The Divorcée*.

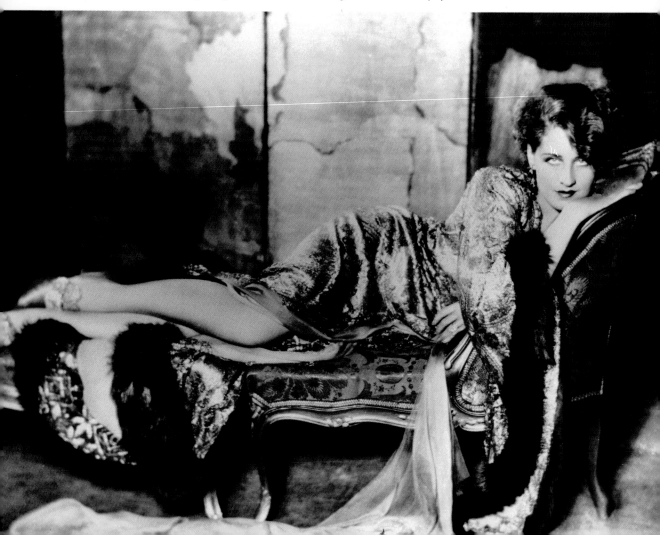

played tennis regularly to keep her body toned, and she did acrobatics to perfect her coordination; cartwheels were her specialty, and she enjoyed demonstrating them for her fellow actors on the set. Madame Sylvia continued to pound away more excess flesh. For Norma, dieting was simply a way of life.

Nor did she place her career entirely in the hands of Thalberg. While other actresses were criticizing the microphone, declaring sound a passing fancy—even Thalberg was slow to accept it—Norma took part in experiments at the University of Southern California in "the first scientific terminology of the speaking voice." With the professor who led the study, an MGM publicity man at her side, and a photographer, she spoke into a microphone attached to a recording machine. What came out was a medium-pitched voice, made all the more pleasant by a cultivated mid-Atlantic accent derived from her Canadian roots. Soon every actress in Hollywood wanted to speak like Norma Shearer.

The Trial of Mary Dugan (1929) was Norma's first talkie and MGM's first dramatic story to be made in sound. Winning the role of a tough showgirl on trial for murdering her rich lover took some convincing on Norma's part. Thalberg worried that the role was too demanding for her speaking debut, as it would require her to sustain a series of long dramatic monologues. Norma saw the part as more than a way to be the first MGM star to break the sound barrier. It was proof that she could play meatier roles. Her instincts were right. The film was a critical success and financially profitable enough to help build a new MGM lot, and Norma was dubbed "First Lady of the Talkies."

Still, Thalberg didn't encourage her to try more demanding roles. He had typecast her long ago: she was to play refined, genteel characters. When it came time to make *The Divorcée*, Norma played the shrewdest hand of her entire career. "Strong, ruthless, perfect for me!" is how she described the role of the disillusioned woman who trades marriage for sexual freedom. "But Irving won't give it to me, because he thinks I'm not glamorous enough."

Instead of pleading and coaxing and testing for the part, her way to show him was through visuals. She commissioned George Hurrell, then an unknown photographer, to do some portraits. Arriving at his studio with a publicist, her hairdresser, and a maid carrying several seductive dressing gowns, she explained her mission to Hurrell.

"That was the kind of determination Norma had," recalled Hurrell. "Always the tenacity to follow a hunch. Thalberg had doubted she could be sexy enough to bring off the part, and my pictures proved she could. Of course, the way she brought it off was a commentary on the time and its approach to expressing sexuality."

It was Hurrell who noticed that her short hair, plastered down in marcel waves, was too prim. He instructed the hairdresser to comb it in a downward sweep so that it fell seductively across one eye. What Hurrell didn't have to tell her was how to pose her legs to make them look slender. And when he saw her left eye wander he observed that she adjusted it immediately: "She knew how to focus just beyond what she was looking at. She looked *through* the lens—to something right past it. In the movies she also did the same thing, looking *past* someone or something, but when she had to refocus back, she couldn't always control it. Not enough time."

Thalberg was amazed at what he saw, which was, in Hurrell's words, "a woman of the world, waiting for an invitation." The film was Norma's turning point. She projected a unique mixture of glamour and ladylike sexiness— and won the Academy Award for Best Actress. Hurrell, as a result, became MGM's number one portrait photographer.

She created an even bigger sensation in her next film, *Let Us Be Gay*, when she became the first non–sex symbol to wear a clinging bias-cut dress without undergarments. Realizing the excitement this dress generated, she instructed Adrian to include a white satin bias-cut dress in every one of her pictures; he described those dresses as "Norma's night-gowns." The backless gowns she wore so suggestively in her next string of movies became her signature. Adrian handled her flaws with his usual brilliance. To make her hips looker narrower and her short legs appear longer, he gave her a raised waistline and lowered the hemline. To slim her hips, he elongated the line of the shoulder, which in turn highlighted her superb neck and shoulders.

Norma now understood that costume was the key ingredient. In a great dress she could convince the public she was a flawless beauty, as well as sexy. Costumes became her obsession, and Margaret Booth, one of the industry's top film editors, remembers "the reels and reels of wardrobe tests" that were done when she was preparing for a role.

That she could create an illusion of svelteness in *Let Us Be Gay* is all the more incredible, considering that she was pregnant at the time. Irving Thalberg Jr. was born in August 1930 (a daughter, Katharine, was born in 1935) two weeks after the release of the film. Norma's reaction to motherhood was to make another film, for fear her fans would forget her if she stayed away from the screen for too long. Motherhood was not a role Norma felt comfortable in; she would always have a distant relationship with her children. Such was her uneasiness that the time she spent with them was always in the presence of a nanny. For their part, what they always saw was Norma Shearer, the public image—charming, polite, reserved. In 1930 she viewed motherhood as the linchpin of a perfect domestic scenario. Then too, it was the perfect opportunity to escape from a suffocating environment. Until then the genius of Hollywood and his wife lived with his doting mother. "It was the only way I could get out of there," she told Irene Selznick, who was the daughter of Louis B. Mayer.

She now had everything she had waited for—Thalberg, money, fame, and the ultimate maternal coup, a son. But all this made her more restless, more ambitious. She was more neurotic than ever about her looks, her figure. She was obsessed that pregnancy had left her pudgy and worried that the audience would be able to see her stretch marks through the costumes. In fact, motherhood had given her a new kind of womanliness that made her more appealing on the screen.

She more than proved that point in *A Free Soul* (1931), in which she burned up the screen with a sexual fire that blended eroticism and poise. The message was clear: she was a woman who, if her buttons were correctly pressed, would leap into a forbidden zone of sexual desire. "She was like a cork on a sea of wantonness," observes an actor who knew Norma well. "There was something dangerous about her."

It might have been Clark Gable, her costar, that got the hormones jumping. Their on-

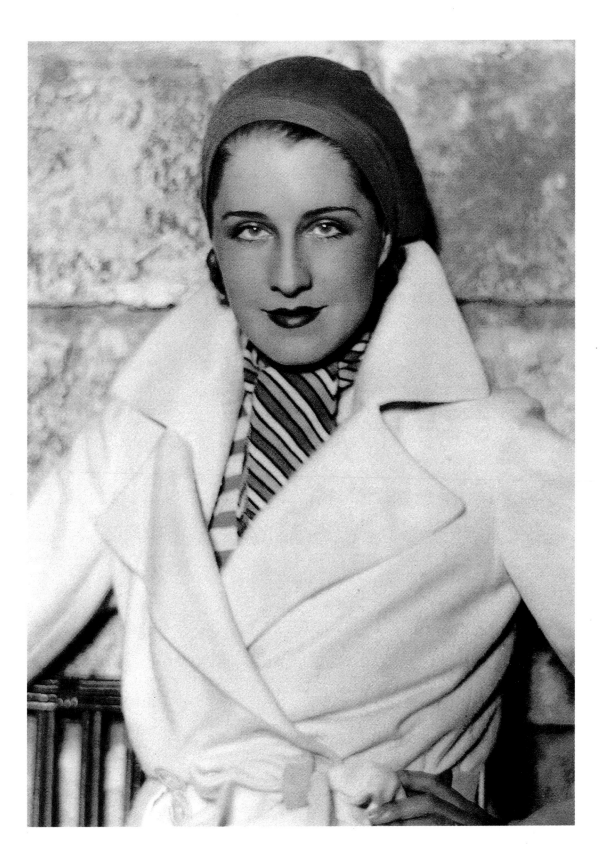

IN HER limousine
with Dolores Del Rio.

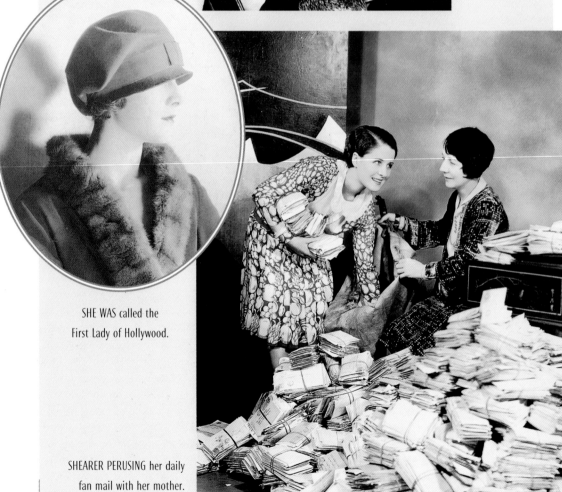

SHE WAS called the
First Lady of Hollywood.

SHEARER PERUSING her daily
fan mail with her mother.

NORMA SHEARER and Irving Thalberg, Hollywood's royal couple during the 1930s.

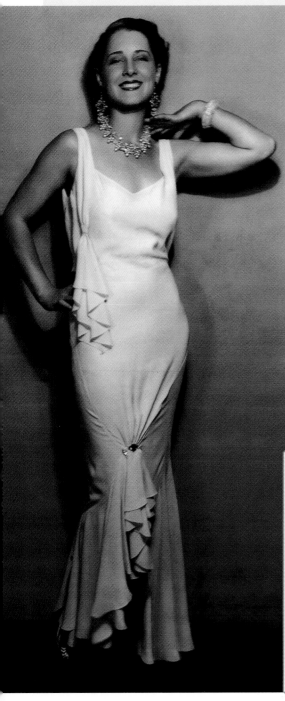

DESIGNER ADRIAN created bias-cut gowns to camouflage her figure flaws.

WITH HER second husband, Marti Arrouge.

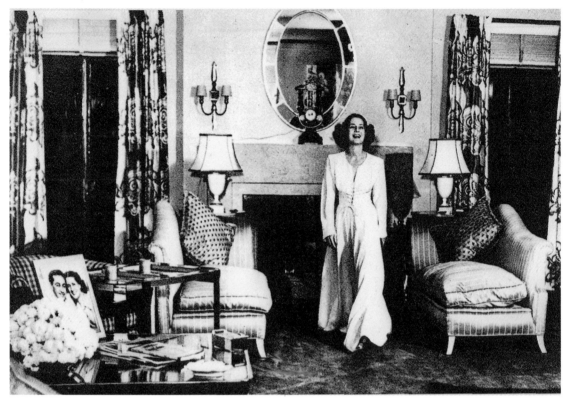

AT HER Santa Monica home during the forties.

screen electricity fueled all the obvious rumors. Gable's reaction, however, gave no indication of that. "The dame doesn't wear any underwear in her scenes," he told Clarence Brown, the film's director. "Is she doing that in the interest of realism or what? She must be one hot lay if she can behave like that with cameras turning."

In reality, she was putting *all* her sexual energy on the screen as a way to compensate for the lack of it in her personal life. The Thalberg marriage was based not on passion but rather on a shared passion for the movie business, a mutual professional respect (Thalberg's admiration for her increased the more he dealt with the demands of difficult stars), and a true friendship with shared values. In the area of sex, the overachieving but physically weak

Thalberg was an underachiever who conserved his energy for his work.

"She was romantically in love with Irving," Hedda Hopper observed. "She told me once that he was too handsome to be a producer and that he was the most gentle, tender, and sweet man ever, but I don't know that all that translated into good old-fashioned lust." Norma would withhold her sexual drive until after Thalberg's death.

"She was my first introduction to glamour," says the actress and singer Marti Stevens, who witnessed a great deal of glamour at close range as the daughter of Nicholas Schenck,

president of Loew's, Inc., the parent company of MGM.

Norma's beauty was not entirely a fantasy created by lighting, makeup, and camera angles. Friends recall that she had lovely hair, a wonderful mouth, and an elegant nose. "She was attractive, but it was really a self-contained aura that gave the illusion of great beauty and also gave her great style," recalls her friend J. Watson Webb, a film editor.

Off-screen Norma played a complicated dual role: on one hand, she was very much a movie star. On the other, she was a corporate wife who considered her husband the star of the marriage. This balancing act required careful orchestration. Norma the movie star learned how to make a dramatic entrance at parties by uttering a witty remark or timing her arrivals so she was fashionably late. Her most

memorable one was at the 1936 Mayfair Club Ball, Hollywood's major social event. The hostess that year was Carole Lombard, who had requested that ladies wear white. When Norma made her typically late and dazzling entrance, Lombard saw red both figuratively and literally. For there in front of her was the queen of Hollywood, having arrived décolleté in a strapless scarlet dress. Lombard's opinion of this was laced with her usual profanity. Another guest labled Shearer's stunt "pure ego."

"She made a complete study of Norma Shearer," observed Colleen Moore, one of the top stars of the silent era. "She knew how to make up to the best advantage, she knew the clothes that looked best on her, and how to wear them."

To other observers, Norma's artifice was done with a subtlety that obliterated any sign of

THE BEDROOM of the Santa Monica residence, designed by Cedric Gibbons, MGM's art director.

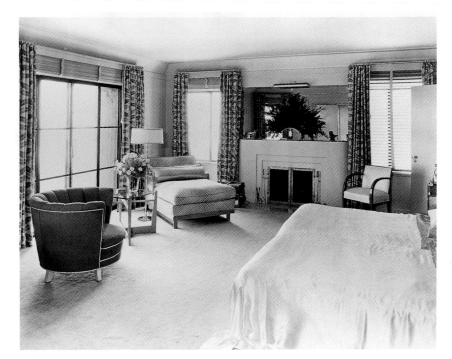

pretension. "I never got the impression she was trying to look glamorous," recalls the columnist Dorothy Manners. "Unlike Joan Crawford—who you knew had made the effort."

Her clothes reflected the duality of her position. At parties and premieres she was every inch the star in shimmering gowns. She was bathed in jewels and drenched in ermine, chinchilla, rich velvets, and brocades. For informal publicity shots she was the epitome of throwaway chic—white sailor pants, sleek fitting jersey sweater, a beret. On these occasions Irving would pose in a cream V-neck sweater with a shirt and tie and matching flannel trousers that made him look more Yale than MGM.

The promotional value of this glittering merger was not overlooked by MGM's publicity department. Norma's studio biography went from wholesome down-to-earth Canadian girl to a woman with breeding and an Anglo-Saxon pedigree. She now had a "patrician profile." Her manners and poise were "aristocratic." Together the couple played out the Hollywood version of high society, projecting an image that was more East Coast elegance than movieland glitz.

Shearer was as focused on Thalberg as she was on her career. They settled into a house they had built on the beach in Santa Monica, a favorite enclave for Hollywood luminaries. "I want nothing show-offish," said Norma. "I want it comfortable and homey—something Irving will look forward to at the end of a hard day at the studio." Still, the rooms were designed by Cedric Gibbons and recalled his memorable Art Deco movie sets.

She organized the household to suit Thalberg's needs and schedule. She made sure she was home from the studio to greet him with the one mild Scotch and water that his doctor had prescribed. Such was her concern for his health that she had the entire house sealed and air-conditioned because ocean air was bad for his heart condition—it was the first L.A. beach house to have this amenity. To help alleviate Thalberg's insomnia, the house was also heavily soundproofed to block out the sound of crashing waves.

"A house built for great emotional moments" is how F. Scott Fitzgerald, a frequent guest, described it. "There was an air of listening, as if the far silences of its vistas hid an audience." Norma's dinner parties were prized invitations; once Mary Pickford and Douglas Fairbanks divorced, Thalberg and Norma replaced them as Hollywood's royal couple. She shone as a hostess at her Sunday afternoon teas, which centered on an eclectic group of writers and actors and were a novel alternative to the more sedate dinner parties.

The owners themselves were their own best audience. Their off-screen life was so mannered, so poised, that they seemed more like movie characters than the dreamy ones created on the MGM lot. Here on the oceanfront, the Thalbergs created a living stage on which the only emotions played out were happiness, security, and success. "Fear and doubt, grief and anger were private emotions they sealed off from the world," observes biographer Gavin Lambert. "Irving discussed them freely and openly at script conferences; Norma 'lived' them for the camera."

Though Thalberg was proud of Norma's success as a femme fatale, it was still not the

SHEARER'S ON-SCREEN look was like her off-screen style: crisp and tidy.

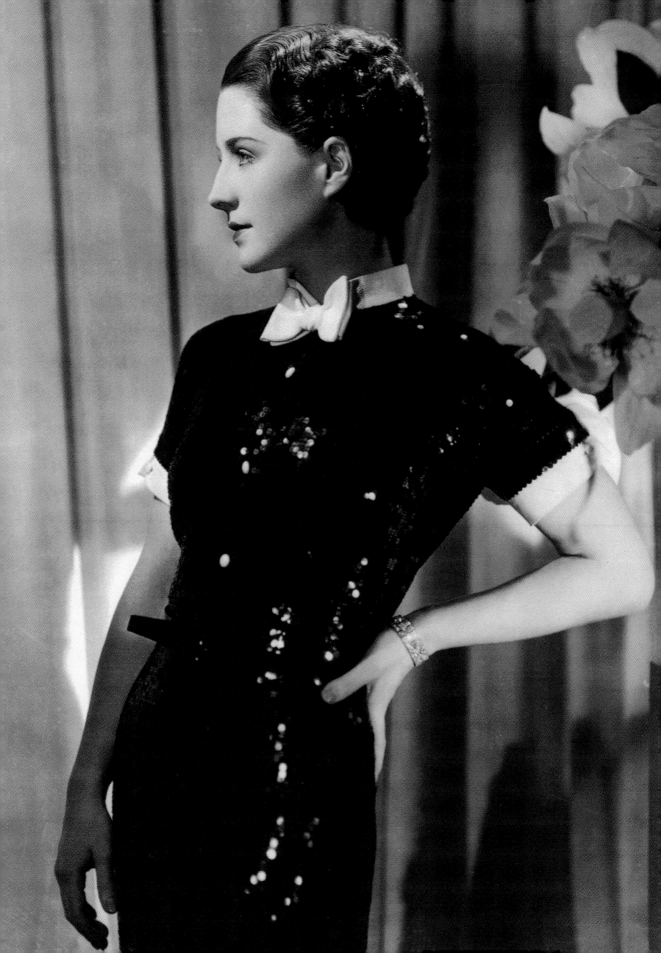

screen image he envisioned. He thought the roles she was playing didn't befit the "first lady of the screen," a title used by the press and publicity department. His dream was to make her the film equivalent of great American stage actresses like Helen Hayes, Katharine Cornell, and Lynn Fontanne. Thalberg wasn't completely off-base. Her portrayal of the poet Elizabeth Barrett Browning in *The Barretts of Wimpole Street* is a tour de force and prompted veteran actor Charles Laughton to call her "the best emotional actress in films."

There was an even grander plan at work here. In Thalberg's myth-making scenario, he wanted Norma's career to escalate to a glorious climax, and then, while still at her peak, she would retire. That point of view coincided with his own reality. His health was deteriorating, and he knew time was of the essence. The films he planned for Norma would be a part of his own legacy. "*Romeo and Juliet* and *Marie Antoinette*," he announced in May of 1935, "will mark the end of Norma's acting career. Too many stars stay on camera too long. I want her to bow out at her highest point."

Thalberg's expectations had become greater than Norma's. And as the pressure mounted to live up to those dreams, she became more obsessed with the image she had created. She spent hours refining her makeup to the point where she kept the cast and crew waiting. She was exasperating to colleagues because of her paranoic worry over camera angles, lighting effects, and costuming.

When, at age thirty-five, Norma had to convince an audience that she was the fourteen-year-old, star-crossed Juliet Capulet, her desire to live the part took on epic proportions. Off the set, she wore her hair in the long flowing curls that MGM hairstylist Sydney

Guilaroff had created for the role. She appeared at dinners wearing Renaissance-style gowns and Juliet's trademark skullcap, which Adrian designed specifically for these occasions. She altered her movements to give the impression of a sprightly adolescent. For all who witnessed it, she pulled off the illusion. Off-screen that is. As for the film, the reviews were polite.

On September 14, 1936, two weeks after the release of *Romeo and Juliet*, Irving Thalberg died at age thirty-seven. He had the kind of funeral usually reserved for heads of state. MGM studios closed for the day, and rival studios observed a five-minute silence at the time the service was due to begin. Thousands of stargazers lined Wilshire Boulevard to watch as every MGM contract player and almost all of Hollywood's living legends arrived to pay homage.

Norma went into semiseclusion until the middle of 1937. "It was no 'widow's front,'" the usually acerbic writer Anita Loos observed. "She had loved Irving deeply in her protective, motherly, sustaining way, and now, suddenly, there was no one to love anymore. I think she felt very bewildered and lost and alone—for a while."

When she emerged, it was to fight Louis B. Mayer for what would have been Thalberg's share of the profits of future MGM movies. Mayer argued that she was owed nothing. Norma insisted that Thalberg's contractual agreement, which was due to expire in 1938, lived on.

"Norma is brilliant; she should have been an attorney," Mayer once told Sydney Guilaroff. Norma more than proved herself. Her iron will, which she disguised in a rich veneer of impeccable manners, shocked even the titan

and his steely band of MGM executives. In addition to skillful lawyers, she hired a masterful public relations man, who waged her battle in the media. The press rallied support for her. Realizing the situation was bad for MGM's image, Mayer backed down.

As for her own professional future, Norma also triumphed. Her contract was renewed for six pictures a year at $150,000 each, and she received a $900,000 bonus for agreeing to stay at Metro. Her next task was to realize Thalberg's final celluloid dream of bringing the life of Marie Antoinette to the screen.

Without Thalberg to lend support, however, Norma became increasingly unsure of herself. While preparing for *Marie Antoinette,* she gave full vent to her preoccupation with costumes. After giving a dinner party, she would drive her guests to the MGM wardrobe department and

SHE FOUND ways to pose so that her legs looked thinner.

model the huge crinolines and flowing fur-trimmed capes. At home she practiced wearing the heavy sculptured wigs and weighty costumes so that when filming began she would be as graceful as a ballerina. This supreme attention to detail also prompted her to eschew makeup in the scenes when Marie Antoinette is waiting her execution.

With her fortune secure, and with a contract that suggested she was still a star, Norma now shed her veil of mourning and played out her version of the Merry Widow. She had Hurrell photograph the "new" Norma Shearer. She lightened her brown hair, swapped her conservative Mrs. Thalberg attire for more revealing outfits. At night she could be found doing the rumba at the in nightclubs with escorts like David Niven and Douglas Fairbanks Jr.

Even as a solo act, her off-screen entrances were often noteworthy. When Marion Davies and William Randolph Hearst gave one of their legendary costume parties with an American history theme, Norma came dressed as Marie Antoinette. Her defiance might have been overlooked if Hearst hadn't recently been thrown out of France and hadn't openly lobbied for Marion to play Marie.

Norma's real renaissance at age thirty-seven was her freedom to unleash the sexual drive that had been dormant for a decade. She became hopelessly infatuated with Tyrone Power, eleven years her junior, during the making of *Marie Antoinette,* but her eagerness scared off the complex star. She shocked even the more jaded members of the movie colony as she embarked on a prolific series of affairs that ran the gamut from crewmen to Howard Hughes to Jimmy Stewart to the sixteen-year-old Mickey Rooney, whom she reportedly seduced in her

dressing room on the MGM lot. That incident could have caused a major scandal if Louis B. Mayer and the underage actor's mother hadn't intervened. Norma finally settled down for several years with George Raft, the screen's quintessential gangster, whose off-screen image was shadowed in underworld connections. Marriage was in the cards, but when Raft tried to divorce his wife she made it financially difficult. Norma couldn't reconcile herself to love without marriage and ended the relationship.

Marie Antoinette was released in 1938. Praise was given all around for Adrian's lavish costumes, Cedric Gibbons's sets, and Norma's performance. For the fifth time since winning the Academy Award for *The Divorcée* she was nominated for a Best Actress Oscar.

As her last cinematic connection to Thalberg, *Marie Antoinette* was a watershed event. She was now faced with making her career decisions solo. Shortly after the film's release, she forfeited the opportunity to play Scarlett O'Hara because her fans disapproved of her playing a "bad woman." Though she regretted the decision, her fans actually saved her from disaster. It never occurred to Norma that at age thirty-six she might be too old for the part.

Her next film, *Idiot's Delight* with Clark Gable, fit into Thalberg's dream, for it had been a Broadway hit with Lynn Fontanne. But wearing a ridiculous blond wig and puffing away on a cigarette holder, Norma overacted the part of a fraudulent femme fatale and turned the delicious character into parody.

She next starred in Clare Boothe Luce's screen adaptation of *The Women* and played a virtuous wife who handles being dumped by her husband with a dignity that made her a role model to millions of women. Norma's fine performance suggested that she would have become a star without Thalberg's guiding hand. Unfortunately *The Women* was her last good instinct.

"Never let them see you in public after you've turned thirty-five. You're finished if you do," Edith Shearer once cautioned her daughter. Off-screen, Norma no longer stuck her head out for even a breath of fresh air without full makeup. As a guest in other people's homes she always checked the lighting before positioning herself in an area of the room. At the same time, her sexual awakening made her feel sixteen inside.

She now had, as Thalberg had once, a fixed image of herself. On-screen she was costarring with younger actresses, which increased her anxiety. Her attention to lighting, camera angles, and makeup bordered on neurosis. She

SHE COULD look at a hundred photos of herself in a few minutes and know exactly which ones should be eliminated.

had no interest in playing mature glamour; she wanted light romantic roles, and her choices reflected that. She turned down the lead in memorable films like *Mrs. Miniver*, which earned an Oscar for Greer Garson, and *Now, Voyager*, which elevated Bette Davis to queenly status at Warner Brothers. The failure of her 1942 film, *Her Cardboard Lover*, signaled that it was time for her to exit.

That decision was followed by her marriage that same year to Marti Arrouge, a ski instructor and champion athlete she had met while vacationing in Sun Valley. Tall, handsome, and virile-looking, he was, at twenty-eight, twelve years her junior. Naturally their merger aroused the usual suspicions—namely that he was marrying her for financial security. To dispel those rumors, Norma held a press conference to announce the details of a prenuptial agreement—a virtually unheard-of idea in the forties.

NORMA ENJOYING a tender moment with her son, Irving Thalberg Jr., during a publicity shoot.

The marriage was, in fact, a love match. To Norma, Marti was a robust version of Thalberg; he had, in addition to dark hair and the same coloring, a similar combination of strength and gentleness. For Arrouge's part, he saw a woman who was both strong and feminine; though she had a regal manner, she was unusually sportif. She also lavished on him the same devotion she'd given Thalberg. "I never saw her denigrate Marti," recalls Arlene Dahl. "She never played the grande dame."

She set up a new home with Arrouge in the Beverly Hills Hotel, where she lived for many years with an impressive staff of several servants, a chauffeur, personal maid, and separate governesses for her children. "She lived simply in a Cedric Gibbons time warp kind of way," says her longtime friend Mignon Winans. "She entertained stylishly on a small scale at home or gave dinners at Trader Vic's."

Their social life centered on her friends from the movie colony and Los Angeles society figures. Norma was an accomplished skier; winter vacations were in Sun Valley, the ski resort favored by many Los Angeles and East Coast society figures. "She looked great in ski togs. And she was the first to wear an all-in-one ski suit," says Arlene Dahl. For several years the couple set up residence in the swanky Swiss ski resort of St. Moritz.

As a reminder of the dreams she'd realized with Thalberg, she kept the house in Santa Monica for another nineteen years and maintained it as if she still lived there. Occasionally she returned to play out her role as a leading hostess and give dinner parties there. At one point she rented it to Moss Hart and his wife,

the actress Kitty Carlisle, when he was in Hollywood writing the screenplay for *A Star Is Born*.

"Once a week, Norma would arrive at the house with a huge bouquet of fake flowers to replace the ones from the week before," Kitty Carlisle Hart recalls. To Hart, Norma's appearance in 1954 was in stark contrast to the glamorous figure she had been dazzled by when she was a dinner guest at the Thalbergs' in the 1930s. "Now she seemed housewifely to me. She wore shirtwaist dresses." Hart had not been in the house for too long before she stumbled upon the legend. "When we rented the house, Norma told me the attic would be locked. I told her I wouldn't rent the house if there was a room that was locked in case of a fire. So she agreed to leave the key on a nail next to the attic door. Well, on the first rainy day, I went up. It was an Aladdin's cave. All her leatherbound scrapbooks were there. Racks and racks of clothes—evening capes, gowns. There were shoes that looked like they'd never been worn. There before me was the detritus of a lifetime."

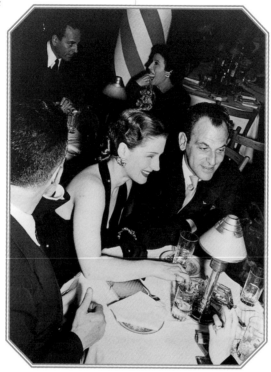

WITH MOSS Hart at the Mocambo, 1944.

In her desire to maintain a link to the past, Norma took an option on *The Last Tycoon*, F. Scott Fitzgerald's thinly veiled novel whose protagonist was based on Irving Thalberg, in the hope of developing it as a movie with herself as the producer. She even went as far as to discover an unknown ingenue who could play the fictional version of herself—Janet Leigh.

And there were a few fleeting attempts to get Norma to return to the screen. She was offered second leads and character parts, but anything less than star status was not acceptable. Movies were now, in her own words, "a closed chapter in my life."

As for Arrouge, he was involved in the development of the Squaw Valley ski resort, but with Norma's "official" retirement in 1947, his attempts at finding a professional identity were diminished. For the next thirty-six years, his career would be playing consort to the woman who thought of herself as Norma Shearer, the movie star.

"I always thought Norma had something funny back there," Marion Davies wrote in her memoirs. The movie set had been a refuge for her fixations and neuroses. Without that outlet, her peculiarities began to manifest themselves. "In the 1960s she was invited to a party in honor of Claudette Colbert," remembers the screenwriter Leonard Gershe, "and arrived three hours late with her hair in curlers. She stopped to kiss everyone and then went into the powder room for thirty minutes to fix her hair." When she reappeared, she looked fantastic and made no apologies. This

incident was not unusual; Norma was habitually late and, according to friends, would leave her house ready to go, look at herself in the mirror on the way out, decide she didn't like what she saw, and go back to her bedroom to start all over again.

Her appearance seemed to be her primary obsession. As she grew older, her mother's words kept coming back to haunt her, and she fought the aging process as if she were fighting for her life—exercising in the middle of the night, taking early morning jogs followed by an hour-long bath in ice water, and then doing a round of calisthenics in the afternoon. "She had a fantastic chin line, and she told me it was no accident," says Arlene Dahl. "She slept on a firm baby pillow so that her face was never squashed or pulled."

Such was her insecurity that when she saw herself in home movies taken in Sun Valley by her friend the producer Ray Stark and his wife, Fran, she became relentless in her insistence that certain shots be cut out of the reel. She preferred to look at the Norma Shearer of the 1930s. As time passed, her dinner parties were followed by a trip to the MGM lot to screen one of her movies. "Her favorite was *Marie Antoinette.* There was a Norma Desmond quality to it all," observes Gershe.

Like Garbo, she preferred to keep the myth alive by letting the public remember her as she once was. She refused to be photographed or interviewed and avoided public functions like movie premieres for fear she would be photographed from the wrong angle.

In later years she grew more reclusive. Her life centered on long walks and dining at her favorite coffee shop. By the 1970s her fear of madness was becoming valid. She suffered a nervous breakdown and entered the same sanatorium as Athole for shock treatments; at one point she tried to kill herself. In 1977 her eyesight began to fail. She was diagnosed with glaucoma, and her mental state began to deteriorate further. Three years later she entered the Motion Picture Country Hospital. Fellow patients who had known the glamour of Norma Shearer found her nearly unrecognizable. She wore dark glasses to protect her eyes; her hair, now snow white, flowed down her back, and she refused all attempts to spruce up her appearance. By 1982 she no longer recognized her family and referred to Arrouge as Irving. She died a year later of bronchial pneumonia, just shy of her eighty-third birthday.

In 1952, when the Screen Producers Guild honored Louis B. Mayer, Norma Shearer was the only woman invited to speak. When she got to the lectern, her hands were trembling and her eyes were already filled with tears. Her voice was steady but soon faltered as she turned to Mayer and said, "Thank you for the happiest days of my life, which brought me the very most of life." It was the last ceremony she ever attended that was connected with the movie industry; after that, she declined all interviews and refused even to autograph photos of herself for her fans.

It is understandable, therefore, that she wanted her funeral service to be private. And it says everything about her that, in her desire to keep the eternal flame of myth burning as bright as it had in the days when she was the queen of Hollywood, she requested to be buried next to Irving Thalberg, the ringmaster of illusions and dreams, who had guided and protected her.

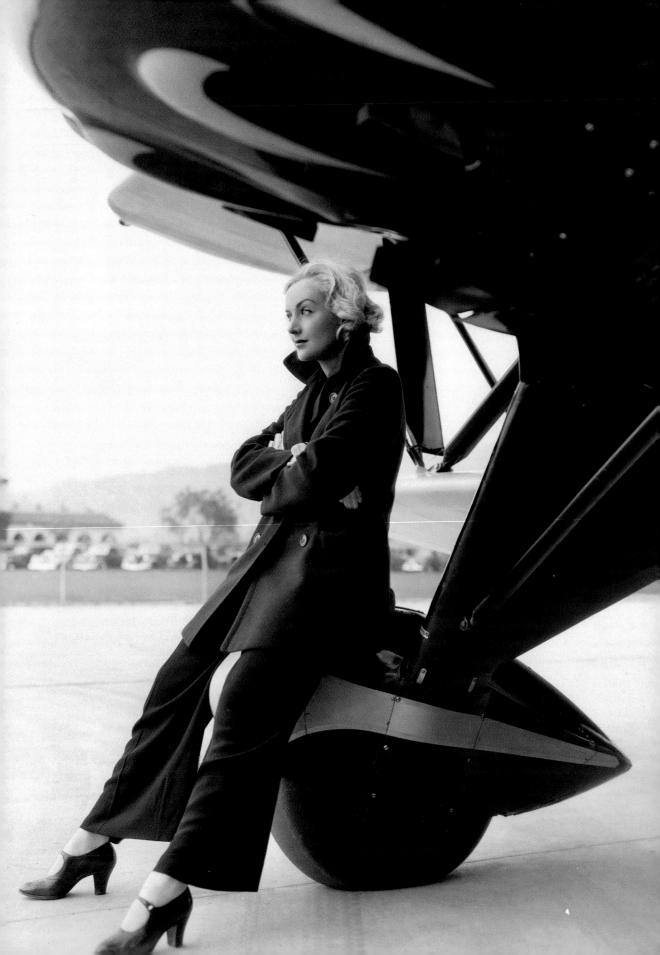

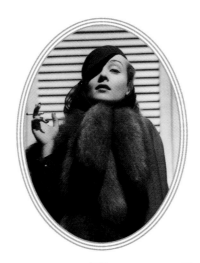

Carole Lombard

In 1934 the director Howard Hawks was looking for an un-known actress to star in his film Twentieth Century, a sophisticated comedy about a stage actress's attempt to escape a possessive director who happens to be her mentor and lover. Having cast John Barrymore, stage and screen's ham extraordinaire, as the histrionic director, Hawks reasoned that it would be more interesting "to see a new girl playing with a man who's well established."

Hawks's choice for a leading lady was hardly an unknown. By 1934, Carole Lombard had been under contract at Paramount Studios for four years, having been featured as an elegant clothes-horse in routine romantic films. Moreover, she was a media favorite as a result of her marriage to the soigné actor William Powell in 1931. And her madcap off-screen shenanigans had made her a film personality in her own right.

Even more curiously, Hawks

considered Lombard "the worst actress in the world," but he knew her—they were second cousins—and the person he saw off-screen was a "marvelous gal, crazy as a bedbug. If she could just be herself, she'd be great for the part."

Lombard had no idea why Hawks had chosen her for this plum role. All she knew was that she adored every aspect of moviemaking and felt lucky to be paid to do something she loved. Her passion for the business made her a dedicated worker. And so, as was her custom, she arrived on the set for the first day of shooting knowing all her lines perfectly.

It was immediately obvious to Hawks and even to the cynical Barrymore that she had indeed worked hard. That was, in fact, the problem. Lombard was so perfect that she was wooden—so completely wrong in her delivery that Barrymore held his nose behind her back as the camera rolled.

Hawks took Lombard aside and asked what she would do in real life if someone like Barrymore's character insulted her as he had just done in the scene.

"I'd kick him in the balls," she said without missing a beat.

"Well, then, do that," Hawks suggested. "Do any damn thing that comes into your mind that's natural, and quit acting. If you don't quit acting, I'm going to fire you this afternoon."

The experience of being turned loose by a director was a watershed event for Lombard. Until *Twentieth Century*, she had doubted her talent, but she now realized that she was capable of delivering first-rate performances. She also saw that she could have a much bigger career than she'd thought imaginable if she just did what she knew how to do best: play herself.

And so, after ten years of "acting," Lombard relaxed and reinvented herself as the queen of screwball comedy.

Lombard may have been zany, but she was also quite sane, for she understood that this transformation wasn't just a matter of choosing the right scripts. She knew that achieving full-blown stardom also meant firmly planting her persona in the minds of moviegoers. And so she pumped up the volume on her off-screen life and turned herself into a seamless invention of her on-screen screwball self.

Fifty-five years after her untimely death in a plane crash at age thirty-four, the Carole Lombard style and personality are still as modern as they were then. During her career, she was symbolic of an American type—insouciant, down-to-earth, sporty. She was recognized for her beauty, emulated for her high-fashion on-screen wardrobe, and envied for her marriage to America's Adonis, Clark Gable.

But the female moviegoing public did not embrace her as a role model. Unlike Joan Crawford, she did not personify the American Dream. Nor did she symbolize Anglo-Saxon breeding and refinement, like Norma Shearer—though, unlike Shearer, Lombard actually descended from WASP stock and came from a wealthy family.

The truth is that Carole Lombard, who was born Jane Alice Peters in Fort Wayne, Indiana, in 1908, was way ahead of her time—a prototype of the kind of liberated American woman that didn't flower until long after her death.

Lombard's allure resided in her ability to blend the masculine and feminine sides of her personality. "I live by a man's code, designed to fit a man's world, yet at the same time I never

forget that a woman's first job is to choose the right shade of lipstick," she once said.

She was warm, openhearted, and generous. And yet her insolent delivery, which conveyed overtones of flippant sexuality, made her able to hold her own against any man in wit and words. Her penchant for profanity shocked even the more jaded denizens of Hollywood and became part of her legend. So did her sexual candor. But Lombard knew that it's not what you say, it's how you say it. As in her summation of Gable's lovemaking skills: "I love the guy, but to tell you the truth, he's not a hell of a good lay."

Lombard could hunt, shoot, and fish and be a pal by day, but once the sun went down she was every inch a woman. Her ease in the company of men was remarkable then and is enviable now. "She was utterly devoid of those coquetries which almost every woman uses in her relationship with the opposite sex and that, in the film business, were so much a part of her equipment for success both on screen and off," recalled John Cromwell, one of her directors.

Those qualities came directly from her childhood. When she was six, her parents separated and her mother took her and her two older brothers to Los Angeles for a vacation that turned into a permanent stay. Lombard adored her brothers, who were now the male

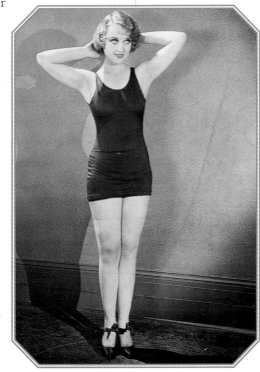

IN 1928 before her transformation into a Paramount glamour queen.

figures in her life, and trailed after them, fashioning herself into a tomboy so she could share in their interests. At school she became a medal-winning athlete in track, swimming, and tennis. Off campus, her brothers coached her in baseball, football, and boxing.

It was while she was sparring in her own backyard that director Allan Dwan, who happened to be visiting the Lombards' neighbor, spied the scrappy twelve-year-old over the fence and cast her in a minor role in his film *A Perfect Crime.* Lombard was hooked, and at fifteen she abandoned junior high school to enroll in drama classes and work on the studio back lots.

Physically, Lombard was anything but boyish. By the time she hit her teens she was over-developed for her age. As a result, she endured endless bottom pinching and bosom grabbing from neighborhood boys. As she tried to find a foothold in the movie business, she became the victim of older studio leches.

It was then that she took action. She had heard that nothing turned a man off faster than to hear a woman indulge in profanity. And so, to fend off her seducers, she recruited her brothers to teach her every vulgar, foul word they knew. The lechers weren't just put off, they were left dead in their tracks, mind-boggled that such filth could come of the mouth of

someone who was so pretty and obviously nice.

"Carole picked out the words and phrases she wanted to use as her weapon," her brother Fred Peters later explained. "Her language never became as blue as some people said, and she was always proper—she never forgot herself. Some words women throw around today, Carole would simply never use. Everything was different then, and a girl could get herself into a lot of trouble just by talking dirty. But she had the style to carry it off."

In later years she would continue to use her technique to ward off offenders like Fredric March, her costar in *Nothing Sacred* (1937), who made repeated sexual advances toward her on the set. She cured the problem by inviting him to her dressing room for a drink and allowing him to rub his hand up to her thigh where she had strapped on a rubber dildo.

Carole Lombard's film career officially began when she was placed under contract with Fox Studios in 1925. Fox mistakenly rushed her into leading roles. When the result was disastrous she was relegated to lesser ones, and at the end of the year, Fox declined to renew her contract.

In 1926 she almost lost her career altogether when she was in a serious car accident that resulted in a bone-deep gash across her left cheek. Plastic surgery saved her face but left a noticeable scar (which did fade over time). Devastated, but determined to press on, she studied makeup and lighting techniques during her recuperation. (In later years she was so knowledgeable about lighting and camera angles that she could light a scene herself, and she once amazed a crew when she knew a small light was out because a minuscule patch

of skin above her right cheekbone felt cool.)

After recovering from her accident, she landed a job at the Mack Sennett Studio as one of the slapstick king's Bathing Beauties. Sennett cared more about a curvaceous figure and athletic ability than a flawless face, which in his zany comedies was usually covered with custard pie. Lombard spent two years and made a dozen two-reelers at the pie-throwing academy, where she developed the comic style and timing that would be so useful to her.

She moved on to features at Pathe Studios, where owner Joseph Kennedy hired her on the condition that she lose 20 pounds. He was right. Her husky curves, so perfect for slapstick, would get her nowhere as a mainstream ingenue.

Lombard subjected herself to the tortures of Madame Sylvia, the masseuse and "physical culturist," who was then under contract to Pathe after having been discovered by Kennedy's lover, Gloria Swanson. "Give me four weeks with her and you'll be amazed," the fitness guru pledged. Sylvia put Lombard on a diet that was practically another word for "starvation," and twice a day for two hours she pounded, squeezed, and slapped the flesh away. A month later Lombard emerged from the ordeal four dress sizes smaller, weighing 110 pounds, and unveiling an enchanting face with excellent bone structure.

At Pathe she also made her first talkie, which revealed a distinctive lilting voice. That, combined with her beauty, made her a desirable commodity. In 1930, Paramount Studios was impressed enough to sign her to a seven-year contract.

Lombard arrived at Paramount on the crest of the new craze for glamour. The studio had successfully molded Constance Bennett, Kay

Francis, and most recently Marlene Dietrich into sophisticated glamour girls. Lombard now had a willowy, well-proportioned body, so Paramount decided she could be marketed the same way. The studio sold Lombard to the public as "the orchid lady"—the flower was meant to be a symbol of sophistication—and for the next three years orchids were featured in her publicity stills and embellished her movie sets.

"Throw a bolt of material around Carole, and any way it hits her she'll look great," said Travis Banton, Paramount's chief costume designer. But that quality wasn't fully realized until Banton costumed her for *Ladies' Man* (1931). He brought out features that she didn't even know she had. For that film he created a full-length beaded shirtmaker gown that remained in vogue throughout the thirties.

Banton loved Carole's long, slim lines, compared her to a greyhound, and thought her proportions (5 feet 5 inches, 110 pounds, 34-24-34) made her the perfect muse for his signature look. He showcased her in slithering, beaded bias-cut gowns that emphasized her graceful body and suited her then-novel preference for wearing no foundation garments or underwear. When she moved into her screwball phase, Banton became more playful and created jaunty, flamboyant designs that suited her urbane slapstick persona.

Lombard was one of the few stars who preferred to dress ahead of what was currently in fashion. She knew that fads for an actress were deadly on the screen and that part of the glamour game was for a designer to predict a trend and create costumes that would remain stylish through the run of the film. Banton, for the most part, gave her classic lines that in no way dated her.

Off-screen, Lombard was so pleased with Banton's creations that she had him design most of her personal wardrobe as well. He perfected a look that she'd been developing for a number of years. Her first influence was Peggy Hopkins Joyce, a New York showgirl turned silent-screen actress, famous for her marriages, jewelry, and fashion chic. Lombard admired Joyce's New York brand of sophisticated glamour, which emphasized simplicity; Lombard adopted sheathlike suits and simple gowns embellished by a strand of pearls or a startling brooch.

"She was the first fashion-conscious star I met, one who could influence the taste of American women," wrote Edith Head, who dressed Lombard after Banton left Paramount. "Carole loved tailored clothes; she hated dresses that looked, she said, 'like a cross between French pastry and a lampshade.'"

Hollywood recognized her clean, elegant style and named her its best-dressed actress of 1935. Lombard's style sense worked for her both on and off the screen: "Her clothes always looked as if they belonged to her," observed Head. "Nine out of ten actresses thought in terms of costumes, but to Carole they were just clothes. Some girls never learn to wear elegance naturally, but it seemed that Carole had always known how."

"I'm a fooler," Lombard once told an interviewer. "I try to be what people want me to be. Perhaps actors reach a point where they're acting all the time and can't do otherwise. What you hear about how naturally I behave is so much horseshit. I mean, what's natural? Of course there is a real me, but I don't value her so highly that I have to force her on people. I like to be liked, but everyone might not like me

as I am, so I bend. It's a kind of acting and psychology and lying all mixed up, trying to be what people want and expect. But I don't apologize. I like people to reveal themselves to me, and not devote all their time and attention to trying to assimilate me. You see, most people can't be flexible. I can, so I am. I take on the attitudes and tastes of other people. And they like that."

That attitude established Lombard as the most popular actress on the Paramount lot. She brought a liveliness to daily studio life, whizzing around the lot on a motorized kiddie car or on roller skates, which started a fad with co-workers. She was beloved by technicians, directors, and fellow actors for her lack of pretense, her warmth, and her infectious sense of fun.

But on screen, during the early thirties, she was the "glazed, immobile heroine of countless woeful dramas in which she concealed tears behind a tinsel mask," wrote Richard Griffith in his book *The Movie Stars.* In spite of her training, the studio didn't see her as a comedienne.

The first glimmer of her comic gift was in *No Man of Her Own* (1932), in which she starred opposite Clark Gable. "Someone complained that she didn't seem to be acting, which was one hell of a complaint," observed Wesley Ruggles, the film's director, years later. "It didn't *look* like acting, it was so damn natural. Look at the picture today. It's dated, but her work isn't. She's playing straight, but using comedy technique, too. Those idiots at the studio—they couldn't even see that. The critics didn't see it, either. She was wonderful, but it just passed by."

Lombard rode out those rocky years by understanding the value of publicity and making a name for herself through the medium of fan magazines. She had a natural flair for publicity and instinctively knew what the movie-addicted public wanted to read.

In her days as a contract player at Pathe Studios, she wrote her own studio biography, which stayed close to the truth. But when publicity executives felt that dullness was creeping in, she was the first to say, "Let's dream something up."

Shortly after Lombard arrived at Paramount an *e* was mistakenly added to Carol in the credits for *Fast and Loose* (1930). She decided to keep the extra letter and fashion a story around the name change. Soon an item was released that Lombard was guided by psychics and that her mother, who was a numerologist (this was absolutely true), told her that thirteen letters in her name created better vibrations for her destiny. As a result she received a mountain of publicity.

John Engstead, the Paramount studio photographer, took more than 1,700 portraits of her. During their first session in 1930, he realized how clever she was. "*Photoplay* was preparing a layout of actresses wearing their favorite pieces of jewelry," he recalled in his memoirs. "Instead of bringing one piece of jewelry, as requested, Carole brought in two pieces and two different dresses. 'Let the editors decide which they like,' she said. So we photographed both, and Carole ended up the only actress with two photographs in the layout."

At the peak of her career in 1937, she was one of the few stars who didn't prefer a closed set. As a result, her wacky antics were duly recorded in print—like the time she brought an air pistol to the set of *Nothing Sacred* and shot

LOMBARD POSING for George Hoyningen-Huene in 1934.

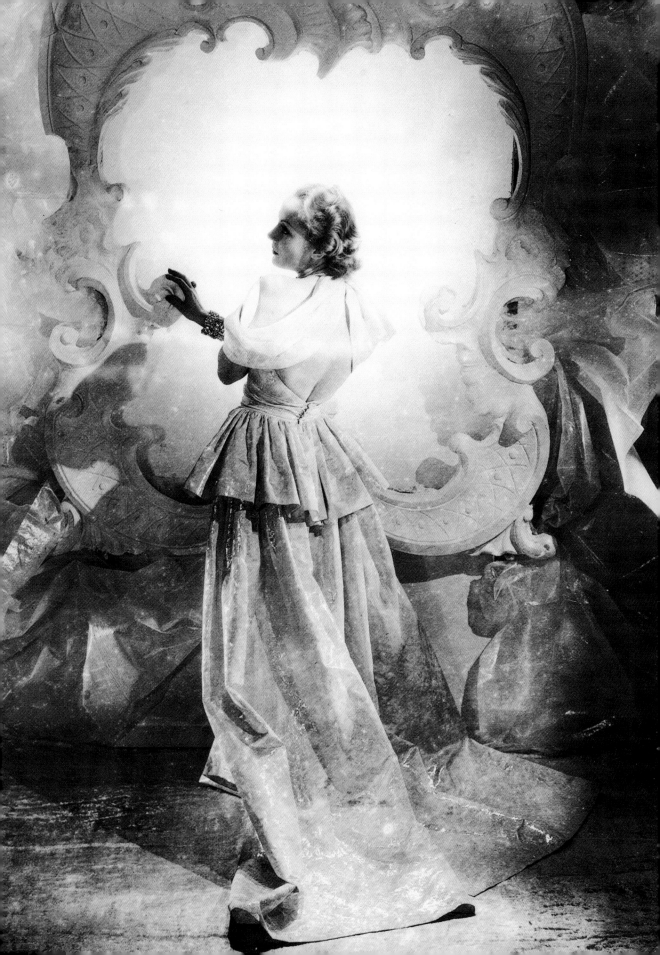

out the lightbulbs while technicians bet on her marksmanship.

Her interest in promotion once prompted her to devote a week off from filming to work in the publicity bungalow where she personally planted seventy stories in the press for producer David O. Selznick, with whom she was under contract. Of course she plunged into the job in true whirlwind Lombard style by installing a fire bell on her desk to summon secretaries and using a siren to announce her presence to Selznick, whose office was four yards away. The stories she released brought so much publicity for her that the mayor of Culver City (the site of the MGM studio) declared her the city's foremost star publicist and decreed July 9, 1938, as Carole Lombard Day.

Journalists loved her for her candor. She never edited her salty vocabulary, told them about her affairs, and freely discussed her views on sex. She once told a reporter that she found sex therapeutic. Another time, she shared her attitude toward marital fidelity: "Marital fidelity was something men and women could demand in equal measure; and they should forgive strayings accordingly."

Profilers for national magazines knew she preferred to go braless and that she rarely wore underwear. At a press conference for her film *True Confession* (1937) reporters asked if she could give them any information about Clark Gable that they didn't already know. "Well, Clark isn't circumcised. Bet you all didn't know *that*," she offered. Of course Lombard knew that none of it would ever be printed. The press in those days was far too conservative to run with anything remotely salacious.

What the public knew was a mountain of trivia: the lily, not the orchid, was her favorite flower; Scotch on the rocks was her signature

drink; she was a tennis nut (she once told a reporter she'd "take tennis over sex anytime") and a chain smoker; she drank far too much Coca-Cola; and she preferred baths to showers. The raciest revelations were that she had a mole on her behind and she loved sleeping in the raw.

The early lackluster years at Paramount were also a reflection of her attitude toward her career. That she had overcome the obstacle of her facial scar and was now featured as a clothes-horse made her feel plenty fortunate. There was also another factor: she lacked confidence in her ability, and, believing that she hadn't been properly trained, she uncomplainingly accepted the insipid parts they assigned her.

Lombard's off-screen life was taking precedence during those first three years. For her fourth film she was cast opposite the well-established actor William Powell in *Man of the World* (1931). It was a professional coup for her as well as a personal one. She had idolized the debonair leading man since she was a schoolgirl, and she imagined herself in love with him before filming began. Oddly enough, her fantasy did nothing for her performance, which was labeled "lazy" by the critics. Lombard later attributed her failure to infatuation.

Powell was sixteen years older than Lombard, a prominent fixture on the chic Hollywood social scene, and a desirable bachelor. He was beautifully tailored, knowledgeable about the arts, a connoisseur of wine; he collected fancy cars and lived luxuriously in an imposing all-white mansion. For the twenty-three-year-old actress, he was, like his screen image, a man of the world.

Powell basked in his bachelorhood (he had ended an unhappy marriage in the mid-1920s), but when he met Lombard he didn't

play hard to get. He was completely captivated by her disarming beauty and zest for life. In the middle of their second film together, *Ladies' Man* (1931), they announced their engagement. Lombard had only a supporting role in the movie, but the spotlight was clearly on her for having snagged the elusive star. The press was riveted, but insinuated that perhaps the refreshing blonde was really a gold digger in disguise. Powell's circle of male friends, who viewed themselves as a cut above the Hollywood colony in matters of class, thought Lombard was beneath Powell's station.

On her side, Lombard thought Powell's friends were just a tad pretentious and told him so. All the same, she was enamored of his sophistication. Both Lombard and Powell were smitten by the qualities that the other lacked. Secretly hoping they could change the things they didn't like, they

HER EXUBERANT personality allowed her to wear dramatic clothes.

were married in June 1931. But it was a tempestuous union from the start.

Powell was moody, lofty, and overly concerned with socially correct behavior; Lombard was blithe, spontaneous, and informal. He favored classical music; she preferred popular tunes. He was an expert ballroom dancer; she was a trophy-winning Charleston addict. He made a conscious effort to be well-read; her attention span was limited to the newspaper. Powell hated Lombard's profane vocabulary; Lombard was annoyed that he browsed through the dictionary looking for big words to further enhance his erudite image.

The scenario was a romantic comedy of sorts.

It wasn't long before Lombard realized that Powell was playing Powell twenty-four hours a day. "The son of a bitch is acting even when he takes his pajamas off," she told a friend. The marriage officially lasted two years, with Lombard describing it as "a waste of time—his and mine."

❋

Lombard's career was in a holding pattern when she divorced Powell in 1933. She was in demand, though not considered a great talent. She was thought of as a reasonably good actress who filled a niche in Paramount's stable. Her continual ability to be good copy kept her popularity up, though she was far below the top ten in the rating charts.

It wasn't until the release of *Twentieth Century*, when John Barrymore said she was "the greatest actress I've ever worked with," that Hollywood and the critics finally took notice. *Twentieth Century* brought into focus the irresistible qualities that had already made her an off-screen legend among her friends and colleagues. And at last Lombard had the courage

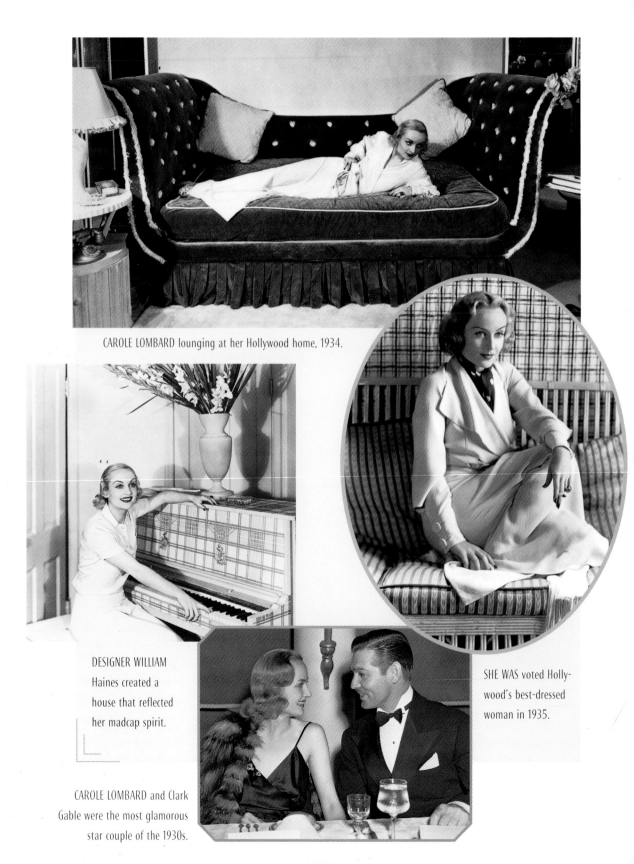

CAROLE LOMBARD lounging at her Hollywood home, 1934.

DESIGNER WILLIAM
Haines created a
house that reflected
her madcap spirit.

SHE WAS voted Holly-
wood's best-dressed
woman in 1935.

CAROLE LOMBARD and Clark
Gable were the most glamorous
star couple of the 1930s.

SHE CAREFULLY planned her
wardrobe for publicity sessions.

EVEN IN casual attire she had an
in-born glamour.

LOMBARD NEVER took clothes or
herself too seriously.

to complain that the studio was misusing her.

This career epiphany was largely the by-product of off-screen circumstances. The divorce from Powell had prompted Lombard to take her profession more seriously. She next fell in love with Russ Columbo, a popular romantic crooner at the time. Three months after the release of *Twentieth Century*, Columbo—who she claimed was the great love of her life even after her marriage to Clark Gable—was accidentally killed while tinkering with an antique pistol. To assuage her grief she focused herself entirely on her career. In tandem, she set out to re-create her personal life so that it would be a mirror of the sophisticated madcap characters she wished to play on the screen.

She settled into a modestly scaled two-story French Provincial—style house right on Hollywood Boulevard and hired William Haines, the celebrated Hollywood interior designer, to decorate it. For Haines, decoration was still a hobby. He had lost his career as a popular leading man when he incited Louis B. Mayer's moral outrage by refusing to suppress his homosexuality. Lombard had made it her personal project to reestablish the now bankrupt Haines in a new profession.

"Carole said if I did her place, I could write my own ticket," Haines commented later in his life. "She was my first major commission, and I offered to do her house without charging a fee, knowing that if people liked what I did, I'd have a business foundation."

What Haines created for Lombard was very much out of sync with the Hollywood craze for the all-white room. Instead he did something completely novel at the time: he decorated her house to suit her personality. He wanted the house to capture the convivial Lombard spirit and sense of fun. But even

more, he wanted to convey Lombard's feminine aura, which mesmerized him. "She was late for a tennis date and I'd driven her home, but she wanted to continue our conversation while she changed," he observed. "I was startled when she stripped completely, staring at me all the while, going on about Hepplewhite and Sheraton. I never lost the image of how magnificent her body was in its deliciously raw state."

Lombard's aim was to entertain comfortably. Haines put that request into a setting that was lush and colorful. The furniture was Empire-Directoire. The dining room had emerald-green satin curtains and chairs covered in salmon-pink velvet. The playroom featured a piano that was wallpapered in green-and-pink plaid to match the walls. Carole's bedroom was done in tones of dusty pink, with a king-size bed covered in plum velvet. On either side of the bed was a three-fold mirrored screen, which became a popular accent in movie colony houses.

"The foremost hostess in the Hollywood social whirl" is how one fan magazine described Lombard when she opened the doors of her new home for a round of buffet dinner parties. She took her cue from Marion Davies who believed that the secret to successful entertaining was to have an eclectic mix of people and to invite only those you liked.

Lombard took that idea a step further by ignoring Hollywood protocol and mixing talent with technicians, even inviting the studio carpenter, which she once did when Noël Coward and the publisher Condé Nast were in attendance. Not knowing who the carpenter was, Nast remarked to Coward, "Oh, he has some odd economic theories; odd but interesting. The chap's in lumber, you know."

"Anyone who can afford to buy the booze

can give a party, but it doesn't guarantee fun," Lombard explained. She reacted against the typical formal affairs she had frequented with Powell, and instead used her own wit and whimsy to create innovative parties that mirrored her appreciation for absurdity. Her first party was in honor of Billy Haines, to show off his decorating efforts. But when the guests arrived she had stripped the house bare and then invited them all back a few nights later for the real unveiling. When a friend commented that she was "too tired to sit up at the dinner table," Lombard responded by giving a Roman banquet where guests reclined on pillows and were served on low individual dinner trays. As a send-up of some of her performing friends who seemed ridiculously self-absorbed by their physical ailments, she threw a "hospital party" and turned her living room into a hospital ward complete with white iron beds and surgical supplies. Guests were required to wear hospital gowns over their evening clothes, and each was given a white iron bed with the guest's name and a medical chart attached to the headboard. Dinner was wheeled in on an operating table.

Some of these parties would later be remembered as crowning events of the Hollywood glamour era, such as the famous barnyard party she staged in honor of her then boyfriend, Robert Riskin, the writer of *It Happened One Night.* The dress code on the invitation read "formal," but Lombard greeted her guests in blue jeans and a gingham shirt. She was barefoot, her hair was in pigtails, and one tooth was blacked out. She had cleared out her living room and filled it with bales of hay; live chickens wandered around the house; a pig, a goat, and a cow were corralled in the garden, and she even strewed some horse manure around to give the affair some authenticity.

For her pièce de résistance she rented the entire Venice Pier Fun House and invited several hundred guests ranging from stars and studio heads to grips and messenger boys. She requested that everyone dress down so there'd be no class distinction. Some of Hollywood's more socially pretentious stars declined when they heard they'd be mingling with the lower ranks.

"Carole went crazier and crazier," one writer noted during her party-girl phase. She was soon rated in the press as America's Madcap Playgirl Number 1. This zany image brought results. After waiting for the right script to come along at Paramount, she was cast in *Hands Across the Table* (1935), which was a huge hit and her first box office success at the studio that had ignored her stellar talent for so long.

But the Venice Pier party was Lombard's swan song. The decision to end her reign as Hollywood's trendsetting **hostess was** as pragmatic as her decision to cultivate the title had been. "You can't have it both ways," she said. "I went through the motions of making pictures for too long, spending most of my energy having a good time. Most people gripe about the elusiveness of stardom but do little to deserve it, and even less to hold on to it. When I saw that I was really getting a fair chance, I decided to work for it."

From there she went on to enjoy massive success in *My Man Godfrey* (1936), starring opposite her ex-husband, William Powell, with whom she had remained friendly. Among the movies she made during the next six years were *Nothing Sacred* (1937), *True Confession* (1937), and *To Be or Not to Be* (1942), all masterpieces of the screwball genre.

The success of *My Man Godfrey* in 1936 made Lombard a hot box office attraction. It

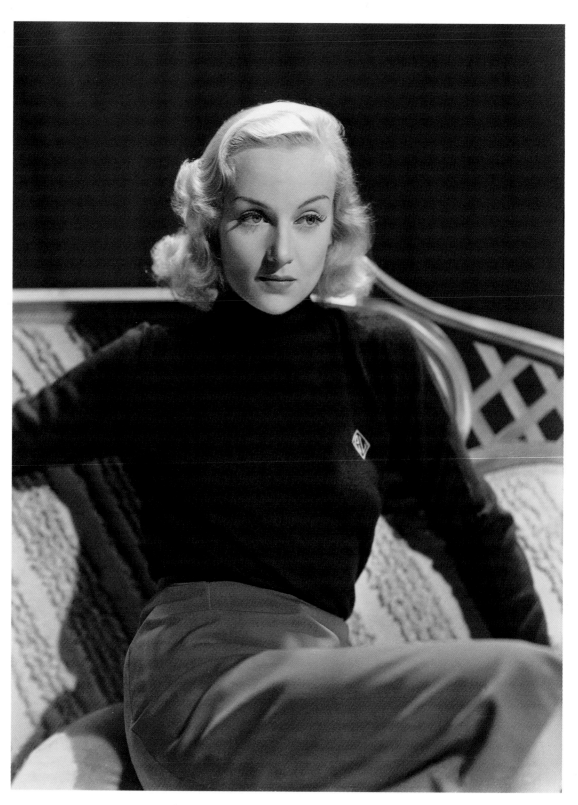

LOMBARD DISCOVERED that overhead lighting emphasized her excellent bone structure.

also coincided with the expiration of her Paramount contract. Earlier that year, the studio had considered dropping her because her pictures weren't turning enough of a profit to merit her $3,000-a-week salary. Now Paramount was anxious for Lombard to sign a new seven-year agreement and offered her $5,000 a week.

Her agent, Myron Selznick, decided to play a little joke on the studio in retaliation for the prolonged lack of confidence in Lombard (like *Twentieth Century, My Man Godfrey* had been made at another studio, Universal). Claiming that her price was going to soar higher, Selznick demanded a one-year contract only. He then offered Lombard to Paramount for three films a year at $150,000 for each picture. When they squirmed, Selznick told Paramount he could get Lombard the same deal at any one of three studios. Unsure if he was bluffing, Paramount took the bait.

At $450,000 a year, Lombard was now the highest-paid film star, which was a miracle considering that she had never been in the top ten at the box office. And Lombard made the studio do more than just reward her financially. She demanded concessions never before given to a star: she could choose her own cameraman, she was consulted on the selection of the director and supporting cast, and she was allowed to make one independent film a year of her choosing. She also insisted the studio delete the clause that it could dismiss her on grounds of moral turpitude.

Lombard's astronomical salary came at a time when industry heavyweights were openly complaining about the exorbitant income tax they paid. But the Depression-era public was outraged by the salaries. Lombard agreed with the public and released a press statement saying she kept only 20 percent of her salary after income tax and business expenses. "But I don't care," she announced. "I enjoy this country, and I don't mind paying my share of the freight." President Roosevelt publicly thanked her.

A sign that Carole Lombard had ensured her place in the hierarchy of the Hollywood community came when she was made the official hostess of the annual Mayfair Club Ball in 1936. The event, which was the cornerstone of the Hollywood social calendar, had been conceived by industry moguls in response to never having been accepted into the clubs and homes inhabited by southern California's socially prominent families. Of course, this ball was equally selective, and for a star to get the nod was a sign that he or she had arrived.

Lombard had lobbied David Selznick for the appointment. She wanted to distance herself from her outlandish party-girl image and prove to some of the colony's self-appointed social arbiters that she was capable of creating something that resembled stately elegance. She instituted an all-white motif: women were required to wear only white gowns, men were to appear in white tie and tails.

That year's Mayfair Club Ball is now part of Hollywood lore. Norma Shearer defied the dress code by wearing a scarlet gown. Lombard was so infuriated that she was whisked off to the ladies' room by the Mexican spitfire, actress Lupe Velez, lest she give the queen of Hollywood—a.k.a. Mrs. Irving Thalberg—a verbal lashing.

More important, that Mayfair Club Ball was the setting for the Carole Lombard–Clark Gable recognition scene. When they had costarred four years earlier in *No Man of Her*

Own, Gable was a notorious philanderer who might have made a play if he'd thought he had a chance. But it was apparent that Lombard was too focused on Powell to do anything other than on-screen kissing. According to Hollywood legend, Lombard thought Gable was a stuffed shirt. On his side, he objected to her swearing and robust behavior. One thing is certain; after filming ended, their paths crossed only at large industry functions.

On this night of nights, Lombard's escort was her pal Cesar Romero. Gable's date was Eadie Adams, a singer who dubbed for MGM stars. But Romero and Adams and everyone else soon faded into the background when Gable encountered Lombard, who was all curves and contours in a diaphanous white silk gown. He flashed the classic Gable smile and topped it off with a wink. She winked back. He asked her to dance, and soon all eyes were on them as they did the rumba.

As soon as the music ended, they were conspicuous by their absence. Gable took Lombard for a drive in his Duesenberg, then tried to lure her up to his apartment at the Beverly Wilshire Hotel. For Lombard the moment was too good to resist. "Who do you think you are—Clark Gable?" she quipped. Gable didn't appreciate the joke. He stepped on the gas and beat a hasty retreat back to the ball.

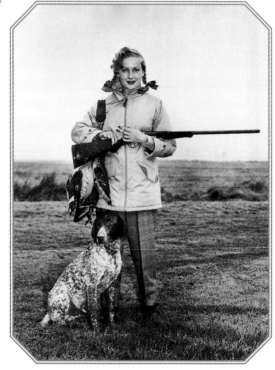

CAROLE LOMBARD at her ranch in Encino, California.

Maybe it was a full moon. Or too much booze. But as legend has it, emotions were high that night. When Gable returned, an actor made a flip remark that Gable didn't like, and Lombard stepped in just as fists were being raised. Lombard, on the other hand, decided that Norma Shearer needed a dressing-down after all. This time it was Gable who pulled Lombard away, and chastised her for even attempting to talk to Norma in any way that was less than deferential.

The evening ended at a post-gala breakfast for friends at Lombard's house. Gable accompanied her home to help prepare for her guests, thinking that he might make a little time with her. He soon found out that Lombard wanted him to serve as bartender and butler, which was her way of saying she didn't sleep with men on the first date. Once Gable got the message, he left in a huff.

The next day he received a peace offering of two white doves with a note attached to the leg of one: "How about it? Carole." And so began the greatest off-screen Hollywood romance of all time. Not since Mary Pickford and Douglas Fairbanks had a star coupling attracted so much media attention.

"You'd be surprised how old I was before I

had an affair," Lombard once told photographer John Engstead. "Never has it been just for a night or a week. I've always been in love with the man. And I've always learned something from each of them. I think a girl should give a tremendous amount to the man she loves . . . adapt her life to his. You know I hate to camp out. I'm not the type for bugs and dirt. But if I married a man who liked to hunt and fish, I'd learn about it. I'd take lessons. I'd have the best hunting jackets made, and I wouldn't wait for my guy to decide to go hunting. I'd suggest it first."

And that's exactly what Lombard did when she made up her mind that she wanted Gable. He was as much her opposite as Powell had been. And by now some of Powell had rubbed off on Lombard. She was more introspective. She was a great reader of biographies and took a keen interest in current events. She surrounded herself with some of the brightest and wittiest talents in the industry. Although she spent freely on her friends and was always ready to aid a cause, she was clever about her finances.

Gable, like many actors, was a tightwad. Though he had earned far more than she had, he complained of being broke. He was not introspective, nor did he share her passion for picturemaking. Outside of his own career, he had no interest in films, never even bothering to read the trades. His interests were hunting, shooting, and fishing, and his friends were people outside the movie business—a gun club president and an automobile salesman among them—who shared his enthusiasm for these pursuits.

Until Lombard came along, he viewed women solely as glamorous accessories who were at his disposal when he chose. Wives, as his two previous marriages indicated, were there to be surrogate mothers. He loved the chase, the games involved in wooing a woman; Lombard captured his attention by playing into that side of his nature. She sent him crazy presents, like an ambulance for Valentine's Day with a red ribbon wrapped around it. As a spoof of his passion for fancy cars, she sent him old jalopies. After he made *Parnell,* she hired an airplane to fly over MGM studios and drop hundreds of leaflets that said "Fifty million Chinamen can't be wrong" and on which were printed excerpts from favorable reviews in Chinese newspapers.

But she also pegged him early on. She realized the only way to get through to him was to give him what he'd never had: a woman who could be a buddy and share in his interests just like his male cronies. What finally sealed it for him was that she wanted to be a mother, and the king of Hollywood very much wanted to be a father.

What was it she loved about Gable? Apart from pure physical attraction, she was captivated by his irresistible combination of boyishness and masculine strength. Though she would have preferred a man with more emotional depth, she saw one who was simple in his pleasures and who, like her, loathed pretension. What she most admired in him was that he was not obsessed with his stardom; he never consciously sought the spotlight; it was drawn to him like a magnet.

They were married in 1939, and moved to a 20-acre ranch in the then sleepy San Fernando Valley town of Encino. This emigration to the other side of the mountain was a trendsetting move. Until then, stars of their magnitude had created lavish estates that were a reflection of their success. The Gables' nine-

room white-brick-and-wood-frame ranch-style house signaled the film colony's shift to more casual, more private lifestyles. Sequestered behind a high fence and electric gate, the couple could escape the curious fans who roamed the streets of Beverly Hills.

This time Lombard needed no one to decorate for her. She knew exactly what she wanted: a comfortable Early American style with quilted wing chairs and club chairs, wood paneling, and large brick fireplaces. Her mission was to create an environment where her macho, outdoorsy husband would feel comfortable. To accommodate Gable's large frame she had oversize furniture custom-built. She reserved her feminine tastes for her separate bedroom suite, which was done in pale blue and white. The only sign of stardom was her mirrored bathroom with its crystal and silver fixtures.

The property contained citrus groves, oat and alfalfa fields, a stable, a cow barn, and hundreds of chickens. Here Gable indulged his fantasy for farming by driving around on a tractor. Though the ranch was truly an oasis for them, Lombard and Gable also knew that this lifestyle enhanced their personae. It ensured Gable's place as the quintessential rugged man, and it established the image that Carole now wanted: a mature, serious woman who could credibly play dramatic roles. Together they entertained reporters and photographers for publicity shoots by tending to the chickens, gathering eggs, or milking a cow, which in turn heightened the legend that theirs was the greatest Hollywood love story ever told.

The Gable-Lombard marriage is, of course, shrouded in myth. Her untimely death never gave us a chance to see how the story would have played out. According to his biographers, Gable became a more compassionate, caring man after Lombard died. But while she was alive, and in spite of what he felt for her, he was a self-centered individual. His lack of generosity toward others was a continual problem for her. He was jealous of her devotion to her mother and brothers. Though she never ceased her efforts to share his pleasures, he unyieldingly refused to share any of her favorite pastimes.

Lombard's jokes about Gable's ability as a lover masked a real problem. "The satisfaction sex had given Clark was a matter of large numbers but small moments," wrote Lombard's biographer, Larry Swindell, in his book *Screwball.* "His triumph was akin to a thief's, who'll snatch and run. It was really a statistical thing with him—his scoring. It was the difference, Carole told him, between screwing and making love. She simply believed that part of a man's pleasure should be the satisfaction he could give to his woman." This inadequacy was exacerbated by the rumors that he was still testing his sexual prowess on others.

Many observers doubt that the marriage would have lasted. Tellingly, Lombard's brothers refused to speak publicly about the relationship long after she'd been dead. Bill Haines was certain that the marriage would have ended in divorce. In spite of her dogged determination to make it work, she would have, he said, eventually tired of always being the one "to give and not receive."

Lombard's decision to tour the country selling war bonds in January 1942 was, in a way, a metaphor for Gable's self-centeredness. In the wake of Pearl Harbor, the Hollywood Victory

WEARING A gown designed by Travis Banton, which he created especially for her to wear to the Lace Ball in New York. The pattern in the lace was outlined in cellophane.

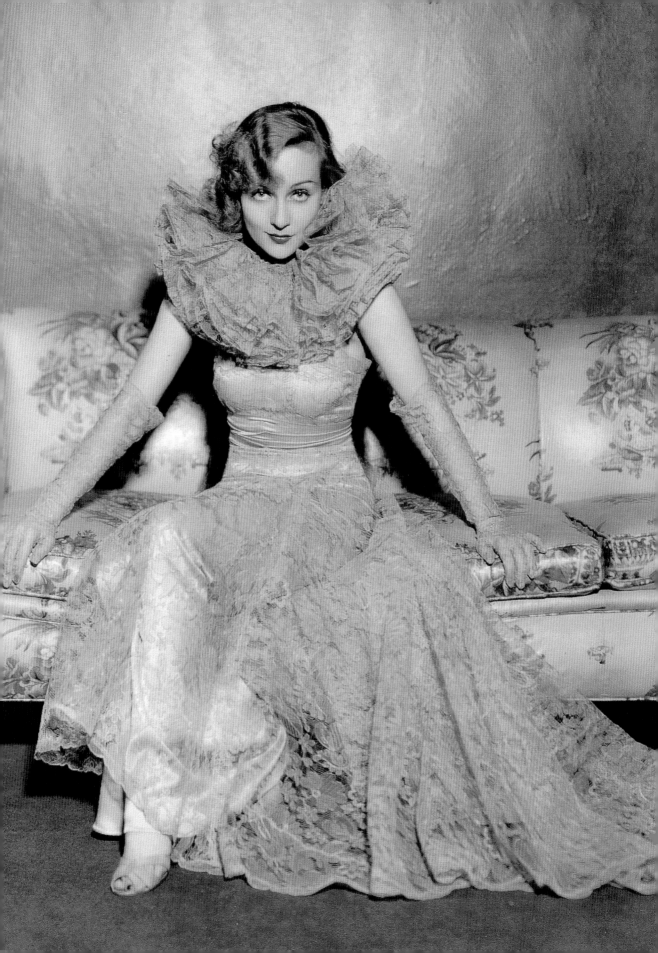

Committee was established to enlist the industry's help in entertaining the armed forces. Gable was made the chairman of the Screen Actors Division, and Lombard was also participating in the committee's activities.

To launch the first national bond drive for the war effort, Roosevelt's advisers felt that a movie star would be the obvious choice to kick off the campaign. Who better than the sexiest man in Hollywood to do the job? But Gable refused because he hated crowds, and personal appearances made him uncomfortable. Lombard tried to exercise her influence on him, even volunteering to accompany him. She reminded him that it was an honor to have been asked. With that Gable nominated his wife for the job.

Carole plunged into this assignment with her usual boundless energy and enthusiasm. The week-long trip was planned so that she would visit several cities in the Midwest to introduce the campaign and make a pitch on the importance of buying bonds. Selling would begin in Indianapolis, her final stop on the junket and the capital of her home state.

Despite the freezing temperatures, Lombard attracted crowds everywhere she went, from Salt Lake City to Chicago. On the morning of January 15, 1942, in Indianapolis, three thousand people lined up inside the statehouse rotunda

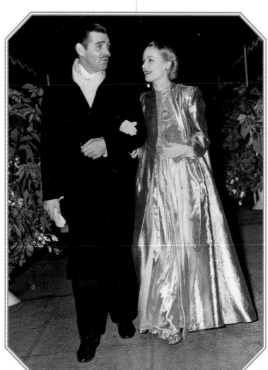

WITH GABLE at the Atlanta premiere of
Gone With the Wind, 1939.

to buy bonds from her. "Like a barker at a carnival," as she described herself, Lombard stood on a table surrounded by the crowds and conducted a feverish sales pitch, refusing to give autographs to anyone unless a purchase was made.

That night, dressed in a black velvet strapless gown, Lombard appeared before twelve thousand people at the Cadle Tabernacle auditorium and made her final appeal. Through tears, she led the crowd in an a cappella version of the national anthem. A black gospel chorus sang the Lord's Prayer. Three military bands and a color guard were in attendance. At the end of the evening it was announced that Lombard had sold $2 million worth of bonds—her quota had been only $500,000.

She was thrilled, but she wanted to get back home to Gable as quickly as possible. The patriotic euphoria of the trip had not alleviated her reservations about leaving him alone; during their three-year marriage the two had never been apart for more than a day. He had just begun filming *Somewhere I'll Find You* with Lana Turner, who had been his costar on his previous film, *Honky Tonk.* Rumors had circulated that there had been a mutual attraction between them, and Lombard had made sure she spent time on the set to monitor the situation. After her

death, rumors would swirl that she and Gable had quarreled just before her departure. "She left on a very quiet and rather sad note, which was unlike her, usually so gay and light-hearted," Gable's secretary, Jean Garceau, said years later.

All these worries prompted Lombard to cancel some promotional stops she was to make on her train ride back west. Instead, she booked a 4:00 A.M. flight out of Indianapolis. Her mother, who had accompanied her on the tour, begged her to stick with the original plan. Bess Peters had never flown and feared it. She also did a numerology reading that predicted an unsafe journey. Lombard, who usually followed her mother's psychic advice, ignored it this time and persuaded her mother to board the plane.

If Lombard had thought about it, she might have intuited that the trip seemed doomed from the start. She had trouble getting the reservations. It was a multi-stop flight, and in Albuquerque civilians were bumped off the flight to accommodate several pilots with military orders. Lombard refused to give up her seat on the grounds that she had served her country by selling bonds. The airline let her and her entourage remain on board. The next stop would have been Las Vegas, but the plane crashed into a mountain about 15 miles

from the airport, killing everyone on board.

Carole Lombard's death was a national tragedy. She was mourned by millions. President Roosevelt gave her a posthumous medal recognizing her as "the first woman to be killed in action in the defense of her country in its war against the Axis powers."

Among the film colony her death struck an even deeper chord. Lombard had offered Hollywood something more substantial than glamour. She had stood out as a beacon of integrity.

Lombard died at the peak of her beauty and fame, a fate that is fodder for hagiographers. But she is one of the few stars whose myth hasn't been destroyed by reevaluation. Her films, unlike those of many of her contemporaries, are still fresh and natural. In them you see a sublime talent that can put most modern-day actresses to shame.

Her personal image remains equally untarnished. In death she has remained what she was in life: a woman for all seasons. She was sexy yet feminine. She had glamour without artifice. She conveyed independence without toughness. Her frankness was tempered with charm. She delivered wit and wisdom without overtones of superiority. She was a romantic who never lost her own identity in the face of love. She was on every level a female character any woman in today's real world would be thrilled to play.

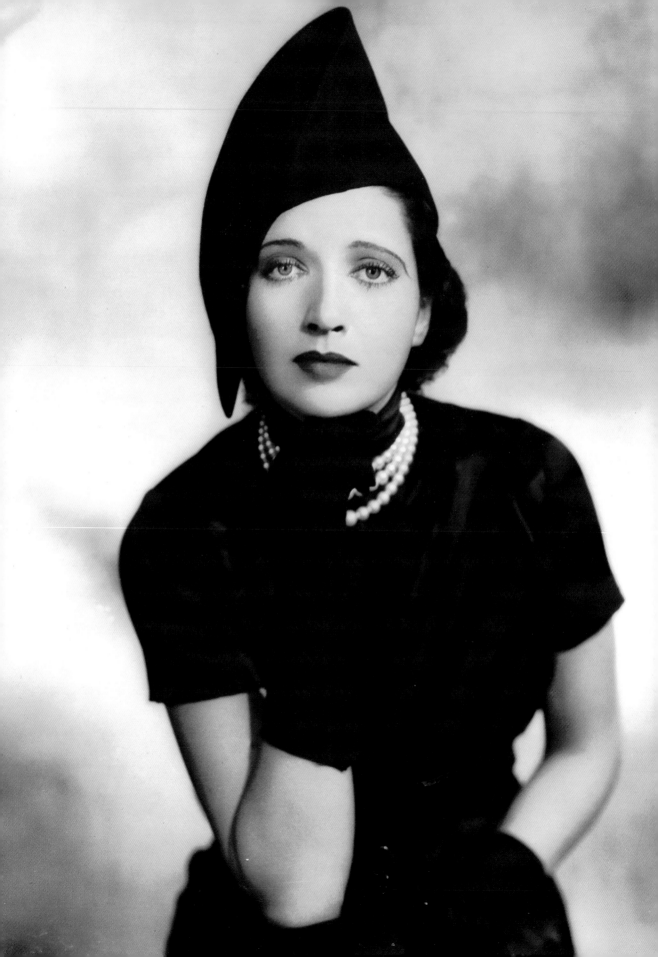

Kay Francis

I can't wait to be forgotten," Kay Francis told a Photoplay interviewer in 1939.

Her wish came true.

Still, when you consider the craze for movie nostalgia that started flowering nearly three decades ago, and which shows no signs of slowing down, it's unusual that Kay Francis hasn't received more attention. Equally surprising is that she's been left out of the pantheon of Hollywood's legendary queens of glamour whose style has been repeatedly resurrected by fashion designers.

I might well have overlooked her myself if it hadn't been for my mother. When I started this book, her single piece of advice was, "You have to include Kay Francis. She was the living end." She was right.

Dripping in real jewels, swathed in fur, shimmering in slinky evening gowns designed by Orry-Kelly, Kay Francis was the embodiment of Hollywood fashion and glamour. And her stardom was built on it: the

box office success of her films was based on the "thirty-six gorgeous gowns" she modeled on the screen. Even more than her illustrious contemporaries like Carole Lombard and Marlene Dietrich, Francis's career demonstrates the importance of fashion and glamour both on and off the screen during the 1930s.

She was, more often than not, cast in romantic, tear-jerking melodramas. And performing against a backdrop of elegant interiors or romantic European settings, Francis alternated between playing an unfaithful wife, a woman who marries in order to protect the one she really loves, a sympathetic mistress, a gallant heroine, and a career woman who must choose between love and work.

Francis made sixty-eight films in seventeen years. Her elegance helped to raise the style level of American women. In 1936 she was the first actress to be named the best-dressed woman in America. At the same time, she was the highest-paid female star on the Warner Brothers lot.

Sadly, she lacked the driving ambition of contemporaries like Bette Davis. Once Francis reached stardom, she made no effort to maintain it. Instead, she chose a concentrated route of self-destruction: she transformed herself from a vivacious celebrity to a bitter recluse awash in pills and alcohol. The rise and fall of this underappreciated legend has all the ingredients for a celluloid tearjerker.

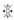

Katherine Gibbs was born in 1903 in Oklahoma City. Her father was a hotel manager, and her mother, until her marriage to Gibbs, had been Katherine Clinton, a fairly well known stage actress. By the time Kay was three, the family had moved several times. Joseph Gibbs was an excessive boozer and an irresponsible provider; though Kay's mother also liked her liquor, she soon found her husband's behavior intolerable. She moved back east with Kay and resumed her acting career.

The publicity biography that was later concocted by the studio describes a fashionable East Coast convent education and regular trips abroad. But Kay's reality was of a life spent touring with her mother up and down the Atlantic seaboard. Home was a series of third-rate rooming houses, and because they had so little money, dinner was often water and popcorn. These were the more bearable details of a youth that was apparently so tawdry that the close friends whom she confided in would never betray her confidences, even long after she died. Kay had no formal education until her mother somehow scraped together funds to send her to a private girls' school in Ossining, New York, when she was fourteen. She was a poor student and dropped out before her senior year to enroll in a secretarial school. She then worked as a publicist, a model, and a real estate agent before becoming the assistant to a New York socialite who booked coming-out parties for debutantes. This job elevated Kay's social world, and in 1922 she fell in love with the son of a socially prominent family.

Dwight Francis was tall, handsome, and amusing; he had gone to all the right schools and was a member of all the right clubs. He was also a playboy and a drunk who lived well beyond his means. But Kay was dazzled and married him anyway. She was soon supporting him—and being beaten by him. She fled two years later, taking with her his last name and a broken heart. Though she married several times and had many lovers, she apparently never recovered from that first marriage.

No sooner had she divorced than she met Bill Gaston, the scion of a Boston family who, according to friends, was a "good-looking bastard." The two had a wild fling; when she thought she was pregnant, they married. Two days after the wedding, she discovered it was a false alarm and he was begging for a divorce.

By day Kay worked as a secretary to two women who handled the finances for society grande dames. By night she traveled in a sophisticated crowd and lived the fast-lane life of her Jazz Age generation: heavy drinking, bed-hopping, and club-hopping till the wee hours of the morning. Her penchant for booze was legendary even in those wild times—she was known to start her morning with a tumbler of gin. Her diary entries for this period are punctuated with phrases like "cockeyed drunk," "shared a quart of gin," "smashed."

Late-night carousing didn't affect her looks, though. She was tall, she had large dark eyes, and her hair was like polished ebony. Her reputation as a great beauty was launched when the portrait painter Leo Mielziner (he later became her father-in-law) was so taken by her sultry looks that he asked her to pose for him. The painting caused such a sensation that it was exhibited at the British Royal Academy.

Kay's circle of intimates included urbane New Yorkers like Charlie Baskerville, who reviewed the cabaret scene for *The New Yorker* under the pseudonym "Top Hat."

"She was an extraordinary person," Baskerville said, recalling a summer trip they took to Paris. "That summer she had no wardrobe, and neither of us had much money. But she took a paisley—gray, black, and white—Persian shawl and had it made into an evening wrap. Whenever we were going to any swell place, she would put the paisley wrap over her gown, and she was a knockout. She carried herself beautifully; her hair was cut as short as mine, and she wore no jewelry. Only lipstick. No eye shadow or anything; she didn't need it. People were stampeded by this creature. They thought she was a maharani on the loose."

Her natural style sense was also noticed by Lois Long, the fashion critic for *The New Yorker*, who was on the trip. "Before we left Paris, she managed to get a beige Patou outfit and a hat and a black lace evening dress—and that's what she wore for two years," Long recalled. "And always looked stunning."

Through Baskerville, Kay met the producer Edgar Selwyn, who hired her to be Katharine Cornell's understudy in *The Green Hat*, not because she could act but for the simple reason that she resembled the star. Still, she made an impression. Selwyn then cast her as the Player Queen in his Broadway production of *Hamlet*, performed in modern dress. When asked how a neophyte like her had landed such a break, Kay responded artfully: "By lying a lot to the right people."

What she had even then was a natural presence that overrode her acting limitations and translated into that certain undefinable something known as star quality. She was also a quick study. She instantly realized that the stage offered better opportunities than her shorthand skills ever would, and so she joined a stock company to gain more experience. "I just went at it calmly and to the best of my ability, not with any of the feverish, pushing anxiety of the usual stagestruck girl," she said. "Probably that's why I was so lucky."

After returning to New York, she played minor roles in several Broadway productions and then landed a supporting part in Ring

Lardner's *Elmer the Great.* From there she made her film debut in 1929 in Paramount's *Gentlemen of the Press.*

The script called for a sophisticated vamp, but the film's producer and director weren't happy with Paramount's contract list. After a discouraging day of viewing numerous screen tests, they took a break and retired to Tony's Club, a well-known New York spot.

"There in the haze of that famous back room," recalled the film's cowriter, Ward Morehouse, in his memoirs *Forty-five Minutes Past Eight,* "we found Kay Francis. She was resting comfortably behind a Tom Collins. She was tall, dark, and interesting-looking, but had made far more appearances in Tony's than she had on the Broadway stage. She looked the part. But the day of just looking the part was gone forever. How was her voice? She was hustled over to Astoria. In the first test her voice came through strong, clear and vibrant. Her career began that very day."

The executives at Paramount were so thrilled with her interpretation of a sleek siren that they signed her to a $500-a-week contract. Before the movie was released they had cast her as a thief in the Marx Brothers farce, *The Cocoanuts.* Though the critics didn't pay a great deal of attention to Kay, the studio's publicity department coaxed the fan magazines to promote her. *Photoplay* magazine soon proclaimed her "the first great vamp of the talking pictures."

Off-screen she had quietly married John Meehan, the dialogue director for *Gentlemen of the Press,* who had devoted considerable time to coaching her to speak and act with that new technological instrument, the microphone. As the studio was keen to hype her as a vamp, it was important for Kay to remain mum on the subject of her marriage. They needn't have worried; the union was so brief that not even her close friends knew it had happened.

Timing is everything, and nowhere is that more true than in Hollywood. Kay hit town at a moment when the studios had turned to Broadway in search of actors who had the ability to project vocally. They were looking for fresh stage performers who had presence and a sleek veneer of sophistication. In spite of her limited acting experience, she had the advantage of a honeyed contralto voice and body language that projected an air of refinement. This diverted attention away from a slight lisp and the fact that she pronounced her *r*'s as *w*'s. Her speech defect would in time become celebrated (her scripts were typed with rolling *r*'s), but it is, in fact, astonishing that the impediment didn't finish her off in that early, sensitive sound era.

Francis also had an irregular kind of beauty that made it difficult for the studio to classify her. At five feet seven inches she was considered way too tall. Her dark luminous eyes suggested tragedy and longing and were made all the more hypnotic by the dark shadows underneath them. Her jet-black hair was framed by a significant widow's peak and a forehead that had the faint trace of a frown. At the same time, she had Pre-Raphaelite ivory skin, a downturned mouth that showed pain, but opened into a wide disarming smile, and perfect white teeth.

"The career of Kay Francis shows how stardom was created in the old studio system," writes the film historian Jeanine Basinger in her

KAY FRANCIS was the embodiment of Hollywood fashion and glamour, and her stardom was built on it.

book *A Woman's View.* "It is clear that no one was quite sure exactly how she should be cast or used or sold to the American public during this period. In her first three movies in 1929, *Gentlemen of the Press, The Cocoanuts,* and *Dangerous Curves,* she is a villainess and her very masculine haircut marks her out as someone who possibly will never be a leading lady."

Still, she quickly built up a body of work. She made five pictures that first year and was singled out by critics as a convincing lethal bitch in *Behind the Makeup* (1930). This led to her leading role in *Street of Chance,* starring opposite William Powell, one of the most debonair leading men of the 1930s. With this film came the opportunity to play a sympathetic character —a devoted wife married to a compulsive gambler.

Favorable reviews and a growth in her popularity prompted Paramount to pump up efforts to promote her to star status. Kay Francis played a variety of roles: a nymphomaniac countess, a charmless socialite, an unfaithful wife, and a faithful one. By the end of 1931 she had appeared in an impressive total of twenty-one films. And she rounded off the year by demonstrating a keen flair for light comedy when she played a wisecracking, gold-digging model in *Girls About Town,* stylishly directed by George Cukor.

Movie exhibitors now considered her a top moneymaker. Female audiences were beguiled by her cool restraint, her husky voice, her wardrobe, and even her speech impediment. Paramount, however, wasn't paying close attention. In 1932, the studio cast her in two ineffective parts and, due to Depression-era financial panic, stalled on renewing her contract. With that, Warner Brothers swept in and offered her the queenly sum of $4,000 a week

and the promise that they would elevate her to superstardom.

Her first three films at Warner's didn't hold much promise. But then came *One Way Passage,* a huge box office success and one of the great weepers of the thirties. Kay received critical acclaim as a dying woman who, on an ocean crossing from Hong Kong to San Francisco, meets and falls in love with a murderer (played by William Powell) on his way to San Quentin. She then scored a back-to-back triumph in Ernst Lubitsch's sophisticated and utterly irresistible comedy, *Trouble in Paradise* (she was actually loaned back to Paramount for this). These two films catapulted her to precisely the place that Warner Brothers had imagined—the zenith of stardom.

By 1933 Kay Francis was the queen of the woman's picture. Her name was above the title of her current release. She was featured regularly in every fan magazine. She was labeled the best-dressed woman of the screen. She was watched by women the world over for her clothes and makeup, and even the length of her drawn eyebrows was imitated. And she was exactly what my mother said she was: the last word in fashion and glamour.

"Money? Is that all she cares about?" Elsa Maxwell wrote in an article about Kay Francis. "It is all. Were she to stop making it, she would be aboard the eastbound train the day after."

The truth was that the personification of chic and glamour was unintoxicated by her stardom. Kay viewed her career as an interlude in her life that would give her an opportunity to earn huge sums of cash. Her plan was to save, invest, and hoard her money until she had enough to retire comfortably. In her scenario,

once she accomplished that, she would exit the business gracefully.

She shunned all the material luxuries that seduced other stars and which were so important for maintaining an image of glamour. When she signed her deal with Warner's, she didn't move to a palatial estate in Bel Air or Beverly Hills. Instead, she chose to remain in Hollywood, the section once favored by silent stars, and rented the former home of ex–silent star William S. Hart, which didn't even have a swimming pool. She drove an inexpensive Ford coupe instead of a Rolls-Royce. Her staff consisted only of Ida, a devoted maid she'd brought with her from New York who doubled as a secretary and cook. Eventually she hired a gardener who could also be a chauffeur.

Kay did live stylishly—just not by Hollywood standards. When she built a house in the Santa Monica foothills, it was an unpretentious white brick home, but it was perched high on a mountaintop with commanding views of the ocean and surrounding hills. She did not succumb to the fluffy white rugs, all-black bathrooms, and fur-lined toilet seats so popular with the movie colony. Instead, her taste reflected the well-bred East Coast polish that she had adopted for herself years before. The house was fur-

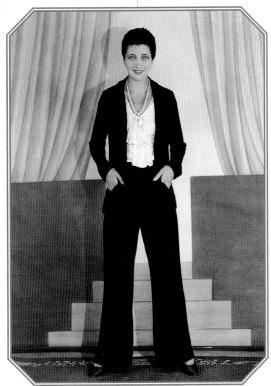

IN 1936, she was first actress to be named the best-dressed woman in America by the Fashion Academy.

nished with Sheraton and Hepplewhite pieces against tones of rose, mauve, and green. "I remember going to her house for dinner," recalls Leonora Hornblow, the wife of the producer Arthur Hornblow, "and her dining room was the most elegant thing I'd ever seen in Hollywood. The walls were antique gunmetal-gray mirrors with ivy designs painted on them. The ceiling was covered in a gray linen—fringed canopy, and the chairs were covered in pink and gray."

Though she often attended parties and premieres for business reasons, she led a relatively quiet life. "I'm not antisocial, just unsocial," she explained. She preferred to entertain a chic Hollywood group that centered on Carole Lombard and William Powell; the actors Herbert Marshall, Richard Barthelmess, Basil Rathbone and their wives; and the actress Miriam Hopkins.

Though she was famous among her friends for being tightfisted, she did have her own ways of spending money. Traveling was her passion, and she devoted more energy to figuring out how to wrangle vacation time from the studio than she did to making sure her career was going in the right direction. She spent Christmas in St. Moritz, summers on the Riviera. She loved shopping in Paris and bought her jewels at Bulgari in Rome.

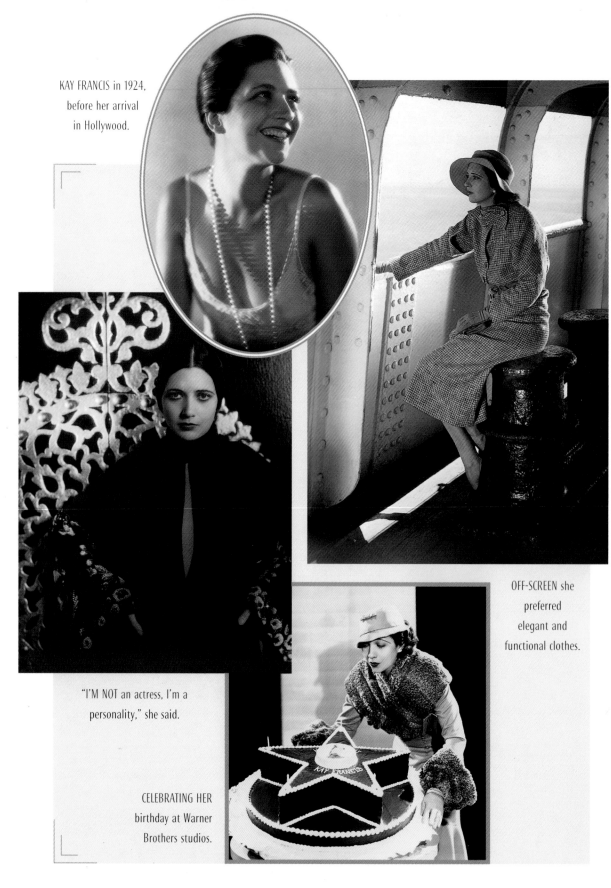

KAY FRANCIS in 1924, before her arrival in Hollywood.

OFF-SCREEN she preferred elegant and functional clothes.

"I'M NOT an actress, I'm a personality," she said.

CELEBRATING HER birthday at Warner Brothers studios.

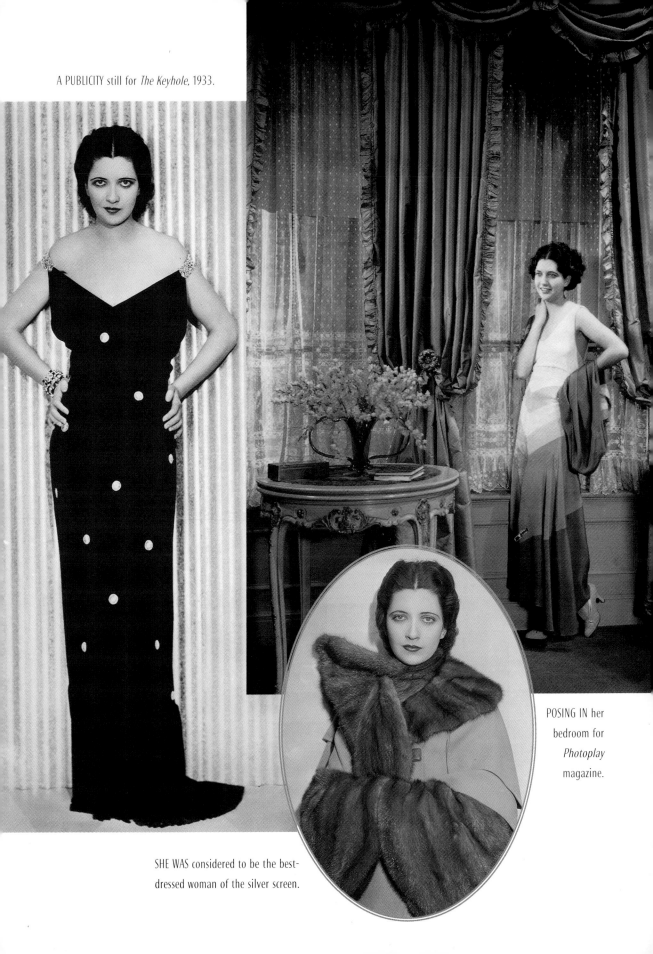

A PUBLICITY still for *The Keyhole*, 1933.

POSING IN her
bedroom for
Photoplay
magazine.

SHE WAS considered to be the best-
dressed woman of the silver screen.

If Kay Francis was unimpressed by Hollywood glitz, she was even more unmoved by her reputation as the screen's best-dressed woman. "I'm not well dressed on the screen; I'm usually overdressed," she remarked. "Old workhorse" is how she modestly described herself when a reporter suggested that she was a film clotheshorse in a league with Norma Shearer.

"In the beginning she was very reserved but well mannered and knew exactly what she wanted," Orry-Kelly, the costume designer, once recalled. "I designed simple unadorned evening gowns in velvet, chiffon, and crepe for *One Way Passage.* And I introduced what was the forerunner of the shirtmaker dress for evening. . . . At first only those with sensitive taste were impressed. Luckily, Kay was the essence of good taste."

The relationship between Kay and Orry-Kelly was a collaborative one. As a personality actress, Kay ran the danger of being dressed according to her own image. She spent considerable time making certain that her costumes reflected the character's personality. And over time she developed a unique film-fashion philosophy. "If I were playing a woman good and true, we used tailored, sophisticated clothes ordinarily reserved for femmes fatales," she once explained. "But when I played the heavy, I had

OFF-SCREEN she preferred a quiet life and guarded her privacy.

them design my clothes with lots of frills. Very fluffy and feminine. I think it makes more sense to dress counter to the character. Because whether audiences realize it or not, they get clues to who will end up with whom from the clothes."

Off-screen she had fashion-editor taste—elegant and functional. She went in for tailored suits for day and frilly feminine gowns for evening. "She spends less time, money, energy, and thought on her personal wardrobe than any star of equal importance," Travis Banton told *Photoplay* in 1936. "One year, she wore only one black frock for an entire season of parties."

The country's best-dressed woman of 1936 hated to shop. She also hated going to the hairdresser; at one point she bought a wig, which she nicknamed "Miss Merkin" in honor of the pubic wigs used by prostitutes in medieval times. Above all else, she hated to be on display unless it was professionally.

"I abhor having to show off. I hate all the attention a star is supposed to give her precious self," she told *Modern Screen.* "I do nothing in particular to keep physically fit, I don't diet. I've no beauty secrets. I wash my face with soap and water when it needs washing. I don't yet know what is meant by 'glamour.'"

In those days of stars sharing with the fan magazines all the delicious beauty and fashion tips their readers could digest, Kay was a nonconformist. It was surprising for a star to possess so little vanity. To her fans it made her seem remote. So much so that *Photoplay* once ran an article entitled "The Least Understood Woman in Hollywood," explaining that Kay was "a woman of simple taste, orderly mind and habits, honest in emotion—people completely miss her personality and what she's about."

The lack of vanity and her man-tailored look off-screen may have helped to fuel the persistent rumor that she was either a bisexual or a lesbian. She was neither. "Both her private diaries (agonizing over Dwight, Allan, McKay, Billy, John, Ken, Del, Don, and later Hap, Joel, and Dennis—to mention only a few of her romantic attachments) as well as the assurances of her friends lay this rumor to rest," wrote George Eels.

So who was she? A complex creature who evoked a variety of responses.

To her friends she was warm, down-to-earth, even at times generous, and she had a self-deprecating wit and a bawdy sense of humor.

To her costars she was unapproachable. "Kay and I made two films together," the late actress Genevieve Tobin told George Eels. "I always felt she snubbed me, and at first I thought it mean of her. But later I decided that behind those velvety, tragic eyes there must have been some tragic thing that made it so she couldn't really be friends with anyone."

To John Engstead, one of the top Hollywood photographers, she was "a classy lady. An unusual arresting beauty, she wore size two shoes, and consequently was uneasy on her feet. Once while filming *Raffles* with Ronald Colman, Kay made an impressive entrance coming down a marble staircase. When she arrived at the bottom, she tripped and fell flat on her face. 'Damned little feet,' she said."

She was also sharp, intelligent, and observant. "She rapidly figured out the rules of the Hollywood game, reduced it to its simplest terms: everyone, even those of the highest echelon, is on the make," George Eels points out. And yet for a talent whose career depended greatly on favorable publicity, she abhorred any invasion of her privacy. She suffered through the studios' photo sessions because she had no choice, but she refused to do the kind of product endorsement that was a popular publicity vehicle and income generator. Despite the fact that everything written about her was favorable, she reluctantly gave interviews and always demanded editorial approval. She was so uncooperative with the press at one point that a newspaper called her "cold as dry ice."

"A star is expected to be a social entertainer besides being an actress," Kay explained to *Modern Screen.* She simply could not accept the idea that her life was the property of her fans and that she wasn't entitled to privacy. And so she guarded hers with a mania resembling that of Garbo. The press was never certain how many times she had been married. Her marriage to John Meehan was never publicized even as her fame increased. When she met Kenneth McKenna, her fourth and final husband, she repeatedly denied any romantic involvement until the day after she quietly married him in 1931. When she divorced him in 1935, the marriage was quickly dissolved in court, even though she had to testify to his mental cruelty—a popular way to get unhitched. What never emerged was that McKenna was

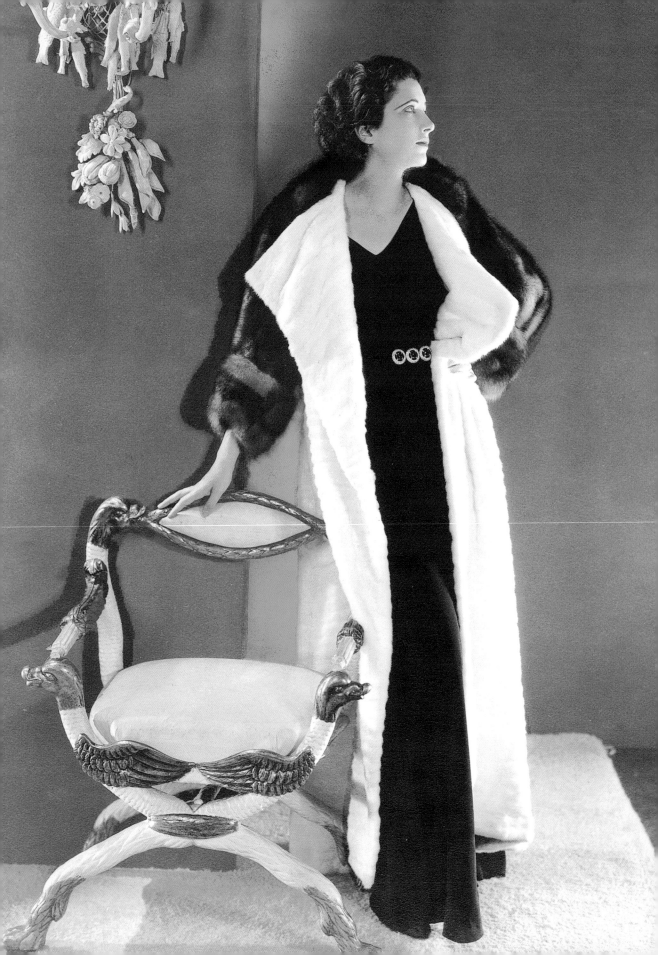

the victimized party. When drunk, which she was quite frequently after a long day at the studio, Kay was vicious and belligerent. She hurled anti-Semitic abuses at him, and knowing he was uncomfortable about having changed his name from Mielziner, she chided him for being a closet Jew. McKenna finally got fed up and walked out on her.

A serious love affair with the producer and writer Delmer Daves was conducted so discreetly that when she took a trip to Europe the newspapers theorized she was on her way to marry Maurice Chevalier—who was, in fact, one of her former flames.

But she couldn't control the controversy in 1939 surrounding her German fiancé, Baron Erik Barnekow. He claimed to be a businessman, though there was always confusion over what his business actually was. Many of Kay's friends thought he was a bounder; others thought he was a Nazi spy because of his frequent and sudden trips to mysterious places. That rumor was started by Kay's good friend Dorothy di Frasso, a café society fixture who had introduced the couple. Barnekow attempted to file a slander suit against di Frasso, and when that failed he used the newspapers to exonerate himself. Kay meanwhile was candidly telling the press she was now a "former film star and a future bride." When England declared war on Germany, Barnekow returned to his homeland and she never heard from him again.

Kay's veil of secrecy included her early life. She always remained vague about her birth, claiming she was born sometime between 1899 and 1910. She allowed the studio to weave a fantasy biography. Her covertness may have been a result of her insecurity about her impoverished roots and her desire to squash the persistent rumor that she was half black.

Perhaps she knew she had something to hide—mostly her drinking. A few outrageous incidents prompted the studio to hire people to keep her out of trouble, particularly when she wasn't on Hollywood turf. Warner's once paid $10,000 for a male escort to accompany her to London. One night in the hotel, he was awakened by loud banging at his bedroom door. When he opened it, there was Kay Francis, drunk, naked, and screaming: "I'm not a star. I'm a woman, and I want to get fucked." His handling of the crisis was deft—he simply performed the task.

While other stars gushed to fan writers about their careers and acknowledged how privileged they were, Kay once again defied convention. "This business of being a star is really spoiling my disposition," she told *Modern Screen.* When her popularity started to wane, she did nothing to bolster it. "I can't wait to leave Hollywood. There are so many things I want to do. I want to read Hemingway instead of scripts. I want to run my house.... I want to get fat, I want to do nothing. I want to sit on my back porch in a rocker and not even think. I can't imagine anything more divine than stepping off a gangplank one of these days, and looking down into a sea of faces to find them all staring blankly away from me, disinterested."

Although Kay Francis was clever enough not to be dazzled by fame, she was, for all her pragmatism, blinded by fortune. Unlike Bette Davis, Barbara Stanwyck, and Katharine Hep-

AT A PHOTO session with legendary photographer Horst in 1932.

burn, she wasn't keeping an around-the-clock vigil on the direction of her career. Her agent, Myron Selznick, cut her a sweet financial deal, but what he failed to include in the contract, and what Kay overlooked, was script approval.

For a woman who seemed to have an understanding of what Hollywood was all about and who trusted so few in her personal relationships, it's curious that she operated on the theory that the studio knew what was best.

Warner's, in fact, had trouble figuring out the correct formula for a Kay Francis film. After her two big successes of 1932, the studio went on to cast her in two films—*The Keyhole* and *Mary Stevens, M.D.*—that did not live up to the promise of grooming her to be a quality star. Her third film in 1933, *I Loved a Woman*, starred the studio's most recent acquisitions, the "class" actors Edward G. Robinson and Paul Muni. Though she was the romantic female lead in the picture, three of her best scenes were cut from the released version and she only had featured billing. It was probably the best film she would ever make at Warner's. "She had the indefinable presence that somehow enabled her to be convincing," Edward G. Robinson wrote in his memoirs.

This picture was a harbinger of the career problems that would plague her. Why did Warner's treat its highest paid star so shabbily almost from the start of the relationship? Although she was a sensation, her box office success was erratic. In the eyes of the studio her lack of cooperation with the press did nothing to stabilize the problem. And perhaps it was her own willingness to appear in almost any film thrown her way that did her in. She was not a fighter; the studio knew it and so played on her weakness. "I don't think a star knows when a story is right for her—or for

him," she said. "We read a script with an eye to our own part rather than to the story as a whole. The studios have done pretty well for me. They've made me an important star and they pay me good money. If they put me in poor stories they lessen my box office value and the returns on their investment won't be so good. Why shouldn't I rely on their judgment?"

She had a point. But the fact is that she knew the scripts were inadequate. She was also aware that several of the parts she accepted were roles that had been rejected by Ruth Chatterton (who was, at the time of Kay's arrival, the highest paid star on the lot), Barbara Stanwyck, Bette Davis, and Olivia De Havilland. She knew that this wasn't the way for a quality star to be treated.

But instead of fighting her contract, she submitted to the scripts, worked herself to the bone, and prayed the filming wouldn't last too long. She eventually aired her complaints when she was assigned a role in *Wonder Bar*, an Al Jolson vehicle in which she saw her role trimmed daily while Dolores Del Rio's was fattened up. "It was a small inconsequential part, and I believe that I should not have been forced, by my contract, to play it," she told the press.

Still, in 1934 she was financially the queen of the Warner Brothers lot—though Bette Davis, earning only one-fifth as much, was receiving more attention. But Kay believed that the higher salary gave her career security. In 1935 she allowed Warner's to put her in another series of undeserving romantic dramas that kept her financially secure but lessened her audience appeal. She missed the real drama: the studio was bored with her.

The critics now regarded her as nothing more than a well-groomed adornment. The

speech defect they had never mentioned before now made its way into their reviews; writers trivialized her talent, referring to her as "the clotheshorse with a lisp." Considering that she still held the number two position on the *Variety* popularity rating of Warner stars, this was a ferocious assault.

Thinking she could regain her popularity by playing serious roles, she pushed for and got the role of Florence Nightingale in *White Angel.* But she was way out of her depth when it came to the art of turning a legendary heroine into a real person. Her stab at dramatic acting was a stunning failure.

"In your choice lies your talent," Stella Adler, the celebrated acting teacher, once said. What Kay Francis never understood was that the perfect vehicle for her was light comedy that took place in a modern setting and, of course, had her decked out in drop-dead clothes. She was no actress; she was a personality. Her real talent lay in her unique ability to transmit class, chic, and charisma to films that would have ended the careers of less skilled actresses.

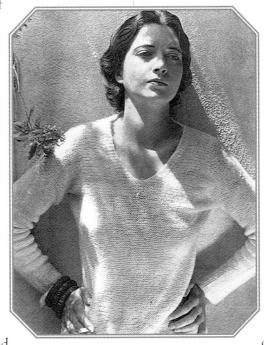

A 1932 portrait by Steichen.

After *White Angel* she made another colossal dud, then returned to playing "nobly suffering clotheshorses." Still she ranked sixth in *Variety's* list of favorite female stars. She ended 1936 having earned $227,500 for forty weeks of work—the highest salary of any star, and, as was noted in the press, more than an industri-alist like Harvey Firestone, the chairman of the Firestone Tire and Rubber Company, who earned a mere $85,000.

Warner's saw more box office mileage in her and renewed her contract in 1937. Kay was ready to put her difficulties with the studio behind her and blamed her past problems on "staleness of scripts." Warner's, in turn, publicly praised her as a star who trusted the producers' judgment: "possibly the only star in the entire history of Warner's who has realized this fact and who has been ready to meet us more than half-way." With that the studio announced that it had purchased *Tovarich,* a play that was a huge hit on Broadway, specifically for her.

The role of Tania in *Tovarich*—the story of an exiled Russian princess who disguises herself as a maid—signaled a new beginning. Kay would have a chance to show off her flair for sophisti-cated comedy and, wearing nothing but a maid's black uniform, she would get away from her clotheshorse persona.

That was not to be. Two weeks after signing her agreement, the studio announced that it would borrow Claudette Colbert from Para-mount to play the role. This time Kay put her dukes up and went to court to demand a release from her contract. She charged that Warner's had promised her the part merely as an incentive to sign a new three-year deal. Kay

claimed the role was a "foolproof part that would automatically enhance the reputation of anyone playing it." She also claimed that Warner's had long been casting her in parts of inferior quality. "I'm tired of being a clothes-horse," she told the court.

After a flood of press, she mysteriously dropped the charges and it was announced that the dispute had been settled amicably. Hardly. What happened behind closed doors is anybody's guess. Perhaps she realized that the other studios were not jumping at the chance to sign her. By now her poor profits at the box office, her volatile behavior on the set, her chilly press relations, and her heavy drinking were no secret. She may have sensed that Warner's regretted ever re-signing her; unable to forgive the studio for past infractions, she may have chosen to stay out of spite instead of gallantly disappearing.

In a scheme designed to have her begging for her release, Warner's announced she would be serving out her contract by being assigned to its low-budget unit. But she wouldn't beg. "You can put me in B's, C's or D's," she informed Jack Warner. With that, he assigned her to six dreary films with scripts that were pointedly spiced with an unusual number of *r*'s.

Ever the lady, she remained silent about this humiliation, but the stress of it all caught up with her. She developed a series of illnesses—impacted wisdom teeth, hemorrhoids, a kidney infection, and, finally, an allergic reaction to medication that caused her face to turn red and swell. Warner's suspended her without pay. Emotionally beaten down, Kay consoled herself the only way she knew how: with booze.

Her plight did not go unnoticed by critics. Among those who rushed to her defense was Bosley Crowther of the *New York Times*:

Back in the old days of friendly panning, it never occurred to us that one day we might be the organizer of a Kay Francis Defense Fund. But after sitting through King of the Underworld, *at the Rialto, in which Humphrey Bogart is starred while Miss Francis, once the glamour queen of the studio, gets a poor second billing, we wish to announce publicly that contributions are now in order. Not that it wouldn't have been a great advantage to Miss Francis if her name had been omitted altogether from the billing; we simply want to go gallantly on record against what seems to us an act of corporate unpoliteness.*

For King of the Underworld, *which is said to be the farewell appearance of Miss Francis (who evidently had no first-billing guarantee in her contract) in a Warner Brothers production, is not merely bad; it is, unless we are misled by all the internal evidence, deliberately bad. The scriptwriters, knowing as they perfectly well do that Miss Francis always has* r *trouble, have unkindly written in the word "moronic." Indeed, considering the plot and everything, it is our settled conviction that meaner advantage was never taken of a lady.*

Kay's dear friend Carole Lombard, who was starring in *In Name Only* opposite Cary Grant, demanded that RKO cast Kay as the other woman in the film. This time critics praised her. And nearly sixty years later, her acting style in this film is clean, crisp, and modern.

In Name Only earned her a new respect, but her career never took off again. By now Kay was succumbing to the clichéd demons of stardom—sleeping pills, drinking sprees, and eating binges. By 1939 her 112-pound figure had shot up to 142. Her love affair with Barnekow made her consider retirement, but when it ended she spiraled further downward.

During the early forties she bounced from

studio to studio, making yet another string of forgettable films. By 1942, when she was playing mother roles, she had the good sense to sign up for a USO tour in North Africa and other combat zones. In this venue, she was well received by the troops and was once again treated like a star.

Hollywood beckoned in 1944 when Twentieth Century Fox decided to make *The Three Jills,* based on her USO work and that of the three performers she toured with—Martha Raye, Carole Landis, and Mitzi Mayfair. The experience proved so enjoyable that Kay decided to resume her career. She now cooperated with the press and the fan magazines, but by 1945 she was rapidly losing her looks. Her weight had mushroomed again, and years of drinking had given her face the telltale bloated look. When offers didn't come from studios, she set up her own production company and entered into an agreement with Monogram Films, the last refuge for washed-up stars. She made three hideous low-budget movies. Even having script approval and being her own boss did nothing for her. The scripts were mindless vehicles in which she once again paraded across the screen in an assortment of stunning gowns.

She knew she had stayed too long at the fair, and when Leland Hayward asked her to replace Ruth Hussey in the Broadway hit *State of the Union,* she was ecstatic. From there she toured in the road company for two seasons. But in Columbus, Ohio, she took a load of sleeping pills and then, fearful that she had taken too many, she called her lover, who was

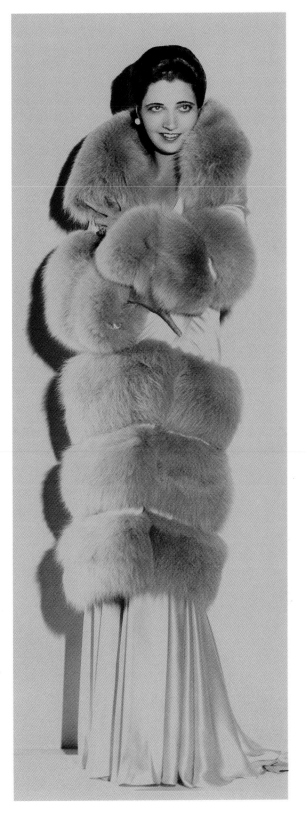

KAY FRANCIS had no interest in fan magazine publicity and posed for their cameras only under duress.

the play's young stage manager. He offered coffee and fresh air. But while he stuck her head out the window her body pressed itself against a steaming hot radiator. She was rushed to the hospital, where her stomach was pumped and she was treated for second-degree burns. The lover was taken into custody and booked for investigation of intent to kill and not released until Kay could get out of the hospital to clear him of the charge.

She returned to New York, endured painful skin grafting, and was forced to wear heavy support stockings and corsets to hold up the damaged muscles. But instead of finally realizing her dream of retirement, which she could have afforded to do, she booked a summer stock tour to prove that she could still command a stage.

She continued to tour the country in stock productions until the early fifties. As it turned out, she was good box office value. She had not lost her ability to dazzle an audience, and she gave people what they most wanted to see: the screen's quintessential queen of fashion and glamour. Though she never improved her acting, she knew her craft within the realm of her own experience and was the consummate professional.

In a production of *Theatre* by Somerset Maugham, in which she played a famous actress, her entrances and exits created such a stir that she performed everywhere from Bermuda to Maine. "She entered on an empty stage lighted with that brown gel she liked so much," the stage manager told the writer George Eels. "There was only a rickety old chair. And she was wearing this black dornfelt cape with a little ermine collar. She moved as if she were bone weary and sank onto a chair, saying 'Oh, my God, I'm so tired.' Then sud-

denly she threw off the cape, which was lined with ermine. She was in black chiffon and her diamond necklace, bracelet, and earrings. And it was *pow!* Like every light in the world had suddenly been turned on."

Another time she had to make a fast change for a scene and she accidentally put both feet through one leg of a pair of lounging pajamas (designed by Orry-Kelly during her Warner days). She didn't realize the other pant leg was dragging behind her until she got on stage. Without missing a beat she picked up the trailing material and gracefully tossed it over her shoulder like a stole.

In the end, the woman who didn't want to be known only as a clotheshorse couldn't escape that identity. It was too ingrained in her and was the only persona she really knew. As George Eels observed, "Having signed for a role, Kay would analyze the character and then begin assembling possible wardrobe by digging out surviving outfits from her Warner days. . . . When something new was needed, she'd consult with Bernie Newman at Bergdorf's, describe the character in detail, and choose those outfits that best suited her purposes. She realized better than anyone else that what she offered was theatrical chic, and she worked tirelessly to achieve it."

On the surface she had what she'd set out to achieve: financial security and a career that allowed her to work on her own terms. In 1951 she bought a lovely apartment on Manhattan's Upper East Side, which she decorated to perfection. For the next ten years she lived with Dennis Allen, a writer and director she'd met on the strawhat circuit.

Kay lost touch with her Hollywood friends. She granted no interviews and refused to be photographed. By the mid-fifties her

health had deteriorated; she had a lung and a kidney removed, and a back injury required her to wear a brace. Now that she was no longer able to work, her drinking problem worsened, causing friends to disappear from her life. Naturally, her romance with Dennis Allen suffered, and in a move of self-protection, she ended the relationship, forever cutting off all contact.

She spent her days knitting, hooking rugs, or playing an occasional game of poker with the few pals who had stuck by her. For those who had known her a long time, the tragedy was too much to bear. One of her old friends, Beatrice Ames Stewart, recalled bumping into her in Bergdorf Goodman: "I hardly recognized her. She had salt-and-pepper hair skinned back in a bun like Grant Wood's *Woman with a Plow.* She was enormous and rolling drunk. . . . she bought a beautiful mink stole—and this was the middle of July. It was terribly sad. I loved her very much, and I'd known her since we were girls, but the drinking was too much for me."

In 1966 she was diagnosed with breast cancer. A mastectomy was performed, but the cancer had spread. She remained housebound, watching television, reading, drinking, and taking painkillers until her death in August 1968.

Kay's will was as cryptic as her personality. She left the bulk of her $2 million estate to Seeing Eye, Inc. No one was more surprised than the foundation, for no one there knew of her interest in the organization. Her bequest was based on the simple reason that she considered loss of sight the worst of all possible fates to befall anyone.

Her burial instructions reflected her long-standing desire for privacy. There would be no funeral or memorial service. All she wanted was for her body to be cremated and the ashes be disposed of by the undertaker so that "no sign of my existence be left on this earth."

The obituaries for Kay Francis praised her as one of the most glittering stars of the glamour era. The writers paid tribute to her poise, style, and intelligence. They chronicled the peaks and valleys of her career. What they did not explain was why it had all ended so badly.

Why didn't she fight the studio tooth and nail for better scripts and better roles, like Bette Davis? Why didn't she work to perfect her craft, like Joan Crawford or Norma Shearer?

For all of Kay's pragmatic philosophy about Hollywood, she sold herself short by misplacing her priorities. If she had wanted a serious career, her star could have shone brighter than any of theirs.

What went wrong is best summed up in a scene between her and her former Warner's colleague, Bette Davis.

During a summer stock run in Ogunquit, Maine, Davis came to see Kay's performance. After the show, the two commiserated about the shabby treatment they'd received when the studio deemed them no longer useful. As Kay described her humiliating experience, Davis asked her why she had put up with it for so long.

"I didn't give a shit," Kay told her. "I wanted the money."

"I didn't," said Davis. "I wanted the career."

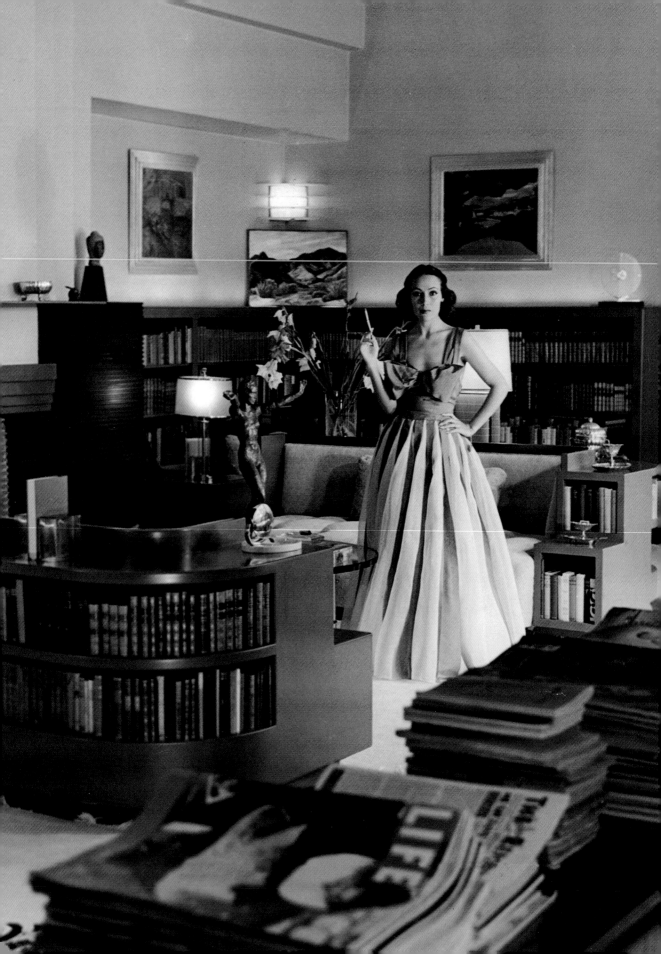

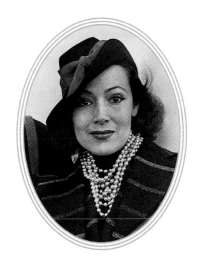

Dolores Del Rio

Orson Welles proclaimed her "the most beautiful woman in the world."

"Ah, this is the real beauty," Marlene Dietrich said of her. "We blondes have to work at it."

The legendary photographer George Hoyningen-Huene ranked her second only to Garbo: "She wears less makeup than any of the stars I have met, yet her vividness is breathtaking. The bone structure of her head and body is magnificent; her skin is like ripe fruit. She has sinuous yet artless grace; her face is so perfectly constructed that she can be photographed in any light, at any angle. . . . I photographed her in the morning sun, it made no difference."

Dolores Del Rio had dark gleaming eyes, shiny seal-black hair, and smooth silky skin the color of pale café au lait. By 1930 her incandescent beauty and fashion elegance had made her a legend both on and off the screen. Del Rio was one of those rare

creatures who never had to invent her looks; she was one of the few truly flawless beauties of the screen.

Nor did she have to manufacture herself. For the first Mexican actress ever to become a movie star, Hollywood was a platform on which to be more of who she was. In their wildest dreams studio publicity executives could never have created anyone as intriguing. If they had, it would have sounded like fiction.

Dolores Asunsolo Lopez Negrette, born August 3, 1905, in Durango, Mexico, had a background that was as flawless as her appearance. She was the only child of a bank president and wealthy landowner who was the third generation of a prominent Spanish-Basque family. Her mother's lineage was equally impressive. The only interruption in Dolores's cosseted, privileged world came in 1909, when Pancho Villa and his rebels seized her father's bank and their home, and they were forced to flee to Mexico City in the middle of the night.

The young Dolores was groomed in all the traditional ways to become a cultivated, poised lady. She received a superior convent education run by French nuns. Early on, it was instilled in her that a young woman of her social standing had to have accomplishments. Dolores's interest was in dancing, and from the age of seven she studied with Felipa Lopez, a famous Mexican dancer.

At fifteen she went straight from the convent to the altar when she was married off to the scion of a wealthy Mexican family. Jaime del Rio was thirty-three and Mexico City's most eligible bachelor. A lawyer by profession, he had been educated in England and France and was immensely cultured. He was only too happy to share his passion for literature, art, and music with the child bride who captivated

him for the rest of his life. He whisked her off on an extended European honeymoon. In Spain they were presented to the king and queen. In Paris she studied dancing and art history between fittings at the ateliers of the great couturiers.

"Jaime taught me to cultivate the spirit and opened my young eyes to a new world," she said. He succeeded so totally that when the couple returned to live on one of his family's ancient ranches in northern Mexico, Dolores had trouble adjusting to the conventional life that was expected of her. She was soon bored with the routine schedule of "teas, dinners, dances, and the same people—in winter the opera, in summer the bullfights." Though Jaime del Rio was a lawyer, he shared her restlessness, for his secret dream was to be a playwright.

Encouraged by her husband, Dolores continued with her dancing. "It was my only emotional escape. With dancing, I realized I wanted also to act," she recalled. As luck would have it, Edwin Carewe, one of the top directors of the silent era, was honeymooning in Mexico City in 1925. When he saw Dolores perform the tango at an afternoon tea she hosted at her villa in Mexico City, he suggested she come to Hollywood to appear in his next film, *Joanna.*

Dolores saw that Hollywood was the escape route from a world where her only responsibility was to look beautiful and bear children. Against violent opposition from both families, she accepted Carewe's offer.

"No daughter from a good family ever became an actress," her mother proclaimed.

THOUGH SHE had been in Hollywood for three years, Dolores Del Rio still advocated a Mexican look in 1928.

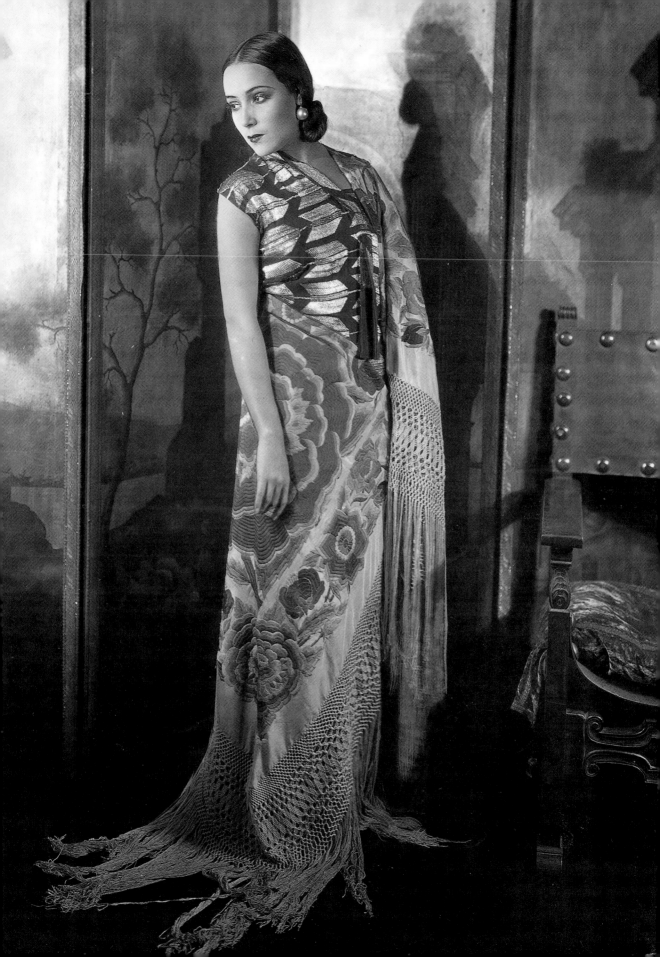

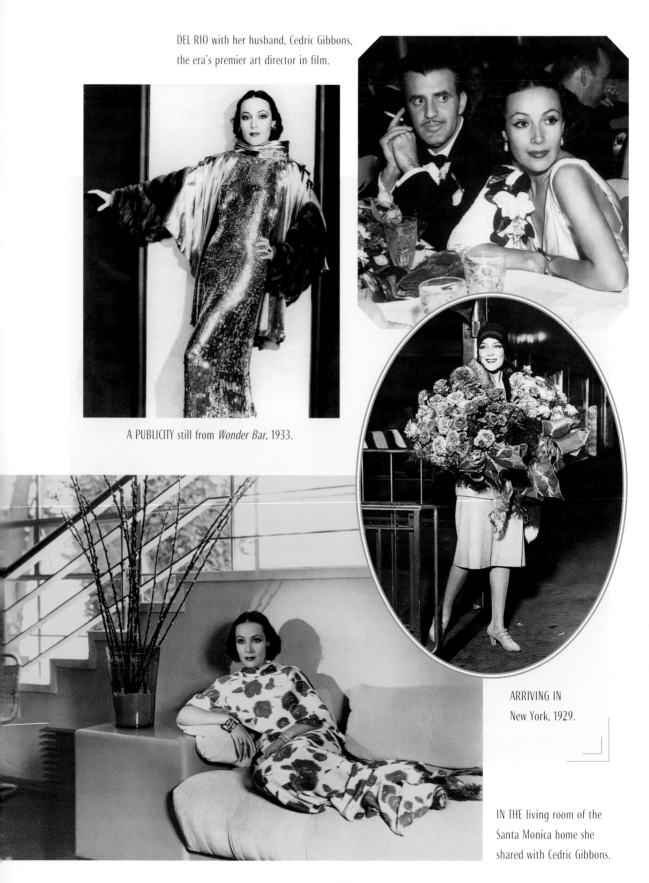

DEL RIO with her husband, Cedric Gibbons,
the era's premier art director in film.

A PUBLICITY still from *Wonder Bar*, 1933.

ARRIVING IN
New York, 1929.

IN THE living room of the
Santa Monica home she
shared with Cedric Gibbons.

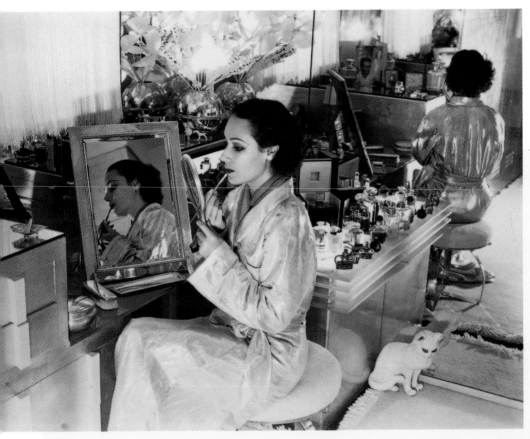

AT HOME in her streamlined dressing room.

"WHITE SUITS me best. It's good for my eyes and my hair," she said.

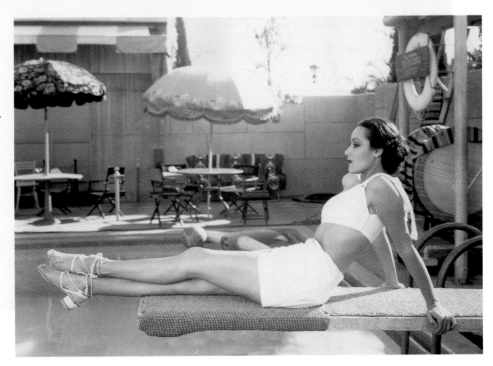

"Very well, then I will be the first," Dolores announced.

Dolores Del Rio—the *D* was now capitalized for screen purposes—arrived in Hollywood in August 1925, when the town was at the zenith of its champagne-slipper decadence. Edwin Carewe's Latin discovery appeared wearing the fabulous jewels her husband had given her—a long-strand diamond necklace in particular—and Hollywood's A-list was knocked for a loop. She was beautifully mannered, she was cultured, and she had an elegance indigenous to her breeding. She had, in short, all the qualities that stars were trying to cultivate for themselves. Even more remarkable is that this Hispanic was accepted so quickly into the top-tier celebrity social world; the only other Mexicans this group knew were their gardeners and domestic staff.

Del Rio's adjustment to filmmaking wasn't so smooth. The woman who could perform the tango for her dinner guests with wild abandon was frightened by the camera, the huge arc lights, and other aspects of the film world. "I remember how I felt when the publicity director asked me to pose for stills, telling me to look this way, smile, look down, look up, look every way," she recalled. "It seemed so foolish."

The camera registered Del Rio's discomfort, and Carewe did her the favor of leaving the bulk of her footage on the cutting room floor. This initial rejection, which Dolores only discovered at the film's premiere, made her consider leaving Hollywood. But Carewe, who was enthralled with her both personally and professionally, persuaded her to stay. He gave her small parts until the grace and fluidity she had acquired from years of dancing worked their way into her screen performances. By the mid-

dle of 1926 she had appeared in four films and had made a distinct impression on audiences, thanks in part to Carewe's decision to exploit her elite social background, which made her a favorite in the fan magazines.

A harbinger of Del Rio's stardom was evident when she was honored in 1926 by the Western Association of Motion Picture Advertisers. The annual WAMPAS "baby star" awards were given to a dozen starlets who exhibited the most talent and showed the most promise of stardom. At the celebration dinner for 3,500 people, each young actress was expected to come onstage to receive her award. Up they came: Joan Crawford, Mary Astor, Fay Wray, and Janet Gaynor. Each was greeted with generous applause. Then Dolores walked onstage. A long silence. Mistaking this reaction for rejection, she fled back to the wings. At that moment, thunderous applause broke out. The master of ceremonies brought her out again, and for seven minutes she witnessed a roaring standing ovation. And massive success followed in three silent films—*What Price Glory? Resurrection*, and *Ramona*, which elevated her to star status in 1928.

By now Del Rio's marriage was floundering. Part of Carewe's ploy to get her to Hollywood was to seduce Jaime del Rio with the notion that his literary ambitions might be realized in scriptwriting. Unfortunately nothing had gelled for him, and as his wife became a star, Jaime worked as a script clerk on her productions. He finally went to New York to collaborate on a play, but when it failed to open on Broadway he was too humiliated to return to Hollywood and too envious of Del Rio's success.

Dolores couldn't alter her own ambition for the sake of the marriage, so she did what any movie star would have done: she began divorce

proceedings. In the meantime, Jaime del Rio went to work for a theater company in Berlin, but shortly after his arrival he entered a sanitarium. The diagnosis was that he had lost his desire to live. When he died of blood poisoning following a minor operation, he was clutching the last cablegram that Del Rio had sent him: "Wish I were with you because I love you. God bless you. I love you."

It was rumored that Del Rio would now marry the recently divorced Edwin Carewe, but she surprised everyone by signing a contract with United Artists for $9,000 a week and ending her five-year relationship with the director. Carewe, who had her under personal contract, was so furious he sued. The case was eventually settled out of court, though not amicably, for they never spoke again.

In 1930, Del Rio married Cedric Gibbons, whom she'd met at a party hosted by Marion Davies. The celebrated MGM art director had been enamored of Del Rio for three years and had even gone to parties hoping to meet her. Ten years older, Gibbons himself was movie-star handsome—tall, dark-eyed, black-haired—and elegantly tailored. His natty personal style and the avant-garde polish of his legendary movie sets were a mirror of Del Rio's ultra-sleek style.

DEL RIO and Gibbons were one of Hollywood's most stylish couples.

Before marrying Gibbons, Del Rio had created an intensely individual look for herself that quickly earned her a place on the list of Hollywood's best-dressed women. She had successfully avoided being redone by costume designers; she created her own artful blend of her Mexican roots and Parisian haute couture style. And she took that personal style to the screen with her. Her ethnic look gave her a dramatic flair—she wore rows of bejeweled bracelets that covered both arms, a gardenia behind her ear, and fringed shawls draped around her shoulders and held in place by a massive brooch. Her frocks were demure ruffled numbers, usually in a color scheme of black and white and done in stripes, geometric patterns, or bold floral prints. "I belong to the traditional French school of wearing black as the most elegant ... white suits me best; it's good for my eyes and my hair," she once explained.

These neutrals were indeed a dazzling foil for her dark Latin looks, which she played up by wearing her hair parted severely in the middle and often pulled back in a chignon. Her marriage to Gibbons signaled a change in her look. He influenced her to wear a more modern shoulder-length hairstyle. And he encouraged her to tone down her Mexican look and

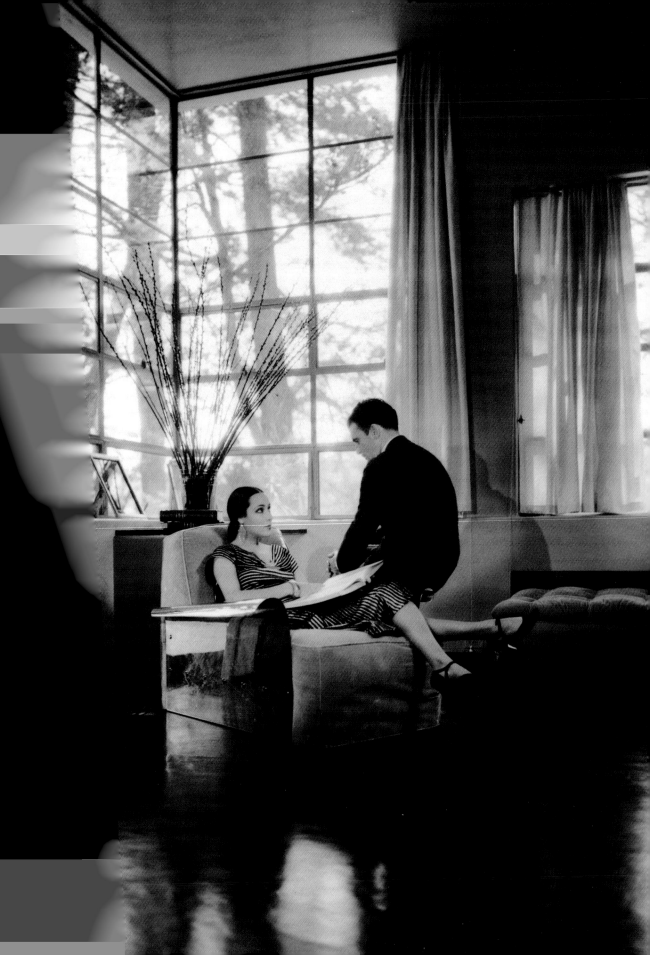

wear more sleek, tailored fashions that were in sync with the thirties style.

After following the advice of Gibbons she looked the part of the worldly Latin woman who had a keen interest in clothing, jewelry, and self-presentation. In later years it was noted that she had 400 Parisian gowns, 250 pairs of shoes, too many fur wraps to count, 200 bottles of perfume, and a fabulous collection of rubies—worn only at night—and pearls, which she wore only during the day.

"I love clothes. I always have loved to dress, and I'm uncomfortable unless I feel well dressed. . . . Slacks? Never! I abominate them. I like feminine things," she told reporters in the 1930s.

For all her fame and happiness in 1930, Del Rio was suffering. She blamed herself for Jaime del Rio's death and for the serious decline in Edwin Carewe's career that began after she broke off the relationship. When vicious gossip trickled back to her, she cracked, and several weeks after her honeymoon with Gibbons she had a nervous breakdown. Her condition prompted United Artists to tear up her contract. At twenty-six, it looked as if she was on the road to being a has-been. "Everything happened to me! Things crashed around me. Tragic, terrifying things," commented Del Rio years later. "I lived in a hotbed of intrigue, of politics, of lies and malice, of crosscurrents of human purposes. I was hurt so often, I was afraid to express myself."

The trauma had left her physically ill as well, and Gibbons nursed her back to health. It was during her illness that he designed and

GIBBONS DESIGNED an Art Moderne house as an homage to his beautiful wife.

furnished a hillside house for them in Santa Monica overlooking the sea. When it was completed he carried her from room to room on her first tour of it as she was still too weak to walk.

The house was and still is a tour de force in what was then known as the Art Moderne style. Beyond the sterile white stucco facade, Gibbons crafted an interior as elegant and flawless as his wife. In fact, the inside seemed to be a direct homage to her beauty and stardom. Del Rio's dressing room was wall-to-wall mirrors, even down to the plates for the electric switches, which were held in place with star-headed screws. Her dressing table was constructed like an altar. A grand staircase for entrances was the focal point of the living room. In a touch that was both characteristic of the era and a metaphor for Del Rio's style, the rooms were marked by angular forms, sleek surfaces, and streamlined built-in furniture. The only thing old was a magnificent van Gogh sunflower painting that hung over the fireplace.

The merger of these two sublimely attractive people prompted many to wonder what it was they actually got up to in Gibbons's three-dimensional production set. Actor David Niven, who had a fundamental appreciation for the absurdity of his adopted town, recalled in his memoir *Bring on the Empty Horses* that he was introduced to Del Rio by Fred Astaire, her costar in *Flying Down to Rio*, who took him to the Gibbons house to try to shed some light on the more intimate details of the marriage:

Dolores had a large sunny room on the first floor containing a huge and inviting bed. Gibbons lived in comparative squalor in a small room immediately below. The only connection between these rooms was by way of a stepladder, which could be

lowered only when a trapdoor in the floor of Dolores's room had been raised. There was a long stick in Gibbie's room with which, we conjectured, he signaled his intentions or hopes by rapping out signals on the floor of his wife's bedchamber.

The rear of the house opened onto multi-level gardens, a swimming pool, and a tennis court with a gallery for spectators. Del Rio and Gibbons were now one of the glamour couples of Hollywood, and this outdoor setting was the scene for the couple's regular Sunday open houses that included other drop-dead attractive couples—Gable and Lombard, Errol Flynn and Lily Damita, Constance Bennett and Gilbert Roland—who would pop in for a game of tennis or a swim.

Del Rio was reinstated as a star when RKO signed her and cast her opposite Joel McCrea, the Adonis-like actor, in *Bird of Paradise* (1932). Produced by David Selznick, it was a vehicle expressly designed to show off the bodies of these two physically perfect actors in a Polynesian setting, where loincloths and sarongs were the only costumes worn. "I don't care what story you use so long as we call it *Bird of Paradise* and Del Rio jumps into a flaming volcano," Selznick told King Vidor, the film's director.

Once again she was one of the most electri-

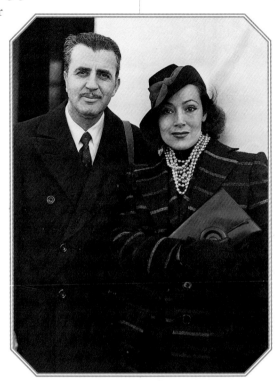

WHILE MARRIED to Gibbons, Del Rio developed a more sophisticated look.

fying beauties of film. But it was her next film, the 1933 hit *Flying Down to Rio*, that established her career in the sound era. For the first time since silent films, she was praised as a talented actress. She also made fashion news by introducing the two-piece bathing suit. Now a classic, *Flying Down to Rio* was the first pairing of Fred Astaire and Ginger Rogers. Del Rio also established the career of the designer Irene by insisting that the unknown talent design the costumes.

Her success in this film also proved to be the ultimate obstacle for the fashion icon who wanted to be a serious actress. "When they give you wonderful clothes, they give you bad parts," Del Rio observed. Her Latin accent didn't help, and she was more often than not typecast in ethnic and exotic roles that offered scant opportunity to display her dramatic qualities. Still, her rare beauty and stunning ability to wear clothes made her a hot property. By 1940 she had been under contract with all the major studios. And with each move came the deepening realization that her employers had no interest in nurturing her talent.

In defiance, she refused to accept any more scripts that would further tarnish her image. This decision made her absent from the screen for two years. Her return was in an MGM

western, *The Man From Dakota* (1940), and though she looked more beautiful than ever, the film did nothing to elevate her.

Off-screen her marriage was unraveling. While extricating herself from Gibbons—who, she told the judge when filing her application for divorce, "wants only to talk of sex"—she had fallen madly in love with Orson Welles. Del Rio met the flamboyant twenty-six-year-old actor-director in 1939, but Welles, like Gibbons, had been infatuated with her image for years. As he was ten years younger than Dolores, he had carried a torch since he was eleven. The night they met, he told her that even then he knew they would be lovers. When he reached adulthood he was still so entranced by her beauty that he once fol-lowed her out of a nightclub in New York and stood admiring her until she drove off in a cab.

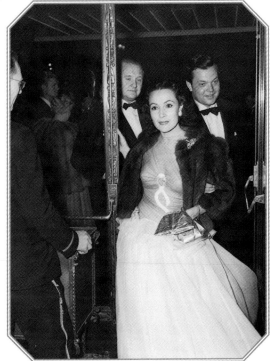

DEL RIO with her beau Orson Welles, who was ten years her junior.

Until she officially divorced Gibbons in 1940, she conducted the affair with Welles with discretion, and their first public appear-ance together came in 1941 when she appeared on his arm at the premiere of *Citizen Kane.*

Del Rio was for Welles the first in a series of legendary beautiful conquests. "She lives so graciously. Everyone around her loves her. She is the one girl you can be with and not feel the need for conversation," he told the press. "She has a mind full of talk, though, when she wants." For three years Welles basked in her glamour and beauty. Del Rio, in turn, was in awe of his genius. She also saw her relationship with the enfant terrible of Hollywood as a way to forge new ground professionally. It was, in fact, the beginning of the end of her career.

Welles gave her the lead in his espionage thriller, *Journey Into Fear* (1942), but his artistic freedom was severely limited at RKO, where he was under contract. Welles, who was to direct and star in the film, eventually turned the directorship over to someone else and left the project during the editing stage. RKO took the liberty of voraciously editing the film so that the final result was a total mess. "It's terrible when you're in something, and people say bad things about you," Del Rio told her friend Douglas Whitney.

While still reeling from this fiasco, Del Rio was dealt another blow when Welles ditched her for Hollywood's latest young goddess, Rita Hayworth. Del Rio packed her bags and returned to Mexico to pursue a film career in Latin America. "I wish to choose my own sto-ries, my own director and cameraman. I can accomplish this better in Mexico," she told reporters.

She more than lived up to that statement.

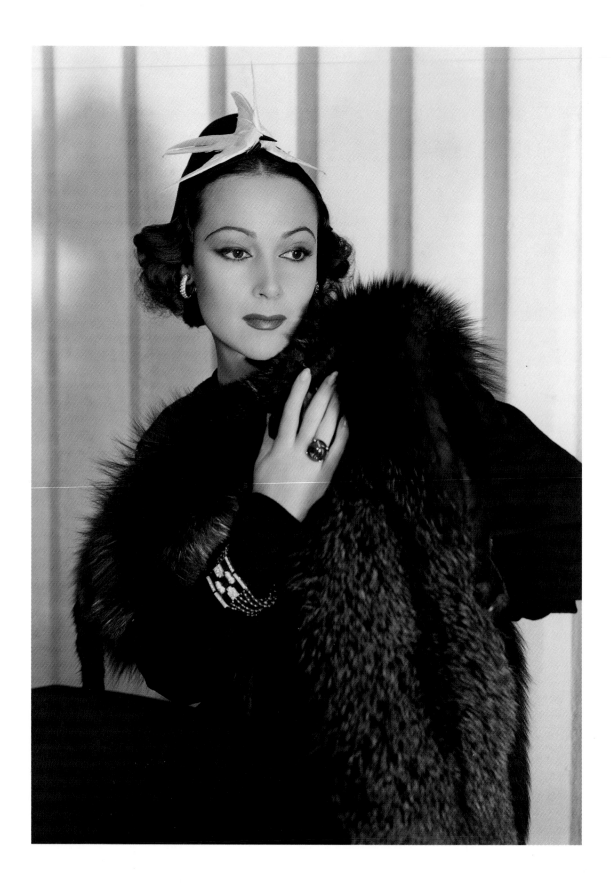

Within a year she had won the first of four Ariel Awards, the Mexican equivalent of the Oscar. She went on to become the most celebrated actress of the Mexican cinema for the next two decades. Proof of that stardom was supremely evident in one incident that occurred in Buenos Aires during the filming of a Spanish version of *Lady Windermere's Fan* in 1947. Evita Perón invited Del Rio to tea, but Del Rio declined because of her filming schedule. The next day the government issued an order that the film industry was to shut down completely so Del Rio could have tea with Mrs. Perón.

In 1956, Del Rio embarked on a stage career that brought her an equal measure of success. In Mexico, South America, and Europe she performed Spanish translations of English-language successes like *The Little Foxes* and *Anastasia*, which she also performed in the United States in a much-acclaimed summer stock tour. She was also confident enough to attack European classics; she stunned audiences with her version of *Camille* when she was well into her sixties. "She looked thirty-two on stage," recalls Douglas Whitney. "She always said, 'When you reach a certain age, the stage is much kinder.'"

She returned to Hollywood in 1960 to play Elvis Presley's mother in *Flaming Star*. While another actress might not have looked on this role as a triumphant comeback, Del Rio saw it as a return to her former terrain on her own terms: "I took the role because it permitted me to play an intelligent, sensitive woman of character." The film proved to be both a critical and commercial success.

"WHEN THEY give you wonderful clothes, they give you bad parts," Del Rio observed.

"Hollywood has a way of grabbing you and wrapping you up," she observed. Del Rio's return to Mexico also afforded her the opportunity to evolve as a person and have by all accounts a fuller life than she might have had if she'd stayed to slug it out in Hollywood. Beyond the admiration and respect she received for her talent, she was also beloved by her country for her commitment to social causes. She established the Estancia Infantil, a nursery for children of working actresses who were on location. She recruited Mexican actresses to form a ladies volunteer society. And she lobbied to get free milk served to schoolchildren.

In 1959 she married Lewis Riley, an American film producer. She and Riley lived in great splendor in Coyoacán, an exclusive suburb of Mexico City, in a seventeenth-century hacienda surrounded by magnificent gardens, an array of dogs, cats, and parrots, an impressive pre-Columbian art collection, and portraits of herself painted by such artists as Diego Rivera, Adolfo Best, and John Carroll.

Her legendary face was virtually unlined. Her body remained smooth and trim until her death in 1983 at age seventy-eight. Indeed, her physical condition was so awe-inspiring that for years Del Rio was besieged by journalists demanding that she reveal the secrets of her eternal youthfulness. She regarded her beauty as a gift from God, and her maintenance of it had a spiritual quality. She favored massage in lieu of exercise. "I never drink, I never diet, I always stay in love," she told a reporter in 1955. Nor did she smoke.

As for her extraordinary unlined skin, she did not, as fan magazines reported in the thirties, eat gardenias and rose petals. But she did attribute her flawless complexion to the fact

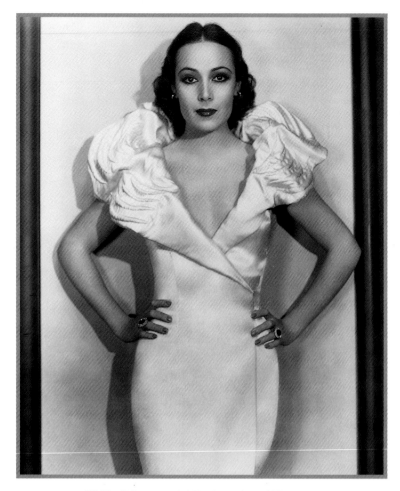

ON OR off the screen, Del Rio always dressed like a star.

that she drank hibiscus juice every day and she slept up to sixteen hours a night. "She told me that a woman's skin is her canvas on which she paints," recalls Arlene Dahl.

Del Rio saw her real secret as more internal: "Exercise, diet, beauty treatments—these things are all a complete waste of time," she explained in 1964, "because everyone must get older. If women were more sensible they would cease going to beauty parlors for facials and would instead lie down quietly in the peace of their bedrooms for the same length of time and arise more beautiful in face and more peaceful in spirit. The fact that I'm aging

makes me a part of life, a part of the bigger scheme of existence. . . . It is my mind, not my body, that I am trying to preserve, because it is through the mind that I can stay young."

Even in her more mature years, she had an intoxicating effect on men. In the mid-1950s, before marrying Lew Riley, she had a love affair with Michael Butler, who was thirty years her junior and whom she met when he was a teenager working as a boat boy in Acapulco.

"I had no idea what a big star she had been, and I was with her for a while before I realized it," Butler recalls. "Nor did I have any idea

what her age was, and I didn't care. Her presence was so electrifying, and it was extraordinary to be around her. I fell madly in love with her and she was my first heavy girlfriend." For Butler, who later became a theatrical impresario, the attraction wasn't just her incredible looks or a body that was still sensational. "She was my mentor in terms of lifestyle. She had no tension; she was very laid back and led a healthy life. In Acapulco she never wore jewels. Instead she went barefoot and wore casual shirts. Her house there was very simple."

According to those who knew her, Del Rio's beauty was an accurate reflection of the person within. "She was intelligent, cultured, well read," says Douglas Whitney. "She was not self-absorbed. She had a great sense of humor and laughed a lot, which I think is one reason why she was so beautiful." It

seems she always retained a sense of reality that served her in good stead, even at the height of her Hollywood stardom. When Whitney met her in 1939, he was a fledgling actor. "She was very kind to me. She said to me, 'If you're ever lonely, come to the house, the maid will let you in, make yourself a sandwich and enjoy yourself, just stand away from the window if Miss Garbo is playing tennis on our court.'"

Del Rio more than anyone understood the foundation of supreme style: "Take care of your inner beauty, your spiritual beauty, and that will reflect in your face. We have the face we created over the years. Every bad deed, every bad fault will show on your face. God can give us beauty and genes can give us our features, but whether that beauty remains or changes is determined by our thoughts and deeds."

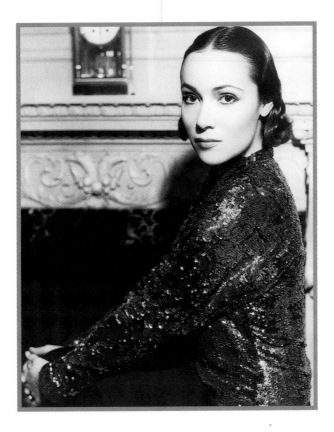

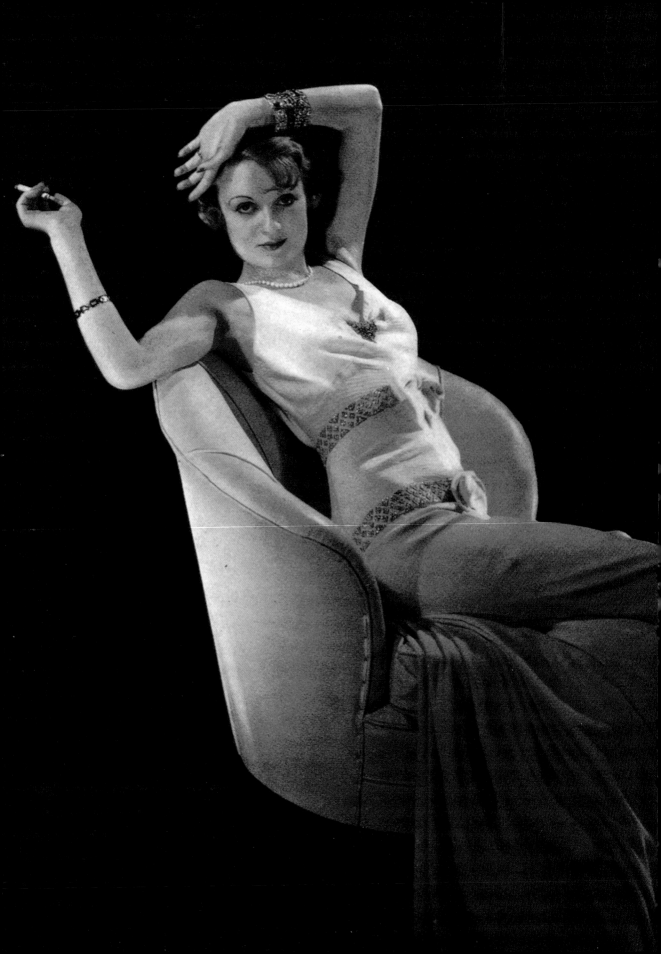

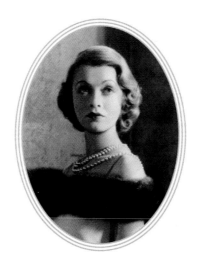

Constance Bennett

In 1965 a cinema historian was preparing an article on the career of Constance Bennett for the magazine Films in Review. He wrote to the actress, asking her to verify some facts. A few days later he received a letter from Bennett thanking him for his interest in her career. "I'm flattered that you would want to write about me," she wrote. "But if you do, keep it light. And be truthful about my film work. After all, I was no Sarah Bernhardt. Good luck."

Constance Bennett was not being modest. She wore clothes better than she acted. And yet any survey of the moviegoing public in the early 1930s would have listed her as one of the Hollywood stars who would be warmly remembered several decades later. For during the early 1930s Bennett was a paragon of movie chic, one of the classiest beauties to grace the screen. Because of that she was also one of Hollywood's highest-paid stars. At one point, in 1932, she was at the

absolute top of her trade, commanding a salary of $30,000 a week.

Of her fifty-five films in a five-decade period, she would acknowledge only five: *Common Clay, The Common Law, What Price Hollywood? Our Betters,* and *Topper. Topper,* in which she starred opposite Cary Grant, is the only film of hers that most people would know today.

If she was no Sarah Bernhardt, she was one of the best interpreters of 1930s sophisticated romantic comedy. The ease with which she delivered wisecracks with an air of detachment had more to do with who she was off-screen than with any craft she had perfected. "A medium-size talent with an oversize personality," observed George Cukor, who directed her in several films.

Even at the height of her career, Bennett was never interested in becoming a better actress. She made movies because she loved the money. She looked on the Hollywood game with amusement and cleverly positioned herself as someone who was bored by the business and didn't really need the career. She infuriated the studio heavyweights with her blatant disdain for the industry, caring not a whit what the moguls thought or what the repercussions might be. This devil-may-care attitude was indeed a great part of her allure. But after propelling her to fame it also caused her to fall.

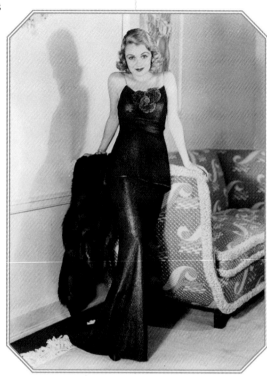

IN 1932, Constance Bennett was Hollywood's highest-paid film star.

"Quixotic, turbulent, stubborn, and aggressive," is how Joan Bennett, the actress, described her sister Constance in her autobiography, *The Bennett Playbill.* "A veritable carbon copy of father. She was like some silvery comet who streaked through life with dancing speed."

Constance Bennett touched down to earth in New York City in 1904. She was the first of three daughters of actor Richard Bennett, a brilliant, flamboyant, and temperamental matinee idol of the stage. Her mother, Adrienne Morrison, had been an actress and was determined that her daughters would not become the fifth generation of Bennetts to follow in the family profession. Richard Bennett agreed that a woman's place was in the home—unless, of course, she wanted to pursue a theatrical career. Naturally, all three daughters became actresses. Barbara, the middle child, had the briefest career, and Joan, the youngest, had the most long-term impact.

To steer her daughter in the direction of respectability, Mrs. Bennett had Constance educated at private schools in New York City. The young girl's disobedient nature caused her to move through several institutions; her mother finally sent her to boarding school in

Switzerland and then, at sixteen, to a finishing school in France. Constance returned in 1921 a lovely vixen, more rebellious than ever. The fact that the 1920s had roared in only added more fuel to her fire. She was a vivid figure on the eastern prom-trotting circuit teeming with college boys bundled up in raccoon coats with a flask of gin at the hip. She had a long line of these boys as suitors, and, delighted at always having her pick of the crop, Bennett changed boyfriends with speedy regularity.

After her daughter's society debut in Washington, Mrs. Bennett had marriage in mind for her daughter. Constance fulfilled that wish, but not in the way her mother had hoped. During Easter week at the University of Virginia, she met Chester Moorhead, an eighteen-year-old student. Two months later she couldn't resist when he dared her to marry him, and the pair eloped to Greenwich, Connecticut. When Mrs. Bennett heard the news, she raced to Greenwich to collect her daughter before the newlyweds could have a honeymoon.

The "unkissed bride" was packed off to Europe to wait out the publicity that the affair had generated, and the marriage was eventually annulled. But the episode and the enforced sojourn in Europe did nothing to sober Constance. In fact, she grew more restless. When she returned to America in 1922, Richard Bennett thought an acting career might be a perfect remedy for his daughter's misdirected energy. With his connections, she landed parts in several movies produced by Lewis Selznick, the father of Myron and David, both of whom would be clamoring for her services a decade later.

Beaming with pride that he'd lured his daughter into the family profession, Richard Bennett invited Constance to be his escort at the 1924 annual Actors' Equity Ball in New

York. There she met producer Sam Goldwyn, who was so bewitched by her beauty and poise that he offered her a screen test. After that test, he offered her a role in a film to be made in Hollywood. Constance may have seemed frivolous, but at twenty she was already savvy about the entertainment business. Before accepting Goldwyn's offer, she insisted that he put all the terms in writing and pay her round-trip transportation in advance. (Years later, she said her decision to try Hollywood was prompted by her sister Barbara's minor stage success; she felt that Barbara had become her father's favorite.)

In her first film, *Cytherea* (1924), she portrayed a film actress. Despite her minor role, she received flattering notices and Goldwyn offered her a contract. Instead, she returned to New York to work for Pathe Studios. This was not, however, a career move. Before leaving for Hollywood, she had been involved in a volatile on-again, off-again romance with Philip Plant, the twenty-one-year-old heir to a steamship and railroad fortune.

Plant hadn't wanted her to go to Hollywood, which only made the contrary Constance more attracted to the idea. Upon her return she once again tested his love with daily rejections of his marriage proposals. For his part, he made continual pleas that she give up her career. With no resolution in sight, she returned to Hollywood to make several more films, most notably *Sally, Irene and Mary* (1925), which also starred Joan Crawford. On the strength of that performance, Louis B. Mayer offered Bennett a seven-year contract, which she signed.

By this time Philip Plant had followed her to Hollywood to beg for her hand in marriage. When he discovered she'd signed with MGM, he returned to New York. Within weeks, Ben-

nett received an invitation to his wedding to a Miss Judith Smith. With her usual aplomb, Bennett wired her congratulations and asked what he wanted for a wedding present. He replied in person—an act that captured her heart.

Bennett asked to be released from her contract, saying she was going to marry Plant and retire from films. In November 1925 she and Plant eloped—once again, the nuptials took place in Greenwich, Connecticut. Trouble began early. Shortly after the honeymoon the couple decided to live in Europe. When Richard Bennett came to the pier to see them off, his daughter told him that Plant was already drunk in the suite. She tearfully asked what she should do. "My only advice to you," her father said, "is don't blow your nose all over the deck."

Once in Europe, the couple became fixtures on the café society circuit, commuting between Plant's villa in Biarritz, his chalet in Switzerland, and an apartment on the Champs-Élysées in Paris, where they indulged in twenty-four-hour cocktail parties with a cast that included Charlie Chaplin, Gloria Swanson, Pola Negri, and a host of European dilettantes.

Bennett spent three years in this chichi world with little thought to her abandoned film career. But by the fall of 1928 this life had begun to bore her. Her relationship with Plant was still contentious. Their rows—now conducted in public—had become a topic of gossip in the press. Bennett filed for divorce in early 1929 in Paris. Shortly afterward she underwent an emergency appendectomy. Plant kept a bedside vigil, and she was also cheered up by Henri, le Marquis de la Falaise de la Coudraye, the estranged husband of Gloria Swanson and now the European representative

for Pathe Films. Upon hearing about her split from Plant, Falaise jumped on the situation with a movie contract, which she accepted. In the course of business, romance blossomed. Again she displayed her knack for cunning and obtained an unheard-of stipulation in the contract: a paid ten-week vacation with the freedom to work at another studio.

When her divorce was final in December—she received a $500,000 cash settlement—Bennett returned to the United States. She was not alone. Not only was the marquis on board the ship, but Constance had a child in tow: a five-month-old son, who, she told reporters, she and Plant had adopted just prior to their separation. But then, taking delight in confusing the press, she announced that the infant was really her sister Joan's daughter, who was actually eighteen months old. Reporters were not fooled by that story, nor did they believe the child had been adopted—press reports always referred to the boy as her "natural" son. Still, her story kept them confounded, which was just what Bennett wanted.

When Bennett returned to Hollywood, movies were talking. Her spicy personality and husky voice were perfect for the new medium. Her sound debut in the fast-paced comedy *This Thing Called Love* (1929) earned her favorable notices, and she quickly picked up where she had left off. Three films later she starred in *Common Clay*, a soapy melodrama that was one of the box office hits of 1930, making Bennett one of Hollywood's leading actresses.

Incongruous with her breeding and style, Bennett was frequently cast as a brittle working girl who descends into a life of unrespectability and then climbs her way out. Her success had as much to do with her personal life as with the role itself. The public was fascinated

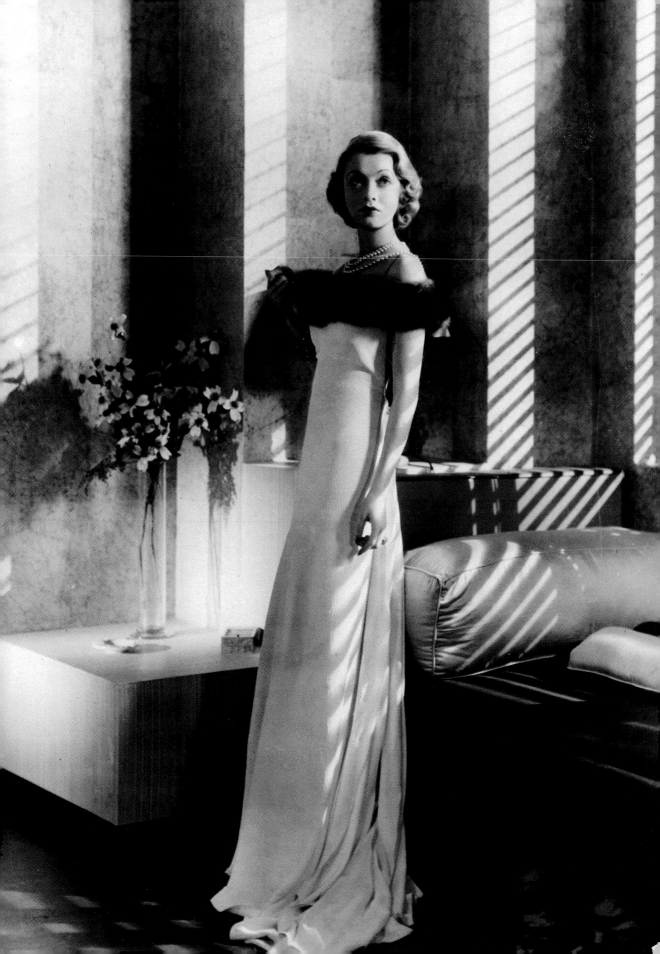

by a woman who really did have a finishing school background and who spoke French. Her fashion sense reflected those years of living in Europe. Because of that, Bennett's brand of glamour was unique.

"She had a kind of romantic, Scott Fitzgerald look about her," observed George Cukor. "It was the look of the 1930s—or perhaps the 1930s looked like her." She was sylphlike, long-limbed, and soignée in appearance. Her ability to wear high fashion was equal to that of Marlene Dietrich. But the crisp, sanguine quality that she exuded made her look more attainable than Dietrich. Unlike many other stars of the era, Bennett didn't need advice about fashion, nor did she need a trainer to help her reinvent herself physically; she was born exquisite and stayed that way. "She was more beautiful in person than on screen," recalls her friend Douglas Whitney. "Her coloring was so wonderful."

For many, Bennett was *the* clotheshorse for the mid-thirties. Her own philosophy was reminiscent of fashion-editor wisdom: "Never follow fads. There is a difference between novelty and originality. The former is for women who allow others to think for them. The latter is for those who think for themselves." As for her on-screen wardrobe, she held to the same point of view and wouldn't allow costume designers to inflict their taste on her. She once tore to shreds a frock that she was to wear in a film, because she didn't like the style.

She had by now earned a reputation with the press for being difficult and uncooperative. Irritated by the gossip surrounding her divorce and the courtship of the marquis, she took delight in confusing reporters about her personal life. It was unfathomable that a woman with such a following could be so indifferent.

After much speculation, she married the Marquis de la Falaise in November 1932. Typically, she instructed the studio publicity department to send only one press photographer to cover the wedding. When a flock of reporters and cameramen arrived, they received a chilly reception. The press now had it out for her. "That conceited, ungracious, high-hat, snooty, independent, hateful Constance Bennett," wrote one journalist. On her honeymoon she was accused of snubbing fans who'd waited hours for her arrival at New York's Grand Central Station. Even the fan magazines zeroed in on her. One of them charged that she had spent over $250,000 for a new wardrobe "while the country, as all you dear readers know, was facing disastrous poverty."

To her friend and fellow actress Marion Davies, Bennett said, "I couldn't spend that kind of money in ten years if I used ermine for toilet paper." To her public she announced: "I have never cut my fans short or discouraged them from seeking autographs. After all, I make pictures for them not for the critics. If I depended upon critics for popularity I would have been dead professionally a long time ago." She did, however, take her new role as the marquise seriously. Her stationery was embossed with his crest, and the fancy blue roadster she drove to the Pathe lot every day had a gold crest on the door.

In 1932 producer David Selznick and director George Cukor made her a sensation in *What Price Hollywood?*—a trenchant study of Hollywood mores that centers around a waitress who rises to become a famous actress and then must battle the problems of career, marriage, and a husband's refusal to take second place. It would eventually be remade three times over as *A Star Is Born*. Though the Bennett version is rarely

shown today on television and isn't available on video, it is immensely watchable.

A solid box office track record now had other studios vying for her services. As a result, Bennett fans didn't have long to wait to read more about her wily behavior. Jack Warner sent word to her agent, Myron Selznick, that he'd pay his client $100,000 for one picture. "Not enough," Bennett told Selznick. Another studio, she claimed, had offered her $125,000. Warner agreed to match that.

Three weeks later Selznick called Bennett to say the contracts were ready. "What contracts?" Bennett demanded. Selznick reminded her of the deal, to which she replied, "But that was three weeks ago! My price is now $300,000." Bennett sidestepped Selznick on the next round and personally haggled with Warner. The compromise was that Bennett would make two pictures for $300,000 within a ten-week period, but only if Warner Brothers would pay the income tax on her salary and Myron Selznick's 10 percent. She backed up her demands by telling Jack Warner, "I'm a businesswoman, not a philanthropist."

Greed and shrewdness weren't always her motivators. Bennett didn't really care if she worked, and as a result of Philip Plant's generous settlement she didn't need to. She often made outrageous demands on the assumption that they'd never be accepted.

And so that crafty bit of negotiating in 1932 made Bennett the highest-paid film star when she began work on *Two Against the World*, a little-remembered soap opera. She never made the second film. Instead, she returned to RKO to make four films, all of them unmemorable. Of the last one, *After Tonight* (1933), Richard Watts, critic for the *New York Herald Tribune*, wrote: "Miss Bennett, a striking and attractive

young woman, who once had ideas about being an actress, has apparently given up the project and is too busy being sophisticated and alluring to bother about a characterization."

It was clear to RKO that her career as a big star was over. She had also been labeled difficult by colleagues because of her capricious demands and periodic tantrums. Many performers refused to work with her. Given all that, the studio opted not to renew her contract. She moved on to Twentieth Century Fox and made several more failures. By now she was so dissatisfied with the scripts being offered to her that she went to Europe in 1935 with the marquis and her son. They lived there for a year. (She made one film in England, *Everything Is Thunder.*)

According to Joan Bennett, it was a miracle that her sister made a film at all during the thirties: "During those years she spent much of her time in the law courts, either suing someone or being sued." She unsuccessfully sued a Hollywood columnist, claiming he'd defamed her character when he wrote an unpleasant item about her. Then she filed a successful breach-of-contract suit against a British movie studio, but she lost the same kind of suit when she brought charges against the noted writing team of Ben Hecht and Charles MacArthur. A Hollywood taxi company turned the tables on her and sued her when she refused to pay a four-dollar fare. "He took the long way around," Bennett said. "It's a point of honor." Another brush with the courts involved an artist she'd commissioned to paint her portrait and whose fee she refused to pay. "That woman is an Amazon!" is how she described herself in the portrait. "I look

A 1933 Cecil Beaton portrait of Bennett.

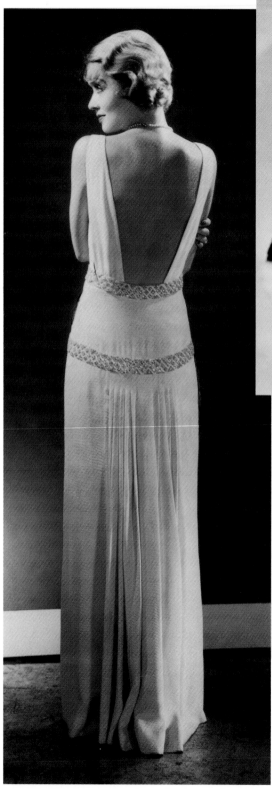

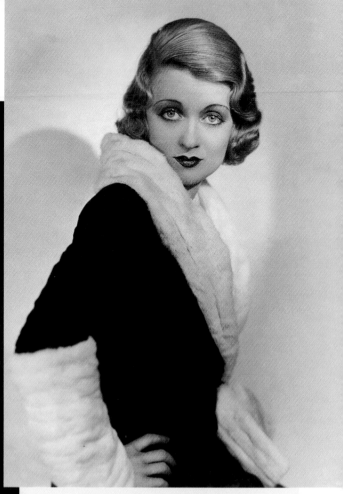

BENNETT IN *Sin Takes a Holiday*, 1931.

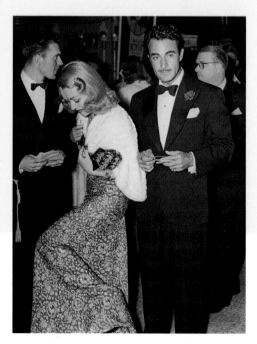

WITH HER third husband, actor Gilbert Roland, 1938.

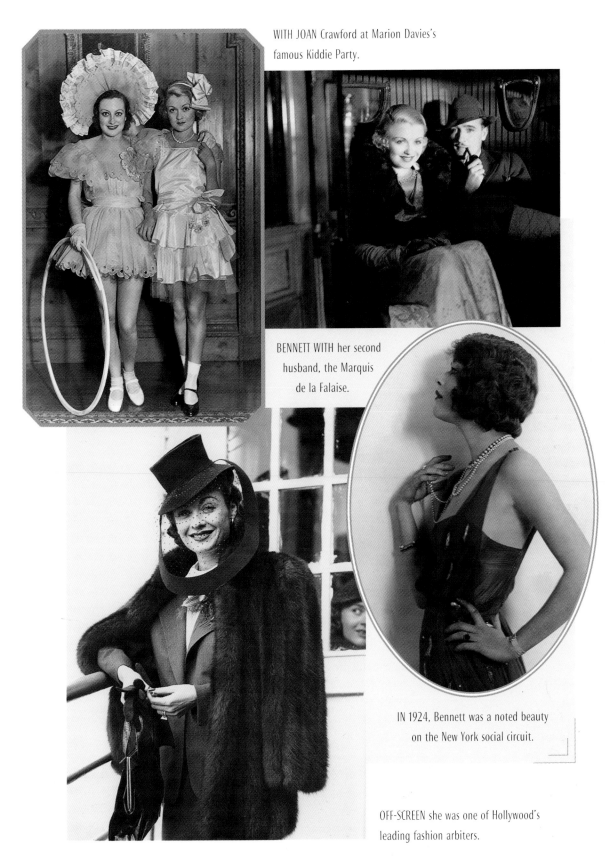

WITH JOAN Crawford at Marion Davies's famous Kiddie Party.

BENNETT WITH her second husband, the Marquis de la Falaise.

IN 1924, Bennett was a noted beauty on the New York social circuit.

OFF-SCREEN she was one of Hollywood's leading fashion arbiters.

THE LIVING room of her twenty-room house in Holmby Hills.

like a sack of Portland cement with a rope tied in the middle." She won that case on a technicality, but the jury foreman later said, "I never signed anything so unwillingly in my life."

"A clever woman. Too clever for Hollywood!" is how one fan magazine described her. "Too beautiful; too rich; too attractive to men; too highly paid; too gold-be-spooned; too outspoken." The fact was, Bennett didn't need movies or stardom to create an identity for herself. Her off-screen life and determination to live it flamboyantly took precedence.

The twenty-room house that she commissioned in Holmby Hills befitted her expansive personality and cosmopolitan tastes. Built to her specifications, the house was designed in the French Norman style so popular with the film colony at the time. Typical of the style, the exterior had arched windows, shingled mansard, white bricks and treillage. There was, naturally, a tennis court and swimming pool. The spacious interiors were highly detailed with arches, columns, and pilasters. William Haines did the interiors. Done in a maroon-and-white color scheme, it was furnished with French and English antiques and accented with Chinese wallpapers. One visiting columnist wrote that the residence was "justifiably considered in the best taste of any home in the picture colony."

In addition to being Hollywood's favored fashion arbiter, Bennett was also a premier hostess. The lavish social activity at her estate ran a close second to Marion Davies's soirees at San Simeon. Sundays were reserved for great afternoon tennis matches. Her son Peter Plant remembers the elaborate parties his mother hosted: "One evening a dance floor was put

down in the backyard. It was surrounded by chicken wire with holly and gardenias stuck into it, and then covered with a tent. Glenn Miller's band played until three in the morning. Dietrich and Noël Coward were among the guests."

Glittering functions, however, took second place to a game of cutthroat poker for which Bennett was famous. She once called herself the "best femme poker player in the country." She was admitted at gaming tables that ordinarily excluded women, holding her own against such moguls as Sam Goldwyn, Darryl Zanuck, and Joe Schenck. In her own home, the games would start on Friday evening and last until Monday morning without sleep. Once her son asked her why they played so long. "It's a way of letting people who aren't very good get out of the hole," she told him.

Bennett returned from Europe in 1936 without the marquis. Her poker-playing comrade Darryl Zanuck gave her a part in a Twentieth Century Fox film, *Ladies in Love.* That led to *Topper,* a delightful comedy in which she and Cary Grant play two madcap sophisticates who die in a car crash but come back to life as playful ghosts who materialize at will in the presence of a stuffy bank president. This film made Bennett a box office favorite again. And she followed that success with a 1939 sequel, *Topper Takes a Trip,* sans Grant. Despite the favorable reviews, her new screen image—charming, urbane, indifferent—did not help to keep up the momentum. Her career spiraled downward during the forties, as she starred in a series of B films. The only A movie she appeared in during these years was *Two-Faced Woman* (1941) in support of Greta Garbo. As a bespectacled playwright, she artfully parodies her own self-image—temperamental, acerbic, sophisticated.

The forties brought more personal changes. She obtained a Reno divorce from the marquis in November 1940 on the grounds of desertion. Five months later in April 1941, she eloped with movie actor Gilbert Roland, whom she'd known since working with him in *Our Betters* (1933), and with whom she'd been romantically involved with since 1936. Roland was a man of great flair. Born in Mexico and the son of a bullfighter, he came to Hollywood as a teenager with less than three dollars in his pocket. Dark and dashing, he quickly established himself as a Latin lover in both silent and sound films. (Bennett and Roland had two daughters, Lorinda and Gyl Christina.)

Bennett's career may not have been gratifying during the forties, but she found a rewarding avenue when she threw herself into the war effort. Though she was one of the first stars to devote herself to patriotic duties, her work went largely uncredited because of her self-perpetuated spoiled-brat image in Hollywood. As chairman of the International Committee for Refugees of England, she was an inexhaustible fund-raiser, speaker, and organizer. She also entertained at military installations and organized studio tours for servicemen.

During this time she started her own cosmetics company (which she ultimately sold), and then, capitalizing on her extraordinary fashion sense, she signed a licensing agreement with Fashion Frocks to design a line of clothes that would be sold under her name. She also had her own radio show, dispensing fashion hints and women's news.

"Like some beautiful, fitful moth, she darted from one emotion to another and never lit long enough to find out if she was happy or not," sister Joan said. And so, in 1945, marriage number four was over.

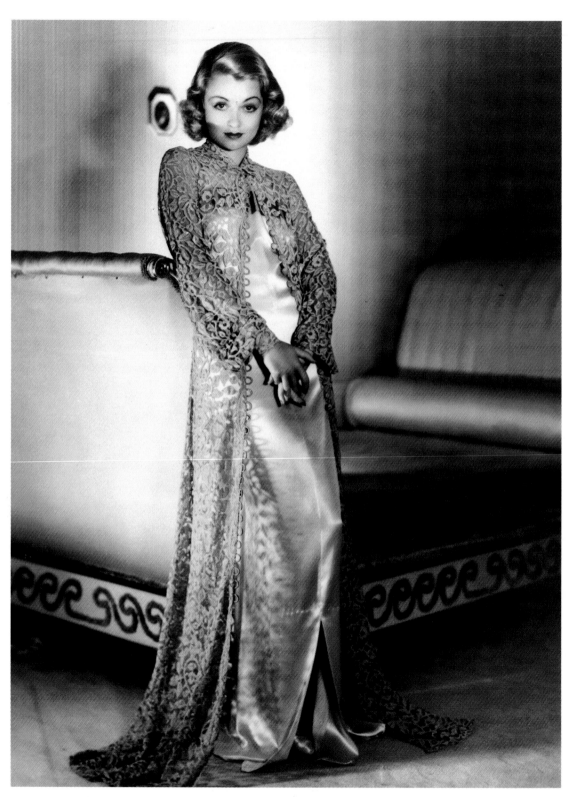

CONSTANCE BENNETT in 1935.

Gilbert's Latin temperament and Constance's fiery personality had been a lethal combination. "Our differences are too great and in order to remain friends we must divorce," she told the press.

She wasn't single for long. In 1946, she married U.S. Air Force Colonel John Coulter (later a brigadier general). They met when Coulter was a technical adviser for a series of air force films being made in Hollywood. "Hurry and get the pictures, boys," Bennett told the press at the time of the wedding in a rare moment of cooperation. "I've been doing this for twenty years and I'm a little tired. I'd like to go lie down." A more than telling line. This union seemed to ground her in a way the others hadn't, and the remaining nineteen years of her life would be the happiest. The secret, according to Joan Bennett, was that her sister had met her match in a man who adored her but would not tolerate her temperamental nonsense.

Her main focus was directed toward being a military wife—during their marriage, Coulter was stationed at twenty-eight different air force bases. But she was not idle. When her husband was sent to command an airlift base at Fassberg, Germany, Bennett applied her glamour in a rather unconventional way as a military wife. Rather than dazzle the spouses of officers and airmen, she organized wives' clubs and shared her beauty and style secrets with them. She encouraged them to be themselves, not to follow fashion trends, and to use their attributes to best advantage. She also organized professional theatrical companies to perform plays there and in other parts of Europe to relieve the grim postwar atmosphere at the Allied bases. Acting as producer and business manager of this project, Bennett commuted regularly between Germany and the United States to persuade actors to volunteer their time. She also chose the plays and scheduled the tours. When Coulter was stationed in Washington, D.C., she staged three months of summer shows at the 4,000-seat Carter Barron Amphitheater.

She made six more films in the late forties and early fifties. They were all unmemorable. While working on her last, *As Young As You Feel* (1951), she said of Marilyn Monroe, one of the film's featured players, "There's a broad with a future behind her"—a line that has gone down in the annals of classic Hollywood anecdotes.

During the fifties, Bennett went farther afield in the world of entertainment. She had a nightclub act at New York's Pierre Hotel, then took it on the road. In her act, which was staged by film director Herb Ross, Bennett sang everything from "Boulevard of Broken Dreams" to a rock-and-roll number called "Lipstick, Candy, and Rubber-Soled Shoes," and she even danced the jitterbug.

"You won't have a hard time making me look good," she told Noel Taylor, the show's costume designer. "When I was at Metro, I had to play a waif and they couldn't make me look like one." Taylor recalls that the main dress for the act was designed by Sophie, but Bennett wanted to contrast that gown with something offbeat and do a number in blue jeans. "I told her she was too glamorous for blue jeans," the designer recalls. "So I gave her rhinestone-studded ones with a matching denim shirt. She resisted at first, but it turned out to be the hit of the show. She used to say to me during our fittings, 'Don't overdress the dancers in the show; they're coming to see me.'" As it turned out, Bennett could sing and

dance well and reviewers dubbed her "the most glamorous basso profundo around."

The 1950s also had Bennett starring in the national road companies of several Broadway shows, most notably *Auntie Mame.* In the theater she found a more rewarding platform for her drive and intensity than she ever did in films. As Mame, Bennett wowed audiences in twenty cities when she appeared in eighteen different costumes designed by former Hollywood master Travis Banton. When praised by critics, Bennett took it in her stride. It was, she thought, her responsibility to give every audience their money's worth. "I'm more sartorial than Thespian. They come to see me and go out humming the costumes," she said.

In 1965, after a fourteen-year absence, she returned to the screen to play Lana Turner's mother-in-law in *Madame X.* To welcome her back to Hollywood, producer Ross Hunter threw a splashy party on the Universal sound-stage. Bennett basked in the attention and even found it in her heart to speak glowingly of the bygone era in which she'd reigned and fallen from grace. "The roles were glamorous and the clothes divine. They weren't dramatic roles; they were more sympathetic. But they were exciting and the actresses acted like movie queens. Pictures have certainly changed today."

What hadn't changed was Constance Bennett. In the film, Bennett was supposed to wear a chinchilla coat and a huge emerald-cut ring designed by jeweler David Webb. When Turner found out, she went to Hunter and demanded that *she* wear the ring and the coat. He gently explained the problem to Bennett. "Honey, don't worry," she told Hunter. "When I'm on the screen no one is going to look at anyone but me anyway." She was right. "Ross and I saw

her nightclub act in New York," recalls Jacques Mapes, associate producer on the film, "and we thought she'd be perfect for the mother-in-law. By the time she got to Los Angeles, she had had a face-lift and she looked younger than Lana." The fact that Bennett at age sixty looked younger than the forty-four-year-old Turner did not go unnoticed by critics and gossip columnists, either.

"No surgeon's scalpel has ever touched my face," she told Hollywood columnist Sheilah Graham, in what would be her last interview. Whether she had a nip and tuck was irrelevant. "She had fabulous bone structure and the most beautiful eyes," recalls her friend, writer Nancy Holmes. And despite the fact that, according to friends, she ate like a truck driver, she was whipcord thin and still weighing in at 98 pounds. "You can hang a hat and coat on my vertebrae, but I love to eat," Bennett said. More than the physical attributes, it was what Bennett translated through her personality that made her still attractive. "She never lost her glamour, because she understood it. She never had the weakness of young or old," says Holmes.

Holmes recalls her arrival in Gstaad during the early sixties:

She stepped off the train wearing a red fox hat and huge mink coat. She had tons of luggage, and she was carrying her two poodles. She looked every inch the star, but it didn't seem ostentatious. Every gesture, every physical quality, was stylish—her hands, her fingernails, the cigarette holder dangling from her mouth, her deep, smoky voice. I remember she wore beige ski clothes, topped off with a chiffon scarf. For all that, there was something down-to-earth about her. She and John stayed with me in my flat in Gstaad. It was a modest two-bedroom apartment—Swiss primitive, there wasn't even a

refrigerator. Connie loved it because she had great innate taste. There wasn't enough hot water for all of us to bathe, so Connie said, "All right, Nancy, we'll fill the bathtub. I'll take the first bath. You take the second, and John will take the last." I would never have suggested it, and of course, it was a given that she would bathe first.

And though Bennett appeared ageless, she lied like a trouper about her age to the very end. When she was rushed to the hospital in July 1965 for an undetermined illness, she insisted to the admitting authorities even under heavy sedation that she was born in 1914. "It's never been properly recorded and it's never going to be," she once said. One of her last wishes was that her gravestone bear only her name and date of her death.

"The worst enemy of a female is having a resentful personality," Bennett told a reporter. "Any woman who habitually has shown meanness and envy will find in time they'll show in her face and make her unattractive." Bennett may have been volatile and dogmatic, but she tempered it with a vibrancy and enthusiasm for living. "She was a completely secure person," Nancy Holmes recalls. "Because of that, she was never demanding of attention; she was a great observer. She exuded a carriage and confidence that seemed more masculine than feminine. She was a beater of life."

And so when she died of a cerebral hemorrhage on July 26, 1965, it came as a breathtaking shock to her family and friends. "A strong and vital personality," Joan Bennett wrote in her memoirs, "a woman of indomitable will who sprinted through life as if it were an obstacle course."

When Constance Bennett wrote back to the film historian, who was writing about her for *Films in Review*, she added a postscript: "Did I really make a film called *Bed of Roses?*" This was so very telling of her personality. Though egocentric, given to wild histrionics, and capable of guile, she possessed at the core an honest, no-nonsense attitude about herself. Temperament and a hectic personal life may have hampered her film career. At bottom she was too intelligent to play the game. And Hollywood, in turn, ultimately found it difficult to embrace an actress who, Joan Bennett said, "reduced absurdity to a proper level with all the delicacy of a bulldozer." Like Auntie Mame, she was a maverick who found life far too absorbing and invigorating to limit herself to a town that, without the great magnifying glass of the screen, would be in most ways smaller than life.

IN LATER years Bennett was still a paragon of chic.

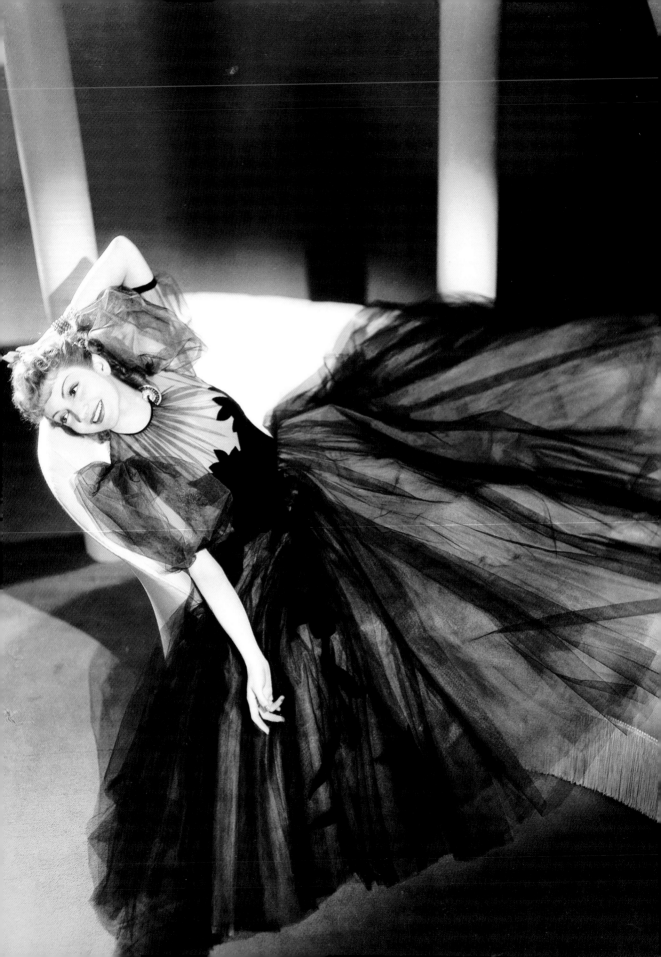

Claudette Colbert

Soft round collars, pearls, a suit with a touch of white ruffle at the neck, and the short curly bob with fluffy bangs were the style signatures of Claudette Colbert. They served her well. She's the only actress in Hollywood history to enjoy a sixty-year career without ever altering her persona or changing her look. Even more amazing is that she never lost the public's interest. In fact, she maintained star status regardless of the films she made or didn't make. During the last decade of her life, most of her still abundant fan mail came from people in the fourteen- to twenty-five-year-old age range.

Colbert's look was forever gamine. On another woman, those trademark bangs would have been a signal that she was trying to hang on to youth. Not on Colbert. She never tried to look younger than her years. The apple cheeks and oval face remained virtually unlined until her death, in 1996, at ninety-two.

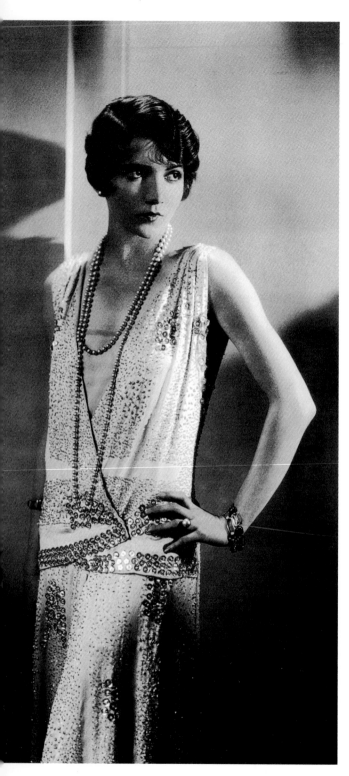

A 1929 photo by Steichen when she was making a name for herself on Broadway.

Over time, the hairstyle, the full mouth, and the vast brown eyes, which remained as mischievous as when she captivated the public in *It Happened One Night,* reflected more than an image. The look was a mirror into the woman herself, a reflection of an eternally youthful spirit. It revealed a woman who never lost her curiosity, a woman who always knew that her off-screen life was separate but equal to her glamorous on-screen roles—in short, a woman who loved life. And never for a moment did she think her existence was justified by her career. "I had a very good life of my own," she explained. With that attitude, the older she got, the younger she became. No one understood the paradox better than Colbert herself: "It takes a very long time to be young," she confided when she was pushing eighty.

Colbert epitomized glamour without epitomizing the movie legend. She achieved this, in part, because she wasn't manufactured or created by others. The well-bred, fashionable look she represented on the screen was a true expression of who she was.

"The first thing one must arrange to do," Diana Vreeland, the celebrated style arbiter, once intoned, "is to be born in Paris." That first lucky break would have a lifelong influence on the style and taste of Lily Claudette Chauchoin, who was born in that city in 1903. Some of her earliest memories were of wardrobe fittings with an aunt who had been a designer for the House of Worth and who made Claudette's elegant handmade clothes.

After the family arrived in America, Colbert's mother continued to run a traditional French household from their apartment in Manhattan's East Fifties. Playing in the streets

like other city youngsters was forbidden. Bread with a piece of chocolate was given as a snack rather than penny candy. And only French was spoken at home.

"Claudette was more French than the French," observes Leonora Hornblow, a long-time friend. "Like her mother, she ran a French house, served only French food, and she had the natural clothes sense so typical of a Frenchwoman."

The Chauchoins had emigrated to the United States in 1910 after Georges Chauchoin, who had been a minor bank functionary, suffered financial reversals. Once in New York City, he found a job in an office that was lucrative enough to provide modest middle-class comforts for a family that included Lily's younger brother Charles, an aunt known as Tantine, and Claudette's maternal grandmother, Marie Loew.

It was a matriarchal family with Grandmother Loew at the helm. She was fluent in English and had taught her granddaughter the language before arriving in America. "I have always thought it was Grandmother who gave my parents the courage to come to America," Colbert observed years later. "She was a woman of great strength of character and stick-to-itiveness. I think she kept us all together and functioning."

While her grandmother's personality would have a lifelong influence on her, her mother—who lived to her mid-nineties—would forever dominate her. Jeanne Chauchoin was a great beauty of classic proportions who had, according to Colbert, a singing voice on a par with that of Maria Callas, but she opted for marriage at eighteen when her own mother forbade her to pursue an operatic career.

"I believe when it happened to me, when my career began, mother was living vicariously, doing through me what she had always felt she could do herself," Colbert once recalled. Still, there was a streak of unconscious envy in Jeanne. "Claudette lived in fear of her mother," says her friend Leonard Gershe. "She withheld approval, and Claudette always tried to please her."

As a teenager, Colbert dabbled in high school dramatics, playing the part of Rosalind in *As You Like It.* She made a more official debut at age fifteen at the Provincetown Playhouse in Greenwich Village in a play written by one of her teachers. But after graduating from high school, she followed Grand-mère's suggestion to pursue a career in fashion. She enrolled in classes at the Art Students League, worked in a dress shop to learn more about designing, and taught French classes in the evening to augment her income.

"Plans are one thing, and life is another," Colbert commented years later. Her fashion ambitions turned pale when she met Anne Morrison, a playwright, at a tea party in 1923. Morrison saw something that Lily did not. The playwright told her she should be an actress and gave her a three-line part in her play, *The Wild Westcotts.* The twenty-year-old novice proved so good that her part was expanded, and it was then that Lily Claudette Chauchoin changed her name to Claudette Colbert—the maiden name of her paternal great-grandmother.

"I just went right onstage, and I learned by watching," Colbert once said. "I've always believed that acting is instinct to start with; you either have it or you don't." For the next three years she toured in stock companies and played in New York productions that earned her favorable reviews. She was a quick study about her

career as well. Realizing she was in danger of being typecast in French roles—"cute little maids with dark bangs and an accent"—she anglicized the pronunciation of Colbert to *Cole-bert* for a brief time.

She became the toast of Broadway when she played a carnival snake charmer in the 1927 play *The Barker.* Walter Winchell called her Legs Colbert in his columns as her gams were a star attraction in the show. Leland Hayward, later the celebrated Hollywood agent and stage producer, saw the show and reported back to the movie director Frank Capra that she was "a real headline maker, the finest young actress that's hit Broadway in years." Capra took his advice and cast her as the leading lady in his silent film *For the Love of Mike* (1927). The movie was such a disaster and the whole experience of shooting it was so unpleasant that Colbert resolved to never make another film.

She returned to the stage to star in several productions that earned her more admiring reviews. And in 1928 she married Norman Foster, the actor who had been her costar in *The Barker.* She kept the marriage a secret for a year because her mother, who had once asked Foster the meaning of the word "threshold" and then told him never to cross hers, didn't approve of him. Colbert might have hidden the union indefinitely if Walter Winchell hadn't blabbed it in his column. Even after that announcement of marriage, the couple continued to live in separate apartments as a result of her mother's domineering influence.

It's conceivable that Colbert would have stuck to her no-film-acting vow if the Depression hadn't hit. By this time her father was dead and she was now the sole support for her family. "Hollywood was not my dream," she said years later. "I only left Broadway when the crash came. The Depression killed the theater, and pictures were manna from heaven." The stock market crash also coincided with the arrival of talkies; Colbert's velvety voice, once compared with cream of tomato soup, made her a natural for sound movies. She signed with Paramount and made five pictures at the Astoria Studios in Queens, New York, before emigrating to Hollywood in 1931 to star in *Honor Among Lovers.* These early pictures established her as a film actress, but they also typecast her. For the next few years, except for her 1931 role in *The Smiling Lieutenant,* she was a sweet, virtuous woman in films like *Secrets of a Secretary, The Wiser Sex,* and *The Misleading Lady.*

Colbert grew dissatisfied with these parts, and in 1932 she vigorously campaigned to play "the wickedest woman in the world"—Poppaea in Cecil B. DeMille's *The Sign of the Cross.* To convince the formidable director she could play a seductive beauty, she designed a revealing tunic for the screen test and got the job. The role of Poppaea and a memorable scene of her bathing in asses' milk established Colbert as a major sex symbol.

Off-screen her male costars—Melvyn Douglas, Herbert Marshall, and Fredric March among them—were consistently smitten with her. "She had a wonderful gaiety, a peerless sense of fun, and her chemistry was a marvel," March recalled. "There was a tremendous, smoldering sensuality to her ... but Claudette had a lot more to offer than mere sex appeal and romantic allure; she was a wonderfully intelligent conversationalist, a really brainy woman, and she had humor and vitality." According to March and others, Colbert's sensuality was tempered by her innate dignity and her "sense of the fitness of things."

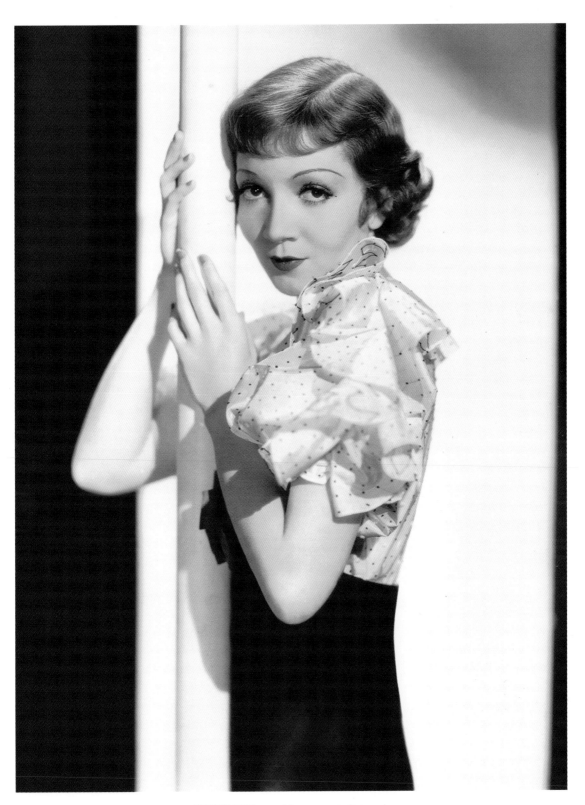

COLBERT FELT her oval face was not photogenic.

Colbert went on to enhance her sultry image in DeMille's *Cleopatra* (1934). But her portrayal of the most glamorous woman of all time was overshadowed by her new image, as the unflappable comic heroine of *It Happened One Night,* which was released the same year.

Colbert had grudgingly accepted the role as the spoiled runaway heiress who, while roughing it on a bus in America's heartland, meets a tough but idealistic newspaper reporter played by Clark Gable. Her reasons for not wanting the assignment made sense: She found the script unappealing. She resented Paramount for loaning her out to the déclassé Columbia Studios. Frank Capra was the director and she knew she wasn't his first choice for the role—or even his second, third, or fourth. Colbert didn't camouflage her displeasure with the assignment. "I don't want to do this role. I'm just a stooge for Clark Gable," she purportedly announced on the first day of filming.

Whatever Capra's reservations were about Colbert, he thought she had "the best figure of any actress in Hollywood," and he wanted audiences to see it. She, on the other hand, was determined not to be compromised by his ideas. Capra recalled in his memoirs, *The Name above the Title,* that when she was required to do a polite striptease, she "refused to even partially undress before the camera. She wanted to feature her acting, not her sex appeal."

Millions of *One Night* fans almost never got to see the memorable hitchhiking scene where Colbert flags down a motorist by raising her skirt—a scene that transformed America's vision of the road—because she refused to do it. Determined, Capra performed reverse psychology and hired a chorus girl to double for Colbert's leg.

"Get her out of here," Colbert said when she saw the double's legs. "I'll do it. That's not *my* leg."

In that anecdote lies a key to Colbert: She was the consummate professional who would never have sacrificed quality for the sake of modesty. During the thirty-six days of shooting, Capra endured many more "little tantrums, motivated by her antipathy toward me."

When Academy Award nominations were announced, no one was more surprised than Colbert to learn she was up for Best Actress. She was certain she'd made nothing more than a corny little comedy—so sure, in fact, that she made plans to leave for New York on Oscar night. But as she was boarding the train, a publicity director rescued her and whisked her back to the auditorium just in time to receive her award. The grace and manners that would be her hallmark were in evidence that night as the Oscar was placed in her hands. "I owe Frank Capra for this," she said.

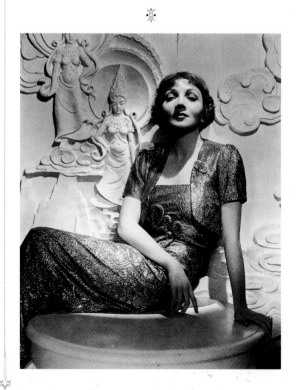

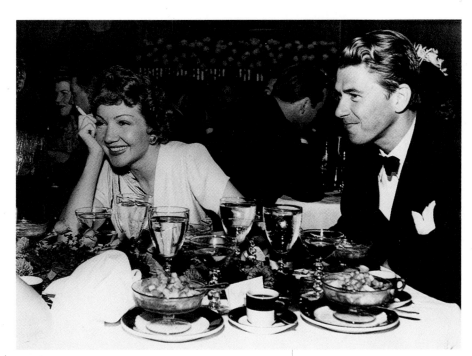

COLBERT WITH her longtime friend, Ronald Reagan.

"No matter what happened to Colbert, she maintained her cool charm, her throaty chuckle, and her ability to emerge a winner," observes the film historian Jeanine Basinger in *A Woman's View.* "Even when she was playing a bedraggled poetess on the lam in *It's a Wonderful World* (1939) or was stepping out into a torrential downpour with nothing but a newspaper to shield her gold lamé (*Midnight,* 1939), she looked perfectly turned out, neat, trim, and competent. Whatever it was, Colbert never stepped in it over her shoe tops. No doubt women yearned for that level of subtle mastery and enjoyed Colbert's triumphs."

That realistic detachment so evident on screen was also a part of her inner posture, which stemmed from a sense of self so complete that external influences had no authority. Nowhere was that off-screen quality more visible than in her handling of her career. Unlike Lombard, she did not court publicity to enhance her persona as a heroine of screwball comedy. Instead, she protected the sophisti-

cated East Coast stage actress who was first and foremost a lady. She used her innate qualities—charm, vivacity, humor—to beat back the slight suggestion that she was a Hollywood product. And in turn, she used her Hollywood position rather than letting it use her.

The Colbert brand of glamour was a paradox. She was boundlessly vital and adorable in a Betty Boop kind of way, and yet, her gamine looks never turned cute on screen. She tempered the coquettish bangs, cloverleaf face, cherubic cheekbones, and bowed lips with a refined sexiness.

Colbert never posed for silly pots-and-pans photos or engaged in wacky publicity stunts. And she was careful to avoid displays of overt sexuality. When John Engstead came to photograph her at home, she refused to pose in a one-piece bathing suit. He reminded her that she revealed a bare limb in *The Sign of the Cross.*

"That was authentic character," she explained. He then recalled the hoisting of her skirt in *It Happened One Night.*

PUBLICITY PHOTOS were
never released without her approval.

COLBERT IN 1930 with her
first husband, the actor
Norman Foster.

OFF-SCREEN she dressed
simply and expensively.

SHE HAD a Betty Boop
quality—boundlessly vital
and adorable.

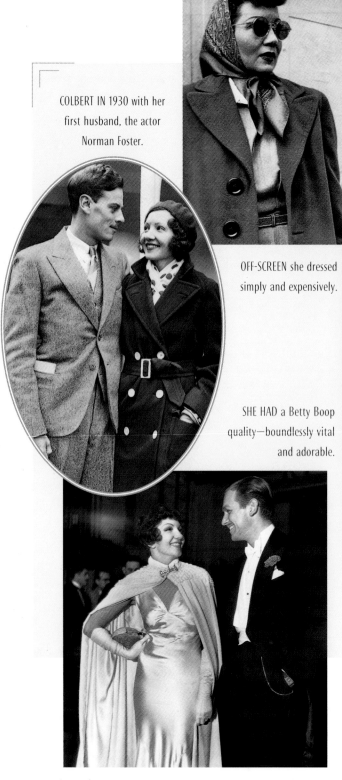

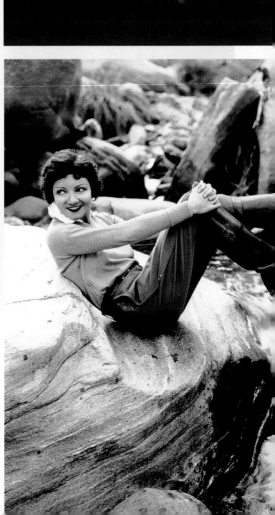

WITH DOUGLAS Fairbanks Jr. in 1932.

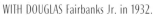

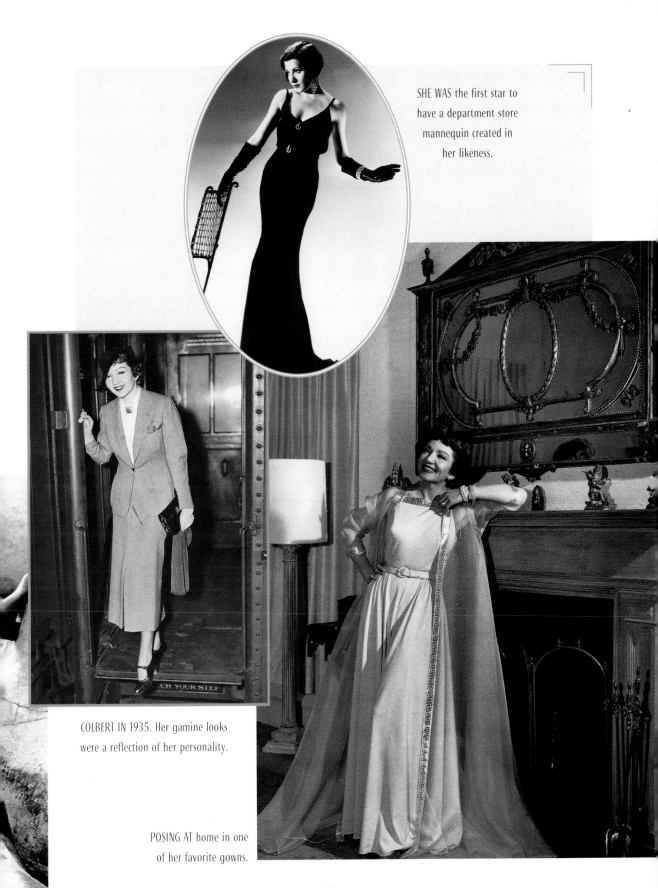

SHE WAS the first star to
have a department store
mannequin created in
her likeness.

COLBERT IN 1935. Her gamine looks
were a reflection of her personality.

POSING AT home in one
of her favorite gowns.

"That was a story point," she shot back.

"So we're shooting you at home. You have a pool. You go in it. What do you wear, authentically, a Mother Hubbard nightgown?" Engstead asked.

Colbert took the point and posed.

She was the first Paramount actress ever to have a clause in her contract forbidding the release of any photograph without her approval. She fought for this clause after a suggestive photo was released early in her career with her costar Fredric March (*Tonight Is Ours*, 1932). March was famous for his roving hands and decided to spice up the publicity shoot by grabbing her bottom. No one realized the gesture was in the photo. A few months later, however, Colbert received a letter from a women's club: "We thought you were a lady. Now we are disappointed and we will not go to see your movies again." Along with the note was the photo of her with March, which had been torn from a magazine, with the caption "Like the Marines, Mr. March seems to have the situation well in hand."

Colbert was also careful about her stills because she thought her oval-shaped face was more interesting if it was in constant motion. And she was right. Her photographs never captured her beauty the way celluloid did. Decades later, when asked by a fan to sign a vintage photograph of herself, she took the felt-tip pen and began retouching her neck and shoulders.

Her obsession with how she looked in stills was minor compared with the way she envisioned herself on film. She insisted on being filmed only from the left side of her face because she had broken her nose as a child and there was a bump on the right side—but she did not, as legend has it, demand that sets be built to accommodate her "best side."

All those who worked with her regarded her as a crack professional on the set and a gifted actress. She was also consistently difficult. Frank Capra had problems with her again in 1947, when he cast her opposite Spencer Tracy in *State of the Union*. Trouble began early on when he gave in to her demands to replace the cameraman with someone she'd worked with before. Then, two days before filming started, she insisted that she be allowed to go home every day at 5:00 P.M., an hour earlier than the typical industry workday. With that, Capra replaced her with Katharine Hepburn.

"I cannot give good work after that hour and will not even consider trying," she told the director. This was not a prima donna tactic. In Colbert's view it was pure common sense. She was forty-four years old and felt that her face didn't photograph well after a long day under hot lights. "It was professionalism, not vanity," she once said when asked about her reputation. "I can't work up to my best level if there isn't a consistent level of professionalism from all parties; it's as simple as that."

Noël Coward wrote in his diary that he found her "extremely tiresome" during the filming of a live telecast of *Blithe Spirit* (1956). "All this is a pity because she is, within her limits, an excellent actress and those limits she imposes on herself. I have for years had a definite affection for her as a person, but these rehearsals are wilting it considerably." So exasperated was Coward that at one point he said, "Claudette, if you had a neck, I'd wring it."

Colbert arrived in Hollywood with a clear sense of how she wanted to look. The bobbed hairstyle had already been created by Sydney Guilaroff in 1928, when he was still an

unknown hairdresser in New York. "Her hairstyle was ordinary, and she told me she wanted to change her look," Guilaroff told me in 1996. "I had seen her on Broadway and she seemed to me quite stunning. I bobbed her hair because she had a combination of French and American elegance about her. There was such a distinction about her." In 1932 she modified the style herself by devising higher, bouncier bangs because she thought she needed height for the shape of her face.

So exacting was she about her hair that she always cut it herself—Guilaroff showed her how to do it—and never let a studio stylist put a comb to it. She had the same policy about her makeup. Once she and the studio artist had worked out a makeup look for the screen, she became an expert at putting it on and applied it at home before departing for the studio.

Colbert's knowledge of fashion and a sensitivity to what she thought were figure flaws made her uncompromising when it came to costuming. During the making of *Cleopatra*, she insisted that Travis Banton bare as much of her bosom as possible. Though she had one of screenland's best figures, she thought her waist was too thick, and she wanted Banton to place all the emphasis

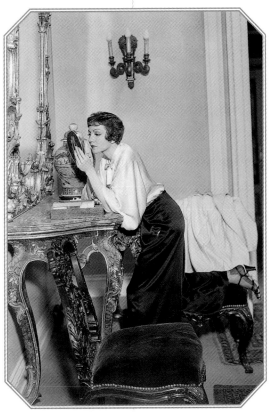

FOR HER movies, Colbert eschewed hairdressers and makeup artists.

above her middle. By calling attention to her chest she also reasoned that it would divert attention from her unusually short neck. Banton gave in to her demands, but the day before shooting began, she refused to wear the costumes she'd approved. Banton went back to the workroom. In twenty-four hours he had the first elaborate costume ready for filming.

Banton wasn't the only one who had problems with her. "She once slapped a fitter at Western Costume who kept insisting her costume fit properly," says Leonard Gershe. "Claudette knew it wasn't right and finally got exasperated with her. The woman had treated her as if she was stupid, which was a mistake. Claudette really was an authority on clothes."

Edith Head, Banton's successor at Paramount, suggested she find another costume designer who would be more willing to give in to her demands. Colbert brought in Irene, who was then a fashion designer with her own salon and designed for Colbert off-screen (Irene freelanced for movie studios and was later head of MGM's costume department).

From the sweater and beret in *I Cover the Waterfront* (1933) to tailored suits and feminine blouses in comedies like *The Palm Beach Story*

(1942), Colbert's strength lay in her ability to wear modern clothes tastefully and unpretentiously so the fashions gave her characters a reality. And there was an inverted sexiness about her wardrobe. She forever changed the public's view of what could be considered seductive dressing when she donned Gable's striped pajamas in *It Happened One Night*.

Though several of Colbert's roles required her to wear period costume, they were not her most successful films. In period costume, she was unable to use her trim, angular body as part of her characterization because the famous Colbert walk—leading with the shoulders, followed by a gentle swaying of hips—was so modern and confident. It was one more element in an intrinsic chic that was key to her persona.

And Colbert's persona had an accessibility that many of her clotheshorse contemporaries didn't have. "When Dietrich, Lombard, and I were all working for Paramount . . . I was the girl next door—but a chic girl next door," she once explained. "Marlene was sexy; and Carole Lombard was the girl next door but crazy." The ease with which she wore clothes on the screen underscored the image of the self-sufficient, sophisticated twentieth-century woman. And in turn, she conveyed the ultimate stylish statement: once she put on a dress, she forgot about it. No other star in her category seemed so comfortable in high fashion. As a result, she was the first movie star to have a department store mannequin modeled after her.

Because she dressed on-screen the same way she dressed off-screen, her real-life designer gradually became her film designer—Sophie Gimbel (Sophie of Saks Fifth Avenue), whom she met in Sun Valley in 1937 and who was one of her closest friends until the designer died in 1981. "These were simple, well-bred, feminine clothes which reflected the woman Claudette was," says designer Bill Blass, who made her clothes for the stage production of *A Talent for Murder* in 1981 and who often dressed her in private life as well.

"I've always believed in the basic institution of the little black dress with a touch of white at the throat," Colbert once said. She was for several years voted Hollywood's best-dressed woman. Her practical chic was also recognized by fashion arbiters outside the Hollywood community, and she was a frequent member of the International Best Dressed List.

The actress herself described the Colbert style as being based on two looks: "the Peter Pan collar look for day and the openly romantic evening dress." She favored that round collar because she felt it elongated her neck and suited the shape of her face. In addition to her clothes, a great part of the Colbert style both on and off the screen was a sense of order and perfection. Over time she implemented tricks of the trade into her real-life dressing: to combat the pulled-out blouse she had hers cut to just below the hipbone and then had long elastic loops attached to either side, front and back, which then hooked on to her undergarments.

Off-screen she was equally demanding with designers. "She was like a precise fitter," says the designer Adolfo. "She would stand in front of the mirror, pulling and fitting." Quite often she took the tailoring into her own hands. During the forties John Engstead witnessed her taking a Hattie Carnegie suit apart because it was lined with horsehair. Three decades later her close friend Helen O'Hagan found Colbert sitting on the floor of her New York apartment taking an entire suit apart.

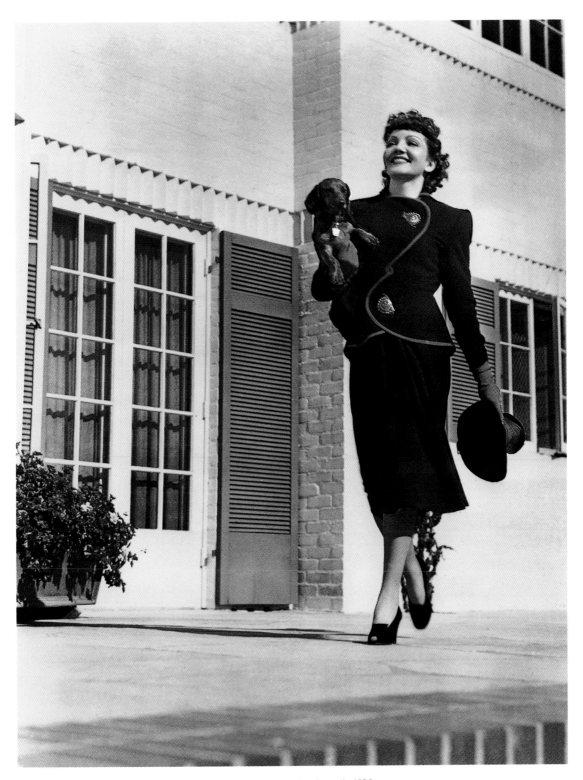

A PUBLICITY shoot at her home in 1938.

"She told me she didn't like the sleeves," says O'Hagan. That incident illustrates, O'Hagan says, why she was so exacting about her film costumes: "She really knew how clothes should fit."

Colbert's fashion ideas were based on years of watching herself on-screen, which she said gave her a certain advantage over other women. "I don't believe in following fashion except when it suits you," she told *Women's Wear Daily.* "That's what most women haven't learned. They should study themselves critically in the mirror from all angles. There would be fewer mistakes. I had the advantage of studying films and stills."

Adrian, who occasionally dressed her during the forties, complained that she was too conservative and was convinced she had a phobia about wearing exciting clothes. To prove his point, he once picked out six of his more cutting-edge designs for her to try on. When she modeled them, he had to concede defeat. "I'll never say another word to you," he said. "You know exactly what is right for you."

❋

The only glitch in Colbert's life when *It Happened One Night* was released was the end of her marriage to Norman Foster. Their professional paths had taken them in different directions.

Though she requested he star with her in one of her early films, his career as a movie actor never took off (he later became a director), and that, in typical Hollywood fashion, drove a wedge between them.

In December 1935 she married Dr. Joel Pressman, an ear, nose, and throat specialist (in later years a leading cancer researcher at UCLA Medical School and the chief of head and neck surgery), whom she met when he treated her for a sinus condition. "Joel was perhaps the most emotionally mature man I had ever met," Colbert said. "I felt I could trust him completely and permanently." Pressman, who was called Jack, was staid but affable and, like Colbert, had a keen sense of humor.

"Jack worshiped her," says Leonora Hornblow. Though they were different in temperament, he was a perfect match for her willful nature. He was devoted to his own work, and Colbert respected him more than any other human being.

Colbert and Pressman settled into a house in Holmby Hills that she had commissioned for herself before meeting him; it had been built to accommodate her mother and her aunt. This home was Colbert's chief extravagance. What had begun with the idea of building "the world's most beautiful small house for only $30,000" ended up costing $250,000.

SKIING WITH a friend in Sun Valley, Idaho.

Rebelling against her French background—or perhaps against her mother—she had the house designed in a Georgian style and filled it with the fine English furniture she had begun collecting when she still lived in New York. Hazel Rae Davie, a popular decorator, aided her, but Adrian designed her bedroom and sitting room in a soothing color scheme of pale celadon and olive green, with the walls covered in handpainted chinoiserie.

Despite Colbert's impeccable taste, she was, every once in a while, capable of folly. The house was situated on a large piece of acreage, which she soon realized was expensive to maintain. She moved the house six feet away in order to comply with zoning rules and so she could sell the other part of the property. "She could have had two gardeners for 250 years for the amount of money it cost to move the house," Jack Pressman later noted. "The most unshowy showplace in Hollywood" is how the writer Cleveland Amory described it for the *Saturday Evening Post.*

Colbert was not a fixture on the glitzy Hollywood social scene. "All the people who went out to nightclubs were a whole different gang," she explained. Colbert entertained at home, and her clique was like a small stock company that included the Gary Coopers, the Jack Bennys, the Danny Kayes, the Arthur Hornblows, William Goetz and his wife, Edie (the daughter of Louis B. Mayer and a queen bee of Hollywood), and a few couples outside the industry, from the medical community and Los Angeles society.

Her lifestyle made an impact on other Hollywood insiders. "I always looked upon Claudette as the one for-sure lady in the community," recalled the late Slim Keith, who was married to director Howard Hawks during the forties. "She dressed with more style and more restraint. Her house was beautiful. Her food was wonderful. She ran her house immaculately, and people worked for her forever."

With her marriage to Pressman, Colbert created a life for herself that was a rarity in Hollywood: she managed to have a successful career and remain blissfully married to the same man for thirty-three years, until his death in 1968. So protective was she of this marriage that she took great pains to make sure Pressman was never photographed with her: "It would hurt him in his medical profession, and I consider his career more important than mine."

In 1930 she signed a long-term contract with Paramount and, until the end of 1935, averaged about four films a year. After marrying Pressman she made two films a year at $150,000 each, which made her one of the highest-paid Hollywood performers (she ranked number one in 1938). Despite being less visible than some of her contemporaries, she continued to receive high marks in popularity polls and was in the top ten exhibitors' list of box office moneymakers (she ranked number one in 1935 and 1945) until the mid-forties.

The battalion of Paramount glamour queens—Marlene Dietrich, Mae West, and Constance Bennett—had hit Hollywood around the same time as Colbert, but after they bowed out, she continued to work. In 1944 she turned down Paramount's renewal offer of $200,000 per film, becoming one of the first actresses to separate herself from the studio star system by announcing she could make more money as a freelance performer. She continued to make two pictures a year until 1950.

Colbert's attitude toward her career was as light and breezy as her comic performances. "I never thought of my career as the primary thing in my life. I looked upon acting as a job, and now, frankly, I regret it," she told *Time* magazine when she was seventy-seven. "I think of all the things I could have done. I just let parts come to me. I never went after them."

Like all perfectionists, she was too tough on herself. She had not been immune to the problems that plagued other first-rate talents —she too was cast in movies whose plots were weak or badly carpentered. But no matter how mediocre the film, Colbert was always radiant. And she was shrewd in other ways. In 1934, in the wake of her runaway success with *It Happened One Night,* she chose not to follow with another comedy; instead she played, at age twenty-nine, the mother in *Imitation of Life,* one of the all-time classic weepers. "I did it in order to be able to do the same things later without being typed as a mother," she told a reporter in 1960. "It turned out to be a very wise move." She also proved that she could play more than sophisticated comedy and romance; she could handle drama with equal success.

In 1950 she received critical acclaim for her dramatic performance as an American woman in a Japanese prison camp in *Three Came Home.* Though it was an excellent film, it cost her a role that would have been as pivotal as *It Happened One Night.* She had refused to allow a stuntwoman to perform a fight scene in *Three Came Home.* That stunt ruptured a disk and put her in traction just before she was to begin shooting *All About Eve.* The part of sharp-witted Margo Channing had been written with Colbert in mind—but the character was immortalized by Bette Davis. Colbert forever mourned the loss of that role. That disappointment also signaled the end of two decades of stardom. "I was no longer young— I was forty-seven—and people thought that because I was not able to work in that marvelous picture I was sick," she told writer Gerald Clarke.

After several relatively unsuccessful films, she made *Parrish* in 1961. In that film—a vehicle created to turn Troy Donahue into a big star, which it did not do—she played Donahue's mother. "If I have to play mothers to any young thing they want to plug, that's all!" Colbert reasoned, and retired.

For the next two decades Colbert directed her attention to her professional roots, appearing on Broadway in several plays and making national and international tours. She costarred with Jean-Pierre Aumont in *A Talent for Murder* and shared top billing with Rex Harrison in *The Kingfisher* and *Aren't We All?* She performed well into her eighties and continued to captivate audiences with the cool style that had made her screen performances so delicious. In *Aren't We All?* she wore a silver-beaded black chiffon gown slit up one side to reveal the famous hitchhiking leg, which critics found the only alluring attraction in a play that was otherwise a flop. "To speak of her as 'well-preserved,'" wrote Frank Rich, the *New York Times* theater critic, "would be an insult—for, unlike so many seemingly ageless Hollywood stars who come to Broadway, she doesn't look like a cosmetically retouched publicity photo; everything about her remains supple and expressive."

For Colbert, her resurrected stage career was the most satisfying period of her five-decade professional life. "After a night of playing to an audience," she said, "I have a sense of

fulfillment which I never had with a day's work on the screen."

✻

"I never had an inferiority complex. I always knew I would get along, whatever I did," Colbert once said.

She spoke truly; never did a woman's on-screen image mirror her own character more accurately than hers did. The sophistication and self-reliance she brought to her roles were native to her personality. And her wit was as quick as any dialogue ever written for her. "Charlie Brackett, who cowrote *Midnight* and *Arise, My Love,* was a great friend of Claudette's," recalls Leonora Hornblow, whose husband, Arthur Hornblow, produced both films. "He was a part of her social group. Those two movies in particular were reflective of her way of talking and her humor."

NO MATTER what age, she always projected youthfulness.

Her own one-liners were often more acerbic than anything written for her. She was once at a cocktail party when someone was babbling on far too long. She leaned forward to a friend standing next to her and said, sotto voce, "When you're born dumb, it's for a long time."

Another time she was staying with her friend Peter Rogers at his Fire Island beach house when she was recognized by a brassy local woman as she and Rogers were entering a tiny grocery store next to the marina. "The woman was ecstatic and told her how much she enjoyed her films," says Rogers, who met Colbert when she posed for Blackglama Fur's "What becomes a legend most" ads. "Of course Claudette was very gracious to the lady. The next day we were in front of the store again, and we heard this voice calling from a huge yacht, and it's the same woman: 'Miss *Col-bert,* Miss *Col-bert,* please come see my yacht. I want you to meet my husband.' Claudette looked up and in her frothiest tone said, 'You're beautiful, your husband's beautiful, your yacht is beautiful, and we're late for lunch.'"

Like her film characters, being a lady had a lot to do with being Colbert. She was well versed in politics, world affairs, and art, and she was by nature curious about the world around her. She enjoyed people and loved to have a good time; laughter was a major part of her life. And, according to friends, she was the least self-obsessed star they knew. "She was the only one I ever met who was genuinely interested in who the other person was," says Rogers, who saw more than his share of star behavior as the mastermind behind Blackglama's celebrity campaign.

But in her own self-contained way she had a keen sense of her stardom and quietly reveled in it. Rogers remembers going to the theater with her in New York and catching a glimpse: "At intermission I asked her if she wanted to

go have a cigarette, which she usually did. This time she said no. At that moment, Rex Harrison, who happened to be in the audience, walked up the aisle and the room burst into applause. Without missing a beat, Claudette turned to me and said, 'Perhaps we will have that cigarette.'"

Behind the delicacy and finesse, of course, was a steel will and terrible temper. "She was bossy and controlling, but that was a result of her having had to be independent all her life. She never had anyone to lean on," says Leonard Gershe.

Jack Pressman's death in 1968 put Colbert's resilience to the test. Just after retiring from UCLA Medical School at age sixty-seven, he was diagnosed with liver cancer; three weeks later he was dead. Colbert was shattered. The couple had recently sold their house in Holmby Hills with plans to move to Bellerive, their two-hundred-year-old plantation house in Barbados. For the first time in her life Colbert was adrift. She moved into an apartment in Los Angeles but found living there without Pressman too painful. She took a flat in Paris, but soon realized her roots were really in New York and that ultimately, Bellerive, the paradise she'd begun to create with Pressman, was her home. Until her death she divided her time between the two.

Except for her occasional emergence to do a play, Colbert spent the next three decades enjoying a life of quiet but far from reclusive celebrity. The role she enjoyed most was playing hostess at Bellerive to her "family of friends." There she entertained in a style that would have impressed any legendary hostess on the international social circuit. In addition to her close circle of regulars, she entertained a cast of luminaries that included President and Mrs.

Ronald Reagan, Frank and Barbara Sinatra, and William F. Buckley and his wife, Pat. "She entertained with such lightness and grace," remembers Peter Rogers. "She struggled to do it right because she was a perfectionist, but when it was finally done, it was with great ease."

The Colbert chic naturally carried over into the decoration of her homes, which she did without the help of a professional. And her instinct about interior design was as keen as her instinct for clothes. Colbert's involvement wasn't limited to choosing fabrics and furniture. She was hands-on, turning herself into painter, carpenter, and upholsterer. If a room needed painting, she mixed the color herself to ensure that it was right. When a valance had to be made for a bed, she got out the staple gun and stapled the fabric. As for furniture, she would have a cabinetmaker create pieces from her own design.

"Claudette was very accomplished," recalls Helen O'Hagan. "She could cook and sew. She was a very good portrait painter and a first-rate athlete. She was a tennis player, an excellent horsewoman, a swimmer. When filming *I Met Him in Paris* in 1936 on location in Sun Valley, she did all the ice-skating for the film, but she had to have a double for the skiing. This aroused her interest in the sport, so she took lessons, and was soon on the California ski team."

Colbert's greatest off-screen accomplishment might well have been her ability to age gracefully. Athleticism was indeed part of the secret to her ageless beauty. She swam twice a day until a stroke in 1993 confined her to a wheelchair. Her physical allure from the beginning was based on naturalness, and her beauty regime was dedicated to retaining that quality. She did stretching exercises daily to keep her

body limber. She attributed her unlined face to never having tanned; she protected herself against the tropical sun by wearing full stage makeup. Instead of dieting, she ate three sensible meals a day and managed to maintain her weight at 108 pounds all her life. She told friends that her recipe for a long and happy life consisted of a vodka a day and one vitamin pill. "When I met her she was already in her late seventies," recalls Peter Rogers. "She could have passed for late fifties. She looked great without makeup. She had an incredible body and still wore a bikini."

⁂

Claudette Colbert was often asked by interviewers why she hadn't joined the legion of stars who had written their memoirs. Her reason was the ultimate irony: "I've had a lovely life. I've been blessed. The only bad thing is that my husband died much too soon. When I went on stage, I had success; when I went on the screen, I had success; when I got married, I had success. Well, my first marriage wasn't too successful. But my life has been wonderful, and for a book I think you have to have had a lot of trouble or a lot of sexual activity. Maybe I'm wrong, but I'm afraid mine is not the kind of life that sells books."

Over time her answer to the question was more dismissive: "I did this picture. I did that picture. I went skiing. Then I did another picture. Then I went swimming. And I was happily married. Who gives a damn?"

COLBERT IN 1978, age seventy-three.

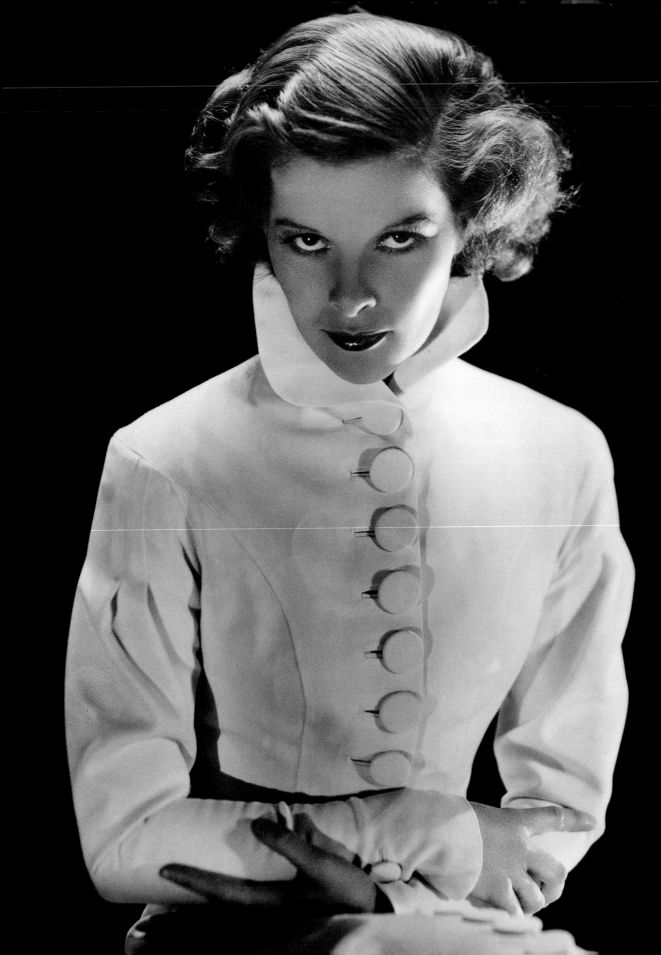

Katharine Hepburn

Of all the characters Katharine Hepburn portrayed in her long career, none suited her as well as Rosie Sayer, the blindly courageous shipmate of Charlie Alnutt (played by Humphrey Bogart) in John Huston's version of the forgotten C. S. Forester novel, The African Queen. In this film, Hepburn was a moralizing scold as well as an adventurer—not unlike the woman herself when she's far away from the klieg lights.

"Nature, Mr. Alnutt, is what we are put into this world to rise above." This line might well have been Hepburn's motto in real life. Her screen persona and her off-screen character were interchangeable. Every role from her first screen appearance in Bill of Divorcement (1932) is some version of the flinty, rock-ribbed New Englander who, as the decades pass, keeps attracting a new generation of admirers.

Her Rock of Gibraltar attitude combined with her sporty, man-tailored taste in clothes has always given her an air of unstudied glamour. Hepburn, unlike other stars of the thirties glamour era, feels real to us. Given that, it seems impossible to imagine that she felt the need to control her persona, just as her contemporaries did. And yet she did control it.

Hepburn, the Bryn Mawr–educated daughter of a doctor, shaped her image as carefully as her wrong-side-of-the-tracks colleague, Joan Crawford. Her desire for privacy rivaled Garbo's. But unlike Garbo, whose flight from fame was based on a paranoia that had afflicted her as soon as her star began to rise, Hepburn relished her popularity. "I didn't have any desire to be an actress or to learn how to act," she once admitted. "I just wanted to be famous."

She saw Hepburn the woman and Hepburn the star as separate entities. "I'm two people," she once told her friend Douglas Whitney. "There's me sitting here with you, and the other is the actress, and I work hard at it." Both identities were fully realized. As a result she never needed her fame to define who she was as a person. Nor did she think the press and the public had to know who she was in private in order to define who she was as an actress. But this theory was oversimplified and ran counter to her definition of stardom: "I think all good actors are personalities. If they're not, they're not stars. What makes you a star is horsepower."

It was the sheer force of her own personality that made Katharine Hepburn a star. Self-possessed, strong-willed, independent, an indomitable spirit, Hepburn the woman always transcended Hepburn the actress. "I think I'm always the same," she told an interviewer. "I had a very definite personality and I liked material that showed that personality. I never played with a sort of fancy accent of any kind. So was I an actor? I don't know. I can't remember."

It's not hard to understand her confusion. In films as diverse as *Little Women* (1933), *Bringing Up Baby* (1938), and *On Golden Pond* (1981), she has always played determined women. The similarities between the willful characters she played and her own independent life have made her a role model for women.

Very few of Hepburn's admirers have probably been as fortunate as she has. Both her parents were well educated and she grew up in comfortable circumstances. She and her five siblings were raised in an unusually enlightened manner by parents who eschewed the Victorian notion that children should be seen and not heard. The Hepburns nurtured their brood from the beginning with the belief that the first five years of a child's life would determine the development of the individual—very advanced thinking in 1907, the year that Katharine Houghton Hepburn was born in Hartford, Connecticut.

"I was brought up by two extremely intelligent people who gave me the greatest gift that man can give anyone, and that is freedom from fear," Hepburn once told an interviewer. These two people had, according to the actress, "a wonderful point of view toward life."

Hepburn's free spirit was clearly an inherited trait.

Both her parents were radicals. Dr. Hepburn, a noted surgeon, was a pioneer in the field of sexual hygiene and the fight against venereal disease. Mrs. Hepburn, a Bryn Mawr graduate and holder of a master's degree at a time when few women went to college, became a prominent advocate for woman suffrage and birth control.

In conservative Hartford, the Hepburns raised eyebrows with their controversial ideas and their fondness for using public venues to champion their causes. Nor did they shield their children from their activities. As a child, Kate marched in parades and handed out pamphlets with her mother. At home there were open discussions about sex. Much to the consternation of other Hartford families, Dr. Hepburn allowed his children to watch their mother giving birth to a new family member. And her father's favorite place to hold court was in his dressing room where, in the nude, he expounded on the problems of the world.

As a result of her parents' radical politics, the young Kate was taunted by her peers and often had to weather a storm of bricks thrown through the windows of her home by neighbors. Instead of forcing her to retreat, the attacks only made Kate more rebellious. She would put up her fists to anyone who dared to criticize her parents. "It made me determined," Hepburn said in a television interview. "It gave me a nice big chip on my shoulder, so that I thought, I'm going to go out and amount to something."

In an era when girls wore petticoats, ten-year-old Kate cut her hair off, wore boys' clothes, and called herself Jimmy. "Oh, I wanted to be a boy," Hepburn has explained. "I had an older brother and then the two younger ones below me. I was ashamed to be a girl." When she was sent home from school, her mother only encouraged her individuality by informing the teacher that how her daughter dressed was "my concern, not yours."

Regardless of sex, the operative words in the Hepburn household were "toughness,"

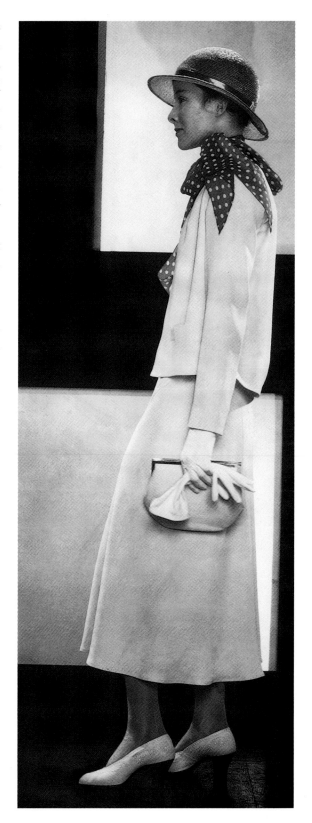

A 1933 fashion layout for *Vogue* magazine.

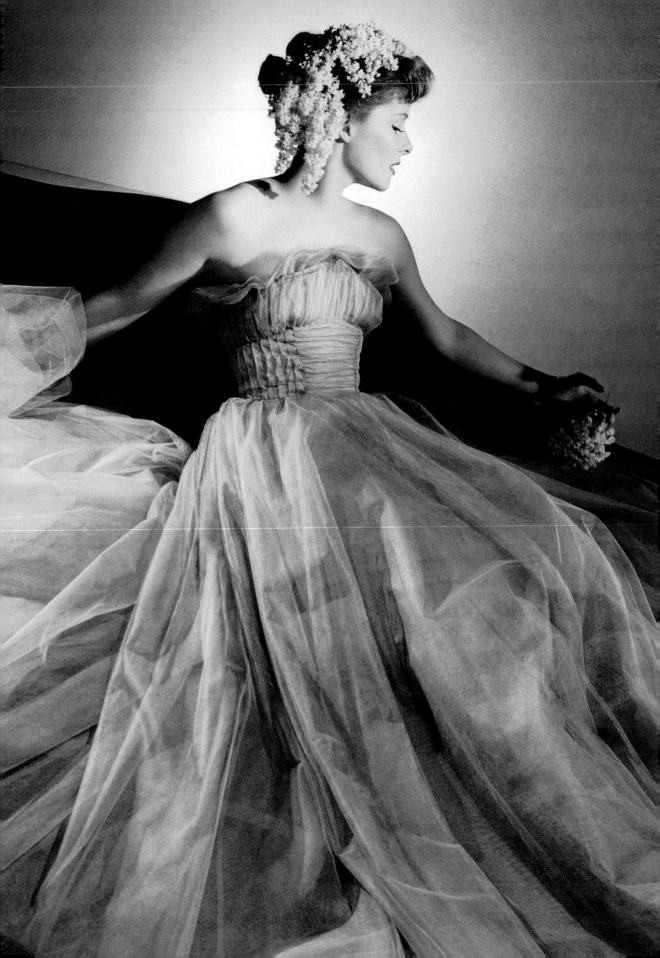

"independence," and "self-confidence." Kate took these values to heart. As a girl, she was a natural athlete who excelled in tennis and golf. And she was fearless. When a neighbor spied her climbing a gigantic hemlock tree, she ran to tell Kate's mother. "Yes, I know," said Mrs. Hepburn. "But don't scare her. She doesn't know it's dangerous."

"Two of the greatest assets for an actress are love and pain," Hepburn once observed. "She must have plenty of both in her life."

At fourteen, Hepburn had her first encounter with pain. While visiting a family friend in New York City, she discovered her sixteen-year-old brother, Tom, hanging from the rafters in the attic of the house. The family refused to believe he had committed suicide, preferring to think he was practicing a magic trick that had fascinated him. For all of her parents' ability to speak openly about controversial subjects, they avoided conversations about emotions and unpleasant experiences. The history of depression and suicide on both sides of the family was kept hidden. After Tom was buried, his death was never mentioned again. "What is past is past," her father announced.

Kate and Tom had been inseparable, and his death caused her to withdraw for the next three years. Privacy became her obsession; alone, she seemed to find solace. She refused to go to high school and finished her education at home. Trying to take her revered elder brother's place in the family, she adopted his birthday, November 8, for her own.

In 1924 the still-grieving Hepburn left home for Bryn Mawr College, located in the

HEPBURN LOOKING very un-Hepburn for photographer George Platt Lynes in 1939.

suburbs of Philadelphia. A change of scenery did nothing to alleviate her antisocial behavior. She was unpopular with classmates and by the end of her sophomore year was failing miserably. In the summer of 1926 she suddenly announced to her family that she wanted to drop out of college and become an actress. Dr. Hepburn, the freethinker, disapproved of a profession that he thought would award her success only if she slept with the directors. He ordered her back to school.

That command forced Hepburn to shed her despair, as did her realization that she would be eligible to participate in school dramatics only if her grades improved. By the spring semester of her junior year she had improved enough to garner the male lead in the annual play—for which she promptly cut off all her hair.

The footlights had an intoxicating effect on her. Offstage she blossomed, and, in reverting back to the daredevil she'd once been, she now became the quintessential collegiate flapper. She bathed nude in the school fountain. She was caught smoking in her dorm. She and a classmate made nocturnal visits to Philadelphia disguised as men. When she visited the home of Ludlow Ogden Smith, a wealthy Philadelphia socialite who would later become her one and only husband, she delighted him by posing naked on the living room sofa while he snapped photos. She liked them so much she took blowups back to campus.

By her senior year, Hepburn was one of Bryn Mawr's premier thespians. After graduating, she did a brief stint with a stock company in Baltimore and then headed for New York to study with Francis Robinson-Duff, a well-known voice and drama coach.

In New York, Hepburn was an immediate

success—but not for her acting. Café society was intrigued by her bohemian style and personality. Even then she dressed in casual, boyish attire—baggy trousers, a faded men's sweater, and a battered felt hat. Instead of wearing rouge or lipstick she scrubbed her face with alcohol until it shone. She wore no jewelry and used safety pins to hide a missing button or to hold her clothing together.

She arrived in New York with only one goal in mind: to be a star. While she quickly landed a series of acting jobs, her lack of training and imperious attitude caused her to be fired from four productions during rehearsal.

Her final theatrical disaster in 1931 had a particular irony. In his new play *The Animal Kingdom*, the playwright Philip Barry had modeled the lead character after Hepburn, the spontaneous, brash, unconventional actress whom he'd met when she was an understudy in his play *Holiday*. At Barry's insistence, Hepburn was given the part in *The Animal Kingdom* but was fired after five days when costar Leslie Howard complained she was too tall. Barry saw her dismissal differently when an enraged Hepburn called him. "Well, to be brutally frank," Barry told her, "you weren't very good."

Hepburn's real problem was that she was just different. She didn't conform to the mannered acting conventions of the day, much less fit the description of what an ingenue was supposed to be. And yet the young woman who seemed to be absorbed in "being herself" was not opposed to reinventing herself if it meant getting ahead.

This was the era of sophisticated comedies with plots that focused on the lives of the wealthy and well bred. In 1928, Hope Williams, who in real life was a New York society girl, had taken Broadway by storm as

the patrician ingenue in *Holiday* who breaks loose from her stuffy family. As her understudy, Hepburn had watched with envy Williams's cool finishing school mannerisms and had set out to cultivate that image. The result was disastrous when she was given an opportunity to replace Williams and struggled to imitate her. Hepburn's delivery of lines that usually sent audiences into peals of laughter was met with deafening silence.

Hepburn's real initiation into the rarefied Park Avenue set came when she struck up a friendship with Laura Harding, the American Express heiress. Poised and urbane, Harding coached Hepburn on the ways of the rich. She toned down Hepburn's mannerisms and got her to modulate her gravelly high-pitched voice to lower tones. By implementing Harding's changes and still retaining her own quirky vitality, Hepburn created a character that the world would come to know in such classics as *Bringing Up Baby* and *The Philadelphia Story*.

After her dismissal from *The Animal Kingdom* she landed the lead in *The Warrior's Husband* on Broadway in 1932. As the Amazon warrior Antiope, Hepburn finally had the opportunity to unleash her earthy, athletic exuberance. Wearing a tunic that revealed a pair of perfect legs, she leaped down a flight of stairs every evening with a stag slung over her shoulders to confront her leading man, whom she wrestled to the floor.

Theatergoers went wild. Hollywood came calling.

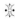

Katharine Hepburn stepped off the train in Pasadena, California, on July 4, 1932, in sweltering heat wearing a Quaker gray-blue silk riding coat with padded shoulders over a ruf-

fled turtleneck and an exceptionally long flared skirt. She accessorized the outfit with dark blue gloves and a blue straw pancake hat. When the agent Myron Selznick saw the skinny, rawboned, freckle-faced client he had yet to meet, he turned to his partner, Leland Hayward, and said, "We got $1,500 for that?"

Hepburn had been hired by RKO Studios to play the role of the sympathetic but strong-willed daughter of a man on the edge of insanity (played by John Barrymore) in *A Bill of Divorcement* under George Cukor's direction. In spite of her aching desire for stardom, she had demanded that her agents negotiate a salary for her that was three times the amount that any other first-time screen actress was paid.

She more than earned it. Her film debut made her an instant star. But even then, the chiefs at RKO didn't know what it was that the public found so electrifying in this ingenue with the boyish body, the brackish voice, and a face that was more angles than curves.

David Selznick, the film's producer, found her sexually distasteful. A studio head labeled her a "cross between a horse and a monkey." George Cukor, who had persuaded Selznick to cast her after seeing her screen test, saw both the flaws and the attractive qualities. "She was gifted at the time," he recalled years later, "and she had the originality that she has, the force, but she had a clumsiness, and she certainly had never been acting in front of a camera."

What Cukor saw was that the camera loved her angular face, and her pale complexion attracted light. What the public and critics admired was simpler: sincerity and the combination of masculine strength with feminine grace. "She is so real, so genuine," raved one reviewer.

David Selznick put his personal feelings aside and offered her a contract. Hepburn's instant success didn't make her any less contrary. After signing the deal, she sailed off for a European holiday without making arrangements with the studio in case it wanted to contact her. By now, the media wanted to know everything about the newcomer. With Hepburn out of reach, a series of conflicting stories circulated. She was a girl of humble origins, she was single, she was married, she had children, she was an "heiress to untold millions," she was an East Coast society girl. The society girl image was exactly the one she wanted to create for herself in Hollywood.

When Hepburn returned to America, she was met at the pier by dozens of reporters eager to know the real story. This was an aspect of stardom for which she had not prepared herself. Kate the extrovert soon became Kate the introvert. She evaded questions about herself and denied facts about her background. "They asked, I thought, idiotic questions—so I gave them idiotic answers," she later explained. "I made up some ludicrous replies . . . and they printed everything! I thought they'd be smart enough to see through my answers, but they weren't. I felt then that the press was my natural enemy."

By the time she began work on her second film, *Christopher Strong* (1933), she had made up her mind to distance herself from the publicity routine that was expected of her. Typically, she set out to create her own rules of conduct and to construct an image for herself. She wanted the public to believe she was a mixture of the young women she portrayed: the ruggedly female pilot in *Christopher Strong*, the wide-eyed aspiring actress in her Oscar-winning performance in *Morning Glory* (1933), and the tomboy Jo in *Little Women* (1933).

WHEN SHE came to Hollywood she wore only skirts until she found a good tailor to make suits for her.

Hepburn controlled the image of the strong but sensitive fresh-faced girl with great care. She struggled to keep every aspect of her personal life hidden. To shield herself from photographers, she never went out to dinner or attended premieres. She didn't even attend the Academy Awards ceremony to collect her Oscar for *Morning Glory.*

"You sell yourself. The part that I sell is the creature. The adorable part," she said with a mischievous giggle in a television interview seven years ago. In her first four roles there were huge pieces of her own character. And yet, at the time, Hepburn was not what she appeared to be. What the world did not know was that she had a husband stashed away in New York—Ludlow Ogden "Luddy" Smith, whom she'd married in 1928. (She divorced him in 1934.) Luddy was her greatest fan and supporter when she was a struggling stage actress. He staunchly supported her decision to go to Hollywood and patiently waited for her return. So total was his devotion to her that when they married he agreed to change his name from Ludlow Ogden Smith to S. Ogden Ludlow because she thought Mrs. Smith and Kate Smith sounded dull.

"I got married to an angel named Luddy,"

she commented several years ago, "who helped me get started. I would say he had a rotten shuffle. I broke his heart, I spent his money." By abandoning Luddy, Hepburn had violated her own moral code. In her own family she had been a witness to her parents' marriage, which was one of mutual devotion both physically and emotionally. Her guilt was further exacerbated when she began a love affair with her agent, Leland Hayward, during the filming of *Christopher Strong*.

But while begging for privacy, she also seemed to enjoy antagonizing the press. She continued to give reporters bizarre answers to stock questions. She purposely distorted the facts of her life. And she was chameleonlike in her dealings with reporters, alternating between being arrogant and playing the good sport.

At the studio she fought with everyone from the producer to the technicians. Here she indulged in what George Cukor described as "sub-collegiate idiotic" behavior. She made bets with the publicity department on whether or not she would grant an interview. She carried a white monkey around the studio lot and tied it to the desks of people she wanted to plague.

The RKO chiefs had hoped Hepburn would be a Crawford or a Dietrich, not a crackpot who insisted upon driving her own station wagon, living quietly, and showing up for work wearing mechanic's coveralls or dungarees. RKO executives stole her jeans when she ignored their warning not to wear them to work. She held her ground: "Unless you give me back my pants," she said, "I intend to walk through the RKO lot naked." To back up her threat, she stepped out of her dressing room in nothing but silk underpants. The studio heads returned her jeans.

These habits, so strange to the studio and to the film colony at large, set a new pattern that would in time be considered accepted behavior for a star.

It is amazing that the studio put up with her shenanigans. Of her first eight RKO films only *Little Women* was a national box office success. Films like *Sylvia Scarlett* (1933), in which she masqueraded as a boy, were too offbeat for the general public; their popularity was limited to New York City.

"Is Hepburn killing her own career?" *Photoplay* asked in 1935. The magazine complained of her eccentricities, her disdain for the press, her craving for privacy. The last, the fan magazine writers thought, was acceptable only for Garbo.

Hepburn's career highs and lows weren't entirely the result of her disagreeable behavior. There were two other problems. In looks, manner, and style, she was the first of her type—always a hurdle. She also experienced the same difficulty as some of her colleagues: rotten scripts.

In fact, the arrogant, willful, independent personality was a buffer against a system in which stars had no power. But unlike many of her contemporaries, Hepburn took risks because she had a foundation: some inherited money, a close-knit family from whom she drew strength, and the knowledge that she could always resume her stage career. All this served her well when she was declared box office poison in 1938.

Ironically, it was three of her best films—*Stage Door* (1937), *Bringing Up Baby*, and *Holiday* (both 1938)—that caused her to be labeled bad news at the box office. They were commercial failures that had, unfortunately, been preceded by four inferior films. With that, she and RKO Studios agreed to part company.

HEPBURN WITH Joel McCrea.

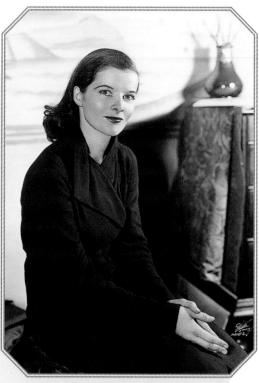

"I DON'T care a rap how I look," she once said,
"though I wash my hair every day."

A 1934 portrait by Steichen.

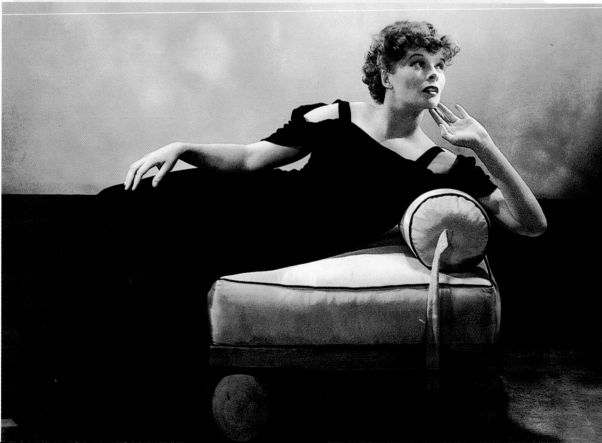

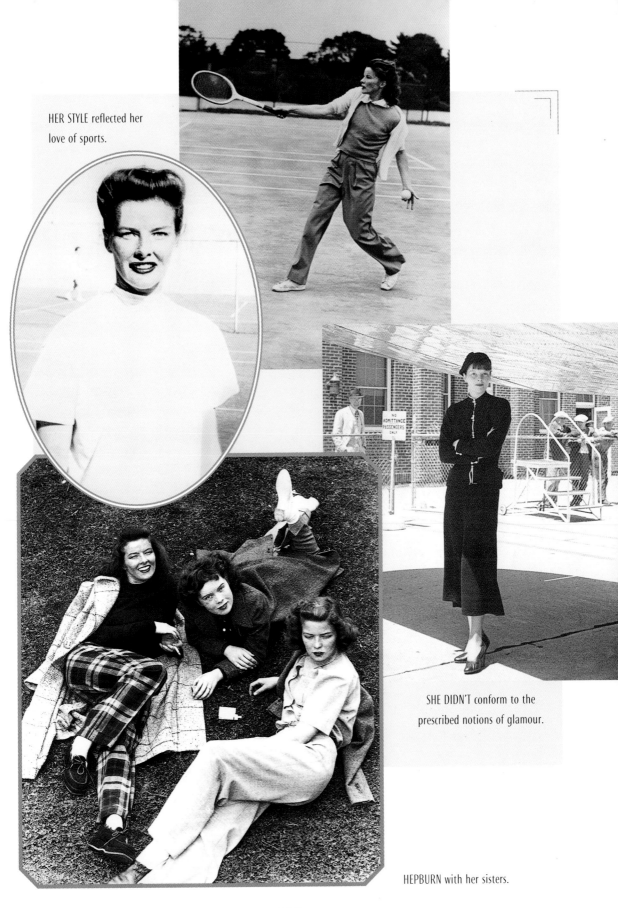

HER STYLE reflected her
love of sports.

SHE DIDN'T conform to the
prescribed notions of glamour.

HEPBURN with her sisters.

197

Hepburn headed back east to Fenwick, the family home where on the stone fireplace were chiseled the words "Listen to the song of life." In the safety of that environment she prepared for battle.

✳

"We're all in a serious spot when the original bag lady wins a prize for the way she dresses," Katharine Hepburn remarked when the Council of Fashion Designers of America gave her its Lifetime Achievement Award in 1986.

For six decades Hepburn charmed America by appearing to be too busy to bother with fashion. And America loved her for that—although she looked and spoke like a patrician, she was down-to-earth, no-nonsense, refreshing. But her anti-fashion posture was not the real Hepburn. It was a role—the greatest and longest-running role she ever played. In fact, she was very much a clotheshorse—an anti-clotheshorse, or a clotheshorse of another color.

How much did Katharine Hepburn care about clothes? Well, at her first meeting with George Cukor to discuss costumes for *A Bill of Divorcement*, she insisted that he hire Coco Chanel to design her wardrobe. He refused. But in that demand was a message as crisp as her

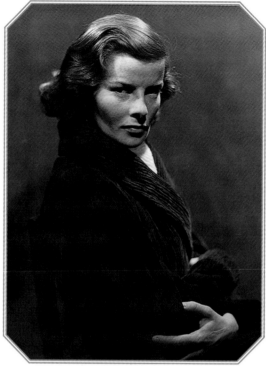

IN HOLLYWOOD she created the image of the wealthy New York society girl.

accent: she never thought she was pretty, but she knew she was smart, and she wasn't going to hide her intelligence behind a sea of frills, furs, and veils.

The bottom line was that Hepburn's angular, bony features and tomboyish body made her the precursor to the lanky runway model. She would have looked sensational in anything. And yet she chose not to flaunt her figure.

In an era of overt glamour, Hepburn represented inverted glamour. Marlene Dietrich had championed trousers because they bathed her in eroticism. Hepburn, on the other hand, favored pants simply because she hated garter belts and stockings and, as she once said, "I like to move fast, and wearing high heels was tough, and low heels with a skirt is unattractive. So pants took over." Her look was rooted in the desire for comfort; at the same time, it could be interpreted as her longing for a low-profile private life.

It was easy to misread Hepburn, to equate her throwaway-chic image with her New England roots. Because she saw, from the beginning, how she could use her clothes as a shield for her driving ambition and steel will, her unstudied look was every bit as orchestrated as Dietrich's high-style image. And, like Dietrich, she knew the impact it made. "I bet it takes us longer to

look as if we hadn't made any effort than it does for someone else to come in beautifully dressed," she once said to Greta Garbo.

Unlike Garbo, who referred to herself as "the little man," Hepburn wasn't confused about her sex. When the occasion called for it, she knew how to dazzle a crowd in more than just gabardine. Once, in 1947, she was chosen to be the opening speaker for Henry Wallace, the Progressive Party presidential candidate, at a rally in Los Angeles. For that entrance, she swept across the stage in a flaming red dress that emphasized all the right contours. When she had to convince Louis B. Mayer to make *Woman of the Year* (1942), she wore high heels to the meeting so she would tower over the mini-megalomaniac.

Though Hepburn will be remembered as a pioneer in the field of "uniform dressing," she packed a wealth of eclectic twists into that utilitarian symphony of beige man-tailored suits. Those touches gave her a Gypsy quality: peaked caps, faded army fatigue jackets, mandarin collars, kimono jackets, oversize men's sweaters, and seriously baggy trousers. "She knew exactly how long her pants were," recalls Noel Taylor, the costume designer she worked with during the last decade of her career. "Her message was, 'I'm simple.'"

Before she starred in *Coco* (1969), the

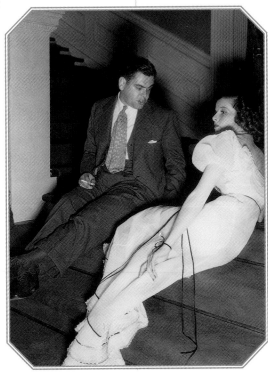

A RARE candid photo of Hepburn at a Hollywood party.

Broadway musical based on the life of Coco Chanel, she went to meet with the formidable designer. "She looked me up, but she didn't look me down," Hepburn said of that first encounter. Though Chanel's look was a far cry from Hepburn's "Civil War veteran's rags," as she called them, these two iconoclasts were in fact kindred spirits. Chanel, like Hepburn, became a fashion icon by swimming against the current and adapting men's fashions for herself and the rest of the world.

✳

Hepburn's self-imposed exile from Hollywood in 1938 couldn't have been better timing for playwright Philip Barry. He presented her with a half-finished comedy he'd written specifically for her. His lead was a Bryn Mawr graduate. She was sharp, socially prominent, and headstrong. The character was Tracy Lord; the play, *The Philadelphia Story*. Even in its early draft, Hepburn saw the script's merits and shepherded the project to completion. Sensing that this was the vehicle to relaunch her Hollywood career, she followed the advice of Howard Hughes, who was then her boyfriend, to purchase the film rights before taking the play to Broadway (Hughes actually bought them for her) so that, when Hollywood stepped in, the studio couldn't detach her from the project.

The Philadelphia Story played to standing room only audiences for one year on Broadway. When the film version was released in 1940 it broke box office records. Hepburn was the film's producer and received her third Best Actress nomination for playing Tracy Lord. (She lost out to Ginger Rogers in *Kitty Foyle*.)

She was back on top again, but she now knew how elusive success could be, so she bankrolled her next script, *Woman of the Year*, which paired her with Spencer Tracy for the first time. Hepburn's Tess Harding character is a beautiful, intellectual newspaper columnist who falls in love with Spencer Tracy's Sam Craig, a craggy sportswriter.

"How can I do a picture with a woman who has dirt under her fingernails and who is of ambiguous sexuality and always wears pants?" Tracy reportedly said before filming began on *Woman of the Year*. As it happened, however, the chemistry between them was so powerful that they made eight more pictures together over the next twenty-five years, five of them in the 1940s alone. The plots invariably focused on the attraction of opposites and the battle of the sexes.

The Tracy-Hepburn combination was irresistible to critics and audiences. Hepburn's character was always refined, eager, idealistic, and frenetic. Tracy was always the common man—cynical, deadpan, unhurried. "I think we represent the perfect American couple," she once said of their professional partnership. "I needle him, and I irritate him, and I try to get around him, yet if he puts a big paw out, he could squash me."

For the next twenty-five years they would also act out their own version of this relationship off-screen. He was lazy, she was hyperkinetic. He was a staunch Republican, she was a die-hard liberal. She thrived on adventure, he preferred sameness. Just as in their films, they were total opposites. The real-life version, however, was considerably messier.

Tracy, an Irish Catholic, was married and had two children. He had moved away from his wife, Louise, years before meeting Hepburn and had had affairs with several of his leading ladies. But he still remained emotionally attached to Louise and was ashamed that he'd left her to care for their daughter and deaf son. Divorce was out of the question. These circumstances only added to Tracy's burden of having been born with an oversensitivity to life. Troubled, insecure, guilt-ridden, he sought relief from his pain in alcoholic binges.

And yet, from the moment Hepburn stepped onto the set of *Woman of the Year*, she found Tracy irresistible. Why she was so drawn to him was a mystery to all those who knew her. Talent, for one, is a huge aphrodisiac. "He was a great actor—simple," she wrote in her memoir, *Me*. "He could just do it. Never overdone. Just perfection. There was no complication. The performance was unguarded.... Spencer Tracy was like a baked potato . . . he was very basic as an actor. He was there skins and all in his performances."

Hepburn writes that she was also attracted to his humor. "He was Irish to his fingertips. He could laugh and he could create laughter." On the surface it might have seemed that she had finally met her match with Tracy. He too was as sharp as a blade, and he wasn't intimidated by her. Ultimately it was his complexity, his vulnerability, and his inability to protect himself emotionally from the difficulties of life that touched her to the core.

Hepburn's love for Tracy inspired her to do something she'd never done before. She was

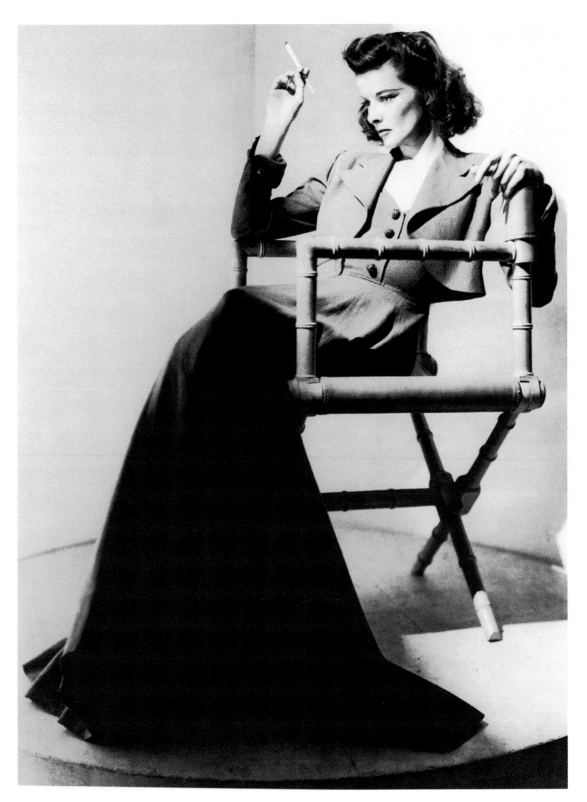

POSING FOR George Hoyningen-Huene in 1940.

willing to suppress her defiant, opinionated personality to please him. To friends and colleagues it was both baffling and painful to see this autonomous woman being subservient to a man who appeared to show no gratitude or affection. He was openly critical of her and seemed to enjoy putting her down in front of others. And yet this most unconventional woman cared for him in the most conventional ways. She catered to his every domestic need. Just in case he might need her when he went on a binge she would sleep outside the hotel room while he drank himself into unconsciousness behind a barricaded locked door. She centered her professional life around his work schedule.

"What does the word 'love' mean? It means total interest," Hepburn explained to Barbara Walters in a 1991 interview. "And total interest means that if things get tough with the object of your love and it doesn't agree with you, you shift your position and fix it so that it works. I think the reason that very few people really fall in love with anyone is that they're not willing to pay the price."

The price she paid was to accept the fact that she was the other woman. Then again, her willingness to live in secrecy for nearly three decades somehow suited her intensely private

"I LIKED to look as if I didn't give a damn."

nature. Their on-screen teaming made them great copy, and though the press alluded to a close personal relationship, their love affair was never turned into a news story. Hepburn describes her twenty-seven years with him as absolute bliss. "I had everything I wanted," she told an interviewer shortly after the publication of her memoirs.

On-screen the world watched these two enigmatic stars grow old together. Their final film was *Guess Who's Coming to Dinner* (1967), in which they play an upper-middle-class couple whose daughter announces that she's engaged to a black man. As Tracy and Hepburn wrestle with the issue of interracial marriage, the audience witnesses the story of an older couple whose love has grown more intense with age. Though the film itself is hopelessly outdated, it now stands as a poignant metaphor for their own off-screen relationship. Tracy died two weeks after finishing the movie. Hepburn won her second Oscar.

Hepburn was now sixty. Most of her generation of actresses had either retired from the screen or, like Bette Davis and Joan Crawford, been relegated to playing harridans or eccentrics. But she flourished. She went on to play meaty roles like Eleanor of Aquitaine in *The Lion in Winter* (1968), for which she won

another Oscar. Her later success was due in part to the fact that by the mid-1950s she had willingly sacrificed her vanity to play her age. In that decade and on into the 1960s she played everything from spinsters (*The African Queen, The Rainmaker,* and *Summertime*) to a devouring matriarch (*Suddenly Last Summer*) to a drug-addicted mother (*Long Day's Journey Into Night*). In later years she was often miscast, but unlike other actresses of her generation she seized every opportunity.

Was she a great actress? That question has always been debated. "Whether what Hepburn does is acting in the strict sense of the word," Kenneth Tynan, the film and theater critic, wrote in 1952, "I do not know; but whatever it is, and wherever you are sitting, you cannot deny the throb and the urgency of that magnificent pulse."

Her style was never free of mannerisms: the brave eyes that moisten up but never brim over with tears, the fluttering of hands, the crackly patrician voice, the overdrawn New England accent, the laugh that is a little too raucous. And yet through these affectations she always conveyed the pulse of life. And that pulse came from the woman herself. Her virtues, her beliefs, were always projected on the screen. And what we see is not an adaptable actress but rather a versatile woman. Her interpretations were always a noble blend of resilience and frailty, straight-from-the-shoulder tomboyishness mixed with womanliness, intelligence, wit, courage, and empathy—all the qualities she embodied as a woman. And although she was intensely private, audiences have always felt they knew her. "If you lead a public life," she told a reporter in 1969, "people are much more on to you than you think."

That extra undefinable something in Katharine Hepburn's personal style will continue to influence and inspire women. We'll study photos of her in trousers and a crisp white shirt buttoned high at the neck, heavy walking shoes, her hair either loosely falling to her shoulders, as it did in the forties, or precariously piled on her head à la concierge, as it was in later years. And, feeling that her chicness and style are attainable, we'll create our own versions of her look.

But Hepburn's legacy is more than a look. It's something that goes beyond the ephemeral world of fashion. Great style is ultimately a result of great content; it's the woman inside those clothes we admire and will continue to revere. That woman is someone we've come to know well: fiercely independent, always keeping her own counsel, with a code of ethics based on discipline, honesty, and simplicity. Her look was thus a window into a purity of spirit; after those dress-down togs helped make her famous, they became a true expression of her character.

Imitating the Hepburn look—any designer could do that. But it would be more difficult to knock off the inner qualities that made whatever she wore look sensational. As her style was all about individuality, any clothing advice she would have imparted to us would have been so utterly practical that it would have doubled as a lesson in living.

I can see her now, chin up, eyes flashing, tendrils of hair framing her features. And, though she is out of the public eye, I can hear her say something like "Be yourself, it's a tough act to follow." After a dictum like that, it would be shallow to pay much attention to something as unimportant as her clothes.

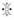

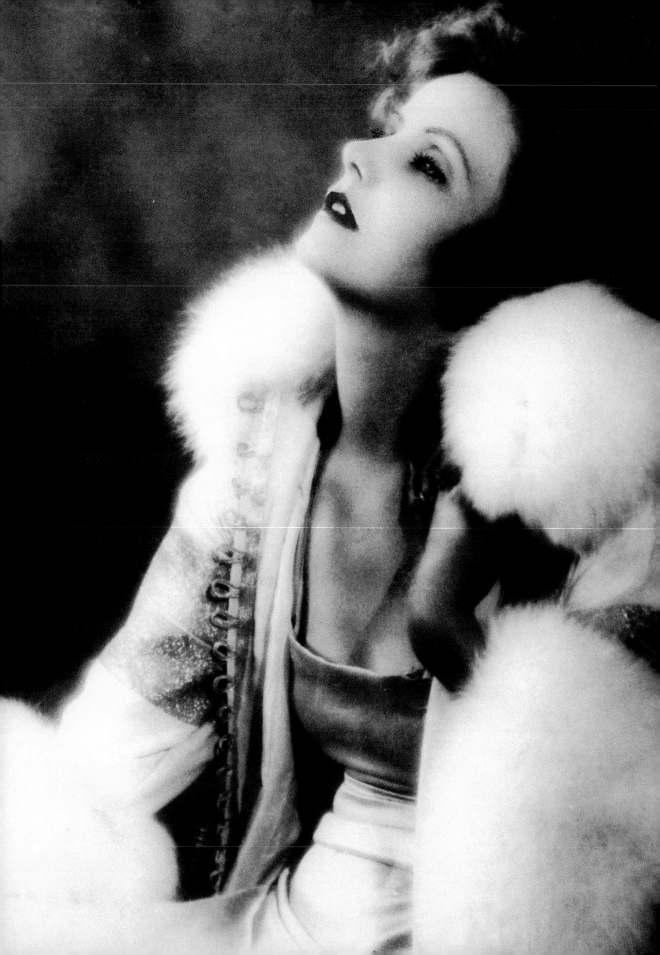

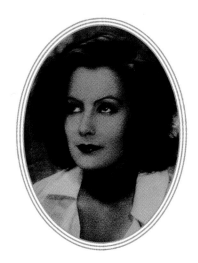

Greta Garbo

"There will never be another Garbo," Greta Garbo told her great-niece. The Divine One uttered that immortal line in response to a magazine article that touted a new actress as the next Garbo. "No, there will never be another Garbo," she continued. "I'm different inside."

How the world's most enigmatic screen star was different has been analyzed and dissected since 1926, when she arrived in Hollywood under contract to MGM. Seven decades later she's still an enigma. No matter how many photographs you see of her or how often you've watched her films, looking at Garbo is like looking at the Mona Lisa. Garbo's face haunts you, holds you. Her beauty put her in a class by herself. And that in a way is symbolic of who she was— a solitary creature who by all accounts felt like an alien visitor, unsure of her place on earth.

But although she had no use for the town that made her a star, she was, whether she liked it or not, in a colony for other aliens not so unlike herself. Hollywood was then, as now, a mecca for beauties from impoverished backgrounds with unformed personalities. And yet Garbo was different.

Hollywood was a long way from the four-room cold-water walk-up apartment in Stockholm where Greta Gustafsson was born in 1905. Her father worked as a laborer for the city, tending to its trees and streets. He suffered from poor health, was prone to frequent depressions, and drank heavily. Her mother was a robust woman of peasant stock who admonished her father for his failures.

Greta left school when she was fourteen to work in a barbershop and then later secured a job modeling hats in a department store. Her first ambition was to be a model; in spite of her shyness, her inhibitions apparently vanished before a camera. Somewhere along the way she thought acting might be her calling and enrolled in Stockholm's Royal Dramatic Theater Academy. Her life seemed fairly unpromising until Mauritz Stiller, an esteemed Swedish director who loved to cast fresh talent in his films, offered her a starring role in *The Saga of Gosta Berling.* The film's success led to the name change to Garbo, which had an international ring of mysterious origin, and an opportunity to go to Berlin to appear in *The Joyless Street* (1925), directed by G. W. Pabst, the noted German filmmaker. After seeing *Gosta Berling*, Louis B. Mayer enticed the Swedish actress to come to Hollywood with a $400-a-week contract—an unheard-of sum for an unproven actress.

When she arrived in Los Angeles on September 10, 1925—ten days shy of her twentieth birthday—she was an "unretouched Swedish dumpling." There was the hint of a double chin, her hair was frizzy, two front teeth overlapped and were slightly protuberant. She was five feet seven, and her rangy frame—broad square shoulders, straight hips, flat chest—still had its baby fat. At a time when the public admired the diminutive silhouettes of Mary Pickford, Lillian Gish, and Gloria Swanson, Garbo was a big girl.

The MGM publicity department employed its typical cheesecake promotional routine for building a star. To the studio, "Swedish" meant outdoorsy and athletic. So Garbo posed with the USC track team, in a swimming pool, and on horseback. She went along with it, but all the while she was observing.

While waiting for her film debut, she visited the set of a Lillian Gish movie. Not only did she absorb Gish's professional ability, but she was also impressed by the way MGM's most prestigious star shunned the publicity nonsense. When Garbo told her of the undignified photo shoots, Gish advised her to refuse to do any further stunts, which she did.

The publicists weren't thrilled with their efforts anyway. They failed to see what all the fuss was about. For that matter, Garbo's appearance had stymied studio chiefs; her first film test had failed to inspire anyone.

Irving Thalberg, MGM's head of production, ordered her to go on a diet. Her teeth were straightened, and her bushy hair was smoothed out into a glistening bob. The heavy eyebrows were thinned and shaped into distinctive arches. It was, in the grand scheme of things, a mild transformation. Once the baby fat was off and her hair was pulled back to give

her face a lift, what remained was quite possibly the most perfect bone structure ever bestowed on a human being.

Garbo's face was so well proportioned that for years plastic surgeons proclaimed it the hallmark of perfection. The space between her eyes was the width of one eye. Her nose length was one-third the distance from the hairline to the chin. Her lower lip was slightly fuller than her upper lip. In addition to balance, Garbo was blessed with eyelashes so long and thick that in photographs they look false (when not coated with mascara they were practically white). She had luminescent skin and, though audiences never saw the color of her magical eyes, they were a translucent grayish blue.

After the makeover, Lillian Gish came to Garbo's rescue once again. She suggested a second screen test by a European cameraman who was a master of soft-focus effects. When studio executives viewed the footage, Garbo was immediately rushed into *The Torrent* (1926).

This film did not bring instant success, perhaps because the plot had Garbo playing a peasant girl who becomes a celebrated opera singer and courtesan. Director Monta Bell was so confused about how to use Garbo that he had her character go through several personality evolutions. The result was a series of quick glimpses of the Garbo that the public would ultimately know—a soulful vamp, a fatalistic beauty. But what the film illustrated was that her magnetism alone could transcend flat material and suggest something deep.

"They don't have a type like me out here," Garbo wrote home in 1926, "so if I can't learn to act they'll soon tire of me, I expect."

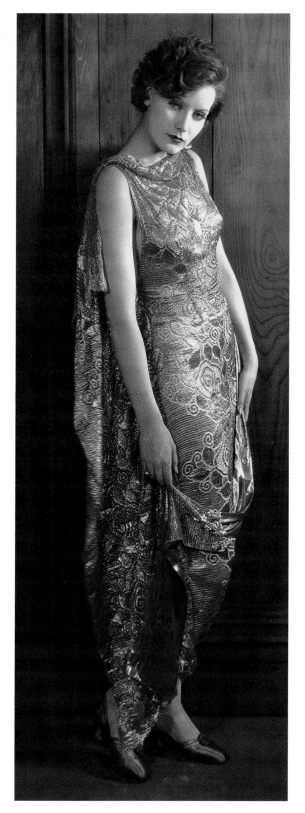

GARBO IN *Flesh and the Devil*, 1927, the film that established her as a sex symbol.

The young woman who was soon to be the world's most enigmatic film star was dead right: MGM wasn't sure what to do with her.

Studio executives later claimed they saw her magnetic quality in the rushes. But only when the critics found her appealing did Mayer put his seal of approval on her. One writer noted that Garbo had a "surprising propensity for looking like Norma Talmadge, ZaSu Pitts, and Gloria Swanson in turn." Another wrote that "she suggests a composite picture of a dozen of our best-known stars. . . . She is not so much an actress as she is endowed with individuality and magnetism."

The studio rushed her into another picture, *The Temptress* (1926). With this film, American moviegoers saw a new type of actress. They saw more than just her spellbinding beauty. The public was captivated by her physical proportions and the way she used her body. Her entrancing walk, always leading with the hips and shoulders, was fluid and seductive. For the first time audiences saw on the screen a body that was not entirely feminine in form. She had an androgynous physique that, in motion, had an erotic naturalism.

She also changed the existing notion of screen acting. Unlike her contemporaries, she was not animated; she was able to convey the whole gamut of emotions without, it seemed, doing much of anything. The feelings were all there instinctively in her eyes, in her face.

MGM now decided on a "type" for her: a vamp. Nothing extraordinary in that persona. The vamp as portrayed by Theda Bara, Pola Negri, and Gloria Swanson was seductive, passionate, and immoral. But Garbo's interpretation was different. She conveyed a beatific, suffering soul who was both moving and sexually provocative. For the first time audiences were sympathetic to a woman who sinned and caused men to suffer. Garbo revolutionized the vamp. In her, audiences saw a woman whose transgressions were a result of weakness rather than sheer lust.

Her third film, *Flesh and the Devil* (1927), in which she costarred opposite John Gilbert, the leading heartthrob of the silents, reinforced her image as a new kind of sex symbol. The movie was yet another potboiler, with Garbo playing a cool enchantress who falls in love with an army officer, played by Gilbert; while he's away, she marries his best friend, then resumes the affair with Gilbert when he returns. The horizontal love scenes between Garbo and Gilbert—with Garbo on top—transfixed audiences. "She becomes a symbol of sexual appeal rather than any particular bad woman," noted a National Board of Review critic at the time.

Sheer talent wasn't the primary element behind her performance. The chemistry between Gilbert and Garbo was also happening in real life. "When they got into their first love scene, nobody else was even there," Clarence Brown, the film's director, later recalled. "Those two were alone in a world of their own. It seemed like an intrusion to yell 'cut!' I used to just motion the crew over to another part of the set and let [Garbo and Gilbert] finish what they were doing. It was embarrassing."

Nothing would have thrilled the MGM publicity department more than to have Garbo and Gilbert, the studio's hottest male star at the time, tie the knot. It would have fed all the most delicious fantasies for a moviegoing public that thrived on the off-screen romances of their favorite stars. Sadly, the experience for

DESIGNER ADRIAN took her off-screen look and stylized it for film, as seen in this still from *Wild Orchids*, 1929.

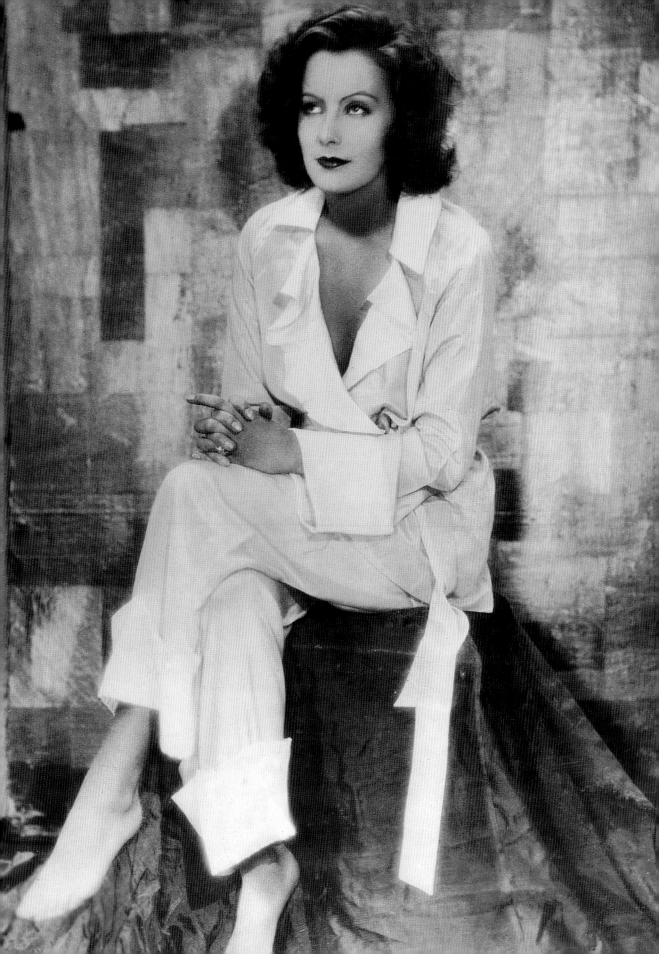

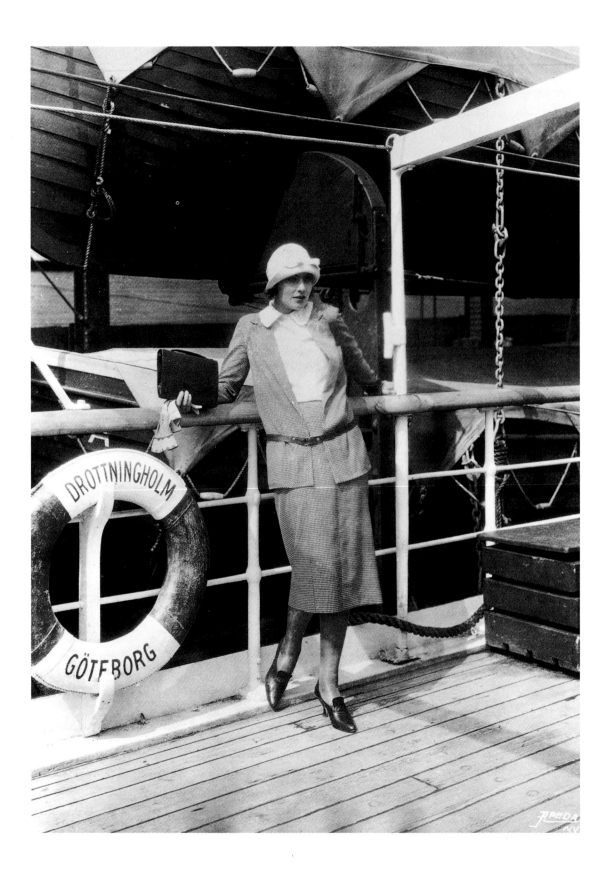

Gilbert was as torturous as the role he played in *Flesh and the Devil*, for Garbo was as unconquerable in real life as she was on the screen. Twice she ditched him at the altar. (Garbo's love life would forever remain a mystery. Over time, she had several homosexual boyfriends—Cecil Beaton, who claims to have bedded her, and nutrition guru Gaylord Hauser among them. Mercedes De Acosta claimed in her memoirs to have had a lesbian relationship with Garbo. Her most enduring relationship was with George Schlee, a millionaire businessman, whose dress-designer wife, Valentina, dressed Garbo during the mid-1940s.)

Flesh and the Devil was a huge hit, and it set a pattern for Garbo films. For the rest of her silent career and for a great part of her sound career, she would be a woman caught in a triangular relationship. She and Gilbert would star opposite each other in two more silents, *Love* (1927), which was a modern-dress adaptation of *Anna Karenina*, and *A Woman of Affairs* (1928). Five years later Garbo requested, and got, Gilbert for *Queen Christina* in an attempt to revive his career, which had been destroyed by sound.

Garbo made eleven silent pictures and was one of the last stars to plunge into talkies. She appropriately christened her sound career in 1930 with *Anna Christie*, based on Eugene O'Neill's play about a Swedish-American prostitute who tries to settle down with a sailor she's rescued from a storm.

"Garbo talks," proclaimed the billboards for the film. Fans and skeptics waited in suspense to see if her silent-screen allure was merely a result of some photographic trickery. As it happened, the voice matched the face.

GARBO'S ARRIVAL in America, 1925.

Audiences heard a voice that was as deep and resonant as her beauty. In the same way that she was able to convey soulfulness with just the slightest hint of movement in her eyes, she could turn the most ordinary line into something profound by changing the timbre of her voice. In *Camille* a friend warns her not to go to Moscow in winter for she will certainly die. "We all die," she replies.

Anna Christie was a huge hit. Though she made fewer films than Joan Crawford and Norma Shearer, the two other major MGM stars, Garbo dominated the studio during the thirties. Nothing was spared to further enhance the legend of the woman whose fans were called Garbomaniacs. The best directors, cameramen, and screenwriters were assigned to her productions. The sets were the most luxurious. As for her costumes, only the finest materials were used. Her jewels were either real or were museum-quality reproductions. "She is like a tree with deep roots," observed Adrian during the thirties. "You must never put artificial jewels or imitation lace on Garbo. Not that it would be noticed on the screen, but it would do something to Garbo and her performance."

The woman who made such an impact on the public in 1926 was not initially a screen clotheshorse. In her first six silents, she was heavily costumed in velvet, ermine, and lamé in a way that reminded filmgoers of that other silent-screen vamp, Gloria Swanson. It wasn't until *A Woman of Affairs* in 1928 that audiences saw a style that was a reflection of the woman herself. The genius behind the image was the costume designer Adrian, who designed the clothes for seventeen of her twenty-four American films. For him, Garbo had the ideal figure:

AN EARLY publicity shoot with the USC track team.

WITH ADRIAN, the MGM costume designer.

A RARE paparazzi photo of Garbo attending a film premiere with actor John Gilbert, 1927.

"THEY DON'T have a type like me out here," she wrote home in 1926.

A CANDID moment in Cecil Beaton's garden in the fifties.

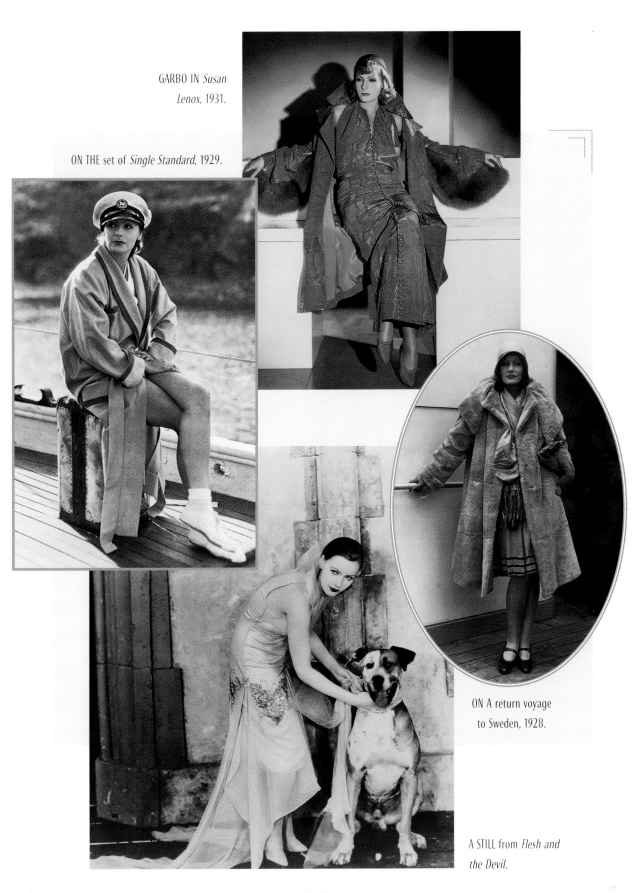

GARBO IN *Susan Lenox*, 1931.

ON THE set of *Single Standard*, 1929.

ON A return voyage to Sweden, 1928.

A STILL from *Flesh and the Devil*.

square shoulders with straight hips that were proportionate to her waist. He also saw that in real life she wore man-style clothes and had a preference for hats. He seized on this look, feminized it, jazzed it up for the screen, and turned it into a style that would make Garbo a perennial fashion influence.

For *A Woman of Affairs* he put her in an oversize wool trench coat with an ascot, and he designed a cloche hat, which she wore turned up at the front. That hat soon came to be known simply as "the Garbo." In the next two silents he established the Garbo look. For *Wild Orchids* (1929) he showcased her in men's oversize silk pajamas. And several years before Marlene Dietrich began making waves in her all-white man's suit, Adrian put Garbo in white trousers, white ankle socks, sneakers, and a V-neck sweater for *The Single Standard* (1929). For that film she also sported butch-femme outfits, like a man's dressing gown with a white yachting cap. Looking at stills from this film today, it's remarkable to see how far ahead of their time these outfits were and how seventy years later they're still novel.

Garbo was as apathetic about clothes as she was about her stardom. "I care nothing about clothes.... When I am off the set I don't want to have to think of clothes at all.... I like to live simply, dress simply," she once said. And yet, like her personality, her manner of dress was a contradiction in terms. Her trousers, her trench coat with its turned-up collar, and her slouch hat shrouded her in mystery. But while she used her clothes to shield herself from the public, she also wanted to camouflage what she didn't like about herself. Garbo was self-conscious about her body. Though she weighed only 126 pounds, she thought of herself as large and ungainly.

Unlike Dietrich, who was nattily dressed in her masculine threads, Garbo's look was thrown together. "She had a taste for bulky, ugly clothes," recalled Joe Ruttenberg, the cameraman on *Two-Faced Woman*, "that made her look much older than she was. It was like she couldn't stand to look beautiful, she only felt comfortable frumpy." Garbo's uniform was, for the most part, an old pair of slacks, a turtleneck sweater, men's socks, and brown loafers so clunky that Hedda Hopper commented she had huge feet. In fact, she wore only a size seven.

By 1930 the public had picked up on her off-screen wardrobe. When she was photographed walking down Hollywood Boulevard wearing trousers, the headlines shouted "Garbo in Pants!" and women began to raid their husbands' closets. She created a sensation when she attended a film premiere wearing a beret, a sweater, and a tweed skirt. Suddenly the beret, like the trench coat, was a hot-selling item. And because of Garbo, the turtleneck became a classic. "If she liked a thing," Adrian once told Hedda Hopper, "she wore it with complete unconsciousness. No matter how eccentric it was, she gave it an air of authority."

"What when drunk, one sees in other women, one sees in Garbo sober," wrote Kenneth Tynan, the late film critic and historian. It wasn't just her clothes that millions of women embraced. Garbo's face had a greater impact on the public and on her peers than that of any other actress before or since. Off-screen she wore very little makeup—pencil to darken her nearly white eyebrows, a touch of lipstick, a dash of powder. Except for the famous darkened crease in her eyelids and the eyeliner, on the screen her face didn't require much more than what she used in real life. Store man-

nequins began to resemble her. Joan Crawford, Katharine Hepburn, and Marlene Dietrich were all influenced by her straight hair, minimal makeup, and thin eyebrows. In the real world everyone from models to office girls copied her shoulder-length bob, tried to imitate her eye makeup, and donned long fake eyelashes.

She altered the appearance of an entire generation, but the majority of the movies she made during her sound career made it difficult for her on-screen clothes to be a mass fashion influence in the way Joan Crawford's were. Because of her accent, she was always cast as a European in an exotic locale, as in *Mata Hari* and *As You Desire Me.* And many of her films were period costume dramas like *Queen Christina, Camille,* and *Romance.* Though the clothes in these films couldn't be easily adapted for contemporary women, fashion designers took pieces of them and turned them into trends. The stiff white collar Garbo wore in *Queen Christina,* for example, created a minor fad and was sold in Macy's Cinema Shop. The long-sleeved, high-necked gowns Adrian created for her because she didn't like showing her cleavage also became fashionable. But Garbo's real influence during the 1930s was in millinery. The skullcaps she wore in *Mata Hari,* the white panama hat in *Camille,* the Empress Eugénie hat in *Romance,* the

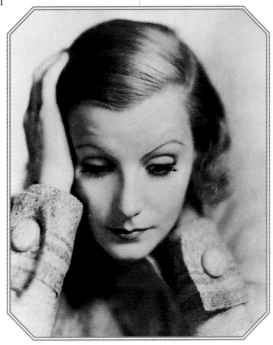

SHE KEPT a print of every picture taken of her at photo sessions.

turban in *The Painted Veil,* and the peaked hat in *Ninotchka,* which Garbo designed herself, were all major fashion trends.

Considering her influence, it's ironic that a key factor in the failure of her last film, *Two-Faced Woman* (1941), was her appearance. Adrian designed fourteen breathtaking gowns for that film, but the studio refused to let her wear them. The major profits from her pictures had always come from the European market, which was now cut off because of World War II. MGM wanted to Americanize Garbo and turn the goddess into a sweater girl.

So she was put into low-cut gowns. Sydney Guilaroff, the MGM hairstylist, was ordered to cut five inches off her hair and perm it. The hairdo was then held in place by two diamond butterflies, one on either side of her head. The result was so catastrophic that *Time* magazine called the makeover "almost as shocking as seeing your mother drunk." The only one who had seen the potential for disaster was Adrian, who resigned rather than design plunging necklines for Garbo. "When the glamour ends for Garbo, it also ends for me," he told the studio. "She has created a type. If you destroy that illusion, you destroy everything." For her part, Garbo wasn't so solicitous of the man who had established her as the most glorious screen image of the golden era.

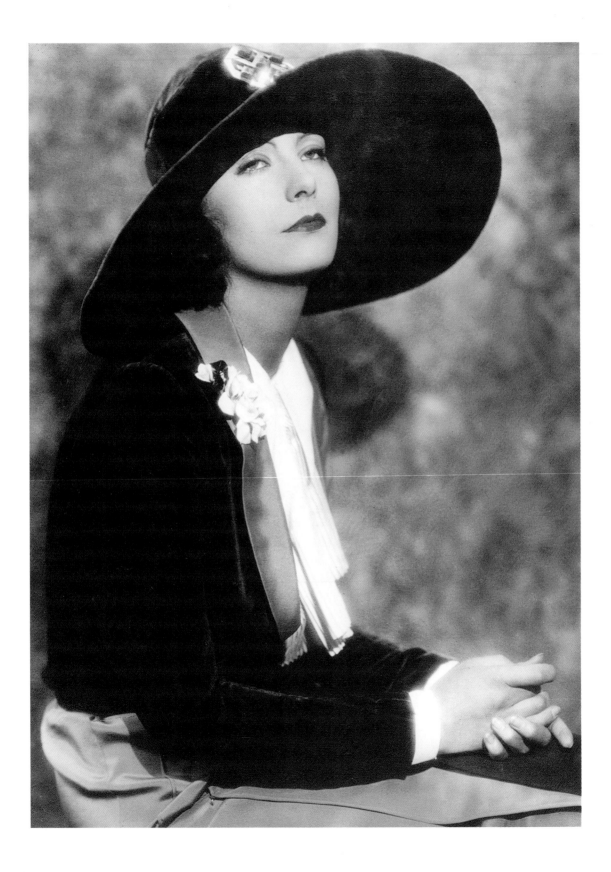

"I'm sorry that you're leaving," she told Adrian on the day of his departure. "But you know, I never really liked most of the clothes you made me wear."

✳

In addition to the ethereal beauty and the artistry that could never be fully explained, a third curious ingredient went into the making of Greta Garbo: the mysterious behavior of the woman herself. "Garbo's career," wrote film historian Alexander Walker, "was the triumph of the apathetic will."

A European émigrée from an impoverished background who is rewarded with success only nine months after her arrival in Hollywood was the stuff of which American dreams are made. Garbo's success was somehow the pinnacle of an immigrant's dream. But she was miserable.

"Garbo's temperament," Lillian Gish wrote in her memoirs, "reflected the rain and the gloom of the long, dark Swedish winters." She hated the California climate. The English language did not come easily to her. She was baffled by Louis B. Mayer's pleas to sign a long-term contract with MGM. "Why do they want me to sign a contract for five years when I haven't even finished my first picture?" she asked.

And so while the world went mad for her, Garbo walked the beaches of Santa Monica in the rain wearing a trench coat and a slouch hat. At first she lived in a beachfront hotel; she then moved to a series of sparsely furnished rented houses with only a Swedish couple as servants. She refused the attempts of the Hollywood community to befriend her, preferring to stick with European actors and directors. She was an odd bird indeed.

Howard Dietz, MGM's head of publicity, made use of her strange habits when he crafted Garbo's image. "The woman who walks alone" was the first slogan created for her. For the first time the studio didn't have to reinvent a star's personality to make her more appealing: Garbo's solitary image made an impact on the public. The sheer banality of her existence was exotic. No one could believe that the world's most beautiful, most alluring woman could be this dull. And by doing absolutely nothing off-screen, she again created a new type.

For a time, the public and the press thought Garbo's behavior was a hoax, an act designed by the publicity department. It was because of that disbelief that Garbo came to be hounded by the press. By stalking her, reporters and photographers hoped they might find something inconsistent in her behavior. A chink in the armor, a crack in the mask. But they soon saw that her way of life wasn't a stunt. And the more reclusive she became, the more anxiously the press tried to lift the veil she hid behind.

Her response was to make annual trips to Sweden incognita. Heavily disguised, she would sneak onto the train that would take her from Pasadena to New York. Once there, she would sneak into a hotel under the name Harriet Brown. Then she would smuggle herself onto an ocean liner. The press was always in hot pursuit, but the fruit of their efforts would invariably be nothing more than a blurred snapshot of someone who, in baggy clothes with her face concealed under a hat, looked like a bag lady.

Garbo's hatred of the customary publicity photo shoot was nothing compared to her disdain for the routine interviews she was supposed to give. She was appalled when she saw that she had been misquoted or, even worse,

that words had been put into her mouth that she had never said. Other stars learned to ignore this occupational hazard; Garbo's reaction was to refuse interviews. "I do not like your story," she told Ruth Biery, the *Photoplay* writer who did one of the last official interviews in 1928. "I do not like to see my soul laid bare upon paper."

By 1929 journalists had dubbed her "the Swedish Sphinx," "the woman of mystery." In the early 1930s one newspaper reporter's only assignment was to cover Garbo's movements. Ironically, it was Garbo herself who decided to put an end to the media commotion she generated. In 1935 on a return trip from Sweden, she held a press conference on board the ship in New York Harbor. "The truth," she told a throng of reporters, "is that I feel able to express myself only through my roles, and not in words, and that is why I try to avoid talking to the press."

The most often cited reason for her flight from fame was that her psyche was, quite simply, ill-equipped to handle stardom. And yet she ruled her career with an iron hand. After filming *Flesh and the Devil*, she asked for a significant increase in her salary. The studio refused and attempted to cast her in a western. Garbo agreed, but only if she got the bigger salary.

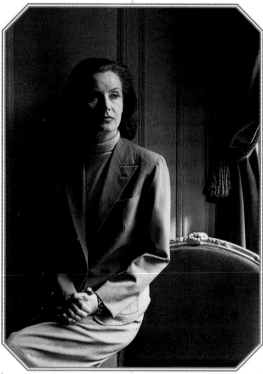

POSING IN 1946 for her friend, the photographer Cecil Beaton.

Mayer then told her she would be relegated to bit parts. Okay with her, she said, as long as MGM paid her asking price. Finally, Mayer warned her that he would have her work permit revoked and send her packing on the next boat back to Sweden. That was all right, too, said Garbo. This last response reduced Mayer to one of his legendary crying scenes; he implored Garbo to recognize what the studio had achieved for her and the bright future that lay ahead.

Garbo listened to him. Then came the bombshell.

"I think I go home," she said.

Mayer placed her on suspension and sent her cautionary telegrams. The sphinx was her usual silent self. But after *Flesh and the Devil* opened to fantastic reviews and then soon became a record-breaking box office success, Mayer had no choice but to give in.

It was 1927, and Garbo was only twenty-two years old.

While Joan Crawford and Norma Shearer were fighting MGM for better parts, Garbo had the studio in the palm of her hand. She sailed through the silent era and into talking pictures getting her demands met. Her film sets were closed to all but the key technicians. She got away with refusing A-list Hollywood invitations. She posed only for photographers

of her choosing—for all her hatred of publicity she adored having her picture taken. For Clarence Sinclair Bull, whom she appointed her official portrait photographer from 1929 to the end of her career, she sat for approximately four thousand photographs. She had a vote in choosing her leading men and the cameramen on her films (William Daniels shot nineteen of Garbo's twenty-four silent and sound films).

Though she hated the powers that she felt dominated her existence, she was allowed free rein to be the distinct individualist she was. And yet, given all that latitude, Greta Garbo never seemed to develop a personal identity for herself that might have helped her overcome her fear of the outside world. The problem seems to have manifested itself before she came to Hollywood. Before she had a chance for personal growth that develops from life experience, her discoverer Mauritz Stiller had molded and shaped a shy, withdrawn girl to his dream specifications. He tutored her not only in acting but in social behavior. Stiller told her what to wear and what to say in public. After the success of *The Saga of Gosta Berling*, she gave her first interview in which she was quoted off the record. Outraged, Stiller prevented her from talking to reporters, and this increased Garbo's antipathy toward the press. Once in Hollywood, it was Stiller who instructed her to be remote in order to foster an enigmatic image. He also organized every aspect of her personal and financial life. But although he had been brought to Hollywood to direct Garbo, Stiller was fired halfway through the production of *The Temptress* and returned to Sweden.

GARBO'S DRESSING room at the MGM Studios.

What Stiller left behind was a rather simple, unformed soul who had a child's literal-minded view of the world. Garbo was confused and frightened by fans and admirers and their reactions to her. The fifteen thousand or so fan letters she received each week puzzled her. "Who are all these people who write?" she asked. "I don't know them. They don't know me. What have we to write each other about? Why do they want my picture? I'm not their relative."

Even simple matters of protocol baffled her. When Howard Dietz once asked her to dine on a Wednesday, her response was, "How do I know if I'll be hungry on Wednesday?" Louis B. Mayer once sent her flowers, and she wanted to reject them because she thought it inappropriate for anyone who wasn't a personal friend to send her a present. But when the right situation arose, she became the pragmatic Swede. In 1946 a besotted fan in England whom she'd never met or

corresponded with died and willed his entire estate (worth roughly $210,000) to her. She accepted it without question.

Garbo's isolation caused her to be totally self-involved, and in that respect, at least, she was no different from other stars. She used her myth and her stardom when it suited her to do so. But she took her obsession with privacy to an extreme. If you were her friend, you were instructed not to discuss her with anyone else. You were never to mention mutual friends in her presence. And above all else, you were never to ask her to commit to a date. She even imposed these rules on her film set with the few colleagues she trusted. And yet, if Garbo decided she wanted to see you, you were expected to drop your prior plans.

"It's hard to enshrine with words what Garbo was like," explains the writer Peter Viertel, whose mother, Salka Viertel, wrote several of Garbo's films and was Garbo's close friend and confidante for fifty years. "There was a kind of discomfort and awe she created by her tortured personality," Viertel says. "I was never at ease in her presence. Not because she was famous or beautiful but because she created a special atmosphere by her unforeseeable reactions. With close friends there should be no taboos."

Her obsession with privacy was limited to hers alone. She had no problem invading that of others when the occasion suited her—like the time she showed up unannounced at the door of Edward G. Robinson, whom she had never met. Her mission was to show the actor, who was also a serious art collector, a painting she had recently purchased and to get his expert opinion.

"I would have been good at many things," Garbo said of herself long after her career ended. Sadly, what she was best at was being alone. After retiring from films, her obsessive search for privacy became a full-time job. What Garbo never understood was that if she had made an effort to cultivate a life for herself after leaving Hollywood for New York City, the aura around her would have gradually and naturally dissipated. Her own behavior fired the fuel of curiosity. And yet she must have aspired to something more than isolation, for in her spacious New York City apartment the dining room was designed for lavish entertaining and her pantry was stocked with complete sets of nineteenth-century dinnerware.

"She wanted to be profound, but she never realized the way you do it is by getting on with life," observes Viertel. Instead, she spent the last thirty years of her life drifting, prey to frequent depressions because she was alone most of the time. She was drawn to the world of fashionable society as a result of her relationship with George Schlee, her wealthy companion from 1944 until his death in 1964. She was close to members of the Rothschild family; she took trips on Aristotle Onassis's yacht. The world of the rich and titled offered her a gilded cage where her myth was safe.

Beyond herself, she seemed to have little interest in the world. "Her answers to most questions of a personal nature were mystical non sequiturs," says Viertel. "Not dumb, but evasive, self-protective, self-concealing." It could have been that she was trying to hide a personal vacuum, an understandable phenomenon if you're famous and a goddess.

Firsthand Garbo anecdotes invariably have her uttering banal one-liners. Leonard Stanley,

CECIL BEATON'S friendship wth Garbo, seen here at his home in England, enabled him to document her off-screen life after she retired from films.

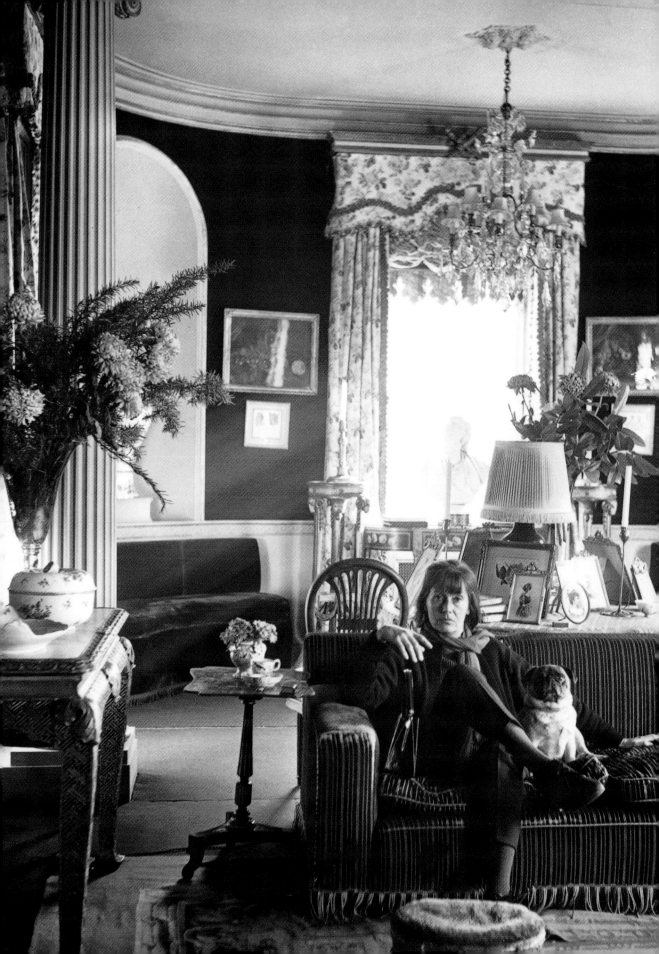

a Los Angeles interior designer, once had drinks with her at the home of a mutual friend. "We were both drinking Scotch and soda," recalls Stanley. "At one point she turned to me and said, 'You know what I like with my Scotch and soda?' I was fascinated to know. What could it be? Caviar? Foie gras? 'A bag of Fritos,' she said."

Her listeners always came up short, for they expected that out of that gorgeous mouth would pour something riveting. Riveting, yes, for its sheer simplemindedness. But as she was so conscious of her persona, one can't help thinking that she knew exactly the kind of reaction her prosaic pronouncements would produce.

After her retirement, her friends never heard her discuss her career or her fame, and yet she had a clipping service. In this, as in everything else, she was a sea of contradictions. Some friends recall that she had a delicious sense of humor; others say she was dour. A few who knew her during the Hollywood years say she was well read and had good native intelligence; another camp says her reading matter didn't extend beyond health-and-beauty magazines. When someone asked why she didn't make a film of Chekhov's *The Cherry Orchard,* she smiled vaguely and replied, "That's the story of the woman who is afraid of losing her farm, isn't it?"

As for how she felt about the way she'd lived, she was again a series of conflicting reports. "I have nothing," she told Irene Selznick, the daughter of Louis B. Mayer, in the 1970s. To her niece in 1989, she said, "You know I've led a fabulous life."

In the end, the most interesting thing about Garbo is her screen persona. "Her instinct, her mastery over the machine, was pure witchcraft," observed Bette Davis. "I cannot analyze this woman's acting. I only know that no one else so effectively worked in front of the camera." Garbo herself could never really explain it: "I know the person I am in the picture, and I feel that I am that person for the time being. How I get what you call effects, I do not know. . . . I do not know how I do it."

Her secret may be simple: that what she brought to the screen was herself, a mythic figure playing mythic parts—Queen Christina, Anna Karenina, Camille, Mata Hari. And many of her roles resembled the woman she was off-screen—a tragedienne, an exile, a fatalist. Even the dialogue is, at times, eerily metaphorical.

The only time Garbo officially said "I want to be alone" was in *Grand Hotel.*

"Others know nothing of my motives and little or nothing of my character and way of life, for I let no one look inside me" (*Queen Christina*).

"I'm tired of being a symbol—I long to be a human being" (*Queen Christina*).

"One day I shall find myself alone" (*Anna Karenina*).

And finally and perhaps the most telling, a scene in her final film, *Two-Faced Woman,* after Garbo dances the "chica-choca," which arouses everyone in the nightclub, her costar Constance Bennett asks her, "What kind of a woman are you?"

"Honest," Garbo replies.

Her reason for retiring after *Two-Faced Woman* says it all. Her previous film, *Ninotchka,* (1939), in which she played deadpan comedy with stunning precision, had been a major triumph both financially and critically. With war beginning in Europe, the studio wanted to give

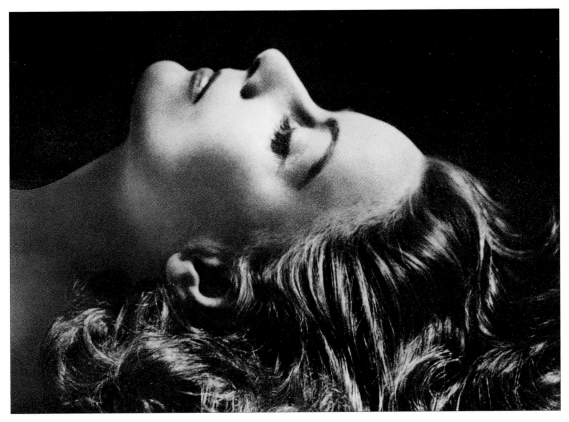

THE WORLD'S most enigmatic beauty posing for Cecil Beaton.

its audiences more escapist comedy. Now that Garbo had proved herself a comedienne, production executives thought this was a perfect time to introduce a fun-loving Garbo. The advertising campaign for *Two-Faced Woman* signaled the new celluloid image the studio was after: "Who is the screen's rumba queen? Who no longer wants to be alone? A gayer, grander, *greater* Greta, every other inch a lady—with every other man!"

The plan backfired. *Time* magazine summed up the devastation by saying "it was like seeing Sarah Bernhardt swatted with a bladder." Out of respect for Garbo, most critics placed the blame on director George Cukor and the screenwriters. Nevertheless, Garbo was unnerved by the reception. "I think Greta's regret," wrote her friend Mercedes De Acosta in her memoirs, *Here Lies the Heart,* "was more in her own soul for having allowed herself to be influenced into lowering her own high standards. She said, 'I will never act in another film.'" Every major star of the glamour era had suffered failures. After fifteen years, she had been at the top longer than any other star. To quit after her first failure was unthinkable. But she did it.

For all her neuroses, there was ultimately something noble about Garbo. She was unwilling to sell herself cheap, and she was invulnerable to the trappings of stardom. Beyond the perfection of her face or the fantastic costumes that Adrian encased her in, it is our sense of her integrity that makes her myth so sacred.

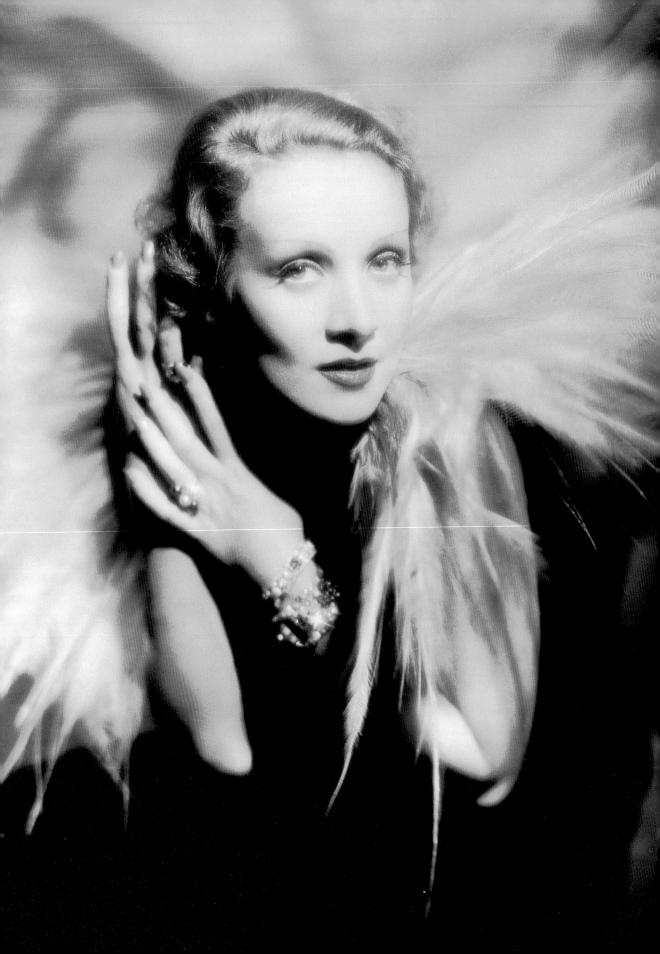

Marlene Dietrich

It is early May 1945, and in Europe the war is almost over. The members of the Second French Tank Division find themselves in the Bavarian village of Landsberg-am-Lech, being reviewed by none other than General Charles de Gaulle. Suddenly a woman dressed in the uniform of the American Army, but wearing penny loafers instead of combat boots, material-izes out of nowhere.

She is looking for someone.

Is he in this tank? No. She runs on. In this one? No. Again and again, she cries out, "Jean! Jean!" Heads turn. The larger-than-life general no longer has the full attention of his troops.

At last the woman spots her beloved Jean.

"Damn it to hell, what are you doing here?" he asks.

"I want to kiss you," she replies.

This unusual, intense moment takes a cinematic turn when you know that the woman is Marlene Dietrich, then serving in the U.S.

Army as part of a USO unit, and her beloved is the actor Jean Gabin. Given all that we know about Dietrich, it is easy to create a mental movie of this scene: an overhead key light making her hair lighter and shinier, her cheekbones more pronounced, her upturned nose straighter, her pale blue eyes dark and sultry. And the voice: throaty, sexy, with her German accent coloring even her most emotionally charged words with world-weary indifference.

This is the Dietrich of the movies, a femme fatale—a cabaret singer, a prostitute, a mistress—rising above ennui to give love a chance. She's a riveting character. But in the end, the screen legend is much less riveting than the woman who was Dietrich.

Marlene Dietrich was a bohemian, a freethinker, a world-class self-promoter. She was bisexual without fear that the press would invade her private life. In the best sense of the word, she was an adventuress—so much so that, of all her talents, acting was the smallest. And Dietrich knew that. She thought her work against Nazism in her native country was "the only important thing I've ever done." She said the film roles she played "have nothing to do with what I really am." Had he lived to know her, Oscar Wilde might have been thinking of Dietrich when he said, "An actor is less than a man, an actress is more than a woman."

Marlene Dietrich was brought to Hollywood in 1930 by Paramount to compete with Greta Garbo. Their similarities, however, were superficial: two European beauties with distinctive voices and unique personal styles that made them credible as vamps and sex goddesses. But unlike Garbo, Dietrich worked until she was in her seventies, burnishing her legend as an age-

less beauty, and when she withdrew from the public eye, she did it so completely that Garbo looked, in comparison, like an extrovert.

The key to Dietrich is her discipline, a commitment to professionalism and glamour so complete that her only real rival was Joan Crawford. "I grew up with discipline. I knew nothing else in my life," she wrote. Her father, Louis Otto Dietrich, had been a lieutenant in the Prussian Army and then served as an officer in Berlin's Imperial Police Force. Her mother, Josephine, was the daughter of a prosperous clock and jewelry manufacturer who'd been raised in a strict upper-middle-class home in which dignity, duty, and discipline came first.

Over time, Dietrich would rewrite the family history. "My parents were quite well-to-do, and I received the best education imaginable," she wrote in her memoir, *Marlene.* "I had governesses and private tutors." The army officer father that she refers to in her book, who died on the Russian front during World War I, was actually her stepfather, Eduard von Losch. Dietrich's mother, who was a Red Cross volunteer, was at the eastern front when von Losch was wounded and she married him over a field hospital bed. He offered Mrs. Dietrich his aristocratic name in exchange for her promise to look after his mother in Germany.

Dietrich's real father had never risen in the ranks of the police force; in fact, he had been demoted several times. As a result, there was a downward turn in the Dietrichs' mobility. She was born Maria Magadalena Dietrich on December 27, 1901, in the Berlin suburb of Schöneberg. By the time she was six, Dietrich and her older sister had moved with her parents five times to a series of modest apartments.

In 1911, when she was ten, her father fell

off a horse and died. Even with the help of her family, Dietrich's mother found it difficult to make do on a police widow's pension and went to work as a "glorified housekeeper" for Eduard von Losch, the scion of a prominent family. Her wages provided her daughter with tutors in French and English and with lessons in piano and violin. The music lessons revealed a gifted pupil; Dietrich's first ambition was to have a career as a violinist.

Dietrich's superior education had less to do with privilege than with the iron hand of a mother who put intellectual endeavors before pleasure. In the end, it was her mother, not her police lieutenant father or her military officer stepfather, who was the commanding influence on her. "She herself was a kindly general," Dietrich wrote. "She followed the rules she laid down, she set a good example; she furnished the proof that it was possible. No pride in success, no pats on the shoulder. The only aim was humble submission to duty."

Still, there was room for imagination. And Dietrich's first creative act occurred at thirteen when she changed her name to Marlene (pronounced Mar-*lay*-na), an unheard-of name at the time and definitely not a German derivative of Magadalena.

While her mother was teaching her the virtues of hard work, Dietrich's style influences came from observing her grandmother and her two aunts, particularly her uncle's wife, Tante Jolly, an exotic Pole who had actually lived in Hollywood. Jolly had long fingernails, which Dietrich later copied to make her own short hands appear longer, and Jolly decked herself in jeweled turbans, sables, and foxes. In time, Dietrich would appropriate a similar glamorous aura.

Inspired by three powerful females, Die-

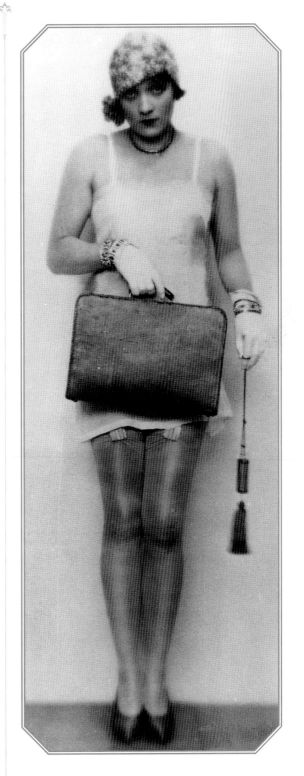

DIETRICH AS she looked in 1922 while still an aspiring actress in Berlin.

trich had high standards for beauty. And as a child, she didn't think she measured up. "I was thin and pale," she wrote. "I had long red-blond hair and a translucent complexion, the white skin characteristic of the redhead, and a sickly look, thanks to this long red-blond hair."

By the time she went to Weimar at age seventeen to pursue her violin studies, she had become a disarming beauty. When it became clear that her talent wasn't sufficient to lead her to a concert career, she returned to Berlin, where she found her first job playing in an orchestra that accompanied silent films in a movie theater. She was its only female member. Four weeks later she was fired, not because of any professional inability, but because her legs were a distraction to the other musicians.

Dietrich took those legs into the theater and joined a chorus line in a touring company. Soon she was appearing in musical revues in Berlin. By 1922 she was studying at the Reinhardt Drama School, the prestigious conservatory founded by noted German director and producer Max Reinhardt.

Those were the great days of the theater in post–World War I Berlin. Dietrich worked steadily onstage in Reinhardt productions and soon made her way into silent films. Dietrich

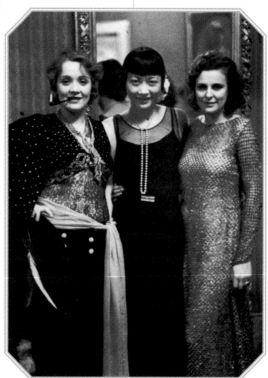

WITH ANNA May Wong and Leni Riefenstahl in Berlin, 1928.

would later deny that she ever wanted to be a film star, but those who knew her in Berlin realized that wasn't quite true. She'd spent her youth performing in piano and violin recitals; she had experienced the thrill of applause and adulation. And she had been movie-mad since she was a child.

Her uncle had friends in the film business, so she badgered him for introductions and finally succeeded in landing a screen test. Her first experience in front of a camera registered a broad expressionless face and coarse movements. Nevertheless, a certain quality caught the eye of Wilhelm Dieterle, a well-respected actor who cast her as the ingenue in his debut film as a director. "Many people have their dreams behind them, many before them," Dieterle observed much later. "Marlene carried hers with her, and wore them like a halo."

In later years Dietrich denied having appeared in numerous German silent films, in part because she was somewhat plump. "I look like a potato with hair," she supposedly remarked after seeing herself on-screen in one of her silents. She still had flat German features and her cheekbones were camouflaged by baby fat. She hadn't yet learned that on film less is more or that lighting is all-important.

Her movements were animated, and there is no trace of the cool, sophisticated persona she would later develop.

In 1923 she had married Rudolf Sieber, an assistant director who'd cast her as an extra in a film. A year later a daughter, Maria, was born. Sieber, who was four years older than Marlene, had been one of the Berlin film community's leading Lotharios until Dietrich captured his attention. Sieber saw something in her cinematically as well, and he fueled her ambitions. When they married, Dietrich was still struggling to get ahead. Sieber's connections obviously appealed to her. But so did the fact that he was, as she wrote, "blond, tall, clever—everything that a young girl longs for." In spite of her astounding success, their frequent separations, and her many affairs, their marriage would last for half a century. Though they ceased to be lovers early on, he would forever remain her friend, soul mate, and adviser; their devotion to each other was a constant.

The twenties were the era of Berlin's "divine decadence," as Christopher Isherwood called it in *Goodbye to Berlin*. Dietrich and Sieber were a well-known, ambitious couple on the Berlin nightclub scene, indulging in the Berliners' craze for jazz and touring the ambisexual

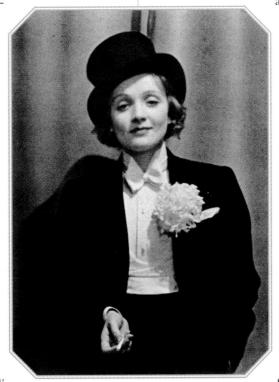

PHOTOGRAPHER ALFRED Eisenstaedt captured her in 1929 wearing top hat and tails.

clubs. Although she was working on the stage and in films, Dietrich was better known as a personality, famous for her gorgeous legs and her gift for original self-presentation.

In those days, Dietrich cut a swath through Berlin wearing a monocle and feather boa. Sometimes she wore five red fox furs or wolf skins. Men found her irresistible. "If I were as beautiful as Dietrich," the great German actress Elisabeth Bergner once commented during those heady days, "I wouldn't know where to begin with my talent."

The film director Josef von Sternberg spotted Dietrich onstage in Berlin's musical comedy hit of 1929, *Two Bow Ties*. By then she had appeared in twenty-six stage productions and seventeen films. But when she met with Sternberg in his office the next day to discuss his latest film project, *The Blue Angel*, she acknowledged only three of her movies—all of which, she said, were terrible. She further concealed the extent of her ambition by telling him she photographed badly. That he knew. For Sternberg might never have discovered her if he hadn't seen her in the flesh—her photo had been sent to his office several weeks before and he had passed it over.

Sternberg saw Dietrich's films. She was right: they were terrible. But that didn't matter.

He didn't want the actress, he wanted the woman he had met in his office—insolent, discouraged, sexually provocative. "Never before," Sternberg wrote in his memoirs, "had I met so beautiful a woman who had been so thoroughly discounted and undervalued." Sternberg recognized in Dietrich a face "that promised everything."

The Blue Angel is the story of a middle-aged professor who falls in love with, and is ultimately destroyed by, Lola-Lola, a sleazy cabaret singer and part-time hooker. This coarse, seductive character is created almost entirely through singing. Out of this film was born "Falling in Love Again," which would become Dietrich's theme song in later years.

Sternberg molded and shaped Dietrich. "She responded to my instructions with an ease that I had never before encountered," Sternberg recalled. "Her remarkable vitality had been channeled." *The Blue Angel* was the first great German talkie (an English version was shot simultaneously). For Dietrich, sound was the liberating element in the creation of what critics called "a new incarnation of sex."

In this film, writes Dietrich's biographer, Steven Bach, "she takes possession of the screen with an assurance that is breathtaking. The first time on screen she can use her voice to insinuate what she could earlier only mime." Dietrich's work was so remarkable that Paramount chief B. P. Schulberg, who was visiting Berlin during the filming and who saw the rushes, asked her to come to Hollywood.

The Blue Angel opened in Berlin on April 1, 1930. Every German newspaper had written about the film extensively, as it was an adaptation of a Heinrich Mann novel, *Professor Unrath.* The premiere was a major event; what Berlin saw that night was the birth of a world-class star. After thunderous applause, Dietrich came onstage dressed in a simple long white gown and furs. As she basked in several curtain calls, the toast of Berlin had other things on her mind. Directly after the premiere, she slipped into travel clothes and sailed for Hollywood.

"I did not endow her with a personality that was not her own," Josef von Sternberg observed in his memoir, *Fun in a Chinese Laundry.* "I gave her nothing that she did not already have."

When Dietrich arrived in Hollywood, Sternberg was waiting for her. He was scheduled to direct his discovery in her first American picture. But first he ordered—and supervised—a complete makeover by Paramount's glamour experts. Dieticians put her on a diet. Madame Sylvia, the Hollywood masseuse, pummeled away the Teutonic pudginess. The makeup department thinned out her eyebrows, redesigning them so they became winged and arched. Dietrich's upper eyelashes were lengthened and darkened with mascara. To enlarge her eyes, she was instructed to draw a white line inside her lower eyelid, using a technique that began with her dipping the rounded end of a hairpin into white greasepaint. That trick would also take attention away from the nose that she described as looking like a duck's behind. To straighten and narrow her nose, a thin silver line was drawn down the middle. She used gilding powder to lighten her strawberry-blond hair and make it look golden.

Sternberg's decision to position a key light directly overhead brought the makeover into stark focus. It illuminated the bone structure that dieting had unearthed, emphasized her

deep-set eyes, and achieved a halo effect that made her hair glisten. Bathing her in light created a moody, seductive effect. Through this lighting, Sternberg articulated his vision of a goddess: "I put her into the crucible of my conception, blended her image to correspond with mine, and poured lights on her until the alchemy was complete."

When Dietrich saw the results of her first photo session with a Paramount photographer, also directed by Sternberg, she proclaimed the portraits "the most beautiful things I've ever seen in my life." These pictures made her recognize that her face was like a blank canvas that could be shaped to suit her own fantasies and extravagances.

Dietrich has the unusual distinction of being the only star who became famous before American audiences ever saw her in a film. Paramount withheld the release of the English version of *The Blue Angel* until after *Morocco* (1930), her first Hollywood picture. In the meantime, a massive publicity campaign had been waged to introduce her. While her face was still only an image on billboards, Louella Parsons referred to her as "the famous actress." Unlike Garbo, whose studio put her up in a Santa Monica beachfront hotel, Paramount set Dietrich up in an elegant one-bedroom apartment in West Hollywood

SHE DEFIED the executives at Paramount by wearing trousers in public.

and provided her with a Rolls-Royce and a chauffeur.

The real proof that the studio was solidly behind her was evident when B. P. Schulberg invited her to one of the major A-list events of the season: the engagement party he hosted for his then assistant David O. Selznick and his fiancée, Irene Mayer, daughter of Louis B. "There was suddenly a suspended silence," Irene Selznick told biographer Steven Bach, "not the clarion call of bugles, but its equivalent in soundlessness. Then these high double doors at the end of the ballroom opened and in walked Marlene. No one had ever laid eyes on her before. She entered several hundred feet into the room in this slow, riveting walk and took possession of that dance floor like it was a stage. I can't think of any greater impact she ever made. It was something out of a dream, and she looked absolutely sensational." At that moment Schulberg announced, "Ladies and gentlemen, Paramount's new star, Marlene Dietrich."

He didn't have to eat his words. *Morocco* made her an overnight sensation. In her American debut film, she plays a weary cabaret singer who comes to North Africa with nothing but a past that has brought her misery. As soon as she arrives, she falls for a

handsome Legionnaire, played by Gary Cooper. At the same time, a wealthy artist falls in love with her and offers marriage. When Cooper rejects her and leaves to trek across the desert with the Foreign Legion, she accepts the artist's proposal. But in the end she's unwilling to sacrifice freedom and passion for security. In a dramatic finale, Dietrich—dressed in white, wearing a flowing chiffon scarf and three-inch heels, with the wind blowing against her face—watches the Legionnaires depart. When she notices a trail of women following them, she too walks out into the desert.

Dietrich, unlike Garbo, was not a vamp who lusted out of weakness, nor was she a woman torn between two men who either repented or died at the end of the film. In *Morocco*, audiences saw a daring, independent woman who coolly challenged the accepted notions of womanhood and sexuality. The film's opening cabaret scene has her in a top hat and tails, nonchalantly smoking a cigarette and singing "Quand l'amour meurt" ("When Love Dies"). When she finishes the number, a man in the audience offers her a glass of champagne. She drinks it in one smooth gulp, then turns to his female companion, takes a flower from the woman's corsage, and kisses her hard on the mouth. Dietrich then tosses the flower to Gary Cooper. What she exudes is male arrogance. She is both sexy and androgynous. Off-screen, she would also exude those qualities. "She has sex, but no particular gender," Kenneth Tynan observed. "Her ways are mannish: the characters she played loved power and were undomesticated. Dietrich appeals to women, and her sexuality to men."

It was difficult for a movie-crazed public to accept Garbo's intensely private off-screen life; with Dietrich, they had to come to terms with a contradictory persona. The on-screen Dietrich was bold, exotic. Off-screen she was that too, but she was also a twenty-eight-year-old wife and mother. In interviews, Hollywood's new sex goddess spoke lovingly of her daughter. But at the same time she had left her and Sieber behind in Berlin to conquer Hollywood. When her daughter rejoined her there in 1931, Dietrich became the only female star who was constantly seen in public with her child.

Dietrich added to her mystery by claiming to be more than just a beauty. She stayed at home nights reading Goethe and cooking. She declared a fondness for cleaning. She was, she said, really at heart just like any proper German hausfrau—though very few Berlin hausfraus had spent their evenings exploring the cabaret district and hobnobbing with transvestites. But while she was baking strudel in Los Angeles, she and her mentor, Joseph von Sternberg, were rumored to be lovers. Scandal ensued when Sternberg's wife slapped Dietrich with a lawsuit, demanding $500,000 for alienation of affections. Her popularity with a straitlaced Depression-era public is amazing when we consider her own marital arrangement with Sieber. Most of the time he lived openly with his mistress in Paris. Dietrich represented a most unorthodox combination: love goddess and mother earth.

That combination was, in many ways, the woman Sternberg wanted to bring to life on the screen. He sought an image that was not just cool and sexually ambiguous but rather, Dietrich later explained, a woman who was "well fed, full of life, with ankles, breasts, and sex appeal—in short, the dream of a little man."

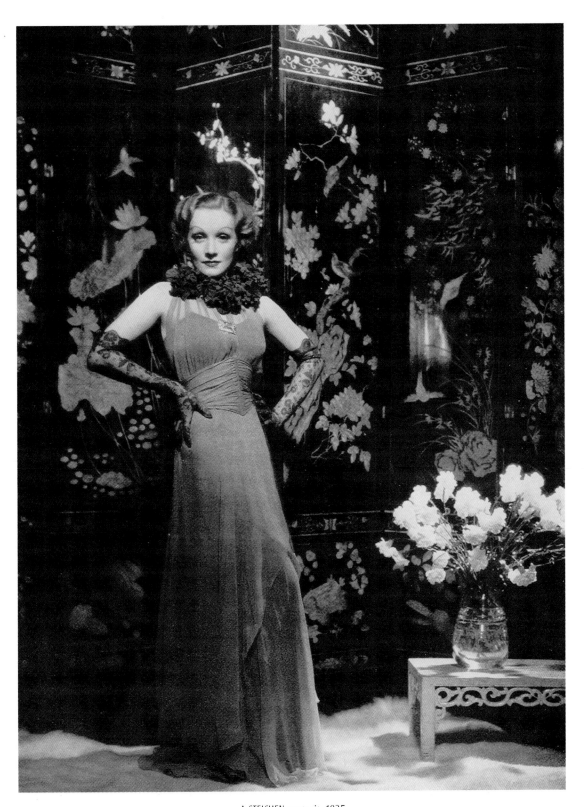

A STEICHEN portrait, 1935.

After *Morocco*, Sternberg and Dietrich made five more films together in Hollywood: *Dishonored, Shanghai Express, Blonde Venus, The Scarlet Empress,* and *The Devil Is a Woman.* During their collaboration they created one of the most remarkable bodies of work ever to emerge from the Hollywood studio system. Highly personal, visually poetic, exotic, abstract, these films stand apart because of their distinctly European edge. In all the plots there is tormented passion, lovers who are independent by nature, both sexes mistrusting the other, men who crumble over women, women who will never be defeated by men. In these films, Dietrich is always an object of desire who instills longing and frustration in the opposite sex.

The Sternberg-Dietrich partnership was a classic in itself. "You Are Svengali and I Am Trilby," Dietrich entitled the chapter on Sternberg in her memoirs. "He created me," she acknowledged, and because she was in awe of his artistic genius, she let him have control. "Turn your shoulders away from me and straighten out," he would instruct her on the set. "Drop your voice an octave, and don't lisp. . . . Count to six and look at that lamp as if you could no longer live without it. . . . Stand where you are and don't move; the lights are being adjusted." Though Sternberg was, she said, "father, confessor, critic, and instructor," the one thing he could never do in the Pygmalionizing process was make her fall in love with him. In that sense, she was like the woman he had created for the screen.

The films themselves are not what made Dietrich adored by the public. It was Dietrich herself. The pictures were far too

DIETRICH WITH her daughter, Maria, at the Santa Anita racetrack.

sophisticated to be embraced by a mass movie audience. After *Shanghai Express* (1932), they failed at the box office; the collaboration ended with *The Devil Is a Woman* (1935).

This last film was adapted from a Spanish story and has Dietrich playing a siren in turn-of-the-century Seville. Her story is told in flashback by a middle-aged grandee who loses his commission and social position after submitting to the fatal charms of "the most beautiful creature I've ever seen."

The Devil Is a Woman was more than just a box office disaster. It was too weird, too steamy, too dark, for censors, reviewers, and audiences. Spanish authorities even claimed it defamed their country and announced that if Paramount didn't withdraw the film from circulation, they would shut the studio's Madrid offices. By then Paramount chiefs realized that the film had no audience in America and withdrew it anyway. It was, in moviespeak, a "lost film," which didn't resurface until 1959, when it was shown at the Venice Film Festival. There it was labeled by one critic as "one of the crowning masterpieces of the American cinema."

The Devil Is a Woman is eerily symbolic of the Sternberg-Dietrich relationship. In the end Sternberg was destroyed by the woman he had created. After this film, his career was in ashes; the nine pictures he made over the next twenty years were stunning for their sheer insignificance.

Dietrich regarded *The Devil Is a Woman* as her favorite film "because I was my most beautiful in it." The persona that Sternberg created for her paved the way for her to leap from actress to legend. Dietrich went on to make three more films for Paramount—*Desire* (1936), *The Garden of Allah* (1936), and *Angel* (1937)—

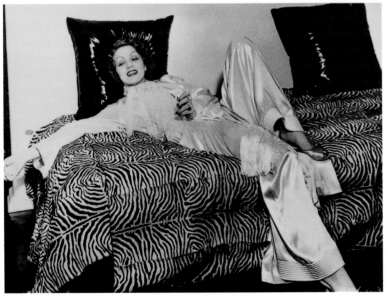

DIETRICH IN the Beverly Hills home
she decorated herself, 1935.

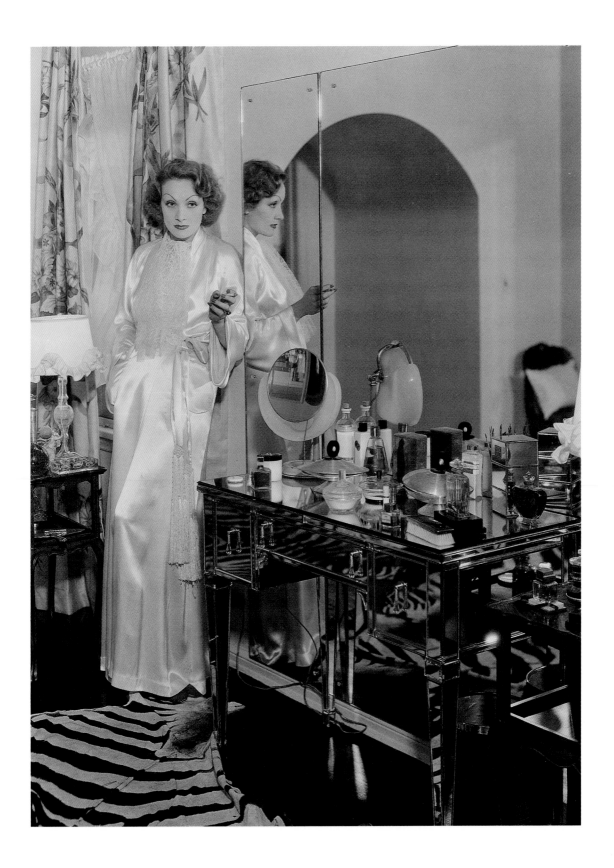

before being declared box office poison in 1938. In these films the studio reinvented her into a watered-down Hollywood version of Sternberg's love goddess. She moved on to Universal in 1939 to play a western saloon girl in *Destry Rides Again.* In this film, like many others she made in the forties, she was a sanitized and somewhat crude version of the Sternberg woman.

Dietrich would be forever indebted to the man she claimed she wanted most to please. "He taught me," Dietrich said, "that the image of a screen character is built not alone from acting and appearance but out of everything that is cumulatively visible in a film. He taught me about camera angles, lighting, costumes, makeup, timing, matching scenes, cutting, and editing. He gave me the opportunity for the most creative experience I have ever had."

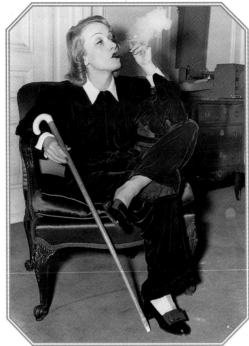

"GLAMOUR: The word which I would like to know the meaning of," she wrote in *Marlene Dietrich's ABCs.*

Through this extraordinary partnership she learned to be the master of her own show. And whether on-screen or off, that show was about being the extraordinary persona who, by 1935, was known to the world simply as "Dietrich."

"Glamour is what I sell, it's my stock in trade," Dietrich told a reporter. Her personal definition of glamour was "something indefinite, something inaccessible to normal women—an unreal paradise, desirable but basically out of reach."

When it came to glamour, Dietrich was in a class by herself. And her ultraglamorous essence was "basically out of reach" for female fans. Her hard-edged, chiseled features made it possible for her to wear exotic clothes that would have looked ridiculous on anyone else. "She dressed to excite attention," Edith Head noted. "Hers was a more sumptuous, more theatrical, more striking look. Dietrich's things were more than fashion—they were superfashion." Her fans knew they couldn't duplicate that exalted level of glamour, but they adored Dietrich for her ability to carry it off.

The costume designer Travis Banton played as great a part in the creation of the Dietrich screen image as Sternberg did. But unlike Sternberg, who regarded Dietrich as his puppet, Banton entered into a true collaboration with Dietrich. She worked tirelessly with him to create the costumes that would be his most inspired designs. Her extraordinary discipline made it possible for her to stand for six hours at a stretch during fittings or to work from midnight until dawn while she and Banton instructed seamstresses in every minuscule detail. She was so exacting that when Banton designed a gown that was beaded with semi-precious stones, she diligently moved one stone

at least fifty times until she found the place where it achieved maximum effect.

Banton artfully blended the masculine and feminine sides of her nature. He draped her in feathers, veils, furs, sequins, leather. Taking his cue from *The Blue Angel*, in which she appeared in a top hat and tails, he had her don them yet again in *Morocco* and *Blonde Venus*. In *Shanghai Express* she wears a military coat and peaked cap; in *The Scarlet Empress* she is victorious in a Russian hussar's uniform. At the same time, Banton consistently emphasized her legs in every film. Dresses had slits up the side or front. For *The Devil Is a Woman*, he created lace stockings.

Off-screen Dietrich worked equally hard to convey a carefully crafted persona. "I dress for the image," she once told a reporter. "Not for myself, not for the public, not for fashion, not for men. The image? A conglomeration of all the parts I've ever played on the screen." By turn, she favored turbans, jaunty hats cocked always at an angle, extravagant furs, hefty cabochon emerald and diamond bracelets, and massive rings worn over gloves.

At the opposite end of that spectrum was Dietrich's love of men's clothing, which she took to a new level. "I am at heart a gentleman," she once said, and she defied the studio bosses when she was photographed with

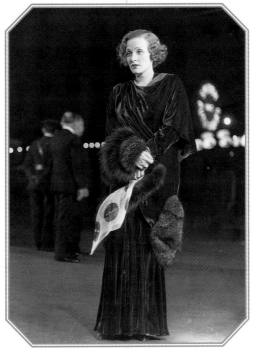

DIETRICH WAS brought to Hollywood by Paramount to be groomed as another Garbo.

Sternberg wearing a nearly identical tuxedo. The inevitable sensation led Paramount to issue publicity shots of her in pants with the slogan "The woman even women can adore."

Unlike Garbo and Hepburn, whose masculine style was about comfort and a desire for privacy, Dietrich wore her berets, wrap coats, pleated pants, and wing tips in a way that only heightened her femininity and sexiness. The message was clear: she was a woman of the world. Although she would forever give thanks to Sternberg and Banton for her celluloid glamour, Dietrich in the end was the supreme master of her breathtaking image. Her own drive for physical perfection made her a slave to her personal quest for idiosyncratic beauty.

Dietrich never worked without a mirror on the set so she could constantly check her appearance. She sucked lemon wedges between takes to keep her mouth muscles tight. She used surgical tape to bind and uplift her sagging breasts. For *Kismet* (1944), she had her legs coated with gold metallic paint; her skin turned green, her pores closed, and she collapsed on the set. For that film, hairdresser Sydney Guilaroff gave her a temporary facelift by making rows of tiny braids all along her hairline. They were so taut that her scalp bled and her teeth throbbed. When the hair began to loosen, he would repeat the process.

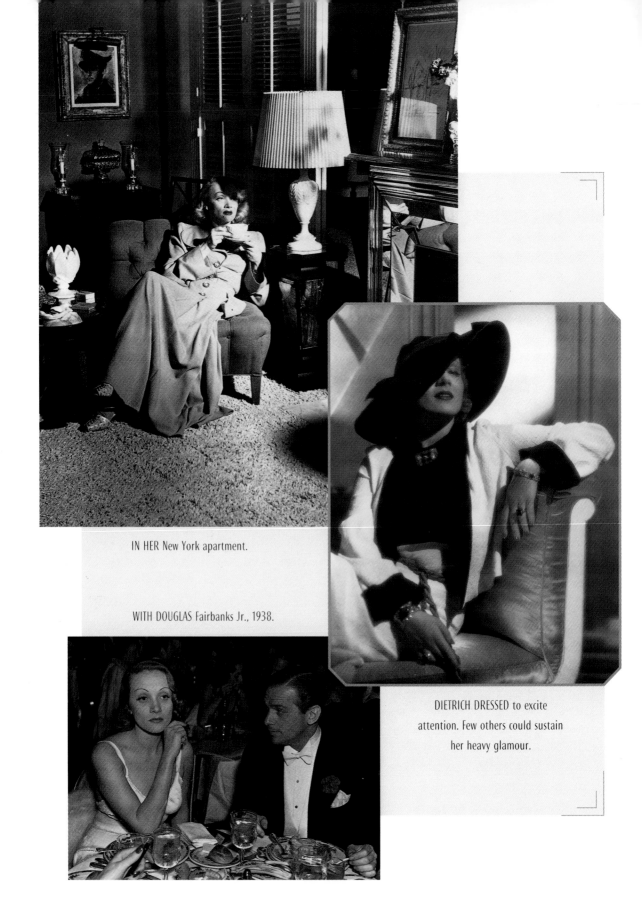

IN HER New York apartment.

WITH DOUGLAS Fairbanks Jr., 1938.

DIETRICH DRESSED to excite
attention. Few others could sustain
her heavy glamour.

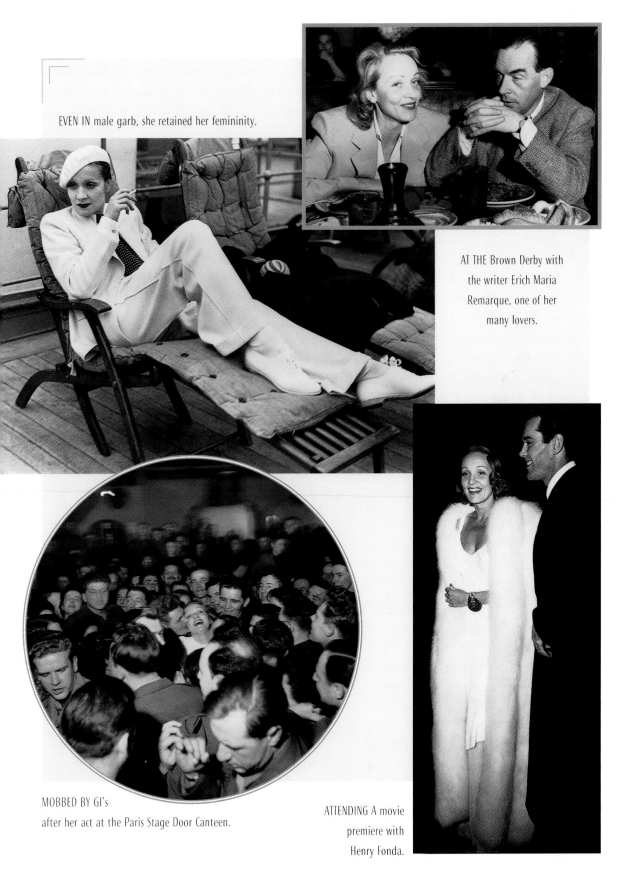

EVEN IN male garb, she retained her femininity.

AT THE Brown Derby with
the writer Erich Maria
Remarque, one of her
many lovers.

MOBBED BY GI's
after her act at the Paris Stage Door Canteen.

ATTENDING A movie
premiere with
Henry Fonda.

"Miss Dietrich is a professional," Alfred Hitchcock said after directing her in *Stage Fright* (1950). "A professional actress, a professional dress designer, a professional cameraman." Dietrich was so expert at hair and makeup that she bears the distinction of being the only actress ever to be admitted to the film makeup and hairdressers' union. She could easily have been a fashion consultant. In her book *Marlene Dietrich's ABCs*, she wrote, "Shoes are more important than suits and dresses. Good shoes give elegance to your entire appearance. Buy one pair of good shoes instead of three pairs of bad quality." She advises women with limited funds to create a basic wardrobe consisting of one gray suit, two black dresses, a black wool skirt, and several sweaters in the same colors. On fashion itself: "Don't follow it blindly into every dark alley. Always remember that you are not a model or a mannequin for which the fashion is created."

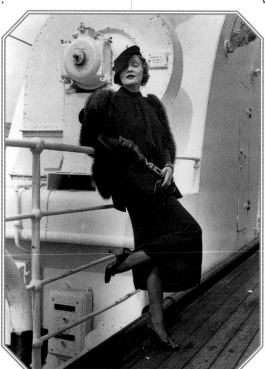

"I DRESS for the image, not for myself, not for the public," she said.

Still, when Christian Dior rocked the world with his "New Look" in 1949, Dietrich was one of the first to embrace the corseted jackets and long full skirts. For *Stage Fright* she demanded that Dior design her costumes. And throughout the 1950s, Dior was her signature designer.

But it was in her career as a nightclub entertainer that her genius for self-presentation reached its highest expression. By now in her fifties, she had Hollywood designer Jean Louis create gowns of flesh-colored silk. He encrusted them with sequins and rhinestones and then made them so close-fitting that her body looked like that of a young girl. "We could work with very sheer material," Jean Louis later recalled, "because Dietrich didn't need any foundation. It was all Dietrich in those days, *everything....* She would stand motionless for eight or nine hours a day in front of mirrors while we made the dresses *on* her. It takes energy and discipline to stand like that. She would say, 'I don't like symmetry. Move that sequin,' and we would, but that might make a symmetry with a rhinestone, so we would move *that,* and this went on all day, all weekend." The Jean Louis dresses would have a great influence in later years on the designs that Bob Mackie created for Hollywood stars like Cher.

In addition to her penchant for top-of-the-line glamour, Dietrich always had a sense of what was right for the occasion. In 1954, for the tenth anniversary of the liberation of Paris, she marched beneath the Arc de Triomphe with former French Resistance workers wearing a regulation trench coat and army cap. Her only accessories were her Medal of Freedom

and the French Légion d'Honneur. The simplicity of the outfit only made her more beautiful.

Dietrich claimed she had no real interest in clothes. "I am not in the least sentimental about clothes," she claimed in 1960. "Nothing makes any difference to the way I feel when I am wearing it. I have no favorites among my clothes, and there are plenty of people waiting when I have finished with them. . . . If I dressed for myself I wouldn't bother at all. Clothes bore me. I'd wear jeans." But when she died in 1992, she left enough clothes for a small museum: 440 pairs of shoes, 400 hats, 150 pairs of gloves, hundreds of dresses and suits, and 50 film costumes.

Dietrich may have claimed she wasn't like the characters she played, but both on and off the screen she inspired love and adulation. Ernest Hemingway said of her, "if she had nothing but her voice, she could break your heart with it," and "she knows more about love than anyone else." Hitler asked her to be his mistress. Her lover Erich Maria Remarque immortalized her in his novel *Arch of Triumph* and dedicated it to her: "The cool, bright face . . . was like a beautiful empty house waiting for carpets and pictures. It had all the possibilities—it could become a palace or a brothel." She had legions of lovers, including Maurice Chevalier, Douglas Fairbanks Jr., John Gilbert, Jimmy Stewart, General James Gavin, Joseph P. Kennedy, Adlai Stevenson, Edward R. Murrow, and Yul Brynner. "In Europe it doesn't matter if you're a man or a woman," she said. "We make love with anyone we find attractive." Among the women she found desirable were Edith Piaf, Ginette Spanier, and Mercedes De Acosta.

And yet Dietrich remained at the core untouchable. "Close as we became," recalls actor Michael Wilding, who appeared with her in *Stage Fright*, "there was an unfathomable quality about Marlene, a part of her that remained aloof." Indeed, of the many legendary nuggets about Dietrich, one of the most riveting was that the floor of her bedroom was flooded with light so that her lovers could find their shoes and socks when they prepared to leave. But the bed and Dietrich always remained shrouded in darkness.

Of all the roles she played, her finest performance was during World War II when the love goddess became a version of Mother Courage. In 1936 she found she had an ardent fan in the form of Adolf Hitler, whose favorite film was reportedly *The Blue Angel.* He sent word that he wanted her to return to Germany to become the queen of Third Reich cinema at an astronomical salary. Dietrich declined, for she saw Nazism "bringing out the inhumanity that resides in Germans." Instead, she pledged her allegiance to America and became a citizen in 1937.

In 1943, after putting most of her possessions up for auction so that her family would have money to live on, Dietrich joined the USO. As usual she took her duty to the limit and played the role of soldier with aplomb, becoming one of the key morale boosters of the war. Dressed smartly in khaki, she toured the European and North African war theaters, visiting front-line hospitals and entertaining the troops.

No front line was too dangerous for her. With shells bursting in the background, she would appear on stage in uniform, then pull from an overnight bag a pair of evening shoes and a gossamer sequined gown that was slit up

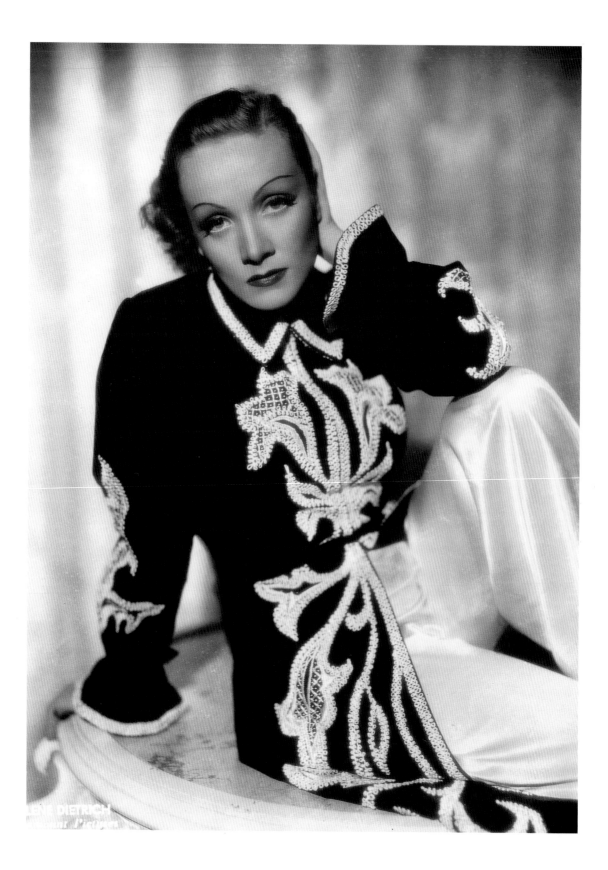

LENE DIETRICH

the front. She would start to change in front of four thousand sex-starved soldiers. Danny Thomas, her costar, would then pull her behind a screen. Seconds later Dietrich would emerge singing "See What the Boys in the Back Room Will Have," her famous tune from *Destry Rides Again.* Then she mesmerized the GIs by belting out "Lili Marlene," and she drove them wild when she sat down to play her musical saw, hiked her slinky gown up to her thighs, and put the instrument between her gorgeous legs.

In these shows, Dietrich became an object of desire for thousands of young men. It didn't occur to them that, at forty-two, she was old enough to be their mother. Along the way she caught pneumonia, suffered a severe jaw infection, had a dose of crabs, endured frostbite, and, like her soldier boys, washed her face and hair in snow melted inside her helmet and slept in a sleeping bag in rat-infested huts.

Dietrich's war work made her a traitor in the eyes of the German people. In Maximilian Schell's 1985 documentary *Marlene,* he asked her why she had turned against her country. "It was very simple: they were killing women and children," she told him. Her hatred of the Third Reich would remain an obsession for the rest of her life.

After spending a year with the troops, Dietrich returned to America in July 1945 (she was the first woman ever to receive the Medal of Freedom), and as a result of having been an employee of the U.S. government, she returned to Hollywood broke.

But her wartime service gave her box office appeal. From 1948 until 1978, when she went into permanent seclusion, she made thirteen films. Some of them were small parts or cameo appearances but she gave memorable performances in several movies: *A Foreign Affair*

(1948), *Stage Fright* (1950), and *Witness for the Prosecution* (1958).

Having started out in life as a musician and played numerous cabaret singers in films, it was somehow fitting that in 1953 Dietrich's career as a star would come full circle when she launched her career as a chanteuse and became the world's highest-paid nightclub performer. For the next twenty-two years she toured the world, singing in English, French, German, and Hebrew, playing to packed houses and acquiring a new generation of fans who were too young to remember her as Shanghai Lily. Her theatrical performances proved what had always been true: Dietrich was a complete entertainer. Unencumbered by plot and character, she could do what she did best: portray Marlene Dietrich.

In this third act of her career, she built an artifice that would make her seem ageless. Garbo stopped herself in time and perpetuated her myth by retreating; Dietrich stopped time itself by strapping herself into skintight body girdles and form-fitting gowns. Even the voice was an illusion, for in reality she was not a gifted singer.

Sternberg had used lighting and camera angles to help her perform his magic. In this final phase of her career, Dietrich was no longer the Sorcerer's Apprentice. She had surpassed her mentor. As she progressed into her seventies, her act became like a form of open magic. She was giving her audience a wink, as if to say, "We all know I'm old, but I'm going to create a grand illusion for you." Faced with her glamorous, smoldering aura and astounding professionalism, the audience became willing dupes.

Dietrich clearly understood what she was doing. Once during a show in New York a

DIETRICH WEARING Christian Dior, who designed for her both on and off the screen during the 1950s.

man sitting close to the stage raised his binoculars. She stopped the performance and said, "You don't have to do that. Don't kill the illusion."

This work had its costs. She fell off the stage several times, breaking her hip. She suffered from circulation problems. She began to drink heavily. By 1975 she knew she was no longer able to maintain the illusion, so she retired, settling into an apartment in Paris. After fracturing her hip joint in 1979, she refused any physical therapy and took herself to bed until she died in her sleep in 1992.

In 1959 the Museum of Modern Art in New York called its spring film series "Marlene Dietrich: Image and Legend." It was an unprecedented tribute. She was not yet sixty, she had never received an Academy Award, and no star had yet been the focus of a retrospective. Dietrich attended the opening night gala and addressed the audience. "I don't ask you whom you were applauding—the legend, the performer, or me," she said. "I, personally, liked the legend."

That was clever rhetoric; for Marlene Dietrich always insisted that who she really was had nothing to do with "Dietrich." The real woman, Maria Magadalena Dietrich, was, she said, "always indifferent to the glitter of fame. I found it troublesome, crippling, and dangerous. I detested it."

For all that, Dietrich's denial aided in the creation of the myth: the cool, jaded, worldly woman. By believing she disliked her fame, she was able to mask the devotion and arduous work that went into creating one of the most powerful personas in the history of film.

Bibliography

In addition to the titles listed below, I gathered mountains of information from movie magazines, film periodicals, newspaper clippings, and the research collections of the Academy of Motion Picture Arts & Sciences' Margaret Herrick Library in Los Angeles.

Bach, Steven. *Marlene Dietrich: Life and Legend.* New York: William Morrow, 1992.

Bailey, Margaret, J. *Those Glorious Glamour Years.* New York: Citadel Press, 1982.

Basinger, Jeanine. *A Woman's View: How Hollywood Spoke to Women 1930–1960.* Hanover, N.H.: Wesleyan University Press, 1993.

Bennett, Joan, and Lois Kibbee. *The Bennett Playbill.* New York: Holt, Rinehart, and Winston, 1971.

Bruno, Michael. *Venus in Hollywood: The Continental Enchantress from Garbo to Loren.* New York: Lyle Stuart, 1970.

Carr, Larry. *Four Fabulous Faces.* New York: Galahad Books, 1970.

———. *More Fabulous Faces.* New York: Doubleday & Co., 1979.

Crawford, Christina. *Mommie Dearest.* New York: William Morrow, 1978.

Crawford, Joan. *My Way of Life.* New York: Simon & Schuster, 1971.

Dietrich, Marlene. *Marlene.* New York: Grove Press, 1987.

———. *Marlene Dietrich's ABCs.* New York: Doubleday & Co., 1962.

Eels, George. *Ginger, Loretta, Irene and Who?* New York: G.P. Putnam, 1976.

Engstead, John. *Star Shots.* New York: E.P. Dutton, 1978.

Fairbanks, Douglas, Jr. *The Salad Days.* New York: Doubleday & Co. 1988.

Flamini, Roland. *Thalberg: The Last Tycoon and the World of MGM.* New York: Crown Publishers, 1994.

Fox, Patty. *Star Style: Hollywood Legends as Fashion Icons.* Santa Monica, Cal.: Angel City Press, 1995.

Griffith, Richard, *The Movie Stars.* New York: Doubleday & Co., 1970.

Guiles, Fred Lawrence. *Joan Crawford: The Last Word.* New York: Birch Lane Press, 1995.

Harris, Warren, G. *Gable and Lombard.* New York Simon & Schuster, 1974.

Head, Edith, and Jane Ardmore. *The Dress Doctor.* Boston: Little Brown & Company, 1959.

Head, Edith, and Paddy Calistro. *Edith Head's Hollywood.* New York: E.P. Dutton, 1983.

Bibliography

Hepburn, Katharine. *Me.* New York: Alfred A. Knopf, 1992.

Hopper, Hedda. *From Under My Hat.* Garden City, N.Y.: Doubleday & Company, 1952.

Hudson, Richard, and Raymond Lee. *Gloria Swanson.* New York: Castle Books, 1970.

Kanin, Garson. *Hollywood.* New York: Viking Press, 1967.

Kobal, John. *People Will Talk.* New York: Alfred A. Knopf, 1986.

Lambert, Gavin, *Norma Shearer: A Life.* New York: Alfred A. Knopf, 1990.

Leaming, Barbara. *Katharine Hepburn.* New York: Crown Publishers, 1995.

Madsen, Axel. *Gloria and Joe.* New York: Arbor House, 1988.

Mordden, Ethan. *Movie Star.* New York: St. Martin's Press, 1983.

Newquist, Roy. *Conversations with Joan Crawford.* Secaucus, N.J.: The Citadel Press, 1980.

O'Connor, Patrick. *Dietrich: Style and Substance.* New York: E.P. Dutton, 1991.

Ott, Frederick, W. *The Films of Carole Lombard.* Secaucus, N.J.: Citadel Press, 1972.

Paris, Barry. *Garbo.* New York: Alfred A. Knopf, 1995.

Parrish, Robert James. *The Hollywood Beauties.* New York: Arlington House Publishers, 1978.

Quirk, Lawrence, J. *The Films of Joan Crawford.* Secaucus, N.J.: The Citadel Press, 1968.

———. *Norma: The Story of Norma Shearer.* New York: St. Martin's Press, 1988.

———. *Claudette Colbert: An Illustrated Biography.* New York: Crown Publishers, 1985.

Riva, Maria. *Marlene Dietrich.* New York: Alfred A. Knopf, 1993.

Sands, Frederick, and Sven Broman. *The Divine Garbo.* New York: Grosset & Dunlap, 1979.

Swanson, Gloria. *Swanson on Swanson.* New York: Random House, 1980.

Swindell, Larry. *Screwball.* New York: William Morrow and Company, 1975.

Thomas, Bob. *Joan Crawford.* New York: Simon & Schuster, 1978.

Trent, Paul. *The Image Makers.* New York: Bonanza Books, 1982.

Tynan, Kenneth, *Profiles.* Introduction by Kathleen Tynan. London: Nick Hern Book/Walker, 1989.

Walker, Alexander. *Stardom: The Hollywood Phenomenon.* New York: Stein and Day, 1970.

Credits

There are many photographers, both well-known and anonymous, who created the drama and glamour of Hollywood, but it is the people from the photo and film archives who have kept the legacy alive. I am grateful to the following people for their patience, attention to quality, and unrestrained access to their collections.

—Ellen Horan, Photograph Editor

Douglas Whitney; Kristine Krueger and Robert Cushman at the Academy of Motion Picture Arts and Sciences; Lorraine Mead, Elaine Soares, Charlie Schieps, and Jennifer Bressler at Condé Nast Publications; Ethylene Staley at the Staley-Wise Gallery; Lydia Cresswell-Jones at Sotheby's, London; Jack Woody at Twelvetrees Press; Marc Wanamaker at Bison Archives; Neal Peters at the Neal Peters/Lester Glassner Collection; Ron Harvey at the Everett Collection; Ron Mandelbaum at Photofest; Bob Cosenza at the Kobal Collection.

GLORIA SWANSON

Pages 14, 16, 19, 22, 26 (left), 34: Courtesy of Douglas Whitney. 16, 26 (top left and bottom): Everett Collection. 21: Photograph by Edward Steichen; courtesy *Vogue*; copyright © 1927 (renewed 1955, 1983) by the Condé Nast Publications. 26 (top right): Photofest. 27 (top): Marc Wanamaker, Bison Archives. 27 (center): Alfred Eisenstaedt, *Life* magazine, © Time Inc. 27 (bottom right), 33: Photograph by Ellen Graham, © Ellen Graham. 27 (bottom left): Kobal Collection. 30: Courtesy of the Academy of Motion Picture Arts and Sciences. 37: Photograph by Jack Mitchell, © Jack Mitchell. 38: Dennis Stock/Magnum.

JOAN CRAWFORD

Page 40: Everett Collection. 41, 55, 60: Marc Wanamaker, Bison Archives. 43: Clarence Sinclair Bull, Photofest. 44, 48 (center), 49 (right and bottom left), 52, 61, 62, 64, 65: Courtesy of Douglas Whitney. 45, 58, 48 (top right), 51: George Hurrell, Kobal Collection. 47: Cecil Beaton photograph, courtesy of Sotheby's London. 48 (top left), 56: Photographs by Edward Steichen; courtesy *Vanity Fair*; copyright © 1932 (renewed 1960, 1988) by the Condé Nast Publications. 48 (bottom left): Neal Peters/Lester Glassner Collection. 49 (top left): Photofest. 57, 67: Corbis/Bettmann. 66: George Hoyningen-Huene; courtesy Staley-Wise Gallery, New York.

NORMA SHEARER

Pages 68, 79, 82, 85, 87, 88, 89: Courtesy of the Academy of Motion Picture Arts and Sciences. 69, 76: George Hurrell; courtesy of the Academy of Motion Picture Arts and Sciences. 71: Everett Collection. 73, 80 (bottom): Kobal Collection. 80 (top), 81 (bottom right), 90: Courtesy of Douglas Whitney. 80 (center): Photograph by Edward Steichen; courtesy *Vogue*; Copyright © 1926 (renewed 1954, 1982) by the Condé Nast Publications. 81 (top right): Photograph by Edward Steichen; courtesy *Vogue*; copyright © 1932 (renewed 1960, 1988) by the Condé Nast Publications. 81 (left): Ruth Harriet Louise, Kobal Collection. 83: Clarence Sinclair Bull; courtesy of the Academy of Motion Picture Arts and Sciences. 91: Neal Peters/Lester Glassner.

CAROLE LOMBARD

Pages 92, 93: William Walling Jr., Kobal Collection. 95: Everett Collection. 97: Photograph by George Hoyningen-Huene; courtesy *Vogue*; copyright © 1934 (renewed 1962, 1990) by the Condé Nast Publications. 101: Courtesy of Jack Woody. 102 (top): Marc Wanamaker, Bison Archives. 102 (center left), 103 (top and bottom left), 108, 111: Courtesy of the Academy of Motion Picture Arts and Sciences. 102 (center right), 103 (right): Photofest. 102 (bottom), 106: Kobal Collection. 112: Corbis/Bettmann.

Credits

KAY FRANCIS

Pages 114: Elmer Fryer, Photofest. **115, 122 (top left), 123 (left), 124, 131:** Everett Collection. **119:** Gene Robert Richee, Everett Collection. **121, 122 (bottom), 123 (bottom):** Photofest. **122 (top right):** Neal Peters/Lester Glassner **122 (center left):** Courtesy Staley-Wise Gallery, New York. **123 (top right):** Courtesy of the Academy of Motion Picture Arts and Sciences. **126:** Photograph by Horst; courtesy *Vogue*; Copyright © 1932 (renewed 1960, 1988) by the Condé Nast Publications. **129:** Photograph by Edward Steichen; courtesy *Vanity Fair*; copyright © 1932 (renewed 1960, 1988) by the Condé Nast Publications.

DOLORES DEL RIO

Pages 134, 135, 139 (all), 141, 144, 146, 148, 149: Courtesy of Douglas Whitney. **137:** Everett Collection. **139 (top):** Marc Wanamaker, Bison Archives. **139 (bottom), 145:** Courtesy of the Academy of Motion Picture Arts and Sciences. **142:** Clarence Sinclair Bull; courtesy of the Academy of Motion Picture Arts and Sciences.

CONSTANCE BENNETT

Page 150: Photograph by Edward Steichen; courtesy *Vanity Fair*; copyright © 1933 (renewed 1961, 1989) by the Condé Nast Publications. **152, 159 (top right):** Courtesy of the Academy of Motion Picture Arts and Sciences. **151, 155, 158 (top right), 159 (top left and bottom left), 162, 165:** Courtesy of Douglas Whitney. **158 (bottom right):** Everett Collection **158 (left):** Photograph by Cecil Beaton; courtesy *Vogue*; Copyright © 1933 (renewed 1961, 1989) by the Condé Nast Publications. **159 (bottom right):** Pach Brothers, Everett Collection. **160:** Corbis/Bettmann.

CLAUDETTE COLBERT

Pages 166, 167, 171, 172, 173, 174 (top right and center left), 175 (top and left), 179, 183, 185: Courtesy of Douglas Whitney. **168:** Photograph by Edward Steichen; courtesy *Vogue*; copyright © 1929 (renewed 1957, 1985) by the Condé Nast Publications. **174 (top left and bottom right):** Courtesy of the Academy of Motion Picture Arts and Sciences. **174 (bottom left), 175 (right):** Corbis/Bettmann. **177:** Photofest. **180:** Photograph by Toni Frissell; courtesy *Vogue*; copyright © 1940 (renewed 1968, 1986) by the Condé Nast Publications.

KATHARINE HEPBURN

Page 186: Photograph by Ernest Bachrach. Copyright © the Condé Nast Publications. **187:** Neal Peters/Lester Glassner Collection. **189:** Photograph by Edward Steichen; courtesy *Vogue*; copyright © 1932 (renewed 1960, 1988) by the Condé Nast Publications. **190:** George Platt Lynes; collection of Jack Woody. **194, 197 (top):** Everett Collection. **196 (top right and top left):** Copyright the Condé Nast Publications. **196 (bottom):** Photograph by Edward Steichen; courtesy *Vogue*; copyright © 1934 (renewed 1962, 1990) by the Condé Nast Publications. **197 (center left):** Courtesy of the Academy of Motion Picture Arts and Sciences. **197 (center right):** Photograph by George Hoyningen-Heune; courtesy *Vogue*; copyright © 1934 (renewed 1962, 1990) by the Condé Nast Publications. **197 (bottom):** Neal Peters Collection. **198:** Lusha Nelson, Condé Nast Publications. **199:** Kobal Collection. **201:** George Hoyningen-Huene. **202:** Photograph by James-Daniel Radiches © James-Daniel Radiches.

GRETA GARBO

204, 216: Ruth Harriet Louise; courtesy Staley-Wise Gallery, New York. **205, 209:** Everett Collection. **207:** Kobal Collection. **210, 215, 219:** Courtesy of the Academy of Motion Picture Arts and Sciences. **212 (top left), 213 (center left):** Neal Peters Collection. **212 (top right):** Neal Peters/Lester Glassner Collection. **212 (center left, 213 (center right):** Corbis/Bettmann. **212 (bottom left), 218, 221, 223:** Cecil Beaton photograph, courtesy of Sotheby's London. **212 (bottom right):** Marc Wanamaker, Bison Archives. **213 (top right):** Clarence Sinclair Bull, Kobal Collection. **213 (bottom):** Photofest.

MARLENE DIETRICH

Page 224: William Walling Jr.; courtesy Staley-Wise Gallery, New York. **225, 228, 229:** Alfred Eisenstaedt; *Life* magazine, © Time Inc. **227, 231:** Kobal Collection **233:** Photograph by Edward Steichen; courtesy *Vanity Fair*; copyright © 1935 (renewed 1963, 1991) by the Condé Nast Publications. **234, 238, 240 (bottom), 242:** Corbis/Bettmann. **236 (top):** Photofest. **236 (bottom), 241 (bottom right):** Marc Wanamaker, Bison Archives. **237, 239 240 (center), 241 (top left), 244, 246:** Courtesy of Douglas Whitney. **240 (top):** Neal Peters/Lester Glassner Collection. **241 (bottom left):** Everett Collection. **247:** John Engstead; courtesy of the Academy of Motion Picture Arts and Sciences.

Index